ANCIENT EGYPT

FARID ATIYA

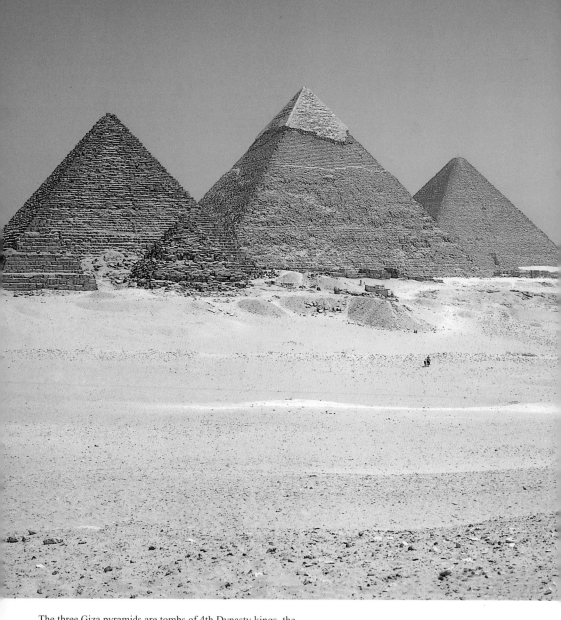

The three Giza pyramids are tombs of 4th Dynasty kings, the
farthest away is the Great Pyramid of Cheops, the middle
one is that of Chephren and in the foreground the pyramid of
Mycerinus. Clustering around the pyramids there are a great
number of smaller stone masonry tombs. In these were
buried the relatives of the king and the great court officials,
who assisted him in the government. These tombs reveal
many things. In the first place, they show that the Egyptians
believed in a life after death and to achieve such a life they
believed it necessary to preserve the dead bodies from
destruction. Their practice of "embalming", by which the
body was preserved as a mummy, springs from this belief.

ANCIENT EGYPT

FARID ATIYA

Ancient Egypt
Standard Edition
Farid Atiya

Text and Photographs by Farid Atiya
Published by Farid Atiya Press
© Farid Atiya Press
First Edition 2006

P. O. Box 75, 6th of October City, Giza, Egypt
email : atiya@link.net

Colour Seperation by Farid Atiya Press
Printed and bound in Egypt by Farid Atiya Press

JUN

2007

Dar el-Kuteb Registration 14523 / 2006
ISBN 977-17-3634-5

4

Contents

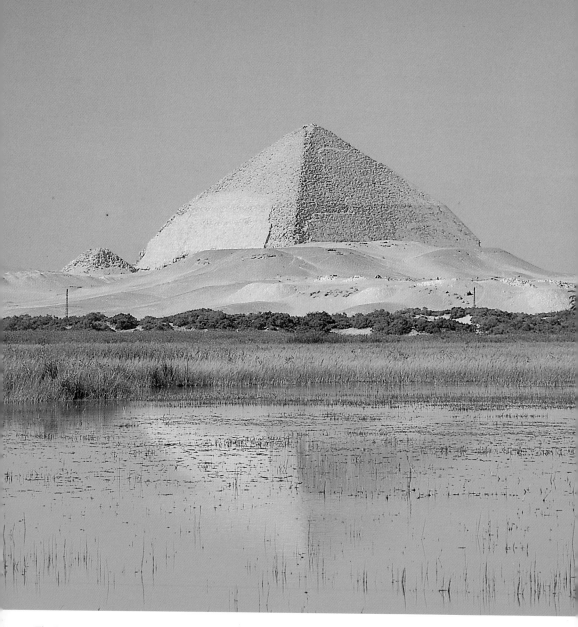

The Bent Pyramid of Dahshur with the lake in the foreground. The pyramid was built by Snefru, founder of the 4th Dynasty. He reigned from 2613 - 2589 BC.

Preface

Adding yet another book on Egypt to those already published may appear presumptuous. Despite the great number of scholars who have devoted themselves to the study of the antiquities of Egypt, other authors and publishers have treated the subject lightly. This book portrays images of the actual sights and thus aims to enhance the readers' interest in ancient Egypt. We invite the reader to accompany us around Egypt. "Enchanting and peculiar" it remains to this day, as when Herodotus, the father of history, declared that the valley of the Nile contained more marvels than any other country.

This publication is not intended as a guide book. The sites of interest are listed according to their geographic location and not chronologically. A brief account of the history of ancient Egypt is also given. The description of a tomb or a temple is supplemented with a concise history of its bearer. We have included a resume of the creation myths as well as the myth of Osiris, the Great Ennead of Heliopolis, a of the gods, the Hereafter, the Cult of the Dead, the night journey of the sun and the resurrection of the dead. An account is also given of the cult of Isis at Philæ which had survived till the sixth century AD in addition to a summary of the Hieroglyphic language.

The of the ancient Egyptians in such fields as architecure, reliefs and sculpture is widely emphasised through the high quality of the pictures. Those who already know Egypt will review familiar pharaonic sites by means of the excellent photography and those who hope to visit the Nile Valley may learn from these pages what they should see there. As for those who desire to learn something about egyptology; the sites of antiquity, the magic of the orient, the beliefs of the ancient Egyptians we hope that this picture book will be a stepping stone in their quest for knowledge.

Farid Atiya

For the ancient Egyptians the Nile was the main source
of the country's wealth. The Nile River flows for more
than 6500 kilometres in all. Two great streams, the
Blue Nile with its source in Ethiopia and the White
Nile in Uganda and Lake Victoria, converge to form it.
They unite at Khartoum to become the Nile proper and
from there the river flows for more than 3000
kilometres to the Mediterranean. From Khartoum it
gushes through a valley, which is surrounded by barren
mountains and desert. Thus it has formed in the midst
of a barren landscape, a giant oasis that for thousands
of years has enriched this civilisation. The Nile
bestowed on Egypt its prosperity; and the surrounding
desert gave it security.

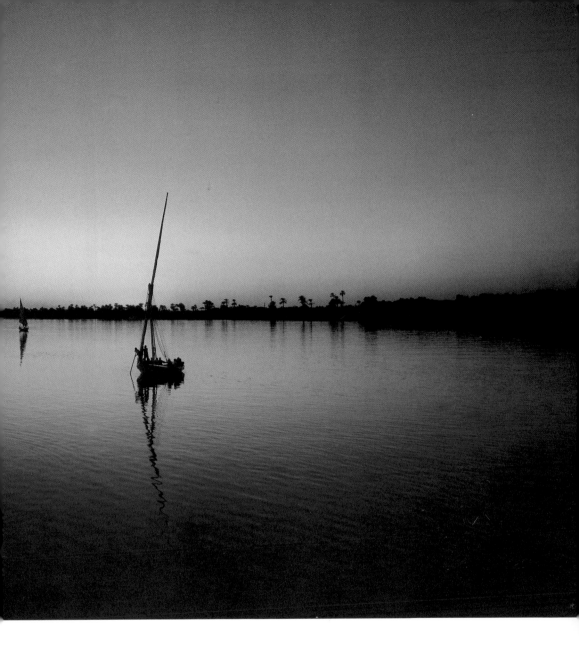

Above: Ancient Egypt, an arid waste of desert extending over thousands of kilometres, left man almost nowhere to live but along a thin green strip of land watered by the Nile. As the river flowed from south to north, from the First Cataract near Aswan, to the Delta north of Cairo, the fertile strip on each bank varied greatly. In some locations it spread less than 1 kilometre, while in other places it covered around 20 kilometres. In the Delta, a triangular network of river branches, fertile fields and vineyards extended for about 250 kilometres in width, but even this fades into insignificance compared to the vast desert beyond. To the farmers, the forbidding, inhospitable expanse of sand and rock that touched the boundaries of their fields was a fearful place.

Right : Statue of Father Nile (now in the Vatican): *Egypt Descriptive, Historical and Picturesque* by Georg Ebers, Leipzig 1879.

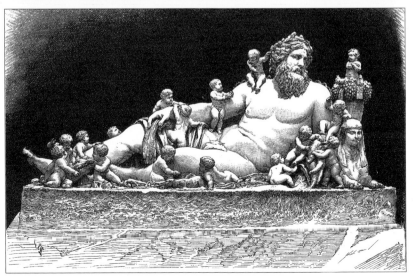

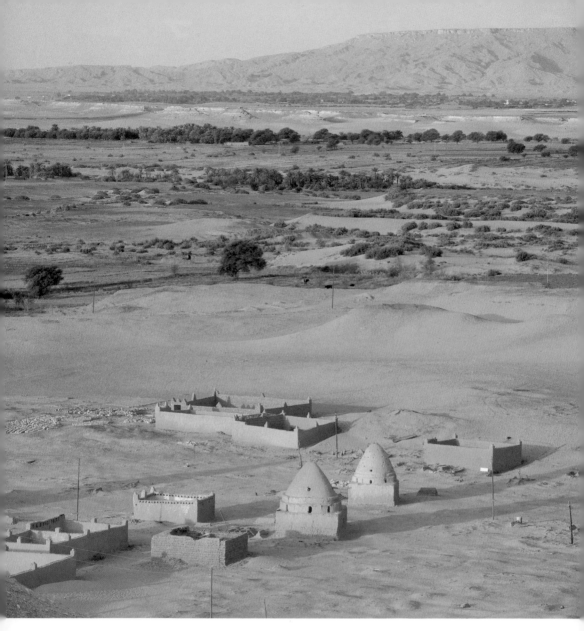

The Dakhla Oasis lies at the heart of the Western Desert. The Western Desert occupies 710 000 square kilometres or three quarters of the whole area of Egypt. About one half of the Western Desert of Egypt lies below 200 m in altitude and a few parts exceed 300 m. It comprises a series of plateaus the most important of which are three separated from each other by a depression. In the far south there is a big plateau of Nubian sandstone, the south western part of which is called Gebel Uwaynat (1907 m high). The rocks of this mountain are ingenious and metamorphic. The plateau is bordered on the north by a depression in which Dakhla and Kharga oases exist. The second plateau whose average height is 500 m is made up of limestone and chalk and has some depressions in which Bahariya, Farafra, Fayum and Wadi el-Rayan are found. Below the plateau there is a depression where Qattara deporession, Siwa oasis and Wadi el-Natrun lie, and some of these parts are below sea-level; Qattara which covers an area of several hundred square km is 134 m below sea-level. Bordering the depression north-ward there is another limestone plateau which is not so high as the second one and stretches to the vicinity of the coastline and its average height is about 200 m. These lowlands resulted from weathering factors. Among the most prominent features in the Western Desert is the formation of sand dunes which stretch from north to south with little deviation westwards.

The Western Desert is very arid and dry, and wells are found scattered. Wells must be dug to tap the water, and then cultivation is possible. The region is rainless except in the north coast.

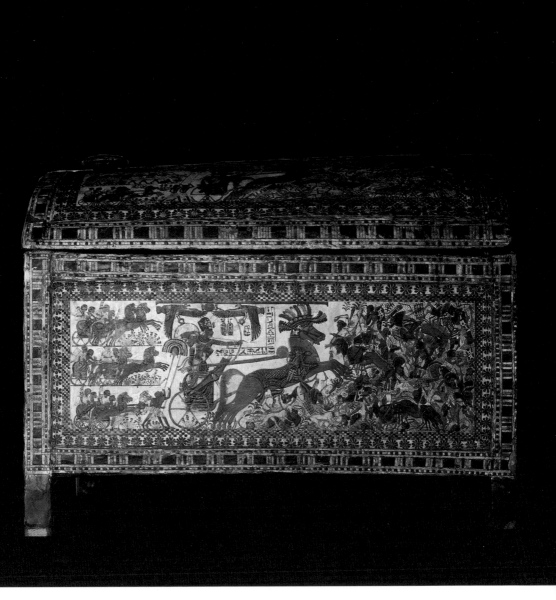

Painted chest of Tutankhamun, 18th Dynasty, 1334 - 1325 BC,
Stuccoed and painted wood, Egyptian Museum in Cairo.
On one of the longer sides of the chest Tutankhamun is
represented in his war chariot slaughtering his southern Nubian
enemies. He is supported by fan-bearers, charioteers and bowmen
and above him are the protective *Nekhbet* vultures and the sun
disk encircled by royal *uraei* with pendent *shen* sign, a symbol of
eternity. The other longer side is similar except that the pharaoh is
slaughtering his northern Asiatic enemies. While the defeated
enemy is fleeing in chaos, the pharaoh in his chariot is represented
in magnified dimensions dominating the scene. Scenes on the side
panels represent the pharaoh as a sphinx trampling his enemies. In
the centre of each panel are the two cartouches of Tutankhamun.

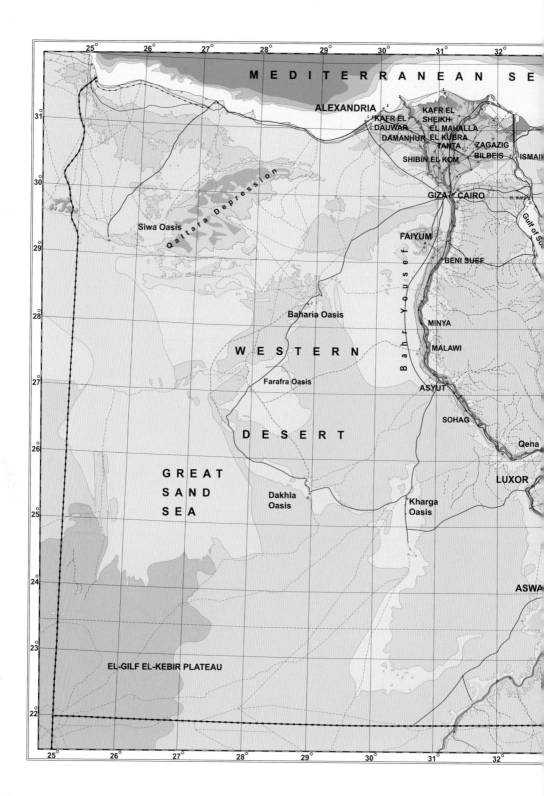

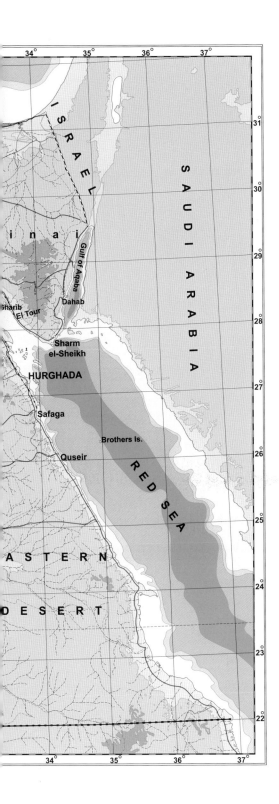

34° 35° 36° 37°

I S R A E L

S A U D I A R A B I A

31°
30°
29°

Gulf of Aqaba

i n a i

Sharib
El Tour
Dahab

28°

Sharm
el-Sheikh

HURGHADA

27°

Safaga

Brothers Is.

26°

Quseir

R E D S E A

25°

A S T E R N

24°

D E S E R T

23°

22°

34° 35° 36° 37°

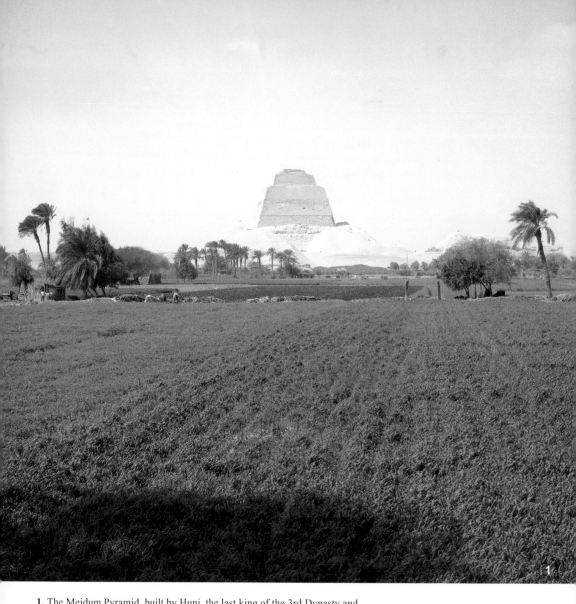

1. The Meidum Pyramid, built by Huni, the last king of the 3rd Dynasty and completed by Snefru the first king of the 4th Dynasty.

In the foreground we see fertile land planted with sillage. Egypt is a land virtually without rain. It is only irrigation that makes it possible for crops to grow and men to live. One of the earliest official positions in Lower Egypt was that of "canal digger", and a measure of a pharaoh's administration was how much land could the "canal digger" open up to the floodwaters of the Nile. To spread the supply of water, Egyptians trapped the flood in immense basins dug out of the earth, and applied primitive but ingenious water-raising mechanisms to get it to where it was needed.

2. Gate of one of the gardens at Farafra Oasis.

3. Acacia tree *Acacia nilotica*, White Desert, Farafra Oasis.

4. Acacia tree at Darb el-Assiout, linking Farafra Oasis with the Nile Valley.

5. Farms at Farafra Oasis are owned and run by the original families, who have grown fruit and dates for export from time immemorial, without changing their methods of farming.

Introduction

Egypt is unique with characteristics that are quite unlike those of other countries. Such are the spontaneous statements of the innumerable tourists and travellers, who have visited the country over the past two centuries.

Egyptian history covers more than 5000 years, many Pharaonic dynasties of both the Upper and Lower Kingdoms; the Greek and Roman periods; the Coptic Church; the rise and glory of Islam; the Turkish occupation; and in more modern times, starting with French and British influence followed by independence.

The Country

Contrasting with the great variety and diversity to be found in the Central European region, the Egyptian landscape shows clear-cut divisions. If physical contrasts are to be found anywhere on earth, it is in this north eastern corner of Africa, located between the Mediterranean Sea and the Sudanese border. The picture unfolds most clearly during a plane flight from Cairo to Luxor, or even as far as Abu-Simbel. Seen from the air, the majestic Nile River looks miniscule set in the midst of the unending desert, like a shining silver thread lying on the naked crust of the earth. Anyone who has seen from the air the narrow green strip of the Nile Valley held firmly in the embrace of the surrounding desert, will swiftly realize the importance of water for man's survival here.

Something of the same feeling may also be experienced on viewing the tops of the Sinai mountain peaks or the Western Desert. This desert stretches westwards like a boundless sea, comprising nothing but yellow sand and brown-grey rocks; almost like the shadow of death set in magnificent solitude. In the direction of the east, in the Delta and along the banks of the Nile shimmers "*the biggest, the greenest oasis in the world*".

Foreigners on first viewing the Nile Valley are often surprised, sometimes even a little disappointed. What can the desert, barren mountains and the fields of the river oasis possibly signify? The scenery does not entrance at first sight as it does in so many places in Europe. The desert is always the first thing the traveller sees. But is it really only barren earth and a wilderness? It comprises boundless expanses, not to be found anywhere in Europe. Its stillness and solitude can be overpowering. And the light over the desert! There in the very early morning hours such pure and limpid air can be enjoyed as nowhere else on earth. Then there is the play of colours in the evening sky as daylight fades. At first it turns to a transparent green, and then blends into a vivid glow slowly turning to a dark violet. A little later the dark night sky is pierced with the radiant brightness of the stars.

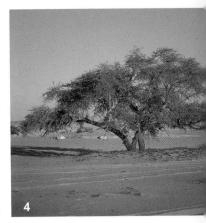

And what of the Nile Valley? Here one encounters the colourful world of the Orient. It is a world that moves at a rhythm, which is very different to that of the West, still based back in another century. Here in the villages are mud houses built from Nile silt surrounded by tall palm trees, and here and there a small white mosque with a slender minaret or, solitary on a low hill top, the white, washed shrine of a *sheikh*, while on the river or the canals glide the fellucas, those deep laden boats with the tall white sails. All this offers so much that is totally different and with such a strange enchantment, that he who has once seen the Nile Valley will retain an everlasting impression of it.

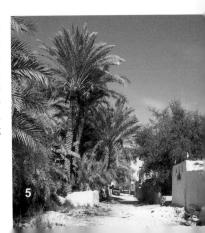

1. Sand dune at Kharafish, Dakhla Oasis. The afternoon light spreads a magical spell over the dunes. The angle of the sun's rays casts exaggerated shadows on the sand ripples. By midday the dunes appear flat and become not only monotonous but dangerous; they can deceive the eye, making driving hazardous. They can only be photographed to advantage either early or late in the day.

2 - 5. Mushroom-shaped rocks in the White Desert, Farafra Oasis. The trunk in picture 4 has almost weathered away.

In the Delta, as in Upper Egypt, everywhere along the edges of the desert, there still tower numberless monuments of one of the most ancient civilisations. No other country in the world has preserved so faithfully, and in such immeasurable abundance evidence of life as it was once lived. Long before the classical ages of Greece dawned, hundreds, nay thousands of years before, there stood on the banks of the Nile the great pyramids, sphinxes, temples and burial places, which are amongst the most important cultural achievements of mankind. At Giza, Memphis, Saqqara, Abydos, Dendera, Thebes (Luxor), Edfu, Kom Ombo, Aswan and many other places, we find these huge, powerful, mysterious and imposing creations, which deeply impress and often overwhelm the visitor to Egypt, be he or she a romantic or a realist.

Geography

Egypt covers an area of 1 million square kilometres, but 96 percent of this is mainly arid desert, swamp, or barren mountains. Only 3 percent is arable land. The country lies between latitudes 31.45° and 22° N. The greatest distance from north to south is 1427 kilometres, from west to east, 1210 kilometres. In the north, the country's shores are washed by the Mediterranean; on its western borders is Libya; in the south, the Sudan; the Red Sea forms its eastern boundary, and in the northeast is Israel. The Sinai Peninsula, already part of Asia, on the other side of the Gulf of Suez, is also part of Egypt.

The two frontiers in the west and the south, running through uninhabited desert regions, do not correspond to natural geographical data; they are simply straight lines between arbitrarily fixed points.

Egypt, in so far as the habitable part of the country is concerned, consists of a narrow river valley, which during the course of centuries has been cut into the tableland of north western Africa by the Nile. In prehistoric times the Mediterranean reached to the gates of the present day capital, Cairo, but over the course of time the region now called the Delta, 13,260 square kilometres, has been covered with the heavy fertile mud deposited during the annual Nile flood. North of Cairo (Lower Egypt), the Nile divides into two great branches (formerly there were seven): the Eastern or Damietta Branch and the Western or Rosetta Branch.

Between them lies a fertile marshland with a network of canals. South of Cairo, the Nile Valley is approximately 10 - 20 kilometres wide. The major part of the cultivated land, and also most of the towns and villages are on the western banks of the river. Towards the south, the valley gradually narrows until the fertile strip is no wider than 2 kilometres. South of Aswan (Nubia), mountains composed of one of the hardest granites in the world, impose limits on the river's boundaries.

The country is divided into Lower Egypt - the Nile Delta, and Upper Egypt - the Nile valley south of Cairo up to Aswan, and Nubia - from Aswan to the Sudanese frontier. The fertile part extends from the First Cataract near Aswan, to the Mediterranean coast. East and west it is bounded by the desert plateaux. To the east of the Nile Valley extends a mountain range with some peaks reaching up to a height of 2000 metres, close to the Red Sea. West to east trails (former caravan routes) run through deeply cut gorges. Owing to the lack of water this region is practically uninhabited. On the eastern side of the Gulf of Suez, these mountains continue in the southern part of the Sinai Peninsula. These are similar in composition and attain heights of up to 3000 metres. In the north they gradually descend into the Sinai Desert. For centuries Sinai was an important route from Egypt to Asia.

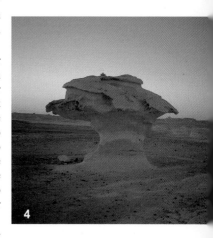

The Western or Libyan Desert crossed by high mountains is very different from the Eastern Desert. From the Nile Valley westwards stretches a tableland rising hardly above 300 metres. Here also are the great depressions such as Qattara and Wadi Natrun, which are below the level of the Mediterranean Sea. Only the big oases, Kharga, Dakhla, Baharia, Farafra, and Siwa, are habitable. Their populations live isolated from the Nile Valley and can only exist if the natural and artificial wells supply enough water to irrigate the soil.

To the west of this belt of oases, there is a region of huge shifting dunes, running northeast to southwest. They have, before now, occasionally buried whole villages. Towards the Libyan frontier this region is succeeded by

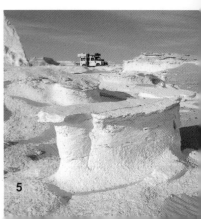

sandy desert. Here lie stretches which have hardly ever been visited by man.

The whole seaboard of Alexandria including the rocky cliffs near the port, and also many places on the Gulf of Suez, are composed of alluvial limestone or lime. The Nile Delta was formed by the deposit of fertile reddish-brown river mud, which has filled up the bay that many centuries ago extended up to Cairo itself. The arable soil of the Nile Valley is also of diluvial origin. The Nile mud is laid on top of the original sand and gravel layers. The northern parts of Libya, as well as the Eastern Desert, are covered entirely with this alluvial sand and gravel. While the region to the northwest of the Suez Canal, has been formed from Mediterranean Sea deposits. Only with the gradual receding of the sea could Port Said have come into being. The coasts of the Red Sea (Gulf of Suez) are in great part formed of coral reefs and the cliffs of Quaternary sedimentary deposits

South of the pyramids of Giza, at the foot of the Mokattam hills, Tertiary sand and sandstone are found. In the Mokattam range (Neolithic limestone) and petrified forests, of silicified wood, are found northwest of the desert Lake Qarun (near Fayum). South of Edfu (775 kilometres south of Cairo), a sandstone region of so-called Nubian sandstone, of several thousand square kilometres extends up to the Sudanese border. South of Aswan this sandstone area is interrupted by mountains (300 metres) composed of granite, one of the hardest in the world.

Between the Nile Valley and the Red Sea, gold mines and granite quarries have existed since ancient times. The mountains of the Eastern Desert, which have peaks rising to heights of up to 2187 metres, consist of crystalline rocks (granite, diorite, hornblende schist, gneiss). East and west of these are deposits of Nubian sandstone, marl and lime, and, towards the Nile Valley, limestone.

Between the Nile Valley and the string of oases from Kharga to Baharia, runs a tableland, rising up to 300 metres, whose rocks are of Neolithic limestone. The area is occasionally broken by shifting dunes. Towards the oases, the plateau slopes steeply. Near these oases whose soil is composed of sand, the fossilised remains of extinct plants and animals are to be found. The Nubian sandstone of Upper Egypt extends far into the Libyan Desert. To the west of the oases towards the Libyan border, begins a great sandy desert with dunes rising up to 110 metres in height. A limestone plateau stretches from Farafra Oasis to Siwa Oasis. The neighbourhood of Siwa consists of Tertiary deposits. The water under the Libyan Desert, brought to the surface by artesian wells, originated in rains which fell thousands of years ago in the hills of Western Sudan.

The Nile

"Egypt is the gift of the Nile" (Herodotus).

Without the Nile Egypt would have had no arable land at all. Without this river, which Egyptians lovingly, gratefully and reverently call "Father Nile," this now green oasis, supporting 65 million people, would be nothing but arid desert.

The Nile is the largest river in Africa and after the Mississippi-Missouri, the longest river in the world. It flows from south to north and is 6400 kilometres long. If you were to walk from its mouth to the source in central Africa, averaging 20 kilometres a day, it would take you nearly a year to reach your goal.

No other river has so strongly appealed to the imagination of man throughout the centuries. Up to the discovery of the sources of the Nile in the middle of the 19th century, the origin of the great river had been one of the great puzzles of mankind. The Romans had a very apt proverb to indicate the impossibility of any task or quest: *Caput Nili Quaerere* ("to search for the source of the Nile").

For Egypt the Nile is the source of life and its chief means of transport; from the point where it breaks through the barrier of granite at the Aswan cataract down to the Mediterranean Sea its length is about 1200 kilometres. Egypt's whole economy depends upon it; the Egyptian farmer cannot count on rainfall. In Upper Egypt rainfall is an exceptional phenomenon. Therefore, rain in the desert which filled the springs is considered a miracle. Here we remember an ancient Egyptian hymn blessing Min, Lord of the Eastern Desert as "the one who sends rain clouds". The hymn was inscribed on a rock in the quarries of Wadi Hammamat during the reign of King Nebheptre, 11th Dynasty, *c.* 2000 BC. The water supply of Egypt is regulated by the two bodies of the Nile, the Blue and the White Niles. The former flows down from the Abyssinian plateau through a deeply eroded valley, which enters the main river north of Khartoum in the Sudan. The White Nile has its sources in the great African lakes. The Blue Nile and to a lesser extent the White carry vast volumes of summer rains from June to September and hence bring the floodwaters to Egypt. Since the 1960's this water is held back by the High Dam at Lake Nasser. Thus this dam prevents the Nile from flooding Egypt. Throughout pharaonic times until the 1960's, the Nile flood determined the farmers' seasons. The year began with its rise and was divided into three seasons,

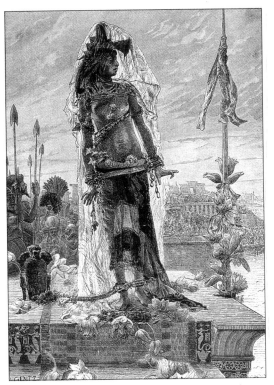

The sacrifice of the Nile: *Egypt, Descriptive, Historical and Picturesque* by Georg Ebers, Leipzig 1879.

Since very early times the pharaohs had understood the necessity of measuring the amount of the Nile inundations and nilometers for this purpose were built on the river's banks. The most famous were on Elephantine Island at Aswan and Rhoda Island now in Cairo. Herodotus tells us that the water must rise to about 16 cubits (approximately 8 metres), for the inundation to be considered a favourable one; if it remained below this mark the waters did not reach the higher fields in sufficient quantities; if it greatly exceeded this it broke through the dam walls and flooded the villages. Thus the priests could by reading the scale of the nilometer tell the farmer, who would not be expecting any rain, what the prospects of a good or bad harvest would be.

Consequently the taxes that had to be paid were calculated in proportion to the height of the river.

The priests announced the happy event to the people who waited in breathless anxiety. Festivals were held on this occasion from the remotest times. As part of the festivals, a coarsely moulded figure made of Nile mud called "the bride"; was thrown into the river with much rejoicing by the people, This was considered a substitute for a fair virgin richly dressed as a bride and cast into the river in return for its favours.

'Inundation', 'Going down of the Inundation', which was the cultivation period and 'Drought', which was the harvest period. The variation of the flood over the years meant either large crops or starvation. Therefore, it was of vital importance to study this natural phenomenon and if possible to regulate it.

According to ancient Egyptian beliefs all water is connected with Nun. The primal hill, the oldest hill, rose up out of Nun at the time of the creation of the world and was thus spoken as is written in the chapel of Hatshepsut at Karnak "Nothing was heard of it since the time when this land which has risen out of Nun was given boundaries". One of the favourite themes of Egyptian myth is that on this hill lived the primal god, who was also the sun god. Nilometers enabled the height of the inundation to be measured; the best known being the "House of Inundation" near Old Cairo. The nilometer gave an official reading to the administrations of ancient Egypt for their use, and there was another one on Elephantine Island at the end of the First Cataract. After extending Egypt's borders during the Middle Kingdom to the Second Cataract, an earlier observation of the approach of the impending flood was possible. But even when the Egyptians of the New Kingdom moved their borders to Napada near the beginning of the Fourth Cataract, the old ideas about the origin of the Nile were not abandoned. In the Ramesside period a sacrifice to the Nile certainly dating from primitive times was offered at Gebel Silsilah, south of Thebes, in the third month of the summer before the beginning of the inundation and again two months later. The reason for the sacrifice was 'not to have insufficient water'.

Astronomers of the Old Kingdom observed the event when the star Sothis (Sirius), after disappearing for 70 days, rose for the first time in the early morning before the sun had risen. This event marked the beginning of the inundation season. Hence they associated the 'rise of Sothis' with new year's day. They calculated a year to be 365 days, which they divided into 12 months each made up of 30 days, plus 5 additional ones. As time went by they noticed a shift by one day every four years or a full year after 1460 years. During the 5th Dynasty they adopted the sidereal year defined as 365¼ days to take account of this error. Observing the rising of Sothos was considered highly significant, because it marked the start of the inundation and the recording of the flood. Of great importance too was observation of the rising of the inundation and recording the maximum levels registered by the nilometers. From the time of the unification of Upper and Lower Egypt, these measurements were recorded. This was the key to the administrative organisation of the state and taxes were directly related to the flood level.

During the Archaic Period and in the Old Kingdom, the Nile was probably measured in the neighbourhood of Old Cairo. Lists written during the reign of Senusert I *c.* 1950 BC, give the following high figures for the height

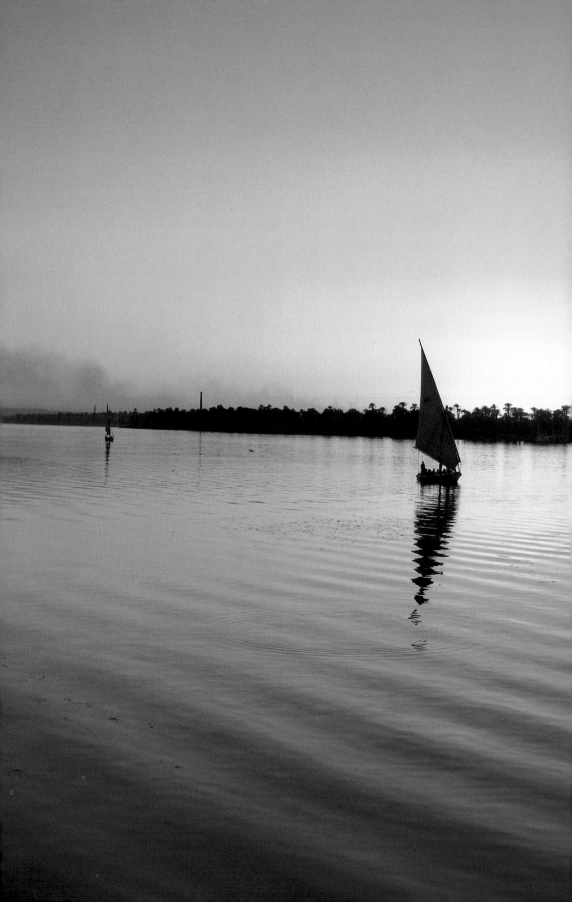

of the floodwaters at various sites on the Nile: Elephantine, 21 cubits, 3½ palms, (approximately 11.7 metres); 'the House of the Inundation' near Old Cairo, 12 cubits, 3 palms, 3 fingers, (about 6.5 metres); for Diospolis, the most northerly town of the Delta, 6 cubits, 3 palms, 3 fingers, (about 3.3 metres). The many measurements recorded up to Roman times reveal a further rise of about 20 - 30 percent, with the figures from Elephantine reaching 28 cubits; and for the 'House of Inundation' in Old Cairo, the measurements reaching 16 cubits. The increase can be explained by the rise in the level of the river's bed, which was calculated to be 10 centimetres per century. This rise was associated with the broadening of the river.

On the island of Sehel at Aswan a rock which carries the names of Djoser and Imhotep, was known as Dodekachoinos during the reign of Ptolemy V-Epiphanes, 187 BC. Today it is called the Famine Stela. The remarkable thing is that the cult of Djoser and Imhotep was still flourishing 2500 years after their deaths, right down to the end of the ancient Egyptian period.

The inscription on the Famine Stela states that there was a great famine during Djoser's reign, because for seven years there were no Nile floods. Djoser asked his chancellor Imhotep for his advice. His answer was that the king needed to gain the blessing of the god Khnum of Philæ, the birthplace of the Nile as only he had the power to fill the granaries of Egypt. Djoser took his advice and travelled to the First Cataract and offered a great sacrifice at the temple of Khnum. Almost immediately the Nile floodwater appeared achieving record levels and thus the country was rescued.

The real truth behind this text is that it was written during the Ptolemaic period when the priests of Khnum were fighting the rising power of those of the Isis cult. Therefore, it is regarded as a fictitious account aimed at halting the spread of the rival sect.

Each year the Nile River flooded with torrential rains that fell in Ethiopia flowed north and spread its waters over Egypt. The Greek traveller Herodotus wrote in the 5th century BC: "When the Nile inundates the land, all of Egypt becomes a sea, and only the towns remain above water, looking rather like islands of the Aegean. When the waters recede, they leave behind a layer of fertile silt 'black land' as the ancient Egyptians have called it, to distinguish it from the barren 'red land' of the desert".
Herodotus said "Egypt is the gift of the Nile". Without the Nile the country would have been barren. In antiquity Egypt was the richest country in the world. Like all nature's phenomena, the Nile could be a trial as well as a blessing. If the annual floodwater was too high, the spreading stream created havoc; if it was too low, the life-giving waters missed marginal areas, so there was less land to plant. If the low flood was repeated for several years, there was famine. The margin between relief and worry was thin. A few metres higher than usual might mean flooded villages, while a few metres lower might mean famine.

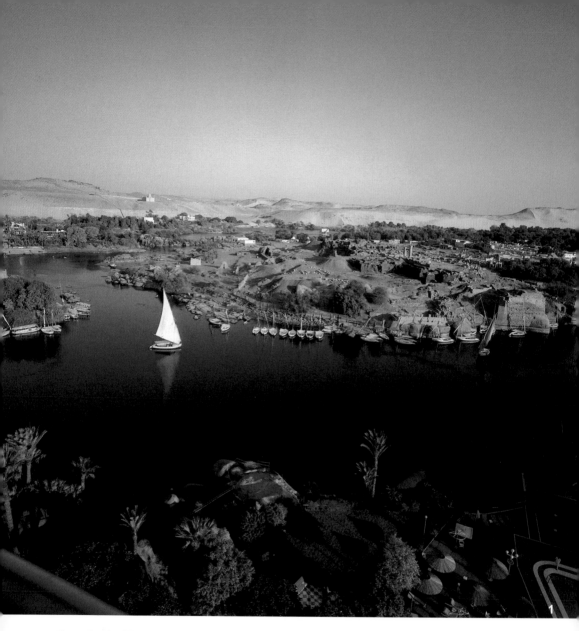

Control and utilization of the floodwater was performed in a number of ways: by building dams to protect certain parts of the countryside from flooding such as gardens and villages; by the construction of enclosed areas or basins to hold the floodwater; by digging canals for distributing water; and finally by digging wells and using the *shaduf*, to raise the water. Because these manmade constructions were carried out more easily in Upper Egypt than in the Delta, we think that the former had a more advanced administration and civilization. One of the oldest administrative titles in the *nomes* of Lower Egypt was that of the 'canal digger'. To make as much land as possible accessible to the floodwater was always regarded as the test of a good administration. The princely rulers of the *nomes* in the feudal era were proud of their achievements in irrigation, the more so if the neighbouring nomes suffered.

The fact that years of famine were invoked precisely at times of internal conflict shows how dependence on the floodwater created a unified state. Similarly today Egypt never allows the waters of the Nile to flow into foreign hands.

The value of land depended upon whether it was reached by the normal inundation, could be irrigated artificially, contained wells or lay alongside a canal. In estimating annual taxes, the state took into consideration

the varying productivity of the arable land and also the estimated harvest yield. Floodwater had to be kept away from villages, but it could cover all the land between the boundaries of the villages and the desert's edge.

The critical period for the farmer was the season called 'the coming ahead', which included the time when the flood reached its height and the subsequent start of sowing, when the farmers confirmed 'the earth had made its appearance and it is ready for ploughing'. The quicker the drying-out, the speedier were the ploughing and sowing. Hence it was in this season that the Egyptians celebrated their great festivals.

In the New Kingdom among the sins from which the judge in the underworld must relieve the dead before they could gain salvation are (as the 125th chapter of the Book of the Dead says): lessening of the arable area, falsifying the boundaries of arable land, illegal damming up of water and the selfish breach of water and land rights to the detriment of a neighbour.

The Egyptian monarchy was divine and consequently the king was the sole owner of the land. For example, on the jubilee of the king's accession, the *sed*-festival when he ran around a field ceremonially four times; an action called 'opposing the earth' in ritual texts, symbolized taking possession of the land anew. The king was accompanied by the warlike jackal god Wepwawet of Asyut, who represented Upper Egypt, while Lower Egypt was represented by the Apis bull of Memphis moving at speed. Here we can observe the contrast between the wild animal of Upper Egypt and the useful breeding animal of the Lower Egyptian farmer. The king could give a portion of his property as a gift. He might give land or cattle to family members or people of high social rank. All these royal gifts were transferred to particular persons and under no circumstances could the king take this property back.

A distinction was made between the so-called *khato* land, which was cultivated on behalf of the treasury and the 'land of the free', the *nmhi*. In this respect land belonging to temples was frequently called '*khato* land of the pharaoh' and in this way it belonged to the crown. We are unable to decide whether this meant that the land originally belonged to the king who had given it to the temple, or if it still remained his property.

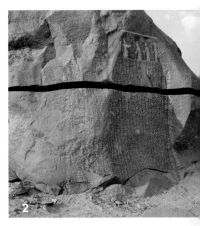

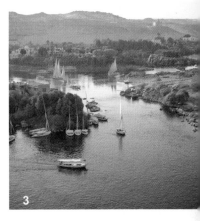

1 & 3. Elephantine Island and the Nile at Aswan photographed from the Cataract Hotel.

2. A rock bearing the names of Djoser and Imhotep on the island of Sehel at Aswan. It dates from the Ptolemaic era when the island was called Dodekachoinos. Today this rock is known as the Famine Stela. This dates to the reign of Ptolemy V-Epiphanes (187 BC). The remarkable thing here is that the cult of Djoser and Imhotep was still flourishing 2500 years after their deaths right up to the end of the ancient Egyptian period.

Overleaf :
1. Elephantine Island with the Aga Khan Mausoleum in the background.
2 & 3. The Old Cataract Hotel, Aswan.
4 & 5. Volcanic rocks near the First Cataract, Aswan.

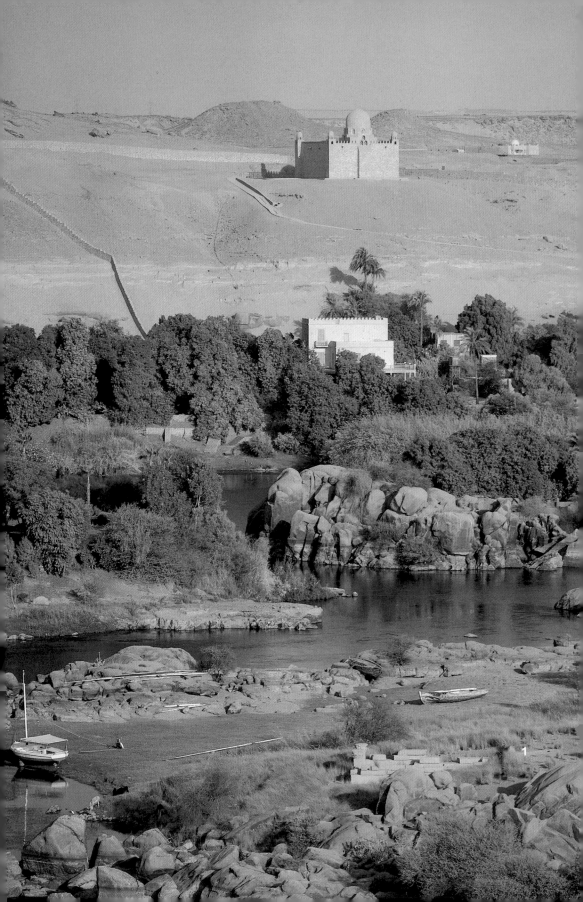

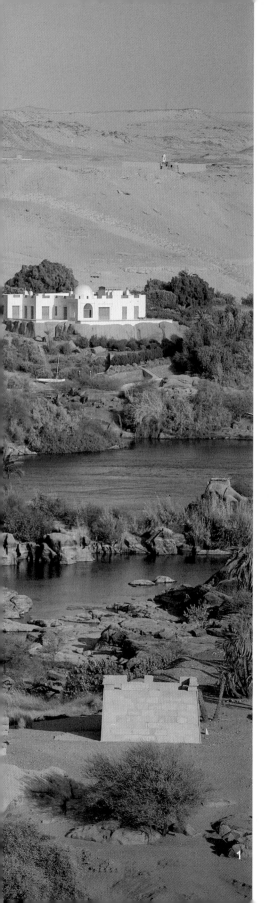

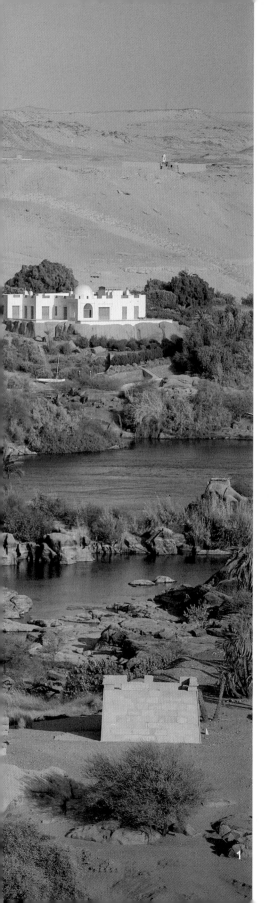

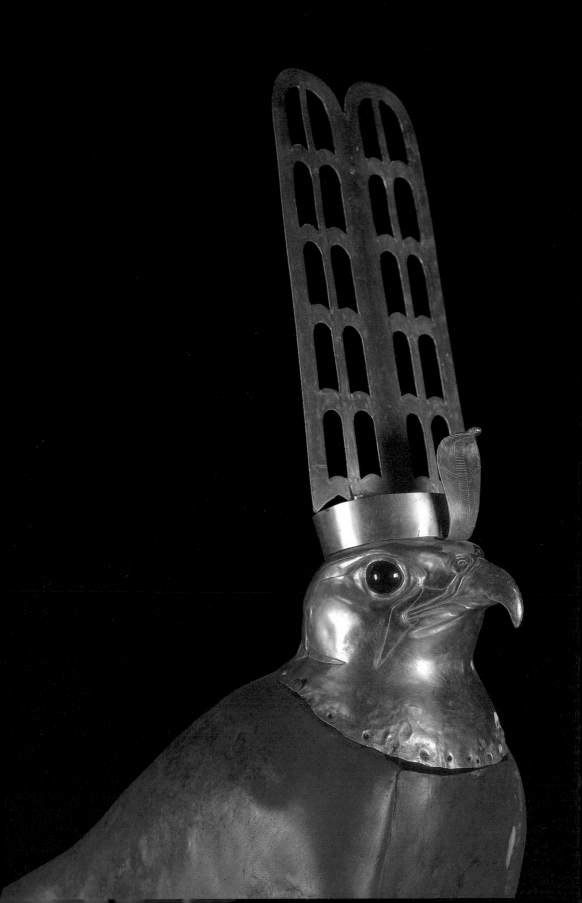

A Brief History of Ancient Egypt

The time during which the Egyptians were a people with a highly sophisticated civilisation was a long time ago. From the building of the pyramids to when Egypt became a Roman province something like 25 centuries had elapsed: a space of time we can better understand from our own historical viewpoint, when we remember that the same number of years would take us back into the prehistoric period.

Even the Egyptians with no regular method for calculating dates, had some difficulty in finding their way through these very long periods of time. They divided them into separate epochs, into dynasties during which the rulers were from the same reigning family. Later, the Egyptian dynasties were given numbers by a priest called Manetho, who wrote a history of Egypt for the Greek kings. We have retained this chronology, and accordingly speak of the 4th Dynasty, whose kings were the builders of the great pyramids, of the 19th, during whose reigns the hypostyle hall of the temple at Karnak was built, and of the 26th, the era of Psammetichus and Amasis. It is a practical expedient, but still only makeshift, and the true dates of the years can only be established roughly. If we say, for instance, that the 12th Dynasty reigned from 1991 to 1782 BC and the 19th from 1293 to 1185 BC that would be fairly correct, but it cannot be claimed that these statements are perfectly accurate.

Prehistoric Period

The Nile Valley has been inhabited by man since the early Stone Age (Palaeolithic period), but recognizable details of the oldest civilization, which may definitely be considered the first steps towards historical Egyptian culture, do not go back further than the Late Neolithic period. Large areas of the present day desert regions are supposed to have been covered with forests and meadows, thousands and thousands of years ago. Only when the rainfall diminished did the appearance of the land change. It is said that "a racially mixed population" inhabited the Nile Valley. From the Pre-dynastic period the earliest evidence of settled life is stone implements. Burial places date back to the Stone and Bronze Ages, and Egyptian history proper begins around the year 3150 BC (Pharaoh Menes). From then on the history of the country is divided into dynasties. Up to the conquest of Egypt by Alexander the Great in 332 BC, 30 dynasties had reigned over the land.

Head of a falcon
Gold and obsidian, H. 37.5 cm, Hierakonpolis, Old Kingdom, 6th Dynasty c. 2350 BC.
The Egyptian Museum in Cairo
This magnificent piece was discovered by Quibell in 1897. It was part of a bronze statue of the falcon god Horus of Nekhen. The head is chiselled from a single piece of gold. The beak is a second piece of gold that had been soldered into the head. The eyes are not made of two pieces of stones as one would imagine but of a single rod of obsidian. The curvature of both ends is polished in such a way to resemble the ferocious stare of a bird of prey. The crown and *uraeus* are fixed with rivets to the head. It is possible that the crown and *uraeus* were part of an interchangable ornament that were surmounting the cult statue according to different events. Other crowns could include the solar disk, the White Crown, the Blue Crown, or the *Atef* Crown. The body of the falcon is made of copper, and the head was fixed to the body with copper rivets.

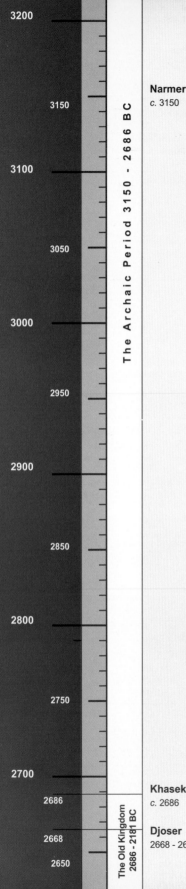

3200

3150

3100

3050

3000

2950

2900

2850

2800

2750

2700

2686

2668

2650

The Archaic Period 3150 - 2686 BC

Narmer
c. 3150

Khasekhem
c. 2686

Djoser
2668 - 2649

The Old Kingdom
2686 - 2181 BC

The Archaic Period, (3150 to 2686 BC)

According to historical records the first pharaoh of a united Egypt was Menes, a king of Upper Egypt, who united both Upper and Lower Egypt and ruled from Memphis. The Narmer Palette is the only contemporary record of this event, other testimonies were written many centuries later. The oldest of these is that of the Palermo Stone dating from the 5th Dynasty (*c.* 2400 BC) at least 700 years after Narmer's reign. Due to the lack of contemporary records, some scholars have suggested that Menes could have been a mythical figure who never existed. Narmer is the first historical dignitary in Egypt, the time before him is counted as prehistory. Thus with Narmer the history of Egypt begins. With the unification of Egypt, Narmer was transformed from an Upper Egyptian ruler into a national pharaoh. This new pharaoh had to consolidate his rule and ensure the total submission of his subjects. The tool that was used was to become a "divine pharaoh or ruler". The concept of divine kingship continued throughout the pharaonic period till Cleopatra's reign in 30 BC. Subsequently religion, government, society and art were, for the first time, clearly defined.

Also as history emerged from prehistory came the invention of the hieroglyphic script, which occurred at the same time as the unification under Narmer. The development of hieroglyphic script must have advanced in rapid steps. At this early stage grammar and spelling rules were not clearly formed. However, Emery has suggested that some evidence shows that the written language was by no means in its infancy at the beginning of the 1st Dynasty. If this claim is true then it is possible that hieroglyphics were originally written on materials such as wood or clay, which have perished with time and not on stone.

From the time of Narmer, all the kings used the image of Horus to symbolise their power while his brother Seth was spurned. Only Peribsen, a king of the 2nd Dynasty used Seth as a symbol and his reign was characterized by unrest and civil disorders, when the unity of Egypt fell apart. His successor Khasekhem or Khasekhemuy, the last king of the 2nd Dynasty was like Narmer possibly a mythical figure. He reunited Egypt under both Horus and Seth. To consolidate the reuniting of Egypt, he married a princess from Lower Egypt, who gave birth to the great Djoser, founder of the 3rd Dynasty.

Approximately 400 years separated Narmer, the first pharaoh of a united Egypt and Khasekhemuy, last king of the 2nd Dynasty. With Djoser, the successor of Khasekhemuy, Egypt entered a glorious period known as the Pyramid Age or the Old Kingdom. When we marvel at the pyramids, the Sphinx, the statues and achievements in art and religion in the Old Kingdom, we must consider it as the end rather than the beginning of a line of cultural development. Searching for the forerunners, we find the 400 years of the Archaic Period formed the bridge between history and prehistory.

The Old Kingdom, (2686 to 2181 BC)

Djoser came to the throne as a young man and with him the achievements of the 3rd Dynasty began and a new chapter in Egyptian history. There were no more internal conflicts and the country entered upon an era of peace and prosperity. In the following centuries a superb civilization developed. The priests of Heliopolis and the sun god Ra became an integral part of the royal family. The first became the most sacred site in all of Egypt. The king held the titles of the Hawk King, the Reed King, the Hornet King, and Lord of the Vulture and the Cobra.

Pharaoh Djoser, whose Horus name was Netjerikhe, extended Egypt's southern boundaries as far as Aswan. His most famous achievement was building the Step Pyramid, now regarded as the first large stone building ever built by man. The genius who planned and executed this pyramid was his *vizier* Imhotep.

During the 4th Dynasty (2613 – 2498 BC), during which nine pharaohs reigned, the greatest pyramids in the world were constructed. It was a time of considerable expansion of power. Pharaoh Snefru (2613 – 2589 BC), the founder of the 4th Dynasty, came to the throne by marrying Queen Hetepheres, a daughter of the Pharaoh Huni. Snefru's mother was a concubine of Pharaoh Huni. By marrying his half-sister, Snefru confirmed his blood right and legitimacy to ascend the throne. He was a legendary figure, and his reign seems to have been glorious. He was considered a kind and beloved pharaoh, and his cult flourished for centuries after his death. Snefru is the only pharaoh in Egypt who has four pyramids attributed to him. He completed the pyramid at Meidum, which was started by his predecessor Huni. He then built the Bent Pyramid and the Northern Pyramid at Dahshur. Snefru ruled Egypt for over 24 years.

Khufu, named Cheops in Greek (2589 – 2566 BC), was the son of Snefru and Queen Hetepheres. He chose the Giza Plateau for the building of his Great Pyramid in 2589 BC.

It is not clear how long the reign of Cheops lasted. The Turin Canon written 1,400 years after his death, states that his ruled for 23 years, but Manetho wrote that it lasted 63. Cheops was a charismatic ruler, and during his reign art and architecture flourished. His son Djedefre succeeded him to the throne.

Chephren (2558 – 2532 BC) was also a son of Cheops. He succeeded Djedefre, who reigned only briefly. Chephren's reign was considered a return to the traditions of Cheops. Chephren restored the royal necropolis to Giza where he built his pyramid and valley temple, and according to some accounts had the Sphinx sculpted. The creator who carved and polished this statue did so with great care, showing that he must have been skilled in many branches of knowledge. The hawk-god Horus spreads his wings protectively over the pharaoh's head, expressing the ideal connection between earthly and divine power.

The highest level of culture was reached during the 5th Dynasty (2498 – 2345 BC). The title "Son of the Sun" was then added to the other titles of the pharaoh. Magnificent temples were dedicated to the sun god Ra. Neuserre built a pyramid and a temple to the sun near Abusir. Priests and high officials became more prominent. Ti, the pharaoh's chief architect built his famous *mastaba* at Saqqara. The reign of Pharaoh Unas, whose pyramid is also at Saqqara, marked the end of the 5th Dynasty.

Following his death, internal conflicts arose and the royal power declined. Local princes and nobles grew in power and influence. One of the most important pharaohs of the 6th Dynasty (2345 – 2181 BC) was Teti (Othoes), who had been the manager of the royal domains before he usurped the throne. Pepi I conquered Nubia and pushed on into Sinai and Palestine. Towards the end of the reign of Pepi II, civil war broke out. The provincial princes gained independence and the empire fell into ruin. Thus after enduring some 505 years, ended the Old Kingdom.

The First Intermediate Period, (2181 to 2040BC)

Egypt was then ruled by a number of provincial princes, not one of them powerful enough to govern the whole country. The country weakened by a series of civil wars, declined from the 7th Dynasty to the middle of the 11th. The 8th Dynasty lasted about 30 years. The 9th and 10th were based in Herakleopolis, near the present day town of Beni-Suef, and the first pharaoh was Kheti I. During the first part of the 11th Dynasty ending about 2040 BC, Egypt was ruled by two royal families. The Kheti Dynasty reigned in the Nile Delta and in Middle Egypt up to Abydos, and the Intef and Mentuhotep Dynasty from Abydos to Aswan. There were civil wars until Mentuhotep I, from the south, finally overcame his enemies in the north and there was once more a pharaoh of the two realms, thus beginning the period of the Middle Kingdom.

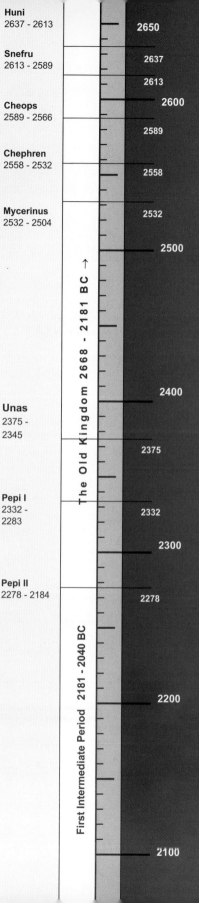

Huni
2637 - 2613

Snefru
2613 - 2589

Cheops
2589 - 2566

Chephren
2558 - 2532

Mycerinus
2532 - 2504

Unas
2375 - 2345

Pepi I
2332 - 2283

Pepi II
2278 - 2184

The Old Kingdom 2668 - 2181 BC

First Intermediate Period 2181 - 2040 BC

2650
2637
2613
2600
2589
2558
2532
2500
2400
2375
2332
2300
2278
2200
2100

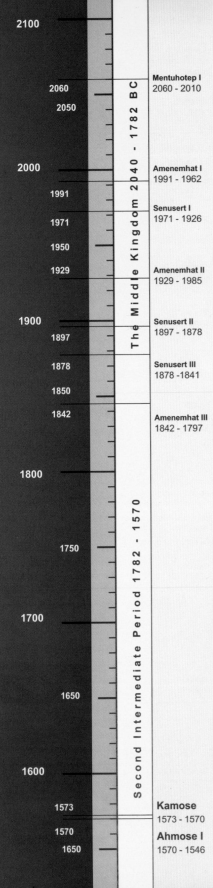

Timeline markings:

2100

2060
2050
Mentuhotep I
2060 - 2010

2000
Amenemhat I
1991 - 1962

1991
Senusert I
1971 - 1926

1971

1950

1929
Amenemhat II
1929 - 1985

1900
Senusert II
1897 - 1878

1897

1878
Senusert III
1878 -1841

1850

1842
Amenemhat III
1842 - 1797

1800

1750

1700

1650

1600

1573
Kamose
1573 - 1570

1570
Ahmose I
1570 - 1546

1650

Vertical labels on timeline: The Middle Kingdom 2040 - 1782 BC ; Second Intermediate Period 1782 - 1570

The Middle Kingdom, (2040 to 1782 BC)

Mentuhotep I (11th Dynasty), reigned for 51 years, for the first 10 years over Upper Egypt only and for the next 41 over Upper and Lower Egypt. He was succeeded by Mentuhotep II (2010 – 1998 BC) and Mentuhotep III (1997 – 1991 BC).

The 12th Dynasty developed into one of the most glorious of Egyptian history. Its founder was Amenemhat I (1991 – 1962 BC), who after a period of strife, restored peace and order in the country. There was a renaissance in architecture and masterly pieces were created in the minor arts of ivory carving, faience, gold and inlay work.

His successor Senusret I reigned for 45 years. He carried out successful expeditions into Nubia and extended the southern frontier to the Third Cataract. The most important temple of this period was that of the sun at Heliopolis. Nothing of it now remains except an obelisk standing near the village of Matareya. The historical events connected with the story of Sinuhe, a contemporary of Senusret I, belong to this epoch.

The most powerful king of the 12th Dynasty was Senusert III, who reigned from 1878 to 1841 BC. He waged war both in Palestine and Nubia, and extended the frontiers of Egypt as far as Syria. A period of peace and prosperity began during the reign of Amenemhat III (1842 – 1797 BC). Extensive dam building was undertaken at Lake Moeris and a nilometer was constructed to record the height of the yearly floods. This pharaoh was followed by Amenemhat IV (1798 – 1786 BC), and then by his sister, Queen Sebek-nefru (1785 – 1782 BC). The death of this queen marked the end of the Middle Kingdom, one of the classical periods of ancient Egyptian history. It was followed by the Second Intermediate Period.

The Second Intermediate Period, (1782 to 1570 BC)

There were 11 pharaohs of the 13th and 14th Dynasties (1782 – 1570 BC). Some of the 13th Dynasty pharaohs were called Sebek-hotep. For much of this period the country was still powerful, but then decline came from within. This began with an uprising of the "princes" or minor kings inst the pharaohs.

About 1663 BC an Asiatic people known as the Hyksos invaded the country, subduing the Delta and part of Middle Egypt. The Hyksos or Shepherd Kings, founded a capital at Avaris in the Delta. The first of these kings was Salitis, and the most important of his successors were Khayan, Apophis I, II, and III. The Hyksos assimilated much of the Egyptian culture but cruelly oppressed the native population. They introduced horses and war chariots into the country. At the same time Theban pharaohs of the 17th Dynasty (1663 – 1570 BC) reigned from south of Asyut to Aswan. The early pharaohs of this dynasty did no more than defend their frontiers against the Hyksos invaders, but the later sovereigns, Seqenenre I, succeeded in driving them out of the country.

The New Kingdom, (1570 to 1070 BC)

Under the rulers of the 18th, 19th and 20th Dynasties, Egypt developed into a great political power. Both the government and the life of the common people were completely reorganized. The wars waged successfully against the Hyksos transformed Egypt into an imperial state, a standing army being established with the pharaoh as its leader. This army, of which one part was stationed in the Delta and the other in Upper Egypt, was strong enough not only to drive out the Hyksos and extend the frontiers to Nubia, but also to subjugate some western Asiatic countries.

Innovations in the administration of the empire were also introduced. The head of state was the pharaoh; under him were the *viziers* (ministers), one residing at Thebes to administer the south from Asyut to the First Cataract, and the second in Heliopolis, responsible for the north, from Asyut to the Mediterranean coast. A viceroy was nominated for Nubia, and in the newly conquered regions of Asia

resident governors were installed. Through the tributes exacted from the provinces, enormous riches began to flow into Egypt. A very important position was now occupied by the High Priest of Amun, who often had great political influence and was the head of the whole priesthood. It was during the New Kingdom that great temples such as those at Karnak, Luxor and Thebes, Abu Simbel, Abydos and Memphis were built, temples destined to become great monuments of the period.

The 18th Dynasty lasted from 1570 – 1293 BC. Under its founder, Ahmose I, the Hyksos barbarians were finally driven out and Upper and Lower Egypt once more united.

Amenhotep I (1551 - 1524 BC) sent forces to Nubia to quell the revolts which had broken out there.

Tuthmosis I conquered Nubia as far as the Sudan, and in western Asia carried his arms to the very Euphrates. His tomb has been discovered in the Valley of the Kings at Thebes. He was the first of the pharaohs to have his rock-hewn tomb there. Tuthmosis I left two legitimate daughters and an illegitimate son, Tuthmosis II (1518 – 1504 BC), who married his half-sister Hatshepsut, a legitimate daughter, and thus became pharaoh. When Tuthmosis II died, his son Tuthmosis III, by another wife, was still very young, so Hatshepsut, who was at the same time his aunt, step-mother and eventual mother-in-law (as he married her daughter), declared herself co-regent, but actually usurped the throne. She was an extraordinarily able and strong queen. She ruled as the pharaohs did, and assumed all the royal titles claiming to be the daughter of the god Amun-Ra by Ahmose; she thus presents the oldest instance of theogamy. She erected the temple of Deir el-Bahari in the Valley of the Kings. After her death, Tuthmosis III had all the representations and inscriptions referring to her reign as well as her statues, defaced or destroyed. Her tomb is in the Valley of the Kings, but her mummy has not so far been found.

Since much of what happened at the beginning of the 18th Dynasty is based on no definite historical proof, there are various stories and suppositions about the life of Queen Hatshepsut.

About 1504 BC Tuthmosis III (1504 – 1450 BC) became absolute monarch. He is regarded as the most active and one of the greatest pharaohs in Egyptian history. For 17 years he was at war with Palestine and Syria, and the boundaries of Egypt extended from Nubia to the Euphrates. It was he who built the temple of Amun at Karnak.

While under Amenhotep II (1453 – 1419 BC) fighting was still going on in Asia, under his successors, Tuthmosis IV and Amenhotep III, an era of peace and tranquillity began. The wealth which had been accumulated in the country led to a greater refinement in the lifestyle and in artistic achievement.

Under Amenhotep III, known to the Greeks as Memnon, who reigned from 1386 – 1349 BC, mighty structures and colossal statues were erected, including the Luxor Temple, additions to the Karnak Temple, and a temple near Thebes, of which only the so-called Colossi of Memnon now remain.

Amenhotep IV (1350 – 1334 BC), who came to the throne at the age of 24, introduced in place of the old religion, the worship of the sun disk (the Aten) and changed his name to Akhenaten (Akhen-Aten). He transferred the capital from Thebes to Tell el-Amarna in Middle Egypt. His dislike of the old religion reached such a point that he erased the figure and name of Amun from monuments and persecuted the priests of this cult. He married Nefertiti. She first followed him to the new capital, Akhet-Aten, but later disagreements arose between them and finally led to separation.

Akhenaten reigned 16 years. During this time, art and language attained an unprecedented realism. Before his reign ended the Asiatic empire had collapsed, and after his death internal troubles arose in the country.

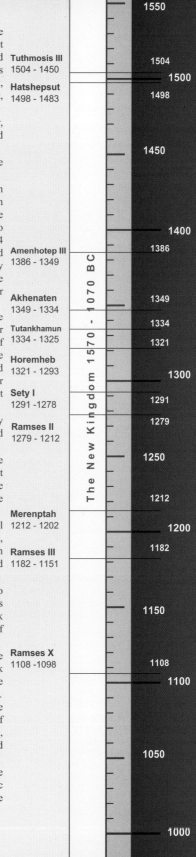

900

850

800

750

700

650

600

550

500

450

400

350

Late Period 1069 - 525 BC

Persian Rule 525 - 332 BC

One of his successors, Tutankhamun, returned to the old religion and the old capital, Thebes, after succeeding the previous pharaoh, Smenkhere, at the age of 9. He reigned until he was 18. His tomb, with his intact mummy and marvellous treasures, was discovered in 1922 in the Valley of the Kings by Lord Carnarvon and Howard Carter. Tutankhamun was succeeded by Ay; Horemheb, a general in the army during the last years of the 18th Dynasty, came to the throne after Ay, and restored order in the country. Horemheb was the last pharaoh of the 18th Dynasty, which had lasted 277 years. The 19th Dynasty covered the years from 1293 – 1185 BC. Horemheb had no son and was succeeded by Ramses I, a former general and *vizier*, whose reign lasted only two years, till 1291 BC. Sety I, his son, waged war against both the Libyans and the Syrians, and, for the first time, against the powerful Hittites of Asia Minor. He built temples at Abydos, Karnak and Qurna. His tomb is in the Valley of the Kings, and his mummy, in the Cairo Museum, is considered the most lifelike of all the royal mummies.

Under his son, Ramses II, Egypt attained her greatest political power. He reigned 66 years, from 1279 – 1212 BC, during which he waged several wars against the Hittites, afterwards marrying the daughter of the Hittite king. He married several other wives as well and had 110 sons and 59 daughters. He made Tanis, in the eastern Delta, his capital. Tremendous building activity sprang up all over the country. The most noteworthy achievements of the period were the Ramesseum at Thebes (one of the mightiest monuments in Egypt), Abu Simbel in Nubia, as well as others in Abydos, Memphis, Luxor and Karnak. Ramses II was followed by his son Merenptah (1312 – 1202 BC), who fought against the invading Libyans, and then by Amenmesses, Siptah and Sety II (1199 – 1193 BC). Then came a period of decline. After a short spell of anarchy at the end of the 19th Dynasty, a saviour appeared in the shape of an old man of unknown origin, named Setnakht, who founded the 20th Dynasty which lasted from 1185 to 1070 BC.

Setnakht, who reigned till 1182BC, re-established law and order. He was followed by Ramses III, who ruled till 1151 BC, and was the most important ruler of the 20th Dynasty. He continued the internal reorganization begun by his father, destroyed the Libyans, who twice attempted to invade the Delta and overthrew the Asiatic tribes threatening Egypt, as well as re-establishing Egyptian rule in Asia Minor. During the 22 years of his reign great buildings were constructed, including the temple of Medinet Habu at the southern extremity of the necropolis of Thebes. From 1151 to 1070 BC, while the pharaohs from Ramses IV to Ramses XI were ruling, the power of the priests of Amun was on a steady increase; the authority of the last pharaohs of the 20th Dynasty consequently declined, to such an extent that Hrihor, the high priest of Amun and at the same time chief of the army and *vizier*, became pharaoh after the death of Ramses XI, and thus the founder of the 21st Dynasty, at Thebes.

Late Period, (1069 to 525 BC)

The period of the 21st to the 24th Dynasties was one of decadence during which the empire broke up and finally fell under foreign rule. In the 21st Dynasty, Smendes (1069 to 1043 BC), a pharaoh of unknown origins reigned in the Delta. He was followed by Psusennes. At this time the high priests at Thebes had as much power as the pharaohs in the north. Towards the end of the 21st Dynasty, Egyptian rule in Palestine came to an end, and in the south, Nubia established its independence. Towards the end of the 20th Dynasty many Libyan families had settled at Herakleopolis. They had acquired wealth and power, and thus furnished the pharaohs of the 22nd Dynasty (945 to 715 BC). Bubastis (Tell Basta) in the eastern Delta became their capital. Towards the end of the 22nd Dynasty, the kingdom was torn by internal feuds and dissolved into small principalities. This was the time of the 23rd Dynasty (818 to 715 BC) of which little is known as is that of the 24th Dynasty from 727 to 715 BC. Around 721 BC, the Nubian King Pi'ankhi ruled in Upper Egypt. He invaded the rest of the country and took Memphis, establishing Nubian garrisons in all the important towns. During this last reign, the Assyrians successfully invaded the Nile Valley. The conquerors divided Egypt into several provinces, entrusting the government to native chieftains as their vassals. Near the end of the 25th Dynasty, Prince Psammetichus of Saïs succeeded in driving out the Assyrian invaders. The power of the chieftains was broken, and thus Egypt was again united under the 26th Dynasty (664 to 525 BC), and an epoch of renewed prosperity began. To guard

Egypt against enemies from without, Psammetichus (526 to 525 BC) posted garrisons at the frontiers, in the south against the Nubians, in the east against the Assyrians, in the west against the Libyans. It was at this time that trade with Greece began. In the domain of art, architecture, literature etc., the Egyptians turned to the Old Kingdom for their models, so that this period is known in history as the Egyptian Renaissance. Necho, who came to the throne in 610 BC, carried out an expedition into Syria advancing to the Euphrates, but was defeated at Karkemish by the King of Babylon. Necho returned to Egypt and henceforward devoted himself exclusively to art and commerce. He attempted to build a canal linking the eastern branch of the Nile to the Red Sea, but abandoned the task when the oracle pronounced against it. His successors were: Psammetichus II, 595 to 589 BC; Hophra (Apries), 589 to 570 BC; Amasis (Ahmose II), 570 to 526 BC; Psammetichus III, 526 to 525 BC. In the reign of the last-named, the Persian King Cambyses, son of Cyrus, invaded Egypt and Psammetichus was killed in battle. By the end of the 26th Dynasty, Egypt was a Persian province.

Persian Rule, (525 to 332 BC)

The 27th Dynasty or the first Persian period lasted from 525 to 404 BC. Cambyses was crowned king of Egypt and assumed all the titles of a pharaoh. His successor, Darius I (521 to 486 BC), also had himself crowned king. The Persians respected the religion of the Egyptians and thereby gained the support of a large proportion of the people. The Battle of Marathon fought on the eastern coast of Greece in 490 BC, ending disastrously for the Persians, had repercussions in Egypt. The Egyptians rose up and routed the invaders, but a few years later Xerxes I (480 to 465 BC) re-conquered the country. Under the reign of his successor Artaxerxes I, the Egyptians again tried to throw off the hateful Persian domination but were again beaten. It was only under Darius II that they managed to overthrow the Persians and regain their freedom. That event marked the end of the 27th Dynasty. It was during this period, in about 499 BC, that the Greek historian Herodotus visited Egypt.

The 28th Dynasty lasted only six years, until 399 BC, the reign of King Amyrtaeos, who resided at Saïs. In the 29th Dynasty (399 to 380 BC) the most important of the four kings was Hakor, who repelled a Persian invasion after three years of fighting. The 30th Dynasty the last of the long series of pharaonic dynasties, reigned from 380 to 332 BC. Nectanebo I, who ruled till 360 BC., routed the Persian army that invaded the Nile Valley under Artaxerxes II. His son Tachos or Teos, led an army of 80 000 Egyptians, 10 000 Greeks and 1000 Spartans into Syria. During this time, a revolt broke out in the country itself; Tachos fled to the Persian court and died there. The last ruler of the dynasty was Nectanebo II (360 to 343 BC) who, among other great works, built the temple of Philæ. The Persian king Artaxerxes III advanced into the Delta, captured Memphis, and took Thebes three years later. The Persians remained in power till 332 BC. In that year the conquest of Egypt by Alexander the Great marked the end of the Egyptian dynasties. A new era began; that of Greco-Roman rule.

Ptolemaic (Greek) Period, (332 to 30 BC)

Alexander was 24 years old when he entered Egypt, where he was welcomed by the population as a deliverer. When the world conqueror, who with his expeditions opened the epoch of Hellenism in the eastern world, visited the Oasis of Amun, now Siwa, in the Western Desert, in 331 BC, he was greeted by the priests as the "Son of Amun". His greatest achievement was the foundation of the city of Alexandria, named after him and built according to his plans. *"By the foundation of Alexandria, Alexander has increased his fame more than by his victories. It was the city which was to become the heart of·the universe."* (Napoleon). When Alexander the Great died in 323 BC, the great Macedonian empire declined. One of his generals, Ptolemy, a member of the lesser Macedonian nobility, took on the regency for Alexander II, son of the conqueror. Six years after the latter's death he assumed the title of king, thus founding the Ptolemaic Dynasty which was to rule for 300 years.

Under the first three Ptolemies, Egypt was not only the richest state and the centre of commerce, but also the cultural hub of the Old World. All the great minds of the time, philosophers, poets, famous physicians, geographers,

mathematicians and other men of science flocked to the metropolis on the Mediterranean, which, in the 3rd century BC, became the garden of the last flowering of the Greek civilization. The prestige of Athens was already diminishing and Rome was making every effort to take her place.

Under the Ptolemies many magnificent structures arose all over Egypt, but with Ptolemy IV (222 to 205 BC) a change began. The prodigality, riches and sumptuousness of the court, its lax morals and vicious lifestyle ended in decadence and anarchy. Through the constant dynastic quarrels from the 2nd century BC onwards, Egypt fell more and more under the influence of Rome.

Cleopatra

One of the most important figures of the last phase of Ptolemaic rule was Cleopatra VII. When Julius Caesar came to power in Rome, Cleopatra was 18 years old and sharing the Egyptian throne with her younger brother Ptolemy XIIIth. Both were under the tutelage of the Roman senate so when discord arose between the brother and sister, Rome intervened. After the murder of their guardian, Pompey, Caesar entered Alexandria in 47 BC in order to settle the Egyptian question. The then 22 year old queen was clever enough to gain the support of the 52 year old Caesar, using her beauty, intelligence and charm. Three years later, after Caesar's murder, she also won over Anthony who had been sent to Egypt with the same mission. She was no crueller than her forefathers, magnanimous in small matters, vengeful in great, highly educated in science and languages, but nevertheless a creature of instincts. She achieved everything by the use of her charms. Cleopatra has often been described as spending only years of pleasure and luxury in Alexandria with the great Romans. More recent and abler historians describe her as "a woman of exceptional genius". This young queen of Egypt was the most outstanding of all the successors of Alexander the Great. Anthony and Cleopatra, then 38 years old, committed suicide when Octavian, later the Emperor Augustus, was sent to Egypt to arrest Anthony, the enemy of his country. In 30 BC, Egypt became a Roman province, placed under the personal control of the emperor.

The Roman Period, (30 BC to 395 AD)

The Roman Emperors, like their Persian and Ptolemaic predecessors, ruled as the successors of the pharaohs. The country now supplied corn to Rome and thereby attained economic importance among foreign countries. In 24 AD, the Greek scientist Strabo visited the Nile Valley and wrote the first great work on the geography of Egypt. The Emperor Trajan (98-117 AD) restored the canal joining the Nile and the Red Sea. Hadrian, who visited the country in 130 AD, erected a number of buildings and in 176 AD Marcus Aurelius came to Alexandria to attend the lectures of the famous scholars there. As early as the middle of the 1st century Christianity had gained entrance to the land of the pharaohs. According to tradition, the church in Egypt was started by St. Mark the Evangelist. Christianity established itself firmly in the country at an early period, because the population saw in the new religion of peace, love and humanity, fresh hope for an end to the oppression it had so long suffered. Alexandria became the centre of the new faith just as it had previously been that of Greek civilization. It was in Egypt too, that monasteries and the hermit life-style first developed, at Thebes, on the Red Sea and in Wadi Natrun. In 395 AD the Roman Empire disintegrated and from then on Egypt formed part of the Byzantine Empire, with Byzantium (now Constantinople) as its capital.

Byzantine Rule, (395 to 640 AD)

Up to this time the traditions of the country had been respected, but during the two and a half centuries of Byzantine rule, a wave of destruction swept over the land. Temples and places of worship recalling the 3000 year era of the pharaohs were destroyed or converted into Christian monasteries and churches. A general decline set in and lasted through the 5th and 6th centuries. Byzantium, while making use of Egypt, was indifferent to the economic and cultural interests of the country. In 640 AD, the Arabs invaded the Nile Valley and brought Byzantine rule to an end. Egypt thus became a province of the caliphate.

Egyptian Art

This land of clear skies, simple landscapes, wide expanses and distant horizons cries out for such massive structures as the pyramids and sphinxes, the mighty temples with their giant columns, the great pylons and the colossal statues of kings. The Egyptian style is "in art, the simple monumental line, weighty and massive".

Temples

The Egyptian temple was always solely the "house of the god". Although many temples of the Old and Middle Kingdom periods have been destroyed, there is probably no other country in the world where sanctuaries dedicated to the gods or to a particular deity more than a hundred generations ago, are still preserved in such number as in Egypt. Most of the structures which the tourist can visit date from the New Kingdom or the Ptolemaic period.

The Egyptian temple consisting in its simplest form of an outer court, a sanctuary and the holy of holies, corresponds in its fundamental layout to the old Egyptian house; that is why it is the house of the god. The court

The Kiosk of Trajan in the island of Philæ dates back to the second century AD. The columns have beautiful plant decorated capitals. A stairway led down to the river. A relief on the southern side shows Isis standing outside her temple watching a crocodile bear the corpse of Osiris. Another relief on the north side shows a number of deities, including Isis and Nephthys, adoring the young falcon as he rises from his marsh; behind lies the stony mass of Biga, with the Nile god Hapi buried in a cave which is protected by a serpent who bites its tail.

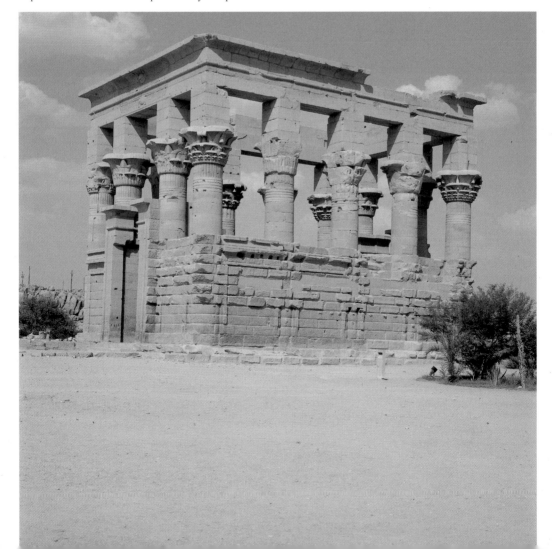

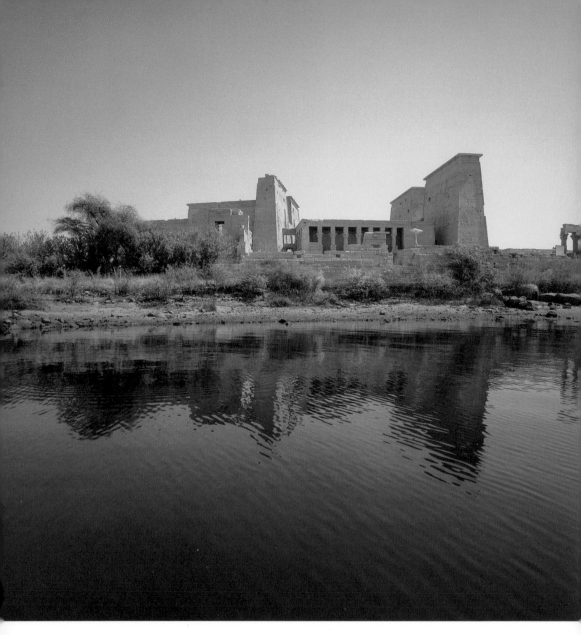

Above and right : The island of Philæ has a special
charm that stems from the splendid buildings on its
soil. The well-known temple combines harmoniously
with the island, the granite peaks, boulders and dark
blue waters. All these factors unite to give the site its
unique atmosphere. It was natural instinct that led the
pharaonic priests to dedicate this pearl of the Nile to a
feminine divinity - Isis, who formed a trinity with
Osiris and Horus.
Facing page : The south colonnade of the first court,
Medinet Habu.

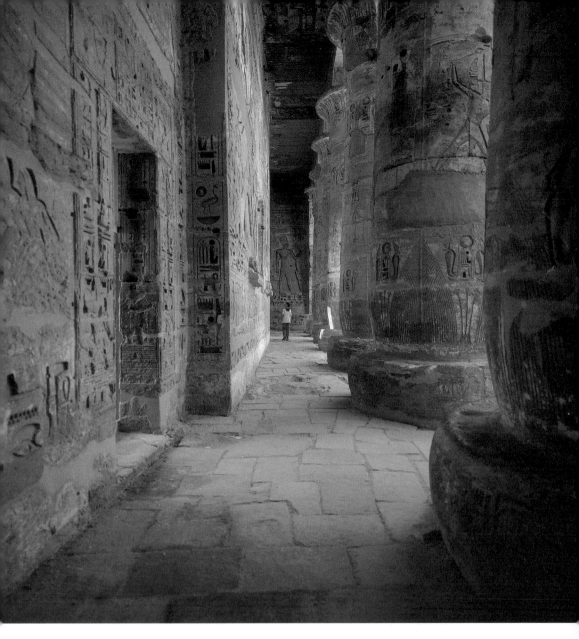

of the house becomes in the temple the great forecourt, which was accessible to every visitor. The hypostyle (colonnaded) hall of a temple corresponds to the vestibule of a house. In a private residence the room of the master of the house is the centre; in the temple we have the inner sanctuary.

The temple of Amun-Ra at Karnak is a good illustrative example. The entrance is formed by two pylons with sloping walls, before which stood obelisks, huge statues and flagpoles. Through the opening between the two pylons one enters the open outer court enclosed by colonnades and giving on to the hypostyle hall, which contains massive columns and leads to a small chapel: the inner sanctuary, to which only the king or the high priest had access. In this inner sanctuary the statue of the deity was kept. It stood in a canoe-shaped barque, which was carried by the priests in ceremonial processions. A triad of gods was worshipped at the temple of Karnak and therefore, there were, besides the inner sanctuary dedicated to the chief deity Amun-Ra, two smaller chapels for the secondary deities Mut and Khonsu. The pylon's walls, ceilings and pillars of the temples were decorated with figurative designs and inscriptions.

The parts accessible to the public particularly the outer walls, recorded the valiant deeds of the king, important state events and battle victories. Representations in the interior dealt with the deities, and the ceremonies and rites performed in the temple.

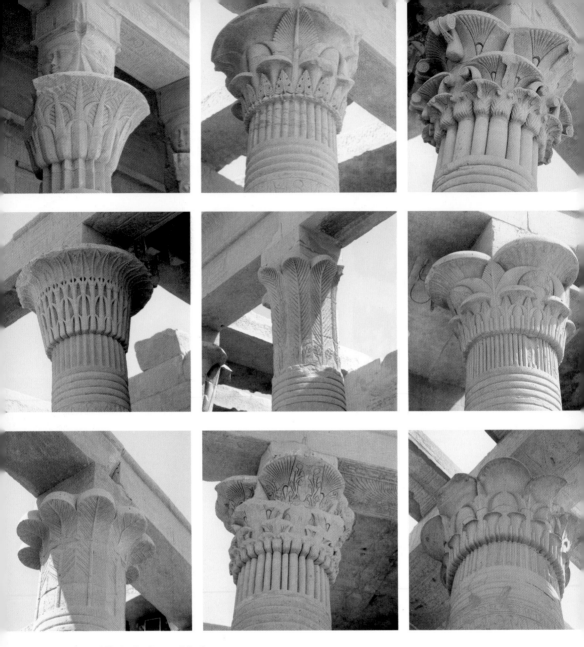

Columns at Philæ in the forms of the lotus, papyrus,
calyx and palms.

Columns and Pillars

The oldest preserved columns are those in the Nile Valley. When the Egyptians began to erect their stone temples and tombs, the architects at first used square pillars hewn from a single block of granite. From the plain square pillars of the 4th Dynasty they developed in time to 8 and 16-sided columns, sometimes with fluting.

Besides these, there are from the 5th Dynasty, artistically executed round columns, suggesting plants growing out of the soil. The Egyptians looked to nature for the prototypes of their columns and favoured plants, especially the papyrus and lotus. There are columns resembling a single plant stem and others a bundle of stems bound together at the base and near the top of the shaft; the capital represents either an open flower or a closed bud.

During the Old and Middle Kingdoms the bundle-style column with a closed capital was preferred, while in the New Kingdom the papyrus column with an open capital was more common. At the beginning, the former were frequently decorated with designs and inscriptions. Besides these two styles of columns there were also, but more rarely, palm columns with round shafts and palm fronds on the capitals.

Tombs

The evolution of Egyptian burial places proceeded from the simple pits of the olden times, later on often lined with brickwork, by way of the mastabas and the step pyramids, to the smooth sided pyramids and the rock-hewn tombs of the kings. Attached to the tomb in which the body was laid was a cult chapel usually a small court where surviving relatives could foregather and leave offerings for the dead. In the Old Kingdom the mastabas, private tombs of nobles and people of rank, were already massive structures enlarged by the addition of cult chambers and numerous other rooms, richly decorated with statues, coloured reliefs and inscriptions, as in the tombs of Ti, Mereruka and Ptah-hotep at Saqqara.

The earliest kings' tombs were constructed of sun-baked bricks. Not until King Djoser of the 3rd Dynasty introduced stone masonry into Egypt, did any important changes occur in the outward form of the royal tombs. His burial place at Saqqara was originally laid out as a *mastaba*, but the superstructure was raised to six terraces built stepwise, one on top of the other to a height of 20 metres. This tomb, the first big stone construction in history, is known as a *mastaba* or step pyramid, and represents the transition to the great pyramids constructed by his successors.

The smooth sided pyramid (Giza) was first built at the beginning of the 4th Dynasty and this form of royal tomb was found until the 18th Dynasty. The chambers, even the burial chambers within the oldest pyramids were left practically without decoration. The walls of the later pyramids of the 5th and 6th Dynasties already showed inscriptions. Connected to each pyramid was its cult chapel, usually on the east side.

In the New Kingdom, tombs cut out of the rock took the place of pyramids during the 17th to 20th Dynasties, as may be seen in the Valley of the Kings in Thebes. These had long galleries and chambers, richly ornamented with inscriptions, reliefs and murals (wall-paintings). Just as the nobles of the Middle Kingdom erected for themselves smaller pyramids, usually of brick, after the fashion of the pharaohs, so did the nobles in the New Kingdom imitate their lords and masters by hewing tombs out of the base rock. The burial sites are nearly always on the west side of the Nile, not on the flood-threatened plains or out on the higher desert plateau. The ancient Egyptians believed that when the soul left the body it went to the hereafter, which was thought to be in the west where the sun sets.

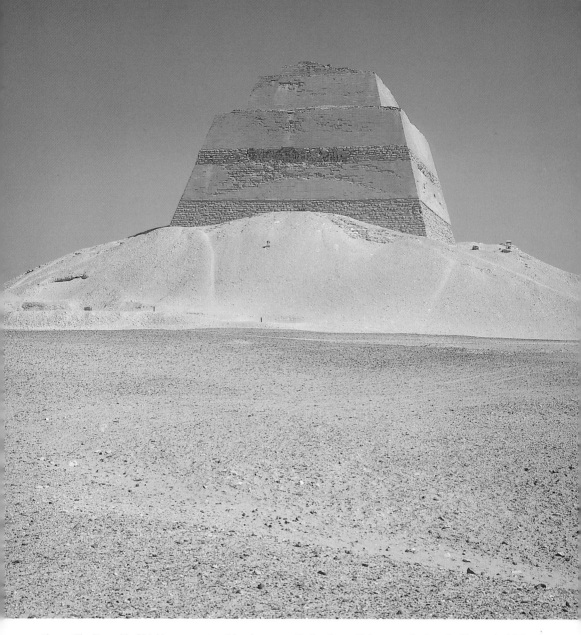

Above : The Pyramid of Meidum was a transitional stage of development from the step pyramid to the full pyramid. The tower-shaped pyramid was originally built as a step pyramid and later modified into a true pyramid by additional casing. This turned out to be a difficult task, and it collapsed. The pyramid is surrounded by debris of its collapsed outer casing. The original entrance lies on the northern face, below the hole cut into the superstructure by ancient thieves. The pyramid was built by Huni, the last Pharaoh of the Third Dynasty, and completed by Snefru, the first Pharaoh of the Fourth Dynasty. Little of Huni's achievements are known. His name is in the canon of Turin but not on the Abydos list. No inscription of him survived on stone and there are no statues of him.

Facing Page : Pair statue of prince Ra-Hotep, the high priest of Heliopolis and commander of the army, and his wife Nofert. The two figures are represented seated on a square cut chair. Ra-Hotep has his right arm folded on his chest and his left arm on his knees. The statues are painted, the eyes are inlaid with crystal and outlined with black. Nofert wears a necklace, and surmounting her head is a heavy black wig that reaches her shoulders. On her forehead is a band ornamented with a floral design. Her eyes are smaller than those of Ra-Hotep. The skin colour of the man is reddish-brown, while the woman's is creamy yellow. It is customary in Egyptian art to represent men as darker than women. This pair statue, found in a tomb near the Pyramid of Meidum, is regarded as one of the magnificent statues of the Old Kingdom, *c.* 2600 BC, Cairo Museum.

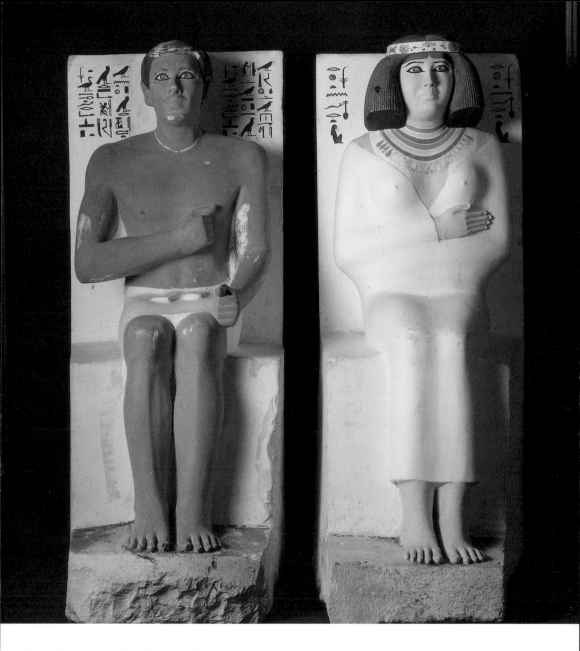

Sculpture, Reliefs, Paintings

To form an idea of the art of the ancient Egyptians one should not only view the monuments themselves, which often served decorative purposes, but also examine the reliefs and murals in the temples, *mastabas* (at Saqqara) and rock tombs (in Upper Egypt) and besides these, one should study the smaller statues now in the Egyptian Museum in Cairo. These are often remarkably lifelike portraits and are a vivid representation of their subjects. And yet it must be borne in mind that the artists, whose names have seldom come down to us, worked on very hard stone with only primitive tools.

The golden age of sculpture was during the 4th Dynasty and the Middle Kingdom period. The artists were more concerned with producing a lifelike image than with an idealised beauty, as was later developed by the Greeks. The nobles and generally all persons of importance were always shown either sitting or standing, in a calm and dignified pose befitting their status. No one who has had the privilege of seeing Old Kingdom reliefs is likely to forget their strength, simplicity and grace, so appropriate to the dignity of the Old Kingdom monarchs, the fathers of Egyptian history. In our opinion these are far lovelier than the artefacts of the New Kingdom,

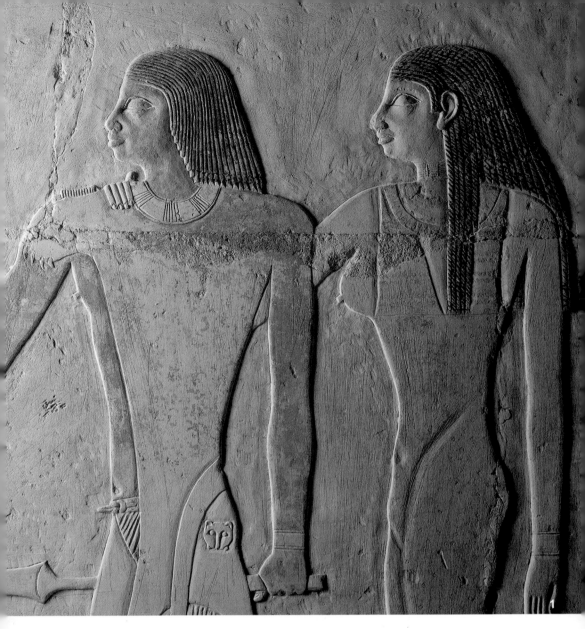

1. An excellent high relief of Nefer, a singer in the royal court, and his wife Seshaat. The remarkable feature of this scene is that Nefer is portrayed the same size as his wife, and her arm is on his shoulder. Nefer wears a panther skin with its face on his side, the customary dress for priests. Seshaat is wearing a tight dress showing details of her body. Rock-cut tomb of Nefer, 5th Dynasty, *c.* 2400 BC, Saqqara.

2. High relief showing wolves mating, from the *mastab*a tomb of Niankhnum and Khnum-hotep, 5th Dynasty *c.* 2400 BC, Saqqara.

3. Drawing of sailing vessel from the mastaba tomb of Niankhnum and Khnum-hotep, 5th Dynasty *c.* 2400 BC, Saqqara.

4. A fishing scene with nets showing various species of Nile fish, such as *Tilapia niolitica* and *Lates nilticus*, from the mastaba tomb of Niankhnum and Khnum-hotep, 5th Dynasty *c.* 2400 BC, Saqqara.

5. High relief of a bird farm, rock-cut tomb of Neferherptah, 5th Dynasty, *c.* 2300 BC.

which, for all their lavishness and elaboration, have an air of decadence, which is absent from the more ancient works.

In Egyptian art great importance must be given to the reliefs, which are to be found mostly in tombs; these were held to be "residences for eternity". There the deceased was to be able to continue to enjoy the happiness of his former existence on earth. The walls of the rock tombs of the New Kingdom were therefore decorated with scenes of daily life, and also with pictures of burial and religious rites. Sculpture in relief was preferred; bas-relief, considered to be the oldest form, is the most frequently seen. Excellent examples of this are to be found in the *mastabas* at Saqqara. There is also another type, a sunken relief, with rather deeply engraved outlines.

All the reliefs were originally painted but many of the colours have faded or deteriorated. In the representation of human figures, especially those of kings and nobles, the artist was bound by certain conventions and had to abide by definite rules. Thus, both in the reliefs and paintings, we find the same standardised forms recurring.

Drawing in perspective as later developed by the Greeks, was not employed in ancient Egyptian art. One of the rules most faithfully adhered to was that in human figures, the head was shown in profile, while the eye was viewed from the front, as were the shoulders, but the chest, body, legs and feet were again seen in profile. The artist tried in this own way to bring into prominence the salient features of the human form. The central or more important figures in a group were emphasized by being drawn much larger than the others. In the representations of lesser people and animals, more freedom was accorded to the artist.

When the walls of a temple were not particularly suited to reliefs, murals took their place. The colours were in definite contrast to each other and some of them still remain as bright and fresh today. The composition of the pictures is sometimes of extraordinary beauty and harmony, but there are no gradations between light and shadow a reflection of the Egyptian landscape, where, in the glaring sunlight, intermediate shades and transitions are unknown.

Handicrafts and Lesser Arts

Between four and five thousand years ago Egyptian potters, cabinetmakers, weavers, metalworkers and glassblowers had already produced objects whose artistry still fills us with awed admiration.

The potter's art is shown in fine goblets, cups and vessels, which in later periods were painted and glazed; ancient Egyptian faiences are famous and had already appeared towards the end of the Old Kingdom. The favourite colours were green and blue.

For decoration, models were sought in nature: lotus flowers or buds, reed designs and so on. The highest standard of skill was shown by the goldsmiths and metalworkers, who produced wonderful ornaments, jewellery and art objects of all kinds, from pomade and paint boxes and pots, to necklaces and rings. Glass bottles, vases and sacrificial bowls were developed till they became exquisite works of art and were even then greatly valued abroad, as were also the amulets produced in great variety. Handicrafts and lesser arts had already reached the highest state of perfection in ancient Egypt.

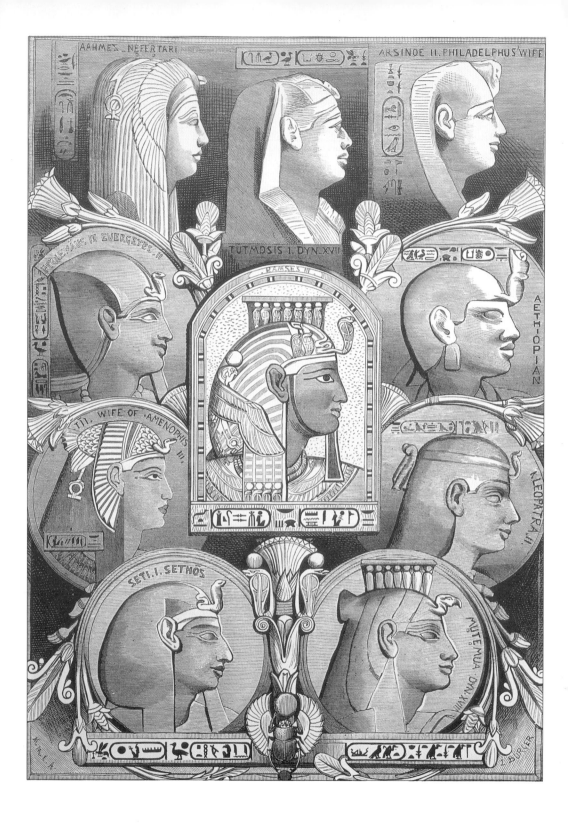

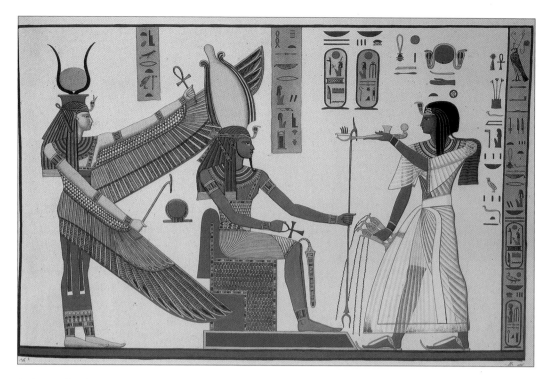

Left: Portraits of the Pharaohs: *Egypt, Descriptive, Historical and Picturesque* by Georg Ebers, Leipzig 1879.
Above: This scene was copied by Rossellini from a wall in the tomb of Ramses III in the Valley of the Kings. The pharaoh stands on the right with the *uraeus,* symbol of royalty on the forehead. He is wearing a transparent kilt and making an offering to Ptah-Sokar-Osiris, lord of the dead. For ritual purification purposes he holds three water containers in his right hand. He pours this water at the feet of the god, who sits on a square throne wearing the White Crown surmounted by two feathers. He holds in his hands the sceptre and the *ankh* sign of life. The goddess Isis is standing behind him. On her head she is wearing the horns of a cow with the solar disk in the centre.

47

Hieroglyphs

The hieroglyphs (from the Greek "sacred inscriptions"), which cover the walls of the tombs and temples and ornament many of the great pillars, were considered for many centuries to be mysterious symbols: "It was thought that learned priests had hidden profound wisdom in these inscriptions so that the profane would not be able to understand it". That this concept of Egyptian writing prevailed for so long was due particularly to a little book dating from Greco-Roman times. Its author Horapollo specified a list of hieroglyphs in which the meaning of each sign was given in Greek. Not content with these statements, he ingeniously thought out interpretations, which appeared to him to accord with the dignity of such sacred writing ... From the 17th century the absurdities contained in this book fostered the delusion that the hieroglyphic inscriptions did not represent words of a language, but were symbols, enigmatic signs, "whose meaning it would be absolutely impossible to guess". (Adolf Erman)

Today the hieroglyphs of the ancient Egyptians are no longer a mystery. After a black stone dating from 196 BC had been found near Rosetta in 1799 by soldiers of Napoleon's expeditionary force, it was possible to solve the enigma. The Rosetta Stone bore inscribed on it a decree dating to the time of Ptolemy V-Epiphanes, in two languages and three different writings: above were 14 lines in hieroglyphs, in the middle 32 lines in demotic writing and at the bottom 54 in Greek. By comparing the inscriptions, the two lower ones being translations of the hieroglyphic text; it was possible to decipher the hitherto mysterious signs of the pictorial writing. The first clue which led to a correct interpretation was obtained from studying the groups of signs enclosed within labels, which contained the names of rulers. These are the so-called royal cartouches. On the Rosetta Stone was the name Ptolemy.

After various attempts at interpretation by, among others, the Jesuit Father Athanasius Kircher in the 17th century, the Swedish Acherblad in 1802, and the English physician Thomas Young in 1819, the Frenchman Jean-François Champollion (1790 - 1832), found the names of those kings who were already known from Greek sources by a methodical study of the cartouches. In 1822 he succeeded in deciphering the Egyptian alphabet and thus made it possible to read hieroglyphic writing. Champollion therefore became the founder of Egyptology.

The script of ancient Egypt evolved with time to become, like every language, simpler and easier to use:

Hieroglyphs: Sacred engravings of the pharaohs, an ornamental writing whose signs consist of small carefully drawn figures, which appear as pictorial writing in almost inconceivable abundance on the walls of ancient Egyptian monuments. This was used for funerary and religious texts.

Hieratic: Cursive form of hieroglyphs, generally on papyrus, used from 1300 BC onwards for administrative and literary texts.

Demotic: Egyptian popular writing, a simplification of the cursive hieratic, used from the 26th Dynasty and during the Greco-Roman period, side by side with Greek script.

Coptic: The final form of Egyptian writing, a mixture of the Greek alphabet and demotic signs. It is the language of the Christian Copts, nowadays only used in the Coptic liturgy.

Deciphering the Hieroglyphs

Ptolemy's name, which appears in the Rosetta Stone's Greek text as Ptolemaic, was the first word recognized in hieroglyphics. But early attempts to interpret its eight symbols were frustrated. The traditional belief at the time was that the hieroglyphs could be translated as picture words, even after the English scientist Thomas Young assigned sound values to several symbols. Champollion believed that the lion symbolized the Greek word for war *p(t)olemos*, anagrammed in the word *Ptolemaios.*

Champollion finally deciding how Ptolemy might be read phonetically, patiently reconstructed the name, sound by sound, from Greek, Demotic and Coptic, then into an earlier hieratic script and finally into hieroglyphics. The result was *p-t-o-l-m-y-s*, or Ptolmis and could be spelled both from right to left and from left to right, and also from top to bottom.

In 1822 a copy of the inscription from an obelisk at Philæ, excavated seven years earlier, was made available to Champollion. He was stunned to see confirmed in its hieroglyphics, a name he had reconstructed many times from a demotic papyrus: the cartouche of Cleopatra.

A comparison of two royal names from the Philæ inscription - a tribute to the goddess Isis from Ptolemy IX and his wife Cleopatra, ancestors of the famous Cleopatra - shows a deductive process by which Champollion confirmed that some hieroglyphics were meant to be heard as well as seen. Assuming the pronunciation would be

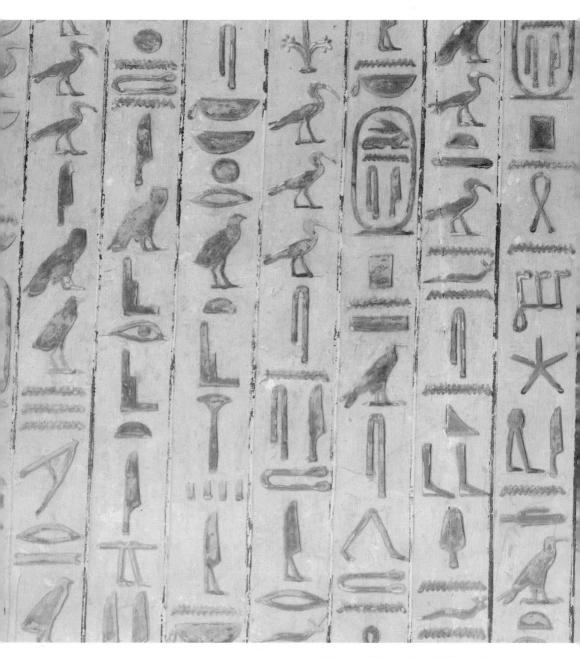

The Pyramid Texts, Pyramid of Unas, Saqqara.

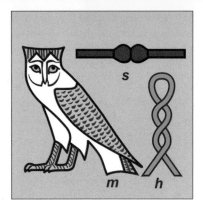

M + S +H = Crocodile

To express the three consonants of the word 'crocodile', which may have been pronounced *mesh, miseh*, or even *emseh* after the vowels were added - the Egyptians combined three single consonant signs. They might have added a purely visual symbol of a crocodile for emphasis.

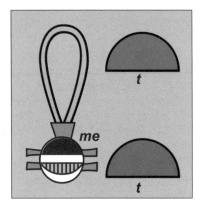

ME + T +T = Likeness

Early decipherers might have translated a jug of milk and two loaves of bread as food symbols, but they would have been wrong, for these are sound values representing a word difficult to express in a picture. The first symbol is actually a double consonant.

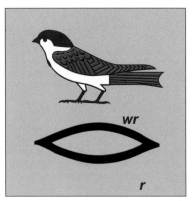

WR + R = Great

An unusual feature of many words is the use of an extra sign a phonetic complement to assist the reader. The mouth symbol for *r* confirmed that the word ended with that sound. Phonetic complements were commonly added to words possessing two or three consonant signs.

similar to the Greek, he first identified three phonetic symbols - the *p, o* and *l* sounds - present in both names. Champollion correctly concluded that the two different *t* signs were one of two symbols pronounced alike, like the *f* and *ph* in English that is equally valid symbols for the same sound. Thus armed with four known letters, Champollion was able to deduce the missing ones from their positions.

Now possessing a combined total of 12 phonograms, or sound symbols, Champollion eagerly applied these to a third cartouche and was able to decipher the name *a-l-k-s-e-n-t-r-s* -Alexander. Convinced that his phonetic approach would work for all non-Egyptian names, Champollion gathered as many cartouches as he could find dating from the Ptolemaic and Roman periods, and quickly transliterated 80, in the process increasing his list of known phonetic signs several fold. The critical test came in September 1822, when he tackled some cartouches predating the Greek and Roman eras, and achieved a tremendous breakthrough by deciphering his first purely Egyptian names: Ramses and Tuthmosis.

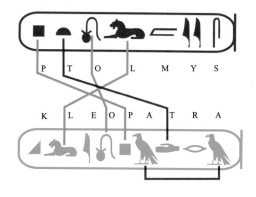

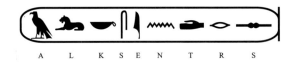

Pictures that Spell Words

Hieroglyphics may have begun in the prehistoric era as picture writing. Then as early Egyptians were confronted with an idea difficult to express in pictures, they probably invented syllables to "spell" the desired word (like combining pictures of a bee and a leaf to show the word "belief" in English). Language experts can only guess at these beginnings however, since the oldest surviving hieroglyphics -

dating from around 3100 BC - represent a fully developed written language. Although the Egyptians never evolved an alphabet as we know it, they set aside symbols for every consonant sound in their speech. The system proved remarkably efficient even though no attempt was made - except in the phonetic reproduction of foreign names - to symbolize vowels. By combining phonograms, or sound pictures, scribes could form a basic version of any word.

Symbols of Sounds

The Egyptian "alphabet" consisted of signs for 24 single consonant sounds and a great number of two and three consonant combinations. The diagram below shows some of these "letters", the objects they signify and approximations of their sounds.

UNILITERALS

| SIGN | | | | | | | | | | | | | | |
|---|---|---|---|---|---|---|---|---|---|---|---|---|---|
| OBJECT DEPICTED | Owl | Mouth | Water | Quail chick | Loaf | Bolt | Twisted flax | Face | Milk jug (in a net) | Goose | Swallow or martin | Beetle or scarab | Sandal strap | Heart and windpipe |
| APPROXIMATE SOUND | m | r | n | w | t | s | ḥ | ḥr | me | sa | wr | Kheper | ankh | nefer |

A Pictorial Glossary

Not all hieroglyphs surrendered their function as word pictures to become phonetic symbols. Of about 700 hieroglyphs commonly used during the New Kingdom, at least 100 remained strictly visual. Used at times to represent words they depicted, more often they were tacked onto phonetic spellings of the same words as determinatives to provide guides. Thus the word for obelisk – *tekhen* - is usually shown as phonetic hieroglyphs forming the consonants t+kh+n, followed by the symbol of an obelisk.

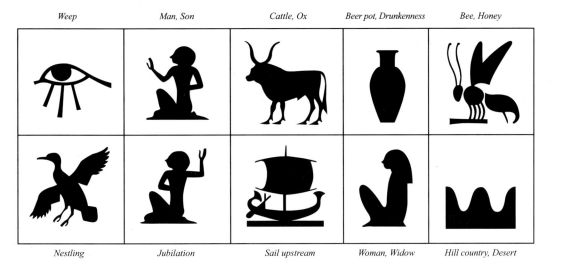

Weep	Man, Son	Cattle, Ox	Beer pot, Drunkenness	Bee, Honey

Nestling	Jubilation	Sail upstream	Woman, Widow	Hill country, Desert

Sight and Sound

Because so many hieroglyphic words could be read as homonyms or near homonyms i.e. similar sounding words, such as the English *wait, weight* and *wade* - Egyptian scribes made liberal use of determinative symbols to be sure their readers grasped the correct meaning. The letters *hnw*, could be pronounced as *hinew* to *ohanow* and could have a number of different meanings. Therefore the word is never seen without one of several determinatives: a beer jug to indicate the word for a liquid measure; a man giving a ritual sign of jubilation to show the word of rejoicing; and the figures of a man and a woman over a plural symbol (three parallel lines) to illustrate the word for neighbours or associates. By this system the Egyptians could use the same grouping of letters to indicate as many as ten completely different words.

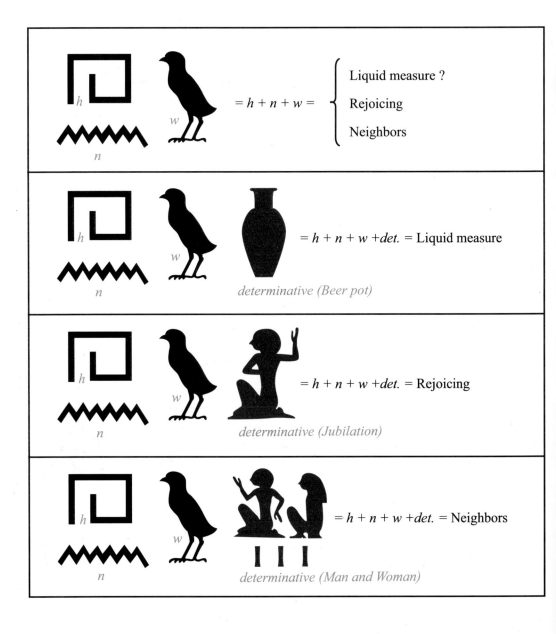

h

w

n

$= h + n + w = \left\{ \begin{array}{l} \text{Liquid measure ?} \\ \text{Rejoicing} \\ \text{Neighbors} \end{array} \right.$

h

w

n

$= h + n + w + det. = $ Liquid measure

determinative (Beer pot)

h

w

n

$= h + n + w + det. = $ Rejoicing

determinative (Jubilation)

h

w

n

$= h + n + w + det. = $ Neighbors

determinative (Man and Woman)

The Flow of Language

The Egyptians were always conscious of the beauty as well as practicality of their hieroglyphics, and often used them purely for their decorative effect. There was no spacing or punctuation to break the flow of words, which might be written either horizontally or vertically. The pictures of flora and fauna usually faced the starting point and the hieroglyphs were read from that direction, with the symbols on top always taking precedence over those below. Each group of signs was symmetrically arranged to fit an invisible rectangle.

Gods, the Hereafter, the Cult of the Dead

Gods

"Like all ancient peoples, the Egyptian saw his gods in his immediate surroundings. Trees and springs, cliffs and mountain peaks, birds and wild animals appeared to him as rational living creatures, like himself, or, perhaps, possessed of strange and uncanny powers which were beyond his control. Some, he felt among the host of spirits animating all around him were his friends that could be placated and would accord him help and protection. Others, however, pursued him with cunning and malignity wherever he went, only awaiting an opportunity to strike him down with illness or plague. These spirits were all confined to certain localities and each one was known only to the inhabitants of these regions; hence the endeavours of men to place them were sufficiently limited and primitive. But it was not only for the palpable environment of man but also for the firmament above him and his earth beneath his feet that man conceived religious explanations." (J.H. Breasted, adapted).

The ancient Egyptian deities were divided into local gods and cosmic gods. The local gods, often also goddesses, were the tutelary deities of the *nomes* (provinces), towns and villages. Originally imagined as flowers, plants or trees: Hathor, a sycamore; Nephertum, a lotus flower... Later they were identified with animals: Horus, a falcon; Sebek; a crocodile; Khnum, a ram; Bastet, a cat; Ra-Harakhte, a falcon...

In the early historical period the gods assumed human shapes; the deities originally worshipped as animals were represented as bird, reptile, or animal headed humans. The cosmic deities were venerated throughout the whole country, as Geb, the earth god; Nut, the sky goddess; Ra, the sun god; Thoth, the moon god; Osiris, the god of the dead and Hathor, goddess of love and joy. Besides these, there were certain sacred animals such as the Apis bull venerated at Memphis. Moreover, many of the deities existed as mythological figures only in the popular imagination, through folklore and tradition; no temples were built to them. This honour was reserved for the supreme deities of Egypt, those who were venerated in the *nomes* of the country.

The Hereafter

The ancient Egyptians believed in a life after death, but just as there never was a uniform or clear concept of the numerous deities, so also there prevailed different notions on life in the hereafter, varying over the course of the centuries. Concerning the beliefs of the ancient Egyptians, Egyptologists answer the question: "What of man survives?" as follows:

"In the life of his body *(khat)* man is permeated by the life principle, which is designated as breath *(nifu)*. This life-principle, in its individual division, is the *ka*, which represents the ideal life of man, the unattainable image. *Ka* is that which survives after death but which only continues to live in connection with the body, which, therefore, has to be preserved. But there is something else that survives, that is the *ba*, the purely spiritual soul, which after death ascends to higher planes independent of the body. The *ba*, however, is only the individual form of a part of the *khu*, the divine highest reason or light, which in its purest form cannot enter into relation with the body, and therefore, in the form of *ba* has already assumed a greater being. From these ideas arises the concept that what in man is really derived from *khu* ascends after death as a spirit of light to the highest heaven and returns to the pure source of the *khu*. The religious hope of an afterlife is concerned with the *ka* and the *ba*, the body bound and the purely spiritual soul".

But to the abode of the blessed were admitted only those who were just on earth, who did right, as the old Egyptian texts say. The deceased underwent judgment before the court of the dead presided over by Osiris, the god of the netherworld. The judgment, pronounced by 42 judges, was dependent upon the behaviour during life on earth. After a questioning on the 42 deadly sins, the heart held to be the seat of the conscience, was weighed against an ostrich feather, the symbol of justice and truth. Only after passing this test could the soul gain admittance to the abode of the blessed.

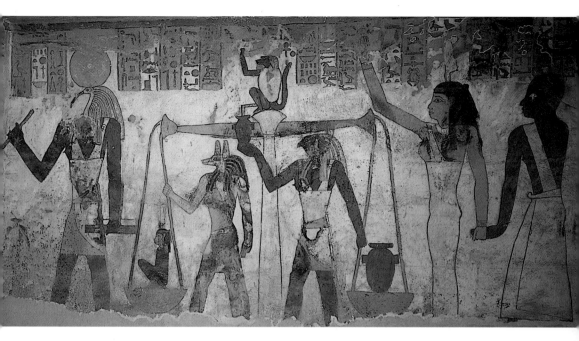

Rock-cut tomb of Bennentiu, in the Baharia oasis. Bennentiu was a rich merchant who lived during the 26th Dynasty. Anubis and Horus weigh Bennentiu's heart against a feather as Thoth declares the results to Osiris. At the other side of the balance, the goddess Maat holds the hands of Bennentiu. The inscription in front of Thoth affirms : "Thoth, the Doubly Great, Lord of Ashmuneim, the Great God Lord of the Temple may he give Life". The inscription over Anubis reads "Anubis who performs the bandaging of the burial of Osiris, Chief of the West, Great God, Lord of Abydos, may he permit to accept Bennentiu, son of Zed-Amen-ef-ankh".

The Cult of the Dead

It is on the basis of the deep-rooted concepts of the hereafter and the belief in the immortality of the soul that the cult of the dead practised by the ancient Egyptians can be understood. The person should continue to live on in the abode of the blessed. Therefore, death held terror for the Egyptian. Since it would continue to exist only if the body was preserved, the body was embalmed; the surviving family and friends had to bring offerings and by providing food and drink, see to it that the dead suffered neither from hunger nor thirst. The walls of the tombs were decorated with scenes from the life of the departed.

There was believed to be a magical power in these representations, which were to serve the dead as a reflection of the reality of the earthly being. We therefore frequently find in the tombs, which were considered "eternal abodes", the whole life history of the deceased depicted on the walls. The abode of the blessed was imagined to be in the west, "where the sun god descended every evening to his grave". Hence later on the dead were generally alluded to as "the westerners."

Egyptian Gods

The Egyptians were the first people to work out a calendar to be of a year's duration and divide it into 12 months. They also defined the week and gave it 7 days. The day was further divided into 12 hours of daylight and 12 hours of darkness. The hour was the smallest time unit. Minutes or seconds were unknown. The definition of 12 gods was also the work of the ancient Egyptians, and was adopted later by the Greeks. Also the Egyptians were the first to celebrate religious festivals and to make offerings. More than one festival was celebrated during the year. One of the favourite sites for these festivals was the city of Bubastis, where the cat goddess Bastet was worshipped. Another was the city of Busiris where a great temple was erected to the goddess Isis, the chief deity. In third position was the town of Saïs, which celebrated the festival of the goddess Neith. The fourth in rank was the celebration of Helios in the city of Heliopolis.

The ancient Egyptians were particularly meticulous in carrying out their religious duties. They also created the concept of divine kingship and hypothesised that the spirit of the deceased was immortal. This religious belief was the main driving force for the cultural and artistic achievements of the ancient Egyptians. Scholars think that some of the contradictory thoughts in the religious dogma stem from the fact that prehistoric migrations took place among peoples with a differing range of beliefs.

Because the sun was visible throughout the whole country it was worshipped as the Lord Ra in all of Egypt, and the cult of other gods was localised. Also, due to the fact that the sun sets in the west every evening, the west was associated with the world of the dead. Upper Egypt is a narrow 5 to 15 kilometre wide strip of fertile land surrounded by barren desert on both sides. It extends for around 1000 kilometres stretching from the First Cataract in the south to Memphis in the north. This geographic characteristic made it an ideal place for the emergence of independent local gods. Here in Upper Egypt the first writing and literature was developed.

The urban centres of prehistory developed into historic towns. Local myths and characteristics of local gods were of limited influence only in their own region. For instance Min in Coptos was considered the lord of the crops for farmers, and because Coptos was also the departure point for the desert caravans to the Eastern Desert, he was also known as the protector god. Osiris was mainly worshipped in Abydos and according to the Heliopolis myth of creation; his brother Seth had murdered him. Later, Horus the son of Osiris who grew up in the care of his mother Isis took revenge for the death of his father. Osiris continued to live in the netherworld, as the judge of the deceased and lord of those who dwelt in the west.

It should be noted that since antiquity the Egyptians had linked their gods with animals. First, they represented their gods in a purely animal form. For example, they associated Basset with the cat, Sobek with the crocodile, Thoth with the Ibis, Hathor with the cow and Anubis with the jackal. Each of these animals had a distinguished feature, which they meant to be the characteristic of that particular god. For example Sekhmet was thought to be a wild and dangerous goddess. Anubis played a major role in deciding the fate of the deceased in the underworld. Anubis's relationship with the jackal came through their observation that graves were the typical habitat of the jackal, and also that the jackal's diet consisted partly of dead human and animal bodies.

The second type of representation was in a human form. For instance, they also represented Amun as a man, Isis and Nephthys as females, Osiris as a human mummy.

The third form was a mixture of animal and human. For example Hathor was represented as a woman with the horns of a cow, and sometimes with a cow's head, Basset as a woman with a cat's head, Anubis as a man with a jackal's head, Khonsu as a man with a falcon's head, Sekhmet as a woman with a lion's head, Sobek as a man with a crocodile's head and Thoth as a man with an ibis's head. Also many gods wore crowns or some sort of headdress with hieroglyphic signs on them.

Myths

Myths could be defined as events belonging to the realm of the gods, or as stories that took place in a time infinitely distant. The stories of the world's creation were an integral part of the myths.

Before the creation of the world, there was the primeval water *Nun*, in which eight primeval gods existed in chaotic order. Similar to the retreat of the Nile flood after bringing fertile soil to the land of Egypt and the creation of small islands midst the waters of the Nile, so also an island emerged from the primeval water marking the creation of the world. The ancient Egyptians defined their deities in a systematic manner within the creation myths. An example of this system is the creation myth of Heliopolis. The story goes as follows: at the beginning was the primeval water *Nun*, and out of the darkness of the water Atum raised himself and created himself on a hill. At that moment neither earth nor heaven existed and Ra had both male and female organs. Then Atum masturbated in On (now Heliopolis), and so were born the twins Shu and Tefnut. In fact, he spat his children out

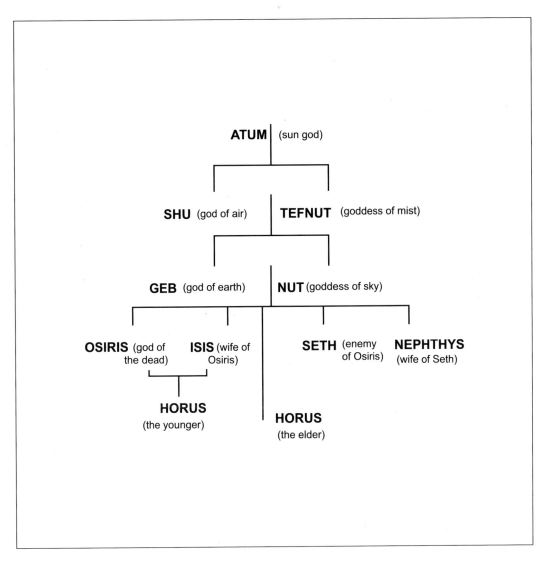

ATUM (sun god)

SHU (god of air) — TEFNUT (goddess of mist)

GEB (god of earth) — NUT (goddess of sky)

OSIRIS (god of the dead) ISIS (wife of Osiris) SETH (enemy of Osiris) NEPHTHYS (wife of Seth)

HORUS (the younger)

HORUS (the elder)

The Great Ennead of Heliopolis.

of his mouth. Shu became god of the air and Tefnut goddess of the mist. The result here is that one god became three gods, chaos ended and for the first time light appeared. Shu and Tefnut married, and Geb the earth god and Nut the sky goddess were born to them. It was Nut and Geb who gave birth to the other gods and goddesses. Ra wept, and out of the tears mortal men and women were created. Nut gave birth to Osiris, Horus the Elder, Seth, Isis and Nephthys. Thus the great Ennead (group of nine gods) of Heliopolis was created.

Atum took the form of Ra the sun and was depicted in various forms depending on his role. He was shown with the sun disk placed on the head, and quite often represented as a man with the head of a falcon. This representation is equivalent to Horus with the difference that Horus wore a crown, while Ra had the sun disk on his head. In other situations Ra was linked to the scarab Khepri in the creation concept. The ancient Egyptians noticed that the beetle laid its eggs in a piece of dung and then rolled it along the ground till it became ball-shaped. They linked it with the sun because of this and the fact that it emitted heat, and thus it also became the source of life. They then represented the sun being pushed across the sky by a giant beetle. As the god of creation, Ra was represented as a man with the beetle Khepri as his head. This was his early morning representation. In the evening Ra took on the role of Atun, one of the earliest representations. Here the depiction is fully human with no animal head.

The Osiris Myth

This story deals chiefly with the revenge of the death of Osiris. After a period of chaos and turmoil, Osiris became king of Busiris, a town in Lower Egypt and then the king of all Egypt. He started to carry out reforms and when stability was established in the country he decided to go on an expedition. While he was away his evil brother Seth hatched a conspiracy with 72 other men to kill him.

When Osiris returned, Seth arranged a huge party, and suggested they play a game. A wooden box was laid in the great hall and the object was to see who would fit inside it. When it was the turn of Osiris, he got into it and naturally it was of the right dimensions and in fact his coffin. The conspirators immediately closed the lid and Osiris died and became lord of the dead in the afterlife. The box with his body in it was thrown into the Nile, where it floated until it reached the Mediterranean Sea and continued all the way to the port of Byblos in Lebanon, and eventually came to rest on a root of a tree. The box was assimilated and became part of the tree's trunk. Later it was cut down and became a pillar in the palace of a king of Byblos.

Queen Isis, sister and wife of Osiris, decided to search for his body to give him an appropriate burial. To concentrate all her efforts on her quest, she hid her young son Horus in the marshes of the Delta, under the protection of the cobra goddess Wadjet. Isis travelled to Byblos and reached the temple. Using her magical powers, she convinced the king and queen to give her the special pillar from the royal palace that housed the body of Osiris. Back in Egypt, she hid the pillar in the marshes of the Delta and went to fetch her son. This was a big mistake because Seth was hunting in the area and could not believe his good luck when he found the pillar. He cut the remains of the body of Osiris into 14 pieces and had them dispersed over a wide area. The stubborn Isis refused to give up and continued her search. At each site where she found part of the body, she made a burial ceremony, hence justifying the explanation that several temples claimed to be the burial place of Osiris. Each piece of the body was found except for the penis, which had been swallowed by a fish. In order to give him an appropriate burial she made him an artificial one.

Amun

Originally the local god of Thebes, who in the New Kingdom united with Ra to become the national deity of Egypt Amun-Ra. The rise of Amun is directly related to the rise of the Thebian pharaohs beginning with Mentuhotep in the 11th Dynasty. But he was raised to the position of a national god after the Hyksos were expelled by the Thebian kings. As lord of the wind and the air, he carries a feather star. Usually he is represented in human form wearing a double-plumed crown, more rarely he is shown as a man with a ram's head. He usually holds the *ankh* sign of life in his hand. He forms the Thebian Triad together with his wife Mut and son Khonsu.

His temple in Karnak exceeded all the other temples in antiquity. The Amun priesthood became the most influential and powerful organisation in the country until the 5th century BC. The Amun oracle in Siwa oasis was the most famous healing site in antiquity. Alexander the Great visited the oracle and was declared the son of Amun.

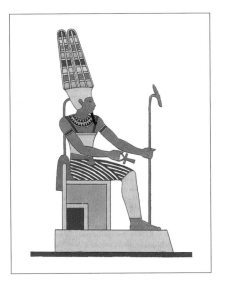

Anubis

The Greek historian Plutarch (46 - 126 AD) visited Egypt and was inspired to write an account of this old legend of Osiris. According to him, Anubis was an illegal or unwanted son of Osiris and Nephthys. Isis claimed that Osiris made love to Nephthys thinking that she was herself. She therefore searched for the boy using trained dogs until she found him, and adopted him. She called him Anubis. Plutarch wrote that the boy was trained to guard the gods, as a dog guards humans. Since the Old Kingdom, Anubis was counted as one of the more important deities related to the cult of the dead. His main role was in the mummification process. In numerous sacrificial models Anubis was asked to provide food for those in the underworld. In the scene of judgement, in the 125th spell in the Book of the Dead, Anubis weighs the heart of the deceased against a feather. The typical representation of Anubis is as a black or very dark brown jackal, or as a man with a jackal's head. Jackals lived in cemeteries, ate corpses and dug for bones and hence were associated with the dead.

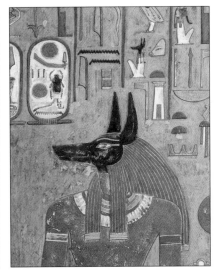

Apis

The cult of the sacred bovine expressing divine force was popular and widespread throughout Egypt, but especially in Memphis where the cult had started around the time of the 2nd Dynasty. The Apis bull can be distinguished from other sacred bovines by its colour and distinctive signs. A collar and a red cover with blue dots decorate the sacred animal, the body of which is entirely black. The whip, placed over its rump is a sign of the rousing power of the god, as the animal symbolically reminds men to worship; the (cobra), wearing the upper part of the *pschent* as a headdress, indicates the dominion of this divinity over the regions of Lower Egypt. The yellow sun disk rises between the horns of the bull; this was the heavenly body whose earthly image Apis was. The two blue plumes that surmount the disk, well known as emblems of justice and truth, are reminiscent of certain funerary functions that the Egyptians attributed to the Apis bull.

When an Apis bull died there was a great mourning and the animal was carried along the sacred way from Memphis to Saqqara to be interred in the burial place now called the Serapium.

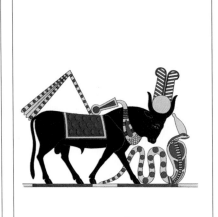

Aten

The naming of the sun disk as the Aten started in Heliopolis around the Middle Kingdom. Its sole meaning was the sun as a celestial star.

When Akhenaten (1350 - 1333 BC) became king he eradicated all traces of the older faiths. Beginning with Amun, he then proceeded to forbid the worship of all the other gods like. Isis, Osiris, Hathor, Ptah and the entire pantheon of lesser deities were swept away. The worship of the Aten was entirely new, but Akhenaten's revolutionary act was to believe only in the Aten and to ban the worship of all other deities. The Aten was understood to be the absolute god, absolute truth and absolute love. All that was good on earth was a demonstration of the Aten: love, music, health, etc. The symbol of the new faith was the sun disk from which the rays stretched down like arms ending in hands.

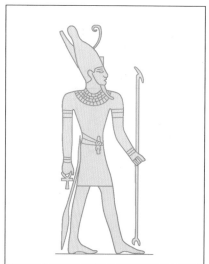

Atum

Atum is a form of the sun god Ra as Atum-Ra creator of the world. In fact he was one of the oldest forms of the sun god worshipped in ancient Egypt. Ra in this form was supposed to have created the world from chaos. In mythology he was associated with the sun god Ra as he made the journey through the netherworld, and sailed in the solar boat in the last hours of daylight. He was always associated with the souls of the dead.

Atum is represented as a man wearing the Double Crown, consisting of the Red Crown of Lower Egypt and the White Crown of Upper Egypt.

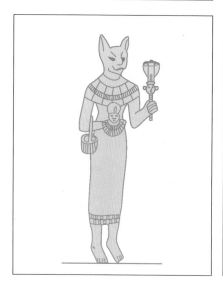

Bastet

Originally Bastet was a local goddess of love and happiness in Bubastis in Lower Egypt. Herodotus wrote: "If you travel to Bubastis during the festival you will see great festivals where many citizens travel in boats. Women sing and men play flutes, other participants dance and clap. Lots of wine is also consumed during the festival". He estimated the number of taking part in the festival reached 700 000.

Bastet is represented as a woman with a cat's head. On her breast she has a shield with a lion or cat's face, and on her arm she carries a little basket.

Bes

Bes is represented as a dwarf-like figure with short squat legs, a rounded stomach, large eyes as well as a lion's ears and mane. The paws on his shoulder, his thighs and the tail on his back belong to a monkey. The mouth is wide open showing the teeth and the protruding tongue.

Bes played a major part in the life of musicians from the 18th Dynasty, and was popular during the Ptolemaic period. Egyptologists believe that Bes was originally a foreign deity from Punt or Arabia.

Geb

Geb is the earth god, his wife and sister is Nut, the sky goddess. They are the son and daughter of Shu and Tefnut, and all of them form part of the great Ennead of Heliopolis. As the earth god he was coloured green with vegetation growing out of him. Beneath the ground he was accountable for the dead. On many occasions he was shown at the judgement of the dead. He was also represented as a man crowned by a goose. On rare occasions, he was shown wearing the Red Crown of Lower Egypt. At funerary events he had an evil character. An earthquake was described as 'the laughter of Geb'.

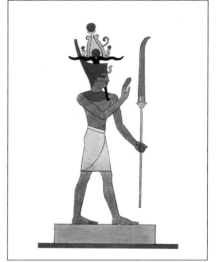

Ha

Ha is lord of the desert. This picture is from the tomb of Bannentiu, 26th Dynasty, Baharia Oasis. Ha, the desert deity holds a spear and is stepping forward. He wears a white and yellow kilt, and his inscriptions read: "Ha, Lord of the West, the Great God of Abydos, may he give life". Representations of this deity are rare. He was mentioned in the Pyramid Texts, as well as in some of the tombs of the Old Kingdom. Ha was also mentioned in the Book of the Dead. This deity held a distinguished place in the oases. He is represented in the tomb of Bannentiu, and at Kharga Oasis he is represented in the temple of Hibis. He has the sign of a mountain above his head. His diadem is the sun disk between two feathers.

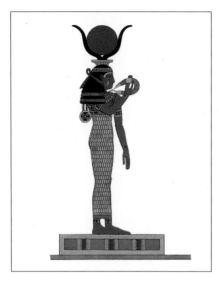

Hathor

Originally she was the goddess of love, happiness and dance. She was regarded as an eminent star among the gods and goddesses. The exact translation of her name means 'House of Horus'. As a universal goddess of Egypt she had very special characteristics. Similar to Isis she is also the sky goddess, who acts as the eyes of the sun god and has the capacity to see and destroy enemies. In Sinai she was goddess of the 'far lands', and in the necropolis of Thebes she was the goddess of the dead. In Dendera she was the wife of Horus. The reliefs of her in Dendera are considered the best preserved today. Hathor appears here in one of the more usual forms found in the paintings and reliefs of ancient Egypt, where she is crowned with the distinctive solar disk enclosed by cow's horns. A diadem encircles the forehead of this divinity whose braided hair is held by a red ribbon; rich *uraei* hang from her ears, and her necklace, decorated with enamel, has a counterweight which hangs down her back; on this ornament, which ends in a flower blossom, is inscribed in the original relief, the name of the Pharaoh Usirei, followed by the title 'Beloved of Hathor'. She holds a *menat* necklace in her right hand and tinkles its beads. As protector goddess of dance and music, Hathor is often represented with either a *sistrum* or *menat* in her hands. Here she is wearing close fitting clothes. Sometimes she is represented as a cow as in the chapel of the cow goddess from Deir el-Bahari, now in the Egyptian Museum in Cairo.

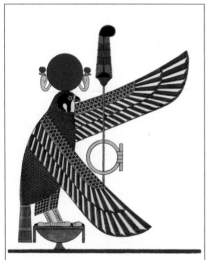

Horus

Horus was one of the most powerful and important gods of ancient Egypt, and was a member of the Great Ennead of Heliopolis.

He appeared in many forms among them Ra-Herakhty, Horus the Elder, Horus the Younger and Horus the Child. Horus the Elder was the son of Geb, the earth god and Nut, the sky goddess, while Horus the Younger was the son of Isis and Osiris. Ra-Herakhty was the association of Horus and Ra representing the early morning sun. Horus was depicted in numerous forms such as a winged falcon, winged sun disk, a falcon-headed man. 'Horus, the great god, lord of the sky, son of Ra, he who carries the skies,". In the Old Kingdom Horus was regarded as 'lord of the sunrise, hence 'Horus in the horizon'.

The legend of Horus tells us that the followers of Horus celebrated his victory over Seth in Edfu. At this event Ra ordered that the winged disk, the form that Horus had assumed when he battled as Ra-Herakhty, must be kept over doors as a symbol that god protected all who entered. Throughout the history of ancient Egypt, the main cult centre of Horus was Edfu. The temple of Edfu built by Ptolemy III is one of the best preserved temples of ancient Egypt. A grey granite statue of the falcon Horus at the entrance is one of the most masterly representations of Horus.

Khnum

Khnum was regarded as god of creation and guardian of the Nile's sources at Elephantine. The lands beyond the First Cataract were unknown at the time, and the First Cataract was regarded as the source of the Nile. Khnum was in general considered the lord of water, including the Nile and its inundations. According to the Famine Stela in Aswan, Khnum intervened on behalf of King Djoser, when the inundation was low for several years in succession. A temple dedicated to Khnum was built on the island of Elephantine.

Khnum is represented as a man seated in front of a table, with a ram's head and two twisted horns. Well preserved representations of him can be seen in Deir el-Bahari and the temples of Luxor and Esna.

Khonsu

Khonsu, 'the traveller', is the moon god, and was represented as a falcon-headed man wearing the moon disk and crescent on his head. Together with his father the god Amun and his mother the goddess Mut, they form the Thebian triad. His role was mainly to help in expelling demons and other evil spirits. Recorded on a Stela in the temple of Khonsu in Karnak is an account of how he miraculously cured a foreign princess.

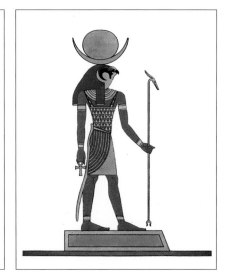

Imhotep

'The king's chancellor for Lower Egypt, the first after the king in Upper Egypt, the manager of the great palace, the prince, the high priest of Heliopolis, Imhotep, the master builder,', this is the description of Imhotep on the base of Djoser's statue. Imhotep was King Djoser's architect who designed and built the Step Pyramid in Saqqara. It was the first stone building in the world. From the Middle Kingdom on Imhotep's deeds and wisdom were mentioned and he was worshipped as the son of Ptah. During the Late Period he was worshipped as the god of medicine. Chapels were built for him in many temples including Philæ. Imhotep was represented as a seated man.

Isis

Through the myth of Osiris, Isis became one of the most important, national goddesses of Egypt. She was the sister and wife of Osiris, and mother of the young Horus. Her painful experience and the loyalty with which she carried out her duty towards her murdered husband and her son earned her the title of 'Great Mother'. As a universal goddess she had temples, shrines and festivals all over Egypt. Her main temples were on the island of Philæ, Memphis and Busiris. Among her other epithets were 'mother of nature, goddess of elements, the highest goddess, queen of the dead, the first resident of the skies' She is represented as a woman with a crown similar to Hathor's consisting of a pair of cow horns and the sun disk surrounded by the cobra. She was also recognised by an amulet, known as the 'blood of Isis' which was made of semiprecious red stones. When placed inside coffins it gave the dead the power of the goddess, who had resurrected her own husband. The amulet had a shape similar to the ankh life sign. In the Late Period she was represented suckling Horus. In fact there is some similarity between Isis and child with Madonna and child. The fame of Isis lasted till the fifth century AD. The most important monument of Isis is the temple of Philæ on Philæ island built by Nectanebo I and Ptolemy II.

Maat

The goddess Maat personifies the idea of truth, of righteousness, order and justness, in short, all the world order established by her father Ra during the creation of the world. Because Maat represents the 'absolute truth' she has the highest position in the judgement court of the dead. She is usually represented as a feather that is weighed against the heart of the deceased. In other judgement scenes she is depicted holding the hands of the deceased as he watches the weighing of his heart by Anubis and Horus against a feather, and declares the results to Osiris. The hieroglyphic symbol for Maat is a feather. She was depicted as a woman wearing a closefitting dress, with a feather on the head.

Min

Min was the god of fertility and crops. He was mainly worshipped in Achmim and Coptos, and since these towns were the starting points of the main desert routes to the Eastern and Western Deserts, he was also the lord of the desert.

Min is represented with an erect penis wearing the double crown of the god Amun and is hence united with him as Min-Amun. The modern word 'semen' is derived from the fertility god Min.

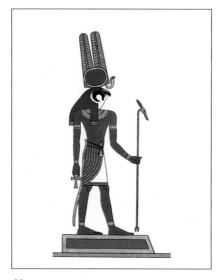

Montu

Montu was the main god of Thebes in the 11th Dynasty then he was replaced by the Thebian triad of Amun and his main role then became that of the great god of war. His main cult centre was at Karnak. Montu is represented as a falcon-headed man. On his head he wears the sun disk, the double feather crown and the *uraeus* snake.

Mut

Mut was the Thebian goddess wife of Amun, and mother of the moon god Khonsu. Mut was considered the queen of the gods.

Accompanied by the titles 'the mother; lady of the upper region', Mut was the faithful companion of Amun-Ra. The Egyptians dedicated the vulture that she is wearing on her head here, to her. This bird symbolised both womanhood and motherhood. She is represented in her more usual aspect as a winged woman seated on a throne and wearing the crown called *pschent*, the royal crown that unites the emblems of the almighty goddess, placed over the body of a vulture. Mut was the symbol of the feminine and the maternal principles of the universe; divine wisdom; inventor of the sciences and the arts of peace; wisdom, which brings victory; the force that moves and sustains nature and later the divine protector of warriors, just like the Greek Athena, whose cult was brought from the banks of the Nile to the coast of Attica.

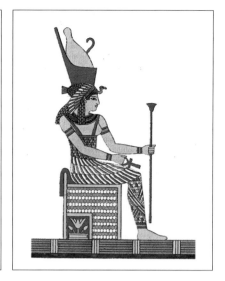

Neith

The terrifying goddess of war and arms and an exorcist of evil spirits. As founder of weaving she had also some peaceful activities. She is one of the four goddesses on the shrines, such as that of Tutankhamun in the Egyptian Museum in Cairo. As goddess of Lower Egypt she is related to Osiris and the crocodile god Sobek. Neith was most famous in the Saitic period. The Greeks related her to the goddess Athena. She is represented as a woman wearing the crown of Lower Egypt and carries in her hand a bow and two arrows and sometimes a shield.

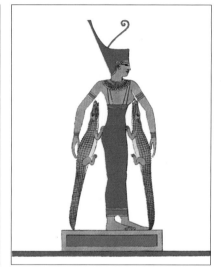

Nephthys

In the Osiris myth, Nephthys was the sister of Osiris and the wife of Seth. She was also the mother of Anubis. The ancient Egyptians believed in the duality of things. Accordingly Osiris and Seth were portrayed as a dichotomy, Isis and Nephthys were another two sides of duality. Isis was the symbol of light and day and Nephthys was the symbol of darkness and night.

The Pyramid Texts describe that in the struggle between Isis and Seth; Nephthys seemed to have supported Isis and assisted her in collecting Osiris' body after Seth had dispersed it. She was admired as the protector of the organs of the dead. Nephthys, together with Isis, Selket and Neith guards the canopic shrine of Tutankhamun in the Egyptian Museum in Cairo.

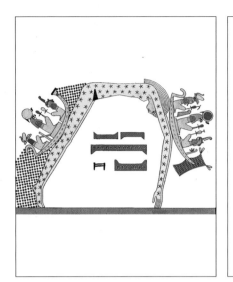

Nut

Nut is portrayed with a limb at the four corners of the sky. She is the sky goddess who swallowed the setting sun in the evening and the following morning gave birth to it again. In the Heliopolitian Theology she was the wife and sister of the earth god Geb, and mother of Osiris, Isis, Nephthys, Seth and Horus the Elder. Her five children were born in five days. According to the Pyramid Texts Nut was responsible for the protection of the dead and for the gods sailing through the daytime sky in their solar boat. She was often depicted in burial chambers such as in the tombs of Sety I and Ramses III. She was also represented in the Osiron at Abydos. The representation of the goddess Nut is semi-circular to express the idea of the vault of the heavens. Her body completely covered with stars, Nut was in fact, the embodiment of the sky. Two boats cross the sky, which is represented by the goddess's body: one placed at her feet rises towards her head thus symbolizing the rising sun. The other on the upper part of Nut, goes down indicating the setting sun. With the falcon head surmounted by the disk and encircled by the *uraeus*, one cannot misidentify the main personage seated in the boat, it is Ra, the embodiment of the sun. Maat, his daughter whom one can recognize by the ribbon and ostrich plume that adorn her headdress accompanies him. The disk of the rising sun is painted in gold and the setting sun is painted red. Thus, the two boats placed on the body of Nut express symbolically the mythical daily course of the sun in the vast expanse of the heavens.

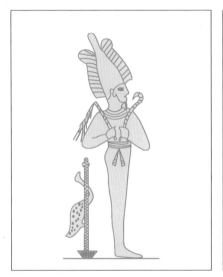

Osiris

According to the theology of Heliopolis, Osiris was the eldest son of Geb the earth god and Nut the sky goddess. Through the famous myth (see above the myth of Osiris, Isis and Seth), Osiris became the universal god in Egypt and with Isis and Horus was regarded as a holy family. Since the New Kingdom, Osiris was worshipped throughout all of Egypt as the god of the dead. As lord to those who are in the west, he reigned over the netherworld. Since the 5th Dynasty the dead king was recognized as Osiris, while the living ruler was identified with his son Horus. After democratisation of religious beliefs in the First Intermediate Period, every human when dead became identified as Osiris to stay in this form eternally. The sun god Ra, the counterpart of Osiris rules over the living world during the day hours and Osiris over our mortal part in the night hours. This alternating cycle between day and night symbolise death in the night hours and resurrection the following morning. The main cult centre of Osiris was at Abydos.

Ptah

Ptah is the universal god of world creation in the Memphite Theology. He was thought to be the god that created man, animals, plants, lands and seas. The Memphite triad consists of Ptah his wife Sekhmet and son Nefertem, and they are all related to Sokar and Osiris, gods of the netherworld. Ptah was the source of time but was himself immeasurable.

The god Ptah is represented in the form of a mummy entirely wrapped in a very tight white garment from the neck to under the soles of the feet, with openings only for the hands. Standing in a richly decorated chapel, he leans against a particular symbol that was specific to him and expressed his qualities of stability and longevity. The Egyptians wanting to link the creation of the earth and the sky claimed that Ptah was the first of their dynasts, but the length of his reign was unknown. It was to him that the pharaohs dedicated their royal city, Memphis. The magnificent temple of Ptah in Memphis where the investiture of the kings took place, was described by Herodotus and Strabo. The most famous pharaohs decorated it with porticoes and colossi.

Ra

Ra played a major role in the creation myth of Heliopolis (see above). Chephren was the first king to adopt the title son of Ra and all his successors followed this tradition. Ra is the sun god that sailed in the solar boat through the sky. Early morning was analogous to a young energetic man, midday to a middle-aged one, and the evening to an elderly man, who had no strength. In the 12 night hours the sun sailed through the netherworld back in space and time and was regenerated or reborn next morning as an energetic young man. By assuming the earth to be flat, this concept could be only be explained if we imagined the sun sailing backwards in both space and time through the night. Therefore, the setting sun in the west would appear next morning in the east only if it travelled backwards during the night. Through the netherworld, the realm of the dead, the sun is reborn next morning and with it the dead are resurrected.

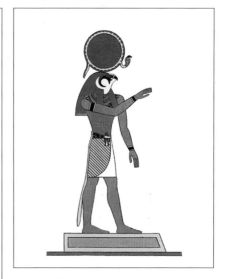

The goddess Maat, daughter of Ra represents absolute justice and truth. Ra is represented as a falcon-headed man topped with the sun disk encircled by a cobra. As a falcon-headed deity his depiction is similar to Horus, the difference being that Horus wears a crown on his head. Ra holds in his hands the *ankh* and sceptre. In a few representations Ra is shown as a seated man with a scarab in place of his head. Since the scarab god Khepri symbolised rebirth this depiction was meant to emphasize him as god of creation and resurrection. Hence, this appearance was Ra in the morning. In the evening he had the totally human form of Atum, which is one of the oldest shapes of the sun god. In the form of Atum, Ra created the world from chaos. In the last hours of daylight he helped humans to battle the enemies of the night.

Serapis

Serapis represents the world creation myth in the Ptolemaic era developed from the myth of Osiris. The Egyptians identified Serapis as Ra, Osiris and Apis, and the Greeks identified Serapis as Zeus, Askleoios and Dionysos. His shrines were in Saqqara and Alexandria. Serapis was also worshipped in Greece and Rome in the early Christian era. He is represented as the bust of Zeus.

Sekhmet

Sekhmet is the strong lion-headed goddess of Memphis, wife of Ptah and mother of Nefertem, who carried the myth of the destruction of mankind. The myth brought death and devastation to the world, but Sekhmet was also the goddess of health. However, her main emblem was as the protective force of the country. The female warrior appeared to prevent the entry of the profane and enemies of civil and religious laws, and therefore her statues were erected at the entrances to the palaces and temples. Her statues are numerous, usually colossal and nearly always of granite, showing the goddess in the form of a lion-headed woman, a specific sign expressing vigilance and protection. Her headdress is always surmounted by a solar disk decorated with the royal *uraeus*. She sometimes stands but usually is seated on a throne and carries the emblems of divinity: the key of life and the sacred lotus. A long, narrow tunic covers her from the breasts down, which remain bare; her arms; wrists and feet are adorned with rings of greater or less value.

Seth

Seth was originally lord of the desert and of foreign lands. Later in the Osiris myth he became a wicked character and a murderer. He killed his brother Osiris and in a fight with Horus knocked out one of his eyes. On the other hand he protected the sun god by travelling with him and sitting on the bow of the boat during the night journey, and attacking the evil serpent of the netherworld, Apophis with an arrow. In this context his violent nature was put to a noble purpose. The 2nd Dynasty King Peribsen chose to have the emblem of Seth instead of Horus. There is a lot of evidence of civil unrest in this era, probably between followers of Seth and Horus. The next King, Khasekhemwi had the emblems of both Seth and Horus crowning his *serekh*. This seems to have been a period of reconciliation between the two faiths. Later the serekh was only associated with Horus. During the Second Intermediate Period Seth was worshipped by the Hyksos in their capital Avaris. Seth was worshipped in the 19th Dynasty and some kings were named after him for example, Sety I. The Egyptian Museum in Cairo has a beautiful statue of Ramses III being crowned by Seth and Horus. The statue of Seth was damaged in antiquity but had now been restored. The damage could have been intentional. However, in the late period Seth was demonised and equated with the devil, who had all the attribute of wickedness, hence the modern name 'Satan'. Seth was married to his sister Nephthys, and Anubis was their son. After Seth had killed his brother Osiris, Nephthys chose to side with her sister Isis and comfort her.

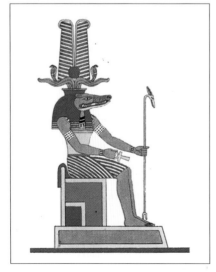

Sobek

The god Sobek appears here with the head of a crocodile, a ferocious awesome, amphibious creature that dwelt in the Nile at the time of ancient Egypt. Seated on the throne, he wears the sacred emblems of the great divinities. The headdress of the god is crowned by two large plumes, a red disk and two ram horns. The horns support two *uraei* because it was believed in Egyptian mythology that this divinity had perhaps once ruled Egypt. This animal is the very emblem of time. Thus, in the hieroglyphic system, various parts of the crocodile expressing celestial phenomena, served as a basis for the division of time. The eyes of the animal mean the rising of the sun or another heavenly body; the crocodile with a curved posture denotes its setting; and the tail the darkness or obscurity of the night. The god Sobek was worshipped in several towns, particularly in the temples of Kom Ombo in Upper Egypt, and of Crocodilopolis in Fayum.

Thoth

Originally Thoth was the moon god but he developed into the lord of wisdom, and was regarded as the founder of writing. In the court of the judgement of the dead, he declared the results of the weighing of the deceased's heart to Osiris. Maat and Thoth together were associated with the components of intelligence, where the former represented truth and justice while the latter wisdom and in particular, he was the god of science and medicine. It is thought that he invented hieroglyphic writing, arithmetic and astronomy. The cult of Thoth stems from the town of Hermopolis in central Egypt. This town was never an important political or religious centre. Unfortunately, there are no surviving documents from Hermopolis, but we can extrapolate its dogma from its influence on other cult centres such as Heliopolis and the Pyramid Texts. The creation myth of Hermopolis is abstract. It tells us about chaos that was transformed into four elements, in addition to an elder leader that gave order to the world. This leader was Thoth and the four elements had no distinct character such as Ra, Atum and Ptah, as in the other myths. Then for each of these four elements a female consort goddess was created, resulting in a total number of eight. Nun, lord of the primeval ocean, whom we had already encountered in the Heliopolitian myth was among the group. Other members were Heh, the god of infinity, Kek, the god of darkness and Amun, the god of mystery.

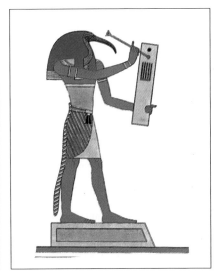

Thwaret

Thwaret, the protector goddess of women during childbirth.

In ancient Egypt the hippopotamus was always equated with evil and wickedness. They considered killing the hippopotamus as a symbolic subduing of evil.

Thwaret is represented as a hippopotamus standing upright with a woman's head, large breasts, with human hands and lion's paws, and a crocodile's tail. The forehead is decorated with the royal *uraeus*, symbol of an all-powerful sovereign. It tops a headdress held by a ribbon and completed by a wig, arranged in layers and formed of beads and enamel, coloured celestial blue and white. The goddess holds the emblem of divine life in her hand. A tunic of light, transparent material imperfectly veils the body of the monstrous quadruped, which used to live in the lower reaches of the Nile. Such is the representation of Thwaret, the divinity who symbolises the divine spirit that watches over pregnant women. Accompanied by the inscription, 'the one who presides over pure water', she appears in the reliefs of temples being worshipped by and receiving offerings from Egyptian princesses.

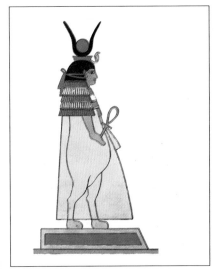

Upuaut

Upuaut as the god of the dead, is related to Anubis. His name means 'opener of the ways'. In Abydos he is related to the Osiris cult and leads the underworld journey of the solar barque. He is represented as a jackal.

The Egyptian Museum

The Egyptian Museum, which contains a more comprehensive collection of pharaonic art than any other museum in the world, merits at least two visits. The first should be a general survey, as a preparation before setting out to view the historical sites at Giza, Saqqara, Luxor and elsewhere. The second should be paid upon returning from visiting these historical places. Thus, in the museum, the impressions of Giza, Saqqara and Upper Egypt will be consolidated and deepened by a thorough and careful study of the appropriate sections in the museum. The building in which the museum is now housed dates from 1900. From 1858 the antiquities were housed in smaller premises at Bulaq and from 1890 in Giza Palace. The founder and head of the Antiquities Department (now the Supreme Council for Antiquities), was the Frenchman Auguste Mariette (1821-1881). He was followed by G. Maspero in 1881, E. Grebaut in 1886, G. de Morgan in 1892, V. Loret in 1897, Maspero again in 1899, P. Lacau in 1914 and A. Drioton in 1936. The visitor would be well advised to follow the chronological order in which the exhibits are shown and to see first the rooms of the Old Kingdom, then those of the Middle Kingdom and so on. It must be pointed out that, as in all big museums, objects are from time to time removed in order to make room for new finds; we therefore indicate only the various sections and the most important exhibits. The museum is housed on the ground and first floors of the building.

Old Kingdom

These rooms and galleries contain sarcophagi, statuettes, Stelas, false doors and painted reliefs. Notice especially three statues of Mycerinus, between the goddess Hathor and a local deity (see plate 6 page 72 and page 97, plates 4 and 5). Then, of importance is the diorite statue of Chephren (see pages 93 and 95), which was found in the valley temple of Giza; there is furthermore a wooden statue of Ka-aper, known as the "Sheikh el-Balad", from the 5th Dynasty, found at Saqqara (see page 72, plate 7); a limestone statue of the Pharaoh Djoser from Saqqara (3rd Dynasty) (see page 72, plate 5); and a painted limestone statue of a scribe with a roll of papyrus on his knees (5th Dynasty) (see page 73, plate 16).

You will also see, among others, limestone statues of Ra-hotep and his wife Nofert, from Meidum (4th Dynasty) (see page 43); the six geese of Meidum (4th Dynasty), and copper statues of King Pepi I and his son; these are the oldest metal statues of ancient Egyptian workmanship (6th Dynasty). There is also a painted relief from a tomb at Saqqara, representing boatmen fighting (4th Dynasty). The collection of Queen Hetepheres contains treasures from the tomb of Queen Hetep-heres, mother of the Pharaoh Cheops (see pages 90 & 91).

Middle Kingdom

These rooms contain burial chambers, royal statues and reliefs. Through the galleries, where a seated limestone statue of Amenemhat III is noticeable, one reaches a room where the items of importance are: a burial chamber with a sarcophagus from Deir el-Bahari (11th Dynasty); a wooden statue of Senusret I (left); and four sphinxes of black granite from Tanis.

New Kingdom

Among other exhibits, these rooms contain statues, statuettes, sphinxes: a remarkable sphinx of Queen Hatshepsut in coloured limestone from her temple in Thebes, and also a schist statue of Tuthmosis II from Karnak, which is considered to be a true to life representation of the king. In the next room: the holy cow, representing the goddess Hathor from Deir el-Bahari; in front of the cow is presumably Tuthmosis III; the same king, kneeling under the animal, is seen sucking its milk (see page 73, plate 18). Behind the cow of Hathor, is the chapel, with beautiful coloured reliefs, in which the holy cow once stood. There is also a granite statue of the god Khonsu, from Karnak (18th Dynasty).

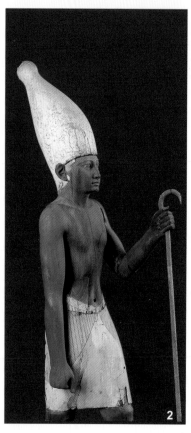

1. The Egyptian Museum in Cairo, built 1902.
2. Wooden statuette of Senusert I, 12th Dynasty; reign of Senusert I, 1971 - 1928 BC; Ground floor, room 22;
3. Statue of an offering bearer, 11th Dynasty; *c.* 2000 BC; Upper floor, room 27;

Akhenaten room: under Akhenaten-Amenhotep IV, (18th Dynasty; 1350-1334 BC), a less conventional trend is noticeable in the artistic forms, replacing the strict stylisation found up to then. Near the walls are gigantic statues of the king from Karnak (see page 73, plate 20); a huge stone statue and a very beautiful unfinished head of Queen Nefertiti (see page 74, plate 28). Then there is a magnificent head of the king, and a coloured relief representing him and his wife Nefertiti worshipping the sun god, the Aten (see page 130). Visitors pressed for time should now return to the stairs to see the Tutankhamun collection on the first floor, but if more time is available, it is advised to continue examining the collection contained in further rooms on the ground floor, devoted to the New Kingdom. From the Akhenaten room, the way leads through the galleries into a room containing statues, reliefs, inscriptions and pillars of the 19th and 20th Dynasties. Among others: works of the Late Period, many of them in schist (slate and granite); granite sarcophagi of the Ptolemaic period, with representations of various deities, and inscriptions.

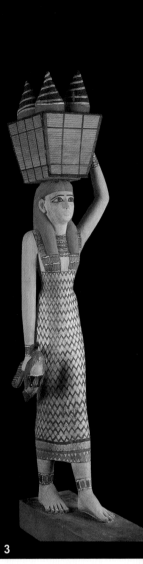

Atrium (Inner Court)

Here we find antiquities of various periods: two wooden boats of the dead found at Dahshur (12th Dynasty); a black granite bed sculptured with Osiris, god of the dead in mystic union with the goddess Isis represented as a falcon; a very beautiful painted plaster decoration, which covered the floor of the palace of Akhenaten at Tell el-Amarna, which has been partially restored. The colossal statues represent Amenhotep III, his wife Tîye and their daughters.

Upper Floor

From the *atrium* on the ground floor, the upper floor is reached through the gallery to the left and up the stairs. On this floor the visitor should start by first looking at the scarabs.

Collection of the Tanite Kings

Here are exhibited objects from the royal tombs of Tanis (21st and 22nd Dynasties). There are a silver coffin, delicate ornaments, and gold and silver vases. Aside from the treasures of Tutankhamun, it is the biggest collection of gold and silversmiths' work in the museum. The most interesting pieces are a gold amulet with the king's titles in lapis lazuli, and large gold necklaces.

Collection of Jewellery

This is a collection of jewellery comprising pieces dating from the 1st Dynasty through to the Byzantine period - a period of several centuries. The whole collection merits attention.

The Tutankhamun Collection

3

The collection contains the gold coffins and jewels of the king; all the pieces shown here are artistic treasures from the tomb of Tutankhamun in the Valley of Kings. The most important are: the second of the three gold coffins, which were discovered in the tomb in 1922. It is of wood, covered with gold and inlaid with coloured glass. In the middle of the room, a solid gold mask, which covered the head of the royal mummy; the eyebrows, eyelids, and the stripes of the royal head-dress are of lapis lazuli. From the forehead spring the emblems of royal power, the vulture and the uraeus (cobra). Then, on the extreme right of this, the innermost of the three coffins, which weighs over 200 kilograms. The king is wearing the false beard that links him with the god Osiris, and he holds the royal sceptre and flail in his hands.

The whole Tutankhamun collection, extending along the eastern galleries, should be seen. Particularly interesting is the famous throne with, on its back, a representation of the king sitting on his throne, the queen standing before him, touching his shoulder with her hand, and in the centre the sun disk of the Aten (see page 76, plate 43). There is also a wooden chest with painted scenes from the wars against the Asians and the Nubians - the top shows hunting scenes and on the two ends, the king is represented as a sphinx; there are also various deities and statues of the king in different poses (see page 13).

In the following rooms are Roman coffins, masks and portraits; a collection of statuettes and figures of Egyptian deities and sacred animals from different periods and localities; studies for reliefs and patterns; manuscripts; objects used in daily life (tools, weapons, musical instruments, toilet articles) from the Greco-Roman period.

Then follow: coffins of the priests of Amun, and their furniture; a model of the pyramid and the mortuary chamber of Abusir (5th Dynasty). Then there are collections from the Archaic Period (1st and 2nd Dynasties).

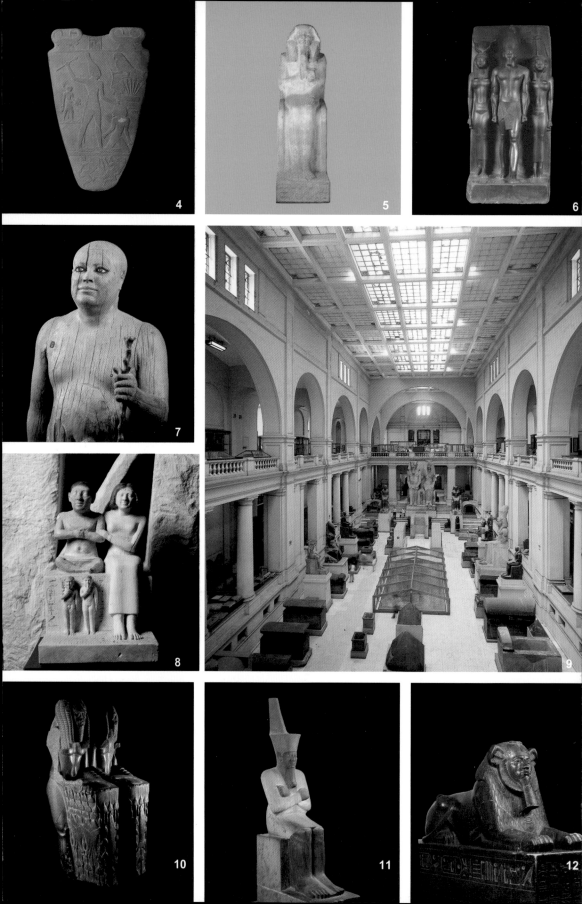

13

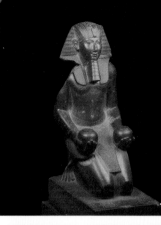

14

15

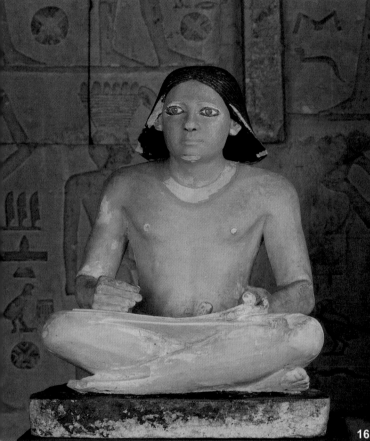

16

17

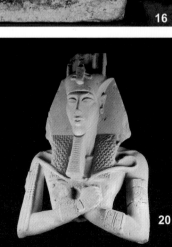

18

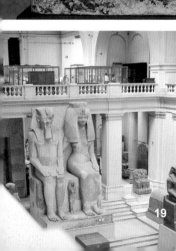

19

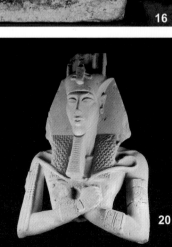

20

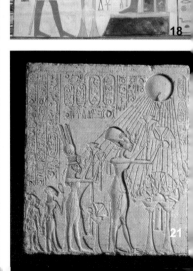

21

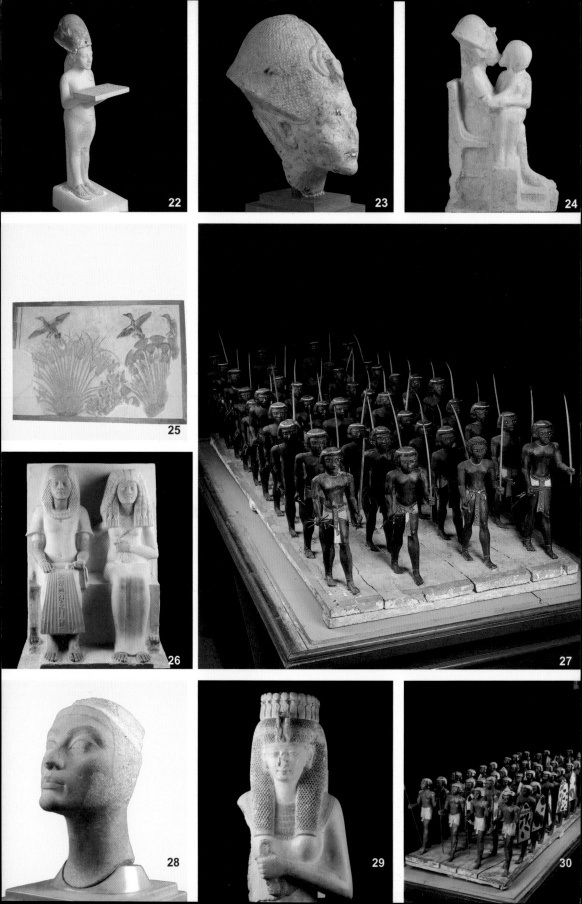

22

23

24

25

26

27

28

29

30

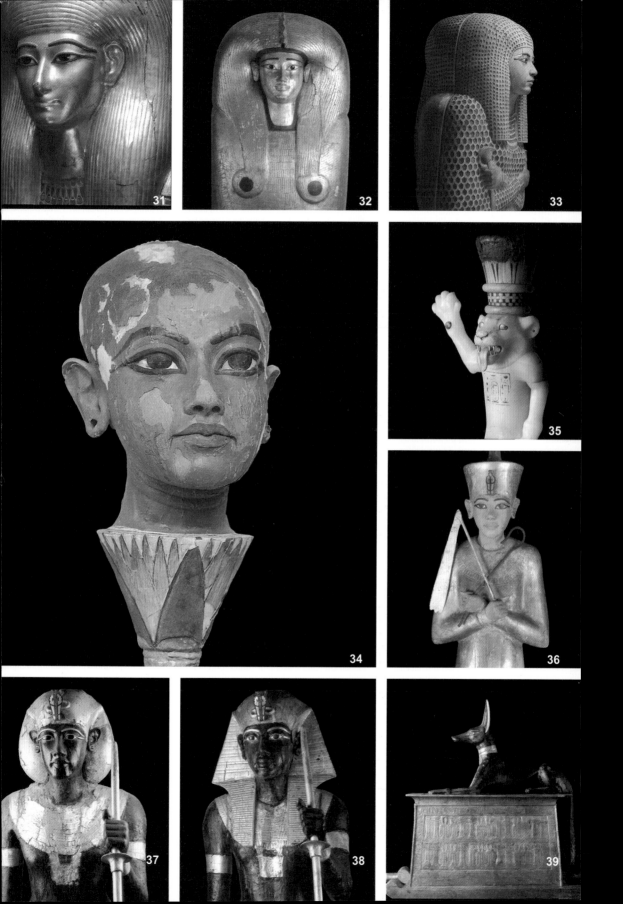

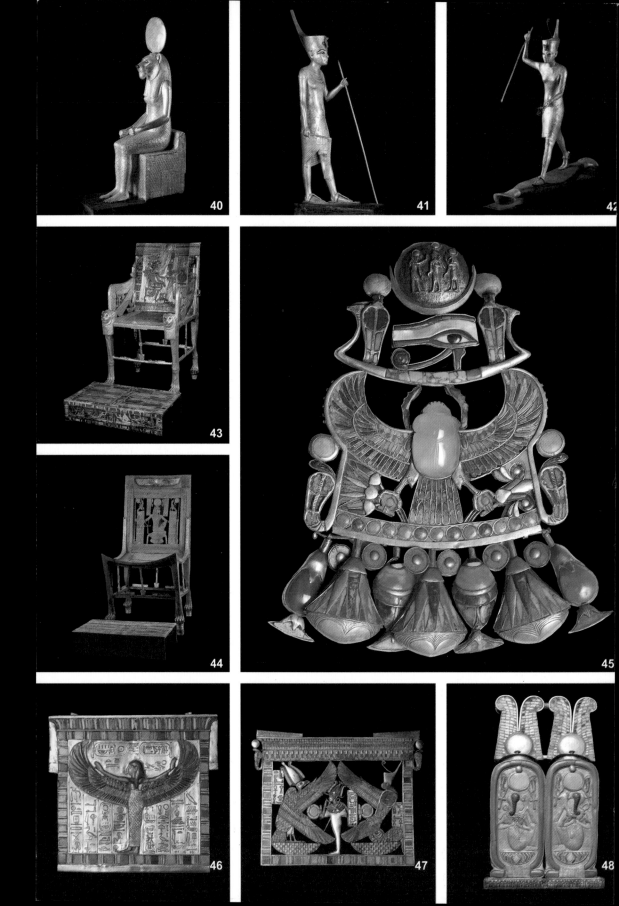

40

41

42

43

44

45

46

47

48

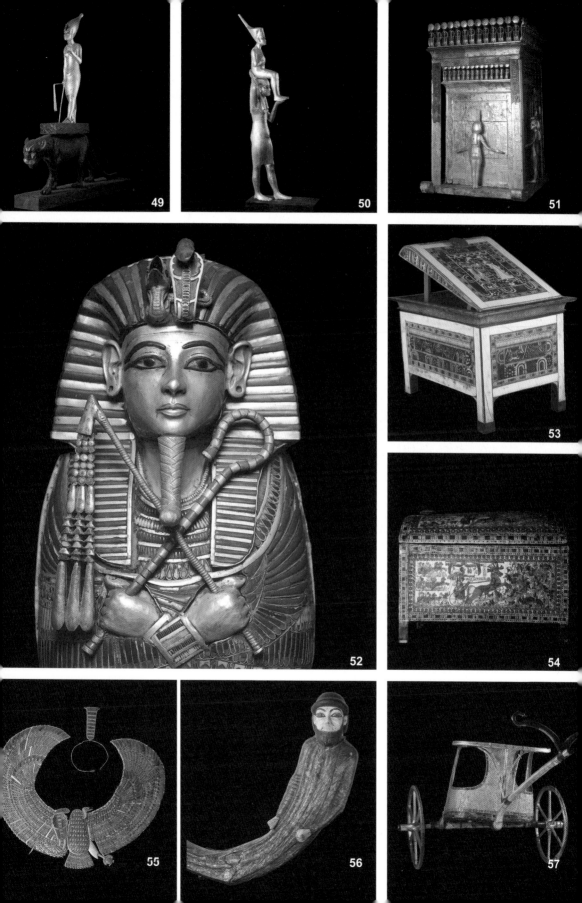

49

50

51

52

53

54

55

56

57

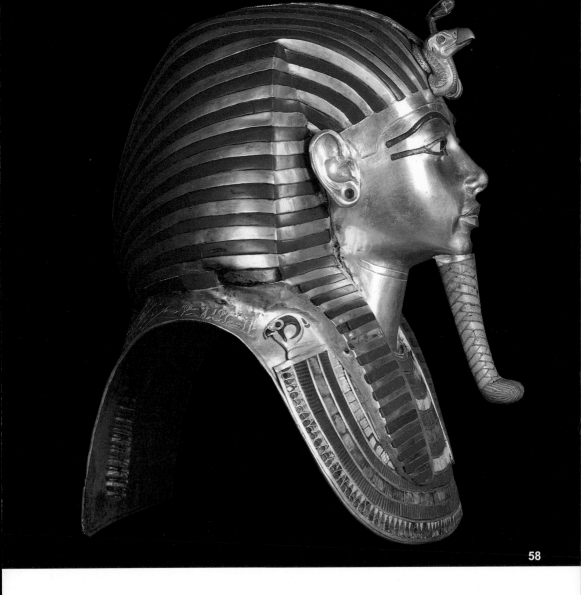

58

4. The Narmer Palette: 1st Dynasty, *c.* 3000 BC; Ground floor, gallery 43;
Smiting the enemy, the Pharaoh Narmer is represented as the king of both Upper and Lower Egypt. He is wearing the tall White Crown of Upper Egypt, and battles to unite Upper and Lower Egypt under his rule. This 1st Dynasty commemorative palette is one of Egypt's oldest surviving historical records. It was found in Hierakonopolis, the ancient capital of Upper Egypt.
Here the pharaoh smashes the head of his enemy, probably an inhabitant from Lower Egypt, with a club. This representation became a standard symbol in Egyptian art for the next 3000 years. The pharaoh is also wearing an animal skin and is followed by his sandal-bearer. Above his foe is the pharaoh incarnated as the hawk god, Horus, holding the enemy with a rope by his strong right hand. The latter is within the papyrus marches of the Delta. The hawk symbolises 'the god Horus', i.e. the divine representation of the pharaoh, and the papyrus means Lower Egypt. One can therefore explain this emblem as the Pharaoh Narmer conquering the Delta. Two bearded men, adversaries of the pharaoh are fleeing naked, possibly running or swimming, or are, as many people see it, lying dead on the ground.
5. King Djoser: 3rd Dynasty; reign of Djoser, 2687 – 2668 BC; Ground floor, gallery 48;
6. Triad of King Menkaure: 4th Dynasty; reign of Menkaure, 2551 – 2523 BC;
Ground floor, gallery 47;

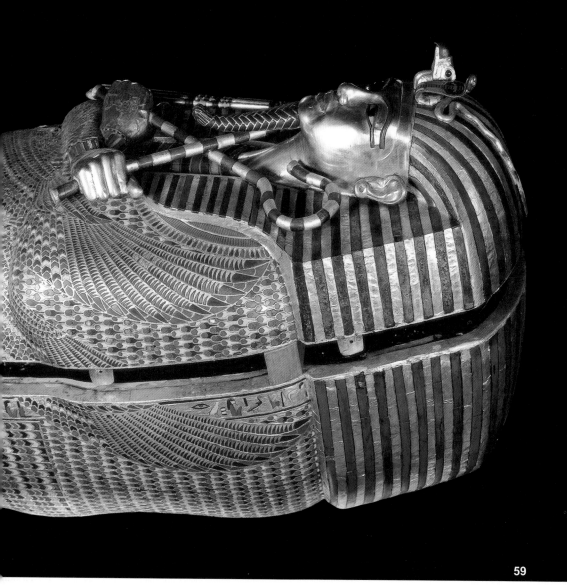

This is a group of three statues. In the centre is the Pharaoh Mycerinus wearing the White Crown of Upper Egypt. On his right stands Hathor, goddess of the sky and love. On her head she wears her characteristic emblem, the solar disk between two cow's horns. On the left of Mycerinus stands a female figure personifying the *Cynopolite nome* of Upper Egypt.

7. Wooden statue of Ka-aper (112 cm) or Sheikh el-Balad: 5th Dynasty; reign of Userkaf, 2513 – 2506 BC; Ground floor, room 42;

The Arabic name Sheikh al-Balad means the 'elder of a village', however, Ka-aper was a priest during the 5th Dynasty. This statue is one of the most magnificent non-royal statues of the Old Kingdom. Standing in front of this figure the viewer is left in awe. It realises the ancient Egyptian definition of eternity. It seems so real that one feels that the priest is standing alive in front of us, and that he will live forever. For an Old Kingdom statue this figure has an unusual pose; the body weight is partly on the left leg and partly on the stick that he is holding in his left hand. The left leg is advanced while he is about to lift or move his right leg. His head is rounded and bold and his figure is somewhat chubby. The eyes are inlaid with crystal and fringed with copper; the arms are made separately and fixed to the body. His kilt is long and knotted at his belly. The stick that he holds is new. The statue was found at Saqqara in 1860;

8. The Dwarf Seneb and his family: 4th or 5th Dynasty; *c.* 2550 BC; Ground floor, room 32;

9. Hall of the Ground Floor.

10. Double statue of Amenemhat III as a Nile god: 12th Dynasty; reign of Amenemhat III, 1843 – 1797 BC; Ground floor, gallery 21;

11. Statue of Montuhotep Nebhepetre: 11th Dynasty; reign of Montuhotep Nebhepetre, 2061 – 2010 BC; Ground floor, gallery 16;

12. Sphinx of Amenemhat III: 12th Dynasty; reign of Amenemhat III, 1843 – 1797 BC; Ground floor, gallery 16;

13. Funerary Stela of Amenemhat: 11th Dynasty; *c.* 2000 BC; Ground floor, gallery 21;

14. Statue of Amenemhat III in priestly costume: 12th Dynasty; reign of Amenemhat III, 1843 – 1797 BC; Ground floor, gallery 21;

15. Kneeling statue of Tuthmosis III: 18th Dynasty, reign of Tuthmosis III, 1504 – 1452 BC; Ground floor, room 12;

16. Seated Scribe; 5th Dynasty; *c.* 2450 BC; Ground floor, room 42;

17. Marble statue of Tuthmosis III: 18th Dynasty, reign of Tuthmosis III, 1504 – 1452 BC; Ground floor, room 12;

18. Chapel with Hathor, the Cow Goddess: 18th Dynasty, reign of Tuthmosis III, 1504 – 1452 BC; Ground floor, room 12;

19. Colossal group statue of King Amenhotep III, Queen Tiye and their daughters: 18th Dynasty, reign of Amenhotep III, 1410 – 1372 BC; Ground floor, gallery 13;

20. Bust of Akhenaten: 18th Dynasty, reign of Akhenaten, 1372 – 1355 BC; Ground floor, room 3;

21. Panel with an adoration scene of the Aten: 18th Dynasty, reign of Akhenaten, 1372 – 1355 BC; Ground floor, room 3;

22. Akhenaten making an offering, 18th Dynasty, reign of Akhenaten, 1372 – 1355 BC; Ground floor, room 3;

23. Head of Akhenaten, 18th Dynasty, reign of Akhenaten, 1372 – 1355 BC; Ground floor, room 3;

24. Akhenaten with a female figure seated on his lap: 18th Dynasty, reign of Akhenaten, 1372 – 1355 BC; Ground floor, room 3;

25. Fragment of a painted floor: 18th Dynasty, reign of Akhenaten, 1372 – 1355 BC; Ground floor, room 3;

26. Meryre and his wife Iniuia: 18th Dynasty, reign of Akhenaten, 1372 – 1355 BC; Ground floor, room 3;

27. Troop of Nubian archers: 11th Dynasty; *c.* 2000 BC; Upper floor, room 37;

28. Unfinished head of Nefertiti: 18th Dynasty, reign of Akhenaten, 1372 – 1355 BC; Ground floor, room 3;

29. Bust of Queen Merit-Amun: 19th Dynasty, reign of Ramses II 1304 – 1237 BC; Ground floor, gallery 15;

30. Troop of pike men: 11th Dynasty; *c.* 2000 BC; Upper floor, room 37;

31. Coffin of Yuya: 18th Dynasty, reign of Amenhotep III, 1410 – 1372 BC; Upper floor, gallery 43;

32. Anthropoid coffin of Queen Ahhotep: 18th Dynasty; Reign of Ahmose, 1569 – 1545 BC; Upper floor, gallery 46;

33. Anthropoid coffin of Queen Ahmose Merit Amun: 18th Dynasty, reign of Amenhotep I, 1545 – 1525 BC; Upper floor, gallery 46;

34. Head of Tutankhamun emerging from a lotus flower: 18th Dynasty, reign of Tutankhamun 1356 – 1346 BC, Upper floor, gallery 30.

35. Lion unguent container: 18th Dynasty, reign of Tutankhamun 1356 – 1346 BC, Upper floor, gallery 20;

36. Shawabti of Tutankhamun wearing the Red Crown of Lower Egypt: 18th Dynasty, reign of Tutankhamun 1356 – 1346 BC, Upper floor, gallery 20.

37 & 38. *Ka* statues of Tutankhamun: 18th Dynasty, reign of Tutankhamun 1356 – 1346 BC, Upper floor, gallery 45. The two statues are almost identical, in plate 37 he wears the *khat* wig, and in plate 38 he wears the *nemes* wig.

39. Statue of Anubis: 18th Dynasty, reign of Tutankhamun 1356 – 1346 BC, Upper floor, gallery 9.

40. Statue of Sekhmet: 18th Dynasty, reign of Tutankhamun 1356 – 1346 BC, Upper floor, gallery 45.

41. Statue of Tutankhamun wearing the Red Crown of Lower Egypt: 18th Dynasty, reign of Tutankhamun 1356 – 1346 BC, Upper floor, gallery 45.

42. Tutankhamun on a papyrus raft: 18th Dynasty, reign of Tutankhamun 1356 – 1346 BC, Upper floor, gallery 45.

43. Throne of Tutankhamun: 18th Dynasty, reign of Tutankhamun 1356 – 1346 BC, Upper floor, gallery 35.

44. Chair with the god Heh: 18th Dynasty, reign of Tutankhamun 1356 – 1346 BC, Upper floor, gallery 25.

45. Pectoral with a winged scarab: 18th Dynasty, reign of Tutankhamun 1356 – 1346 BC, Upper floor, room 3.

46. Pectoral of the sky goddess Nut: 18th Dynasty, reign of Tutankhamun 1356 – 1346 BC, Upper floor, room 3.

47. Pectoral of Osiris, Isis and Nephthys: 18th Dynasty, reign of Tutankhamun 1356 – 1346 BC, Upper floor, room 3.

48. Cosmetic box: 18th Dynasty, reign of Tutankhamun 1356 – 1346 BC, Upper floor, room 3.

49. Tutankhamun riding on the back of a leopard: 18th Dynasty, reign of Tutankhamun 1356 – 1346 BC, Upper floor, gallery 45.

50. A goddess carrying the king: 18th Dynasty, reign of Tutankhamun 1356 – 1346 BC, Upper floor, gallery 45.

51. Canopic shrine: 18th Dynasty, reign of Tutankhamun 1356 – 1346 BC, Upper floor, gallery 9.

52. Coffin of Tutankhamun's internal organs: 18th Dynasty, reign of Tutankhamun 1356 – 1346 BC, Upper floor, room 3.

53. Ornate chest: 18th Dynasty, reign of Tutankhamun 1356 – 1346 BC, Upper floor, gallery 20.

54. Painted chest: 18th Dynasty, reign of Tutankhamun 1356 – 1346 BC, Upper floor, gallery 20.

55. Collar of the two ladies: 18th Dynasty, reign of Tutankhamun 1356 – 1346 BC, Upper floor, room 3.

56. Stick with an Asiatic captive, reign of Tutankhamun 1356 – 1346 BC, Upper floor, gallery 9.

57. Ceremonial chariot: 18th Dynasty, reign of Tutankhamun 1356 – 1346 BC, Upper floor, gallery 9.

58. Gold mask of Tutankhamun: 18th Dynasty, reign of Tutankhamun 1356 – 1346 BC, Upper floor, room 3.

59. Outer gold coffin of Tutankhamun: 18th Dynasty, reign of Tutankhamun 1356 – 1346 BC, Upper floor, room 3;

The Pyramids of Giza

The pyramids of Giza lie southwest of Cairo on a flat elevation of the Libyan Desert. Cheops chose the Giza plateau composed of white limestone, as the place to build his pyramid about 2500 BC. From the plateau an extensive view of the countryside was to be obtained. Away to the north the valley opened onto the green plains of the Delta; and to the south the winding course of the Nile could be seen flanked by vivid fields and luxuriant palm groves as it came gliding down from the upper country, between the highlands of the Eastern and Western Deserts. A few kilometres away to the southeast stood the white houses and temples of Memphis set amidst green fields; and about an equal distance to the northeast across the river, was sacred On (now Heliopolis), with its backdrop of desert cliffs.

A walk around the Great Pyramid of Cheops will give a general impression of its huge size and can be followed by a visit to the burial chamber inside. The Sphinx, in the valley below, should be seen after this. Tourists who are not pressed for time should hire a camel or a horse at the Great Pyramid and after visiting the sites, ride south into the desert for an hour or two. On the way back they can pass the pyramids of Mycerinus and Chephren.

The early morning hours are particularly fresh and pleasant. If possible, another visit should be made to the pyramids by moonlight. Tourists are unanimous in saying that such a visit is one of the unforgettable experiences of Egypt. Around the Giza pyramids a whole city of the dead arose, there being smaller pyramids for members of the royal family, and street after street for the tombs of the nobles. Each tomb had its mortuary chapel or shrine, where offerings were made to the spirit of the deceased and on certain days the relatives came to pay their respects to honour the dead.

The Giza pyramids are part of the great cities of the dead of the Old Kingdom, extending from Abu Roash, in the north to Dahshur, in the south. In all there are six of these pyramid groups, spreading over some 30 kilometres on the eastern edge of the Libyan Desert plateau.

They are:

1. Abu Roash, the most northerly.
2. Giza, the biggest (the pyramid of Cheops).
3. Zawiyet Aryan, which is mostly in ruins.
4. Abusir.
5. Saqqara, the oldest (pyramid of Djoser).
6. Dahshur, the southernmost group, with the Bent Pyramid.

There are also pyramids at Lisht, Meidum and Fayum. Tourists should not fail to see those at Giza, Saqqara and Dahshur.

Each of these pyramid groups is the centre of a city of the dead; all round the big pyramids are smaller ones (usually those of queens) and *mastabas*, the tombs of those nobles who held high office during the pharaoh's life. They were generally buried in proximity to their royal masters, to whom they desired to remain close even after death. To each pyramid belongs a temple in which sacrifices were offered and ritual services held.

Why did the Old Kingdom pharaohs choose the pyramidal shape for their tombs? Scholars believe that the shape came through a process of development from *mastaba* to step pyramid, from step pyramid to true pyramid. This is still the generally accepted belief, but the flaws in this theory have been pointed out by Edwards, who suggests that the reason for choosing this shape may have been religious rather than practical. His theory is summarized as follows: The *mastaba* tombs of the 1st and 2nd Dynasty kings were conceived as eternal homes for their owners. The afterlife was to be lived in and around the tomb. Then at an undetermined period, possibly between the 2nd and 3rd Dynasties, a different concept gained ground, of an afterlife lived with the sun god.

The Pyramid Texts, the earliest religious documents known in Egypt, contain the text: "A staircase to heaven is laid for him so that he may climb to heaven thereby". It is tempting to believe that the Step Pyramid represents this heavenly staircase. Djoser built a tomb of each type, a *mastaba* at Beit Khalaf and his Step Pyramid at Saqqara; as well as the Southern Tomb, which is also a *mastaba* within the enclosure walls of the Step Pyramid. At this time rival religious systems may have been fighting for supremacy.

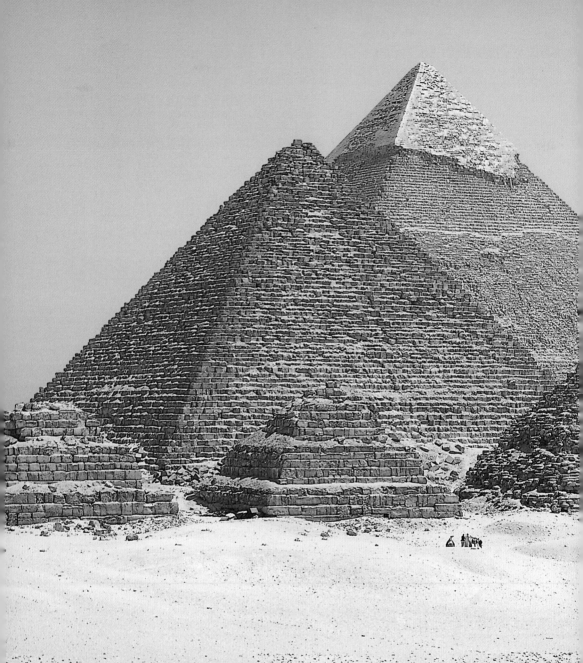

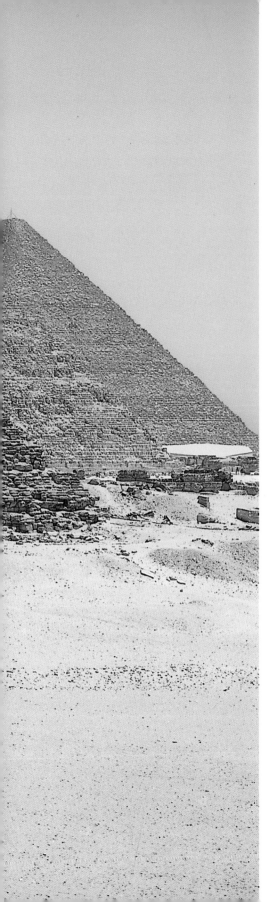

The Giza Pyramids are beyond doubt the supreme expression
of pharaonic majesty and power. The pyramids of Cheops,
Chephren and Mycerinus (foreground). Chephren's pyramid
is built on slightly higher ground than the Great Pyramid of
Cheops, and thus appears somewhat taller.

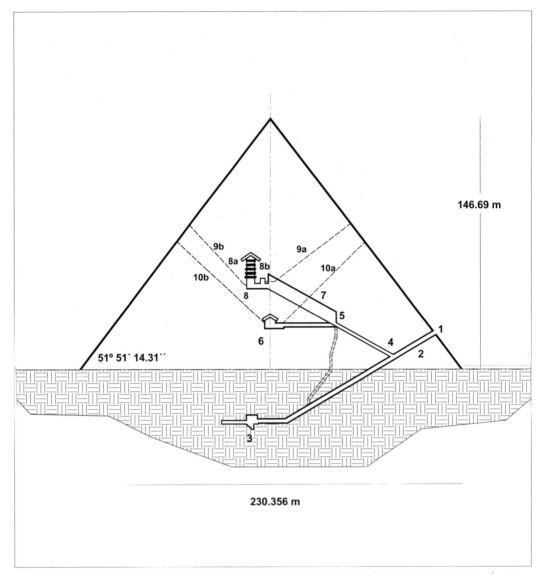

146.69 m

9b 9a

8a 8b

10b 10a

8

7

10b

5

6

4

1

2

51° 51´ 14.31´´

3

230.356 m

Inside the Great Pyramid of Cheops

1. Entrance
2. Descending passage
3. Subterranean chamber
4. Ascending passage
5. Entry to the Grand Gallery
5b. Escape shaft
6. Queen's Chamber
7. Grand Gallery
8a. Stress-relieving chambers above the King's Chamber.
8b. The antechamber with three stopping stones
8. King's Chamber
9a. Northern air shaft in the King's Chamber.
9b. Southern air shaft in the King's Chamber.
10a. Northern air shaft in the Queen's Chamber.
10b. Southern Air Channel at the Pharaoh's Chamber.

The Great Pyramid of Cheops, 'The Horizon of Khufu'

The Great Pyramid, the most gigantic piece of architecture in the world, was built in 2589 BC by Cheops, the second Pharaoh of the 4th Dynasty. The ancient Egyptians called him Khufu, the name Cheops is Greek.

The original height of the pyramid was 146 metres and the volume of the structure is such that it has been calculated that St. Peter's in Rome, St. Paul's in London, Westminster Abbey and the cathedrals of Florence and Milan could find room within it, were it not solid (see I.E.S. Edward's "The Pyramids of Egypt"). The present height of the Great Pyramid is 137 metres, the top (10 metres) being missing, probably owing to earthquakes, wanton destruction, etc. Originally the length of the sides at ground level was 230 metres, but as the Turah sandstone facing has practically all disappeared it is now less. The sloping sides were about 187 metres and are now 174. These incline at an angle of 51° 51′. About 2.3 million blocks of stone weighing on average 2.5 tons each were used to build this gigantic structure. They came from the quarries in the Mokattam range on the east bank of the Nile. When complete, the pyramid was faced with white limestone blocks of which now only a few remain at the base, below the north entrance.

The Greek historian Herodotus, who visited Egypt in about the middle of the 5th century BC., relates that 100 000 men worked for three months a year (probably during the flood period) on the construction, which is thought to have taken 20 years to finish.

There are several theories concerning the execution of the original plan. Since the beginning of the 18th century scholars all over the world have been constantly occupying themselves with the question, whether the whole system of buildings, pyramids, mortuary temples, etc. was planned from the start to be so extensive and was completed from such a vast design, or whether it was originally intended to be smaller and was added to constantly as work proceeded, during the pharaoh's lifetime. However, they are unanimous in concluding that the method of construction involved the building of long ramps along which the heavy blocks of stone were hauled to their positions.

Inside the Great Pyramid are neither decorations nor inscriptions; nonetheless, a visit to the burial chamber is worth the effort. As in all pyramids, the entrance is on the north face. At the present time, entrance (1 on the diagram) is 17 metres above the base. The original entrance lay a little higher (2); from there a corridor about a 100 metres long led into an underground chamber (3). As this is now closed, one passes instead through the present entrance to (4) and from there climbs up a sort of steep, narrow gangway, 39 metres long. The passage is so low that the visitor is obliged to walk nearly double (handrails and electric lighting make this less arduous). At (5) one has reached the entrance to the Grand Gallery (7) and can walk upright and here a passage branches off to the Queen's Chamber, which can be visited on the way back (6) and the Grand Gallery (7), 46 metres long and 8 high. On the stairs furnished with handrails, one climbs to the end of the gallery and there reaches a small passage, just over 1 metre high and about 7 long. This leads to the burial chamber itself, also called the King's Chamber (8), which lies nearly 42 metres above ground level. It is 10 metres long, 0.57 high and 5 wide. Nine granite slabs, each 5 metres long form the ceiling; above them five compartments were formed (8a) to relieve the weight strain on the ceiling.

The chamber itself is of granite; it should be noted how the granite blocks in the walls are so closely fitted as to make them appear almost seamless. The granite sarcophagus, 2 metres long, 1 high and slightly less than 1 metre wide, was empty when it was discovered. Up to the present time the mummy of the pharaoh has not been found; nor is it known what became of the lid of the sarcophagus. The openings in the walls of the burial chamber (9) are presumed to be air vents.

Of the temple on the east side of the pyramid, which once was destined for the cult of the dead, nothing remains except some fragments of its basalt pavement. To the east of this lies an empty boat pit and three small pyramids in which close relatives of the pharaoh were buried. On the west side of the pyramid there are *mastabas* (tombs of nobles) of the 4th to 6th Dynasties.

The building of the Great Pyramid was a miracle of organisation; the final facing·of the sides of the pyramid with smooth and perfectly joined blocks is evidence of the finest craftsmanship. The internal passages and burial chamber were built with unmatched skill, the joints between the huge blocks being almost invisible. The entrance was placed high up in the north side; and after the burial it was closed with masonry similar to that of the whole casing of the surface, so that there was no indication of its position in the glass-smooth and inaccessible face of the pyramid.

The workmen used tools made of bronze. The jewelled cutting joints may have been of beryl, topaz or sapphire. For cutting the stones they employed great bronze saws with jewelled cutting points. In some places,

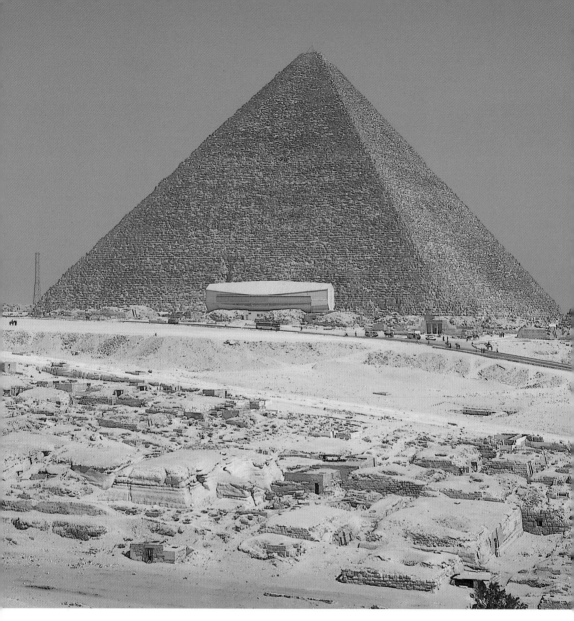

The precision with which the Great Pyramid was built is still, with today's technology, a source of great fascination. It is likely that the experimental phase of Cheops's father Pharaoh Snefru was the main driving force for this precision in work. This precision produced a pyramid whose base level difference in height is less than 2.1cm, and the maximum difference in length between the sides is 4.4cm. The blocks used in the pyramid have an average weight of 2.5 tons, decreasing in size towards the top. Some of the casing stones at the base are very large, weighing as much as 15 tons. The heaviest blocks are of granite, used as the roof of the King's Chamber and as weight-carrying support. Their weigh is estimated as 50 - 80 tons each.

In my opinion Cheops, who was able to undertake such vast work, was the most powerful human being that the world has ever seen.

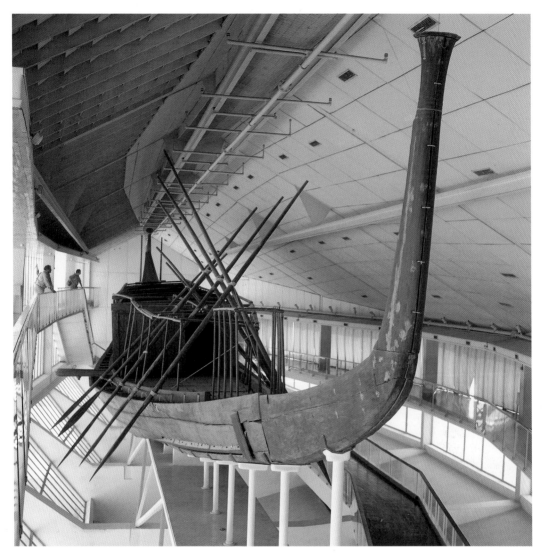

In the Old Kingdom it was customary to bury funerary boats near the burial monument. A number of empty boat-shaped pits occur around the Great Pyramid. In 1954 Kamal al-Malakh discovered two intact boats on the south side of the pyramid. The pit was closed by 41 limestone blocks, each weighing 16 tons, and completely sealed with plaster. A smaller keying block at one end had to be removed, before any of the larger ones could be lifted. The pit is rectangular and not boat-shaped. When opened, two dismantled cedarwood boats were discovered, the oldest boats of that size to be found so far. The pit was 30m long, and the boat after it had been assembled was 43.2m long. A large cabin was placed a little after midship on the deck, its roof supported by palm-shaped columns. The timber was held together by wood pins and ropes. Ahmed Youssef was responsible for the ingenuous work of restoring and reassembling the vessel. He was also responsible for much of the work on the furniture of Queen Hetepheres.

The burial of the boats was performed by Cheops's successor Djedefre. An inscription on the blocks reads 'Re-djed--ef is the ruler'. This must have been carried out by some of the workmen.

e.g. the granite sarcophagus of Cheops, the marks made by these saws can be clearly seen. By curving the saw-blades into a circle drills were formed, which could cut out a circular hole by rotation. For smaller objects the cutting edge was held stationary while the work was revolved; 'the lathe' says Petrie, "appears to have been as familiar an instrument in the 4th Dynasty as in our modern workshops". Some of the superb diorite bowls must have been turned. They are too accurate to have been made by hand. Though the chisels have been found, no examples of jewelled saws and drills have been discovered, but this is not surprising as owing to their value they would be carefully looked after, and when worn the jewels removed and placed in new tools.

Most of the limestone of which the pyramids are built was quarried from the Mokattam Hills, on the opposite bank of the river, and floated across in barges at flood time. The granite for the galleries, Burial Chamber and the Grand Gallery came from Aswan in Upper Egypt.

The Furniture of Queen Hetepheres

King Snefru, founder of the 4th Dynasty, came to the throne by marrying Queen Hetepheres, his half-sister and a daughter of King Huni. Snefru's mother was a member of Huni's harem. With this marriage, Snefru confirmed his right to the throne by blood legitimacy. When Queen Hetepheres died she was buried near her husband's pyramid at Dahshur. There is a small pyramid south of the Bent Pyramid, which may have been her tomb. But at this time her son Cheops had begun his Great Pyramid at the new site of Giza, and it is likely that the Dahshur necropolis was not as well guarded as it should have been. Not long after the burial, thieves broke into the Dahshur tomb perhaps aided by the necropolis guards, or maybe some of the masons who worked on the tomb. They had to do the job at night, and were certainly short of time. When they entered through the masonry filling and broke into the burial chamber they saw the great gold canopy with its curtains covering the sarcophagus. Probably they tore down the curtains and threw aside the gold furniture, which they had no time to strip or remove. Even small portable items like a gold drinking cup were overlooked. They went straight to the sarcophagus, knowing that the most precious objects would be on the royal mummy. With hammers and chisels they opened the lid, dragged out the body and carried it out of the tomb to a hiding place. Then they tore the mummy apart, taking off the gold necklaces, armlets and jewelled rings. Perhaps the inner coffin itself was made of gold. Hurriedly sharing the loot, they dispersed and they may have set fire to the queen's mummy.

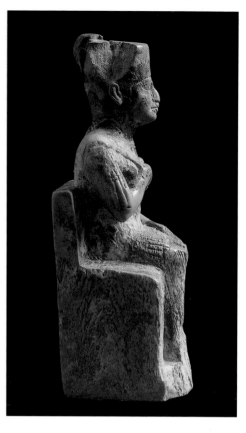

Ivory Statue of King Cheops, builder of the Great Pyramid at Giza. It is the only figure of this king so far discovered. The statue was found near the ancient temple of Kom el-Sultan at Abydos. This is a minature ivory figure ot more than 7 cm high but having all the power and dignity of a colossus. The king is seated and wears the Red Crown of Lower Egypt, and the determined little face seems to have been a portrait as it bears close resemblance to his son Chephren.

This figure in addition to others, some of which date back to the 1st Dynasty, were found by Petrie in a pit near the ancient temple.

All had been slightly damaged, and were coated with some dry brown material. Puzzled by the nature of this material, Petrie sent a sample of it to be analyzed only to learn that it was dry human excreta ! The pit in which they were found was evidently the cesspit of the temple lavatory, and here we get a glimpse of an ancient scandal. It was the custom for kings and nobles to dedicate votive statues to a temple. When these figures became too numerous, or were damaged, a priest would take them away and burry them somewhere in the sacred temple enclosure, and so make room for newer votive offerings. In the case of these statues, the priest was probably a lazy and instead of troubling himself to dig a whole and burry them , he just threw them down the lavatory. And to think that this happened to the only known statue of the great Cheops of all pharaohs of Egypt !! What an unbelievable fate !

1 & 3. The Grand Gallery inside the Great Pyramid.

2, 4 & 5. The magnificent furniture of Queen Hetepheres, mother of Pharoh Cheops, found by Reisner in 1925 inside a 33m-deep shaft near the Great Pyramid. It is the only royal furniture that survived intact from the Old Kingdom. Also found in the shaft was an empty sarcophagus and a canopic chest containing the viscera of the Queen. Buried also were some objects used by the queen in her lifetime such as gold and alabaster vases, rings, knives and a manicure set, as well as her bed and two armchairs covered in gold. Her sedan chair (2) has a gold inscription inlaid in ebony. The inscription reads: 'The mother of the King of Upper and Lower Egypt, Follower of Horus, she who is in charge of the affair of the harem, whose every word is done for her, daughter of the god, of his lions Hetepheres'.

Soon afterwards the robbery was reported to the high official responsible for guarding the royal necropolis. With his staff he visited the tomb and found that the mummy had disappeared, but that most of the tomb furniture remained. Next he had the delicate task of informing the king that his mother's tomb had been violated. The latter ordered that the queen and all her funerary equipment be brought to Giza and re-buried near his own pyramid. Perhaps he chose the site himself, and to guarantee no further violations he ordered a secret tomb to be made. A shaft east of the Great Pyramid was cut into the rock to a depth of 25 metres. Furniture, canopic chest and sarcophagus were hurriedly moved from the open tomb at Dahshur to the new one at Giza. This had been cut in a rush; the evidence is that the chamber has no smooth finish or plasterwork. After the furniture had been transferred to the new tomb, workmen began to refill the shaft and concealed it with stones. They were in such a hurry that they left their tools in the chamber where they were found mixed in with the queen's furniture.

The tomb was discovered by Raisner in 1925. While clearing it, Raisner and his staff took 1057 photographs and covered 1701 pages with notes. With their painstaking work methods it was possible to completely reconstruct most of this unique Old Kingdom furniture. Today, the visitor to the Egyptian Museum in Cairo can see the queen's furniture exactly as it was during her lifetime. Under the gold canopy, which her husband King Snefru gave her, stands the bed. Beside it stands the gilded armchair and her carrying chair with its long gold handles. Nearby are her makeup box with its alabaster jars and the jewel box containing her silver anklets.

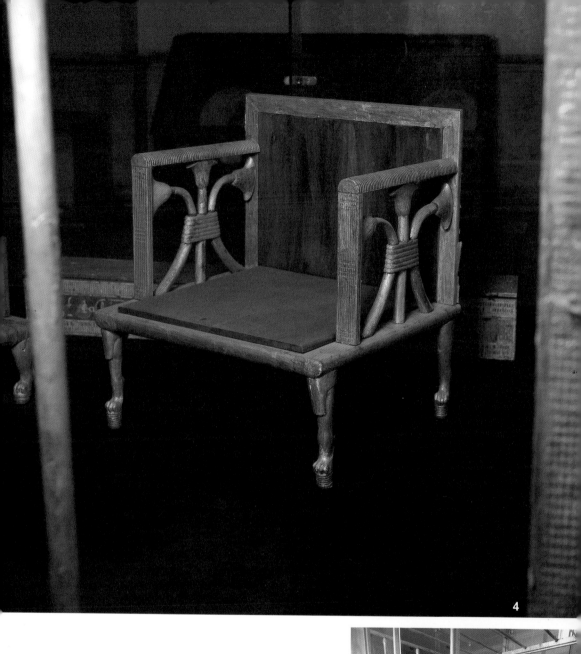

4

5

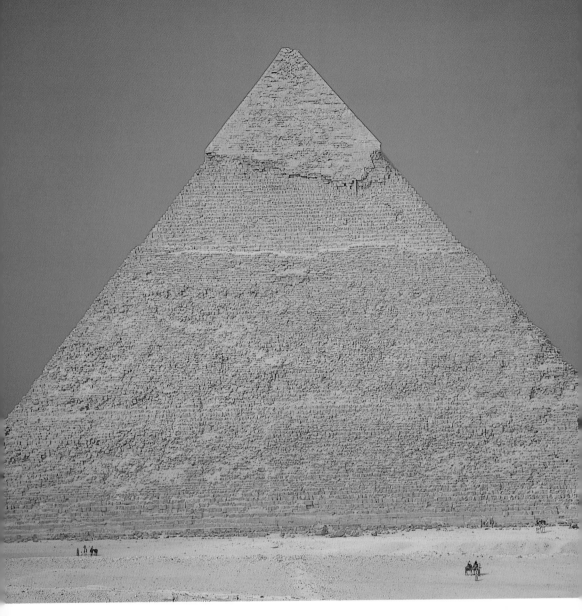

Above : The Pyramid of Chephren viewed from the south.
Facing page top : The magnificent diorite statue of
Pharaoh Chephren is perhaps the finest Egyptian statue
ever carved. The sculptor who carved and polished this
statue did it with utmost care, showing he must have been
skilled in many branches of knowledge. The hawk-god
Horus is spreading his wings protectively around the
Pharaoh's head expressing the ideal connection between
earthly and divine power. This statue was found at the
valley temple of his pyramid, one of 23 statues that once
stood there. All were ruined in ancient times; Egyptian
Museum in Cairo.
Facing page bottom : The upper courses of fine limestone
remain, so that the pyramid has not lost any of its original
height 143.5 m.

Pyramid of Chephren

The second biggest pyramid of the Giza group was built in 2566 BC by the Pharaoh Chephren (in ancient Egyptian Khafre). It lies to the southwest of the Cheops Pyramid on the prolongation of the diagonal of that structure. To the ancient Egyptians it was known as *Wer-khafre*, "Khafre is Great".

In size it is not quite as overpowering as that of Cheops, but since it is built on higher ground, it appears bigger, especially from the southern desert side. Its original facing is still intact at the summit, and its vertical height is now 136 metres, whereas it was formerly 143. Each side measured 215 metres, but they are now 211 long, and inclined at an angle of 52°. To the south is a small pyramid, the tomb of the queen, and on the east lies the mortuary temple, almost a complete ruin. From there a causeway leads to the temple of the Sphinx or Granite Temple.

Chephren, the son of Cheops, came to the throne after the death of his elder brother the Pharaoh Djedefre, who ruled only briefly. He returned the royal necropolis to Giza and built a pyramid there next to his father's. He had the valley temple constructed in granite, and also had carved according to some, the biggest and most famous sculpture of all time - the Great Sphinx. This is 72 metres long, and there are those who believe that it is the likeness of Chephren's head set on the body of the recumbent lion.

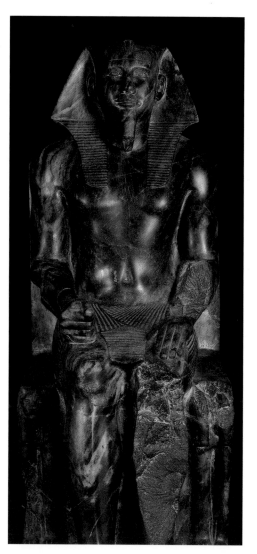

Inside the Pyramid of Chephren

The pyramid of Chephren has two entrances, each leading to a descending corridor that ends in a chamber. The lower passage begins 68 metres north of the pyramid and was cut totally out of the solid rock of the plateau. It is joined to the upper corridor by an ascending passage. The lower passage has a slope of 21° 40′, but becomes horizontal for a short distance before rising steeply to meet the upper corridor. The lower entrance was abandoned in favour of the upper one. The upper corridor has a descending slope of 25° 55′. The reason for building the upper passage and neglecting the lower one is unknown. It has been suggested that after building the lower entrance, the architect decided to build the whole pyramid further south. Part of the upper corridor is hewn out of the rock. The wall and roof of the corridor are covered with red granite; the corridor leads to the burial chamber containing a red granite sarcophagus. The length of the chamber is 14 metres from west to east, its width is 5 metres from north to south and it is 7 in height. Two other passages in the pyramid are the work of ancient thieves. Rectangular shafts, similar to the ventilation shafts of the Great Pyramid, were cut in the north and south walls of the burial chamber to a depth of only half a metre, but were abandoned. Squares marked in red, approximately 1.5

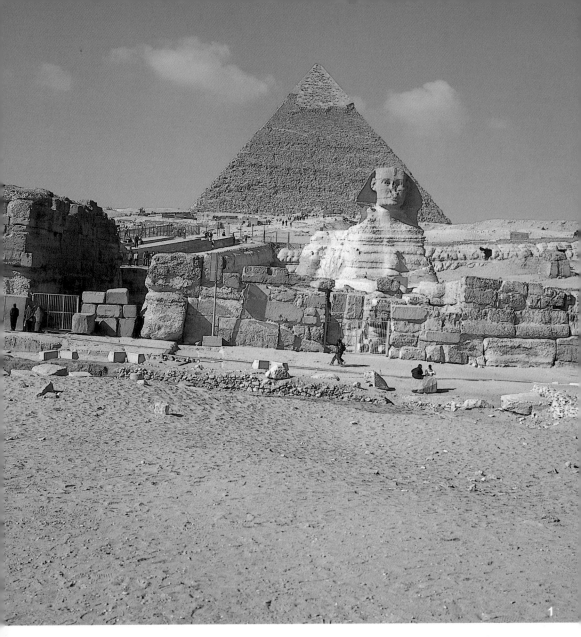

1, 2 & 4. The Great Sphinx guarding the Pyramid of Chephren. carved *c.* 2500 BC by Pharaoh Chephren, it has become the emblem of ancient and modern Egypt.
3. The magnificent diorite statue of Pharaoh Chephren. This hard stone has been worked with excellent skill. The smoothly polished surface gives a natural appeal to the muscular body. The viewer is left in awe as he stands in front of this spectacular statue, which gives the feeling of looking at a divine ruler. The features of Chephren in the statue are very similar to those of his Sphinx **(4)** In both he wears the *nemes* headdress ornamented with a cobra. The Pharaoh, his face dressed up with a false beared, sits on his throne with a slightly dreamy look in his eyes. In his right hand he once had a flail, the symbol of the wealth coming from the soil of the Nile Valley.

metres below the present cavities, suggest that this was a previous plan that had been abandoned in favour of the above cavities.

A chamber measuring 11 X 3.5 metres is situated in the middle of the horizontal passage described above. Archaeologists believe that this must have been where, according to the original plan, the burial chamber was to be situated. Then, for some reason, the construction of the whole pyramid was shifted south by about 68 metres. It is a custom in all pyramids to have the entrance in the north face, and to have the burial chamber beneath the apex. The reason for shifting the construction site south could have been to create direct access to the causeway and avoid the rock of the future Sphinx. However, this argument

94

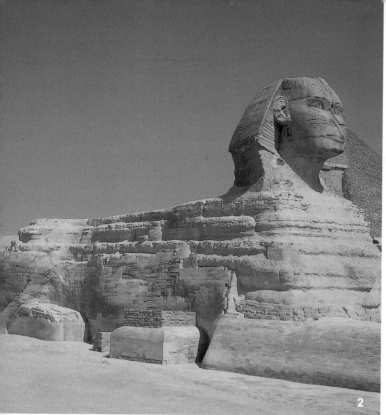

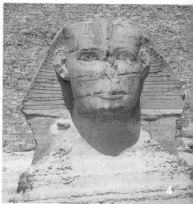

does not explain why the two entrances were connected by an ascending shaft, especially as this shaft was later closed with blocking stones by the builders. The remains of the queen's pyramid lie near the pyramid. The mortuary temple is built of limestone and has an entrance hall, an open court, five niches for statues, magazines and a sanctuary. Around the temple are five boat pits. A small track 500 metres long connects the mortuary temple and the valley temple. The valley temple, a square building with two entrances, is the best-preserved building from the 4th Dynasty. Giovanni Belzoni was the first to enter the inside of Chephren's pyramid in modern times (between 1816 and 1820).

The Great Sphinx of Giza

This is the largest piece of sculpture ever carved by human hands and is called *Abu el-Hol* in Arabic. It lies between 300 to 400 hundred metres southwest of the pyramid of Cheops and is one of the most famous monuments of Egypt. It is in the form of a recumbent lion, having a royal human head, in which the features of Chephren are thought to have been recognized. Later, the Egyptians identified the sun god with the Sphinx and called it therefore *Harmachis* (Horus, "sun on the horizon"). The height from the ground to the top of the head is 20 metres and the length from the front paws to the tail 73; the greatest width of the face is 4 metres. The ear measures 1.37 metres and the mouth 2. The missing nose is said to have been 1.14 metres long. Of the original dark red colour of the face only slight traces remain. In the Arab period the Sphinx was considerably damaged, first in 1380 AD by an iconoclastic *sheikh*, and later by the Mameluks who used the head for target practice. It is said in old descriptions that the face was of noble and harmonious proportions.

Valley Building of Chephren

Close to the Sphinx lies an old sanctuary which goes by this name. From here, in ancient times a sloping causeway led to the mortuary temple in front of the Chephren Pyramid. The temple (45 metres long and 13 high) whose beauty lies in the simplicity of its proportions, was discovered in 1853 during the clearing of accumulated sand from the Sphinx under the direction of A. Mariette, the French Egyptologist. Here Mariette also found the statue of Chephren which now stands in the Egyptian Museum. To the south, at the foot of the rock where caves can be discerned, lies a Muslim cemetery.

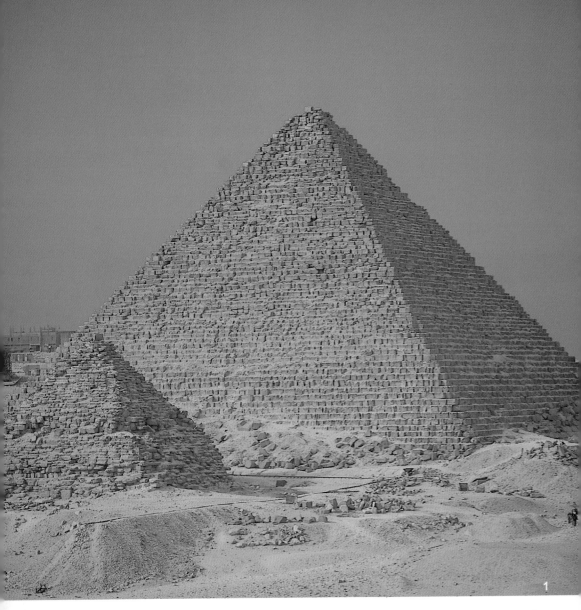

1. The pyramid of Mycerinus viewed from the south east and satellite pyramid in the foreground.
2. The northern face of Mycerinus's pyramid, showing the modern staircase leading to the interior of the pyramid. The casing stone up to one third of the pyramid's height was made of granite. The first few rows are shown in the picture.
3. The mortuary temple of Mycerinus.
4 & 5. The Triad of Mycerinus.
This is a group of three statues. In the centre is the Pharaoh Mycerinus wearing the White Crown of Upper Egypt. On his right stands goddess Hathor, goddess of the sky and of love. On her head she wears her characteristic emblem, the solar disk between two cow's horns. On Mycerinus's left side stands a different figure in each of the three statues.
4. On Mycerinus's left side stands a female figure personifying the Diospolis Parva nome of Upper Egypt, Egyptian Museum in Cairo.
5. On Mycerinus's left side stands a male figure personifying the nome of Thebes Diospolis Magna, Egyptian Museum in Cairo.

96

The Pyramid of Mycerinus

The third and smallest of the Giza group was built in 2532 BC by Menkeure (Greek Mycerinus), the successor of Pharaoh Chephren, known to the Egyptians as Neter-Menkeure, "Menkeure is Divine". It follows the Chephren Pyramid lying to the southwest. The vertical height is now 62 metres, having been originally 66. Each side measures 111 metres and the slopes are 77, originally 85, at an angle of 51°. On the east side is the mortuary temple.

The pharaoh died before his funerary temple was completed, and it was finished by his son Shepseskaf. More construction was carried out on the funerary complex in the 5th and 6th Dynasties. Herodotus wrote the following about Mycerinus: "Prince (Mycerinus) opposed his father's acts, reopened the temples, and allowed the miserable people to resume their ordinary life. His justice was beyond all other pharaohs. He not only gave fair judgements, but if anyone was not satisfied with his sentence, he compensated him from his own pocket and thus pacified his anger".

Reisner excavated the area around the valley temple, finding a large number of statues of the pharaoh. Among these are three magnificent triads showing the pharaoh with the goddess Hathor, and one of the *nome* deities. The intention of Mycerinus was to have 42 of these statues, representing him with each of the 42 deities. Only four were carved, three intact statues are in the Egyptian Museum, and the fourth was found in pieces. Also discovered in the valley building was a statue of Mycerinus and Queen Khamerenebti II, which had not been completely polished, possibly because of the pharaoh's early death.

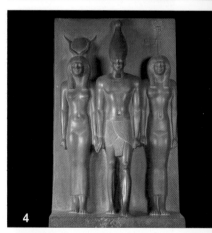

To the south of the pyramid of Menkaure are three further satellite pyramids; all were found empty. This makes a total of ten pyramids at Giza, of which nine survive until today. If you want to photograph all nine pyramids together, take a ride on a camel or horse towards the southwest until you reach a high plateau, where you can take all them in one shot.

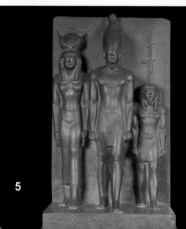

Memphis and Heliopolis

The names of Memphis and Heliopolis dominated the Old Kingdom. Their principal deities, Ptah of Memphis and Ra-Harakhate of Heliopolis, remained rivals or if one so prefers to put it, complements of each other during the New Kingdom, particularly so in the era following the Amarna Period. Their distinct position originated in early historical times. Memphis was a political foundation, its position determined by the unification of Upper and Lower Egypt, and it was in Egyptian eyes therefore a young city. Heliopolis acquired its fame from its religion and its myths; it also looked eastwards in the direction of Asia. In addition to the fact that the Nile separated them, these two cities lie further apart than is often thought. This misconception is largely due to the fact the city of modern Cairo comes in-between. Ancient Memphis lies about 25 kilometres south of the apex of the Delta and 32 kilometres in a straight line from Heliopolis.

Legend ascribes the foundation of Memphis to Menes or Narmer, the unifier of Egypt. Herodotus was told that before the time of Narmer that all the land from the southern boundary of the Memphite *nome* northward was marsh. The Nile flowed to the west of the city, close to the desert. Excavations in the area of Memphis, Saqqara and Abusir have yielded finds dating from the historic period. The only Pre-dynastic remains in the area have been found on the eastern bank of the river, which in the Old Kingdom belonged to the Memphite *nome* and not that of Heliopolis. Here was unearthed the settlement of Maadi.

The part of Memphis that was subsequently established was centred round the royal palace of the Archaic kings. It probably stood where the Late Period palace was built to the north of the temple of Ptah, and it may have been a building something like those of a somewhat later date, the ruins of which are to be seen at Abydos and Hieraconpolis. It would therefore have consisted of a rectangular enclosure surrounded by a double wall of sun-dried mud bricks, the inner one being probably thicker than the one at Hieraconpolis, panelled and whitewashed from the outside. The place was called "White Walls" and by extension later likewise the whole of Memphis. The word Memphis is derived from the hieroglyphic *mn-nfr* meaning the stable monument. White was the colour of the Upper Egyptian crown, red that of Lower Egypt.

From the very beginning the unification of the two lands was closely connected in people's minds with the royal palace of Memphis, and far less with a fortress watching over conquered Lower Egypt. The palace and the temple of Ptah were the places where the king traditionally received the double crown of the two kingdoms and where the coronation was re-enacted on the occasion of the 30th anniversary of the king's accession, the *sed*-festival. On such occasions all the gods of the country and 'the great ones of Upper and Lower Egypt' came together there to pay homage to the king and to receive gifts from him afterwards. At a very early period the local festivals at Memphis became included in the great state festivals. Memphis represented the idea of unity and peace. The two gods Horus and Seth, whose conflicting forces were embodied in the Archaic kings, were said to have been reconciled in the temple of Ptah at Memphis and to have reached an understanding, according to which Horus, in the form of Tatjenen, the primeval god of Memphis, received the rule of the "Two Lands", while Seth received the rule of heaven. "There stands up Horus (as king) over the land. He is the unifier of this land, with the great name, called Tatjenen, he Ptah the Lord of Eternity." Horus and Seth had fought each other on the border between the Two Lands at a place on the east bank of the Nile near Old Cairo; and they were reconciled there. As a consequence Memphis was called the 'Balance of the Two Lands'. According to Egyptian beliefs the duality resulted from the time of creation when 'one god' separated heaven and earth and distinguished the sexes. Divine kingship, however, reflected the natural order and therefore Egyptian political theory thought in terms of dualities. It was thought that the body of the great god, Osiris, who came originally from Busiris in the Delta, rested in Memphis. Osiris was the image of the dead king and his grave was identified in the cave of Sokar.

The religious teaching now known as the Memphite Theology has been preserved for us by the Ethiopian King Shabaka, who had the text recorded on an ancient stone found in a much worn condition. It contains the theological reasoning that explains that the primacy of Ptah as a creator was due to his power over the heart (judgement) and tongue (commanding will). With this power he could judge the gods and all creation, and assign to each its place. To judge by its language, this noble body of doctrine was composed at the beginning of the Old Kingdom at a time when Heliopolis, the city of the sun on the eastern bank of the river, preached the teaching of Atum, "He who has not yet achieved perfection, yet perfects himself" was the creator of the world.

At the same time, Heliopolis declared the sun god Ra-Ra-Harakhte to be the divine king of the existing world, born of the earth god Geb and Nut, the goddess of heaven, who rises daily regenerated from the primeval ocean

A citizen of Memphis from *Egypt, Descriptive, Historical and Picturesque by Georg Ebers,* Leipzig 1879.

and the underworld. The 'King's House' in the Memphite myth of Ptah-Tjenen found its exact counterpart in the 'House of the Princes' in Heliopolis - the place in which the council of the gods assembled under the leadership of Geb, the successor to the throne of Atum and in which Geb, after the death of Osiris, will deliver judgement on Horus and Seth and declare the inheritance of Geb.

The monument of the Memphite Theology shows clearly the rivalry between Memphis and Heliopolis, and between Atum and Ptah. The archaeological search for historical proofs for this struggle has not yet been successful. The early Dynastic cemetery on the edge of the desert plateau starting above the village of Abusir and extending to Djoser's Step Pyramid, which is perhaps the most important burial ground in Egypt, has not yet fully yielded its secrets. The oldest buildings are great brick *mastaba* tombs that rival those in the cemetery of Abydos, and among these is the oldest with a date in which the Horus name of King Aha 'The Fighter' was found. King Aha was always associated with the historical figure of Menes the unifier of Egypt. The proximity of the royal residence to the capital Memphis also exercised an extraordinarily beneficent influence in this part of Egypt. There was here undoubtedly a concentration of power that both confirms and explains the historical tradition that the political centre of gravity in Egypt was transferred from Upper Egypt to Memphis at the end of the Archaic Period, this means at the end of the 2nd Dynasty.

At Abydos the only royal tombs of the 2nd Dynasty that can be identified with certainty are those of Peribsen, the worshiper of Seth and Khasekhemwi, the last king of the 2nd Dynasty. At the end of the 2nd Dynasty a crisis occurred and the slain bodies of Lower Egyptians were recorded on two statues of Khasekhemwi, which were set up in Hieraconpolis in Upper Egypt. The following king was Nebka, who was also a somewhat legendary figure along with Djoser, Snefru and Cheops.

Djoser, the successor of Nebka, is the first king of the 3rd Dynasty, the first true Memphite Dynasty, and with him begins the Old Kingdom. Djoser and his chief architect Imhotep, who was the first high priest of Heliopolis known to history. The religion of Heliopolis first made its appearance during the 2nd Dynasty. Nothing is known about the origins of Imhotep, who was permitted to have himself commemorated on the base of a statue of Djoser

King Khasekhem, end of the Second Dynasty, *c.* 2700 BC, the Egyptian Museum in Cairo.

This statue is one of the first statues of a Pharaoh. It was found in Hierakonpolis. Here the Pharaoh wears the White Crown of Upper Egypt. The head is tilted forward to balance the mass of White Crown. His left arm is folded across his waist while his right arm stretches on his thigh. The right hand part of the face including the nose were ruined in antiquity. The small remaining part of the face, specially the details of the eye and the muscles show the magnificent work of sculpture. It was carved with great care and is extremely expressive.

On the lower side of the statue are drawings showing the Pharaoh smiting his enemy which are probably citizens of Lower Egypt. The inscription states that the pharaoh had captured 47209 of his enemies.

placed in the *serdab* of his step pyramid at Saqqara. This action is unique in Egyptian history and here we find he has inscribed all of his titles. In the Late Period he was deified, and the things that were said about him became legendary.

Nevertheless, in agreement with the contemporary ordering of society, he could have been a member of the royal family to be granted the right to participate in the ruling powers of a 'great god'. Imhotep designed and built the royal tomb as the first stone structure in the world. He raised the superstructure of the royal tomb to form a step pyramid that is to this day the outstanding feature of the landscape of Saqqara. He surrounded the pyramid with a replica of the court in which the jubilee of the King of the Two Lands was celebrated, and the court contained copies of the traditional booths whose purpose was to allow the king to celebrate the *sed*-festival. The court and the pyramid were enclosed by a massive stone wall, an imitation in white stone of the 'White Walls' of the royal palace in Memphis. Everything was intended by replication, to serve the dead.

In Heliopolis, the principal worship was that of the stars, and the important events were 'the festivals of heaven' and the division of the lunar month. From the worship of the stars evolved the worship of Ra in the form of 'Horus of the Horizon', the god of the morning sun. This concept must have evolved at a time when Horus, the god of the Egyptian king, played a dominant role.

As no remains from the House of Ra and the temple of Atum in Heliopolis have survived, we can get a glimpse of them, only from the surviving description of a visit made by the Ethiopian King Piankhi about 730 BC. Perhaps more, however, can be learned from the sanctuaries erected by the kings of the 5th Dynasty close to Memphis to serve the worship of Ra, which became the state religion. The main sanctuary was located on the 'high sands' north of Heliopolis, an artificial mound that mythology considered as the primeval hill 'the place of the first becoming', which rose out of the primeval waters of chaos. In the symbolisation system emphasis was put on the *benben*-stone that stood in the open court as the cult image; it was the forerunner of the obelisk. At sunrise every day when the sun's rays touched the gilded tip of the stone the sun god took his seat there, a deed that was infinitely repeated, the event of the 'first rising of the sun', the creation of the world. Coupled with this was the myth of the phoenix whose return to the sanctuary from a far distant land of the gods symbolised the appearance of the primeval god on the primeval earth. The Egyptian theologian regarded the 'House of the Phoenix' and the 'House of the Obelisk' as equally important.

The great sacrificial altar stood in front of the obelisk's base in the court. The royal annals of the 5th Dynasty tell us that the kings of the time gave everything to Ra and his companion gods in the sun temples, and confirmation of this fact is provided by what we read in the list of donations inscribed by King Niusere, in celebration of his *sed*-festival in the 30th year of his reign. The immense sacrificial offerings include the provision of more than 100 600 meals of bread, beer and cake on new year's day, and 30 000 for another festival. The purpose of these huge offerings was not only for them to be served to the court and priests, but also to the general population. This system of meals for the masses enabling the poor man to occasionally eat something better than his daily bread was continued at least until the New Kingdom, as we know from the great offering lists of Ramses III in his temple at Medinet Habu. For the great state festivals celebrated by the king and gods together, the principal participants were the great nobles and representatives of the priesthood; but in the festivals of the gods, the courts were open to the commoners as well. In ancient Egypt, festivals of the gods were popular events.

The 3rd Dynasty tombs were built close to the early dynastic cemetery at Saqqara extending in a southerly direction. Tombs of the 4th Dynasty, starting with Snefru, were built at Dahshur and simultaneously at Meidum. Cheops, Chephren and Mycerinus, the great kings of the 4th Dynasty, had their pyramids at Giza while Shepseskaf and the kings of the 5th Dynasty devoted to sun worship, returned closer to Memphis, to Abusir. Djed-Ka-Ra. Isesi built further south in the district of Sokar, and here the kings of the 6th Dynasty from Pepi I onwards continued their buildings.

Consequently, through a historical accident, the relatively unimportant pyramid city of Pepi I, which was called Men-nefer, gave the capital city its historical name of Memphis. The history of names is full of such peculiarities. Memphis acquired from its chief temple the sacred name of Hikuptah which means 'House of the *Ka* of Ptah'; foreigners applied this name to all of Egypt and it finally became the Greek Aigyptus.

The central point of the town of Memphis was the temple of Ptah, the site identified by its remains southeast of the modern village of Mit Rahinah, The royal palace of the 'White Walls' lay to the north of the temple, probably on the other side of the depression that may correspond to the ancient Sacred Lake. According to Strabo, the lake still existed in Roman times. In other ancient sources, the royal gardens also lay in this area. South of the temple of Ptah and opposite to its southern door, stood the shrine of Apis, his stall with a courtyard in front, and close by a room for the mother of the god.

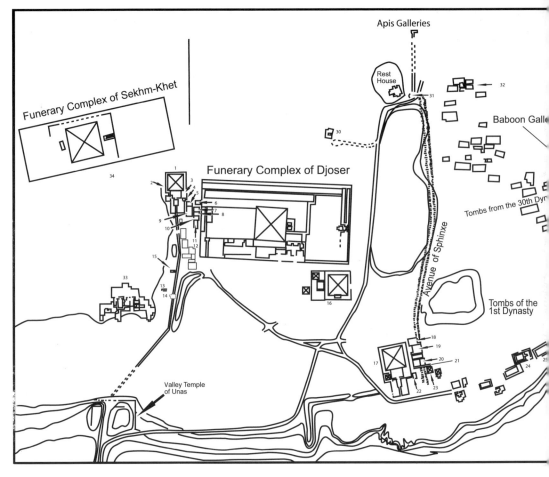

Apis Galleries

Rest House

Baboon Gallery

Funerary Complex of Sekhm-Khet

Funerary Complex of Djoser

Avenue of Sphinxe

Tombs from the 30th Dyn

Tombs of the 1st Dynasty

Valley Temple of Unas

The Necropolis of Saqqara
1 Pyramid of Unas
2 Shaft tomb from the Persian Period
3 Ruins of the tomb of Hotepsekhemwy (1st king of Second Dynasty)
4 Tomb shaft from the Saite Period
5 Tomb of Queen Khenut
6 Mastaba from the 6th Dynasty
7 Mastaba of Iynefert
8 Mastaba of Princess Unis-akh
9 Tomb of Queen Nebet
10 Mastaba of Princess Idut
11 Mastaba of Mehu
12 South Wall of Djoser's complex
13 Mastaba tomb of Nefer
14 Mastaba tomb of Niankh-Khnum and Khnum-Hotep

15 Tomb of the Butchers
16 Pyramid of Userkaf
17 Pyramid of Teti
18 Mastaba of Meruruka
19 Mastaba of Kagemni
20 Tomb of Ankhmahor
21 Tomb of Neferseshemre
22, 23 Pyramids of Queen Ike-khi and Queen Khouit wives of Pepi II.
24 - 29 Mudbrick mastaba tombs
30 Mastaba tomb of Ptahhotep
31 Circle of Greek statues
32 Mastaba tomb of Ti
33 Tomb of Hormoheb
34 Funerary Complex of Sekhm-Khet

 The earliest known High Priest of Ptah was called Ptah-shepses; he was the son-in-law of King Shepseskaf, and became high priest during the reign of Userkaf. The high priest had the title 'Chief of the Craftsmen' and the Greeks identified Ptah with Hephaestus; but the crafts belonged to him only insomuch as he was the Lord of the Earth.

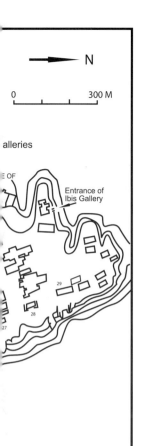

1. The entrance
2. Colonnade
3. Big courtyard
4. The Southern Tomb
5. Small Rectangular Temple
6. The Step Pyramid

7. *Heb sed* court
8. House of the south
9. House of the North
10. *Serdab*
11. Mortuary Temple

The Necropolis of Saqqara

One of the most striking of the cities of the dead of ancient Egypt is on the plateau of the Libyan Desert to the west and northwest of the village of Saqqara. We recommend the following itinerary to the tourist: Djoser's Step Pyramid, from there southwest to the pyramid of Unas, then the *mastabas* of Mereruka and Kagemni northeast of the Step Pyramid, the tomb of Ti, the Serapeum, the tomb of Ptah-hotep and the step pyramid of Sekhem-Khet.

The Step Pyramid

The tomb of King Djoser, who was the most important of the 3rd Dynasty kings (2668 – 2649 BC), is the oldest pyramid hitherto discovered and the earliest great stone construction in the world. It is the landmark of the Saqqara necropolis. Djoser "the Splendid" reigned for 19 years. With the Step Pyramid one can see the very beginning of architecture, the first attempt by man to build monumentally in stone. Even today after generations of plunderers have stripped it of its finely carved limestone casing and blurred the clean sharp edges of its steps, Djoser's great monument still stirs the heart; not only the pyramid itself but the remains of the marvellous complex of courts and buildings which once surrounded it.

To appreciate its full significance one should remember that even as late as the end of the 2nd Dynasty, King Khasekhem, Djoser's predecessor, built his *mastaba* of sun-dried brick, using stone only to line the burial-chamber. Djoser himself built a massive brick *mastaba* at Beit Khalaf, near Abydos, which he seems never to have used. Then seemingly without precedent, this enormous structure of stone surrounded by an elaborate complex of stone buildings, and exhibiting an amazing artistry in design and craftsmanship in its execution, arose. The genius who planned this work was the king's chief architect Imhotep, who was revered by later generations of Egyptians as the traditional wiseman. He was also regarded as a philosopher and magician, and scribes were in the habit of pouring out a libation to him before commencing their work. His sayings were remembered thousands of years later and hundreds of small statuettes of him still exist. After his death he was deified and later by the Greeks equated with Aesculapius, the patron god of medicine.

To the Egyptologist the most significant fact concerning the Step Pyramid is that it began not as a pyramid but as a simple stone *mastaba*. A close study of the structure reveals that there were distinct stages in its development before it acquired its present form. Djoser first built a *mastaba* like the one at Beit Khalaf; but it was of stone not brick, and square instead of oblong. As his reign continued he extended it on all four sides, but the exterior was

103

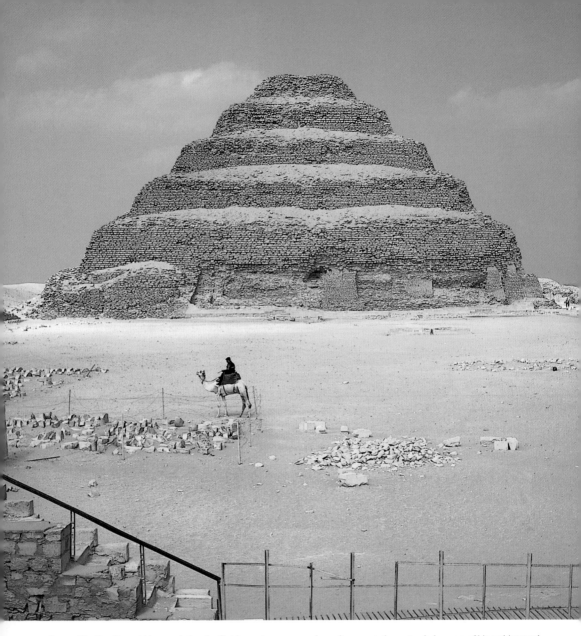

Above : The Step Pyramid is regarded as the first large stone building raised on earth. It was built by King Djoser (2668 - 2649 BC), founder of the 3rd Dynasty. It is difficult to realise the fact that only a few centuries seperate this monumental undertaking with prehistory. In these centuries civilisationmust have advanced in rapid steps. The Step Pyramid began as a *mastaba*, and was later expanded by building on top of it six unequal mastabas, rising to a height of 62 m. Below the pyramid is a vast network of tunnels and shafts. Many were dug by illegal diggers and thieves. A large number of vases was found in the tunnels. Also found was a mummified left leg, which might be the only thing the robbers left behind of Pharaoh Djoser. A mummy of a young boy was also found in an alabaster coffin. The genius who constructed this monument was Imhotep, whose titles are inscribed at the base of a broken statue of Djoser. It says "The treasurer of the Pharaoh of Lower Egypt, the first after the Pharaoh of Upper Egypt, Administrator of the Great Palace, Hereditary Lord, the High Priest of Heliopolis, Imhotep, the builder ..." Imhotep had a legendary reputation not only because of his architectural achievements but also because of his wisdom. In the New Kingdom he was described as a 'patron of scribes', and became the local god of Memphis. He was considered an intermediary on behalf of men who had difficulties. The Greeks knew him as Imouthes and equated him with their god of medicine, Asclepius.
Facing page left : Pannel of blue faïence tiles, from the southern tomb of Djoser, Egyptian Museum in Cairo.
Facing page right : One of the first life-size statues of a Pharaoh. The limestone statue of Pharaoh Djoser was found in a *serdab* next to his Step Pyramid of Saqqara. He is represented seated, wearing the garment of the jubilee festival. His royal head cover extends to his neck but does not conceal his ears. Originally the statue was covered with plaster and was painted. The inscription on the base reads the royal Horus name *Netjery-khet*. The crystal eyes were taken away by robbers. The Turin Papyrus states that Djoser reigned for 19 years and was titled 'Pharaoh of Upper and Lower Egypt', Egyptian Museum in Cairo.

half a metre lower than the original structure so that a step was formed. He altered it again making it oblong. Still unsatisfied, he adopted a new plan. He enlarged the *mastaba* a fourth time and superimposed on top of it a series of three *mastabas*, each slightly smaller than the one below it, thus forming a miniature step pyramid. This seems to have appealed to him, so he extended the base still further until it measured 123 X 108 metres. On this he built the final step resulting in a step pyramid with six terraces.

The whole rectangular complex covers over 37 acres; the enclosure walls were 10 metres high, 547 long from north to south, and 279 from west to east, the total length all around being over 2 kilometres. The visitor enters the pyramid complex at the site of the original entrance, which is on the east side of the enclosure, about 30 metres from the southeast corner. Along the sides of the enclosure wall there were 14 false doors or bastions, besides the true entrance. The present one is a reconstruction built in 1951. After going through the colonnades (restored from fragments of the original columns in 1950), one reaches the great court bounded on the north by the Step Pyramid and on the south by the enclosure wall. Here the visitor should go to the big shaft on the left side. It is 28 metres deep. The best way is to mount the stairs leading to the south wall. At the bottom of the shaft, laterally in the wall, there is a burial chamber of granite of the same type as that of the pyramid itself, but square instead of rectangular and much smaller. It had obviously been visited by grave robbers before being rediscovered in modern times, and is presumed to be the second tomb of the king, a symbolic one for the Kingdom of the South. The frieze with a motive of cobras should not be missed; it is on the south wall (reconstruction). From here one turns to the small rectangular temple (5) which was discovered in 1925. Only stumps of the original columns remain, the three columns now standing were restored later.

The Step Pyramid, the centre of the whole complex (6), was developed from a *mastaba* and heightened to six steps or stages to a total height of 62 metres. The separate steps, each set back about 2 metres from the one below it, vary from 8 to 11 metres in height. The lengths at ground level are 125 metres from west to east and 109 from north to south. The pyramid was built of limestone. From the temple (5) the way leads to the *Heb-Sed* Court (7) and the chapels. These were intended as places where the dead king could hold the ceremonies connected with his jubilees. The group is considerably dilapidated. From the *Heb-Sed* Court one comes to the House of the South

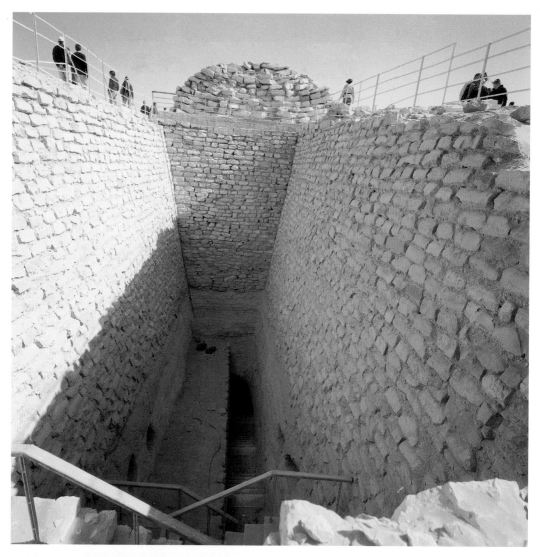

Above : Entrance to the Southern Tomb.
Left : Relief in hieroglyphics of Djoser in the Southern Tomb. Written is *nbty* title of Djoser *ntr-kht* meaning the divine body.
Facing page : Relief of King Djoser in the Southern Tomb showing him running in the ritual of the *Sed*-festival. He is wearing the false beared and the White Crown of Upper Egypt. He is holding the flail *ms* symbol of rebirth. The Horus title is repeated in a serekh in the left and right side of the frame.
On the upper side of the frame the *nswt-bty* and *nbty* titles are written. The *nswt-bty* title means king of Lower and Upper Egypt and the *nbty* title means the one who belongs to the two ladies, Wadjet, the cobra goddess of Lower Egypt and Nkhbet the vulture goddess of Upper Egypt.

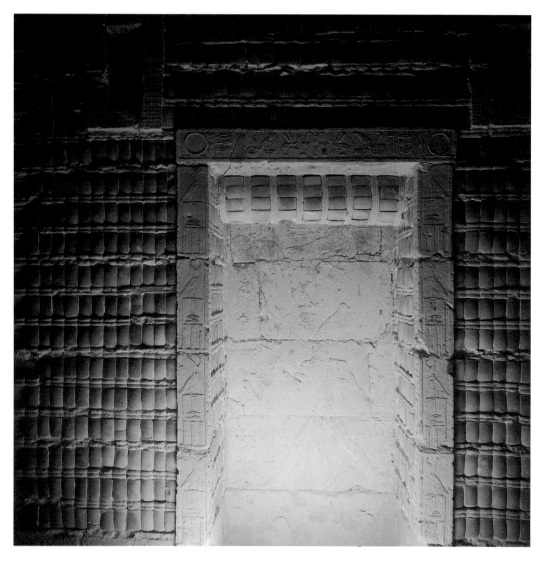

(8) and the House of the North (9), which were obviously symbolical, one representing the kingdom of Upper and the other of Lower Egypt. In the House of the South (entrance restored) are found some observations in hieratic writing, scratched on the wall by a tourist who visited Saqqara in 1300 BC.

Past the northeast corner of the pyramid, in the middle of the north wall, is the mortuary temple (11); east of it is a completely closed chamber of stone (*serdab*) (10) in which was found the limestone statue of Djoser, now in the Egyptian Museum in Cairo. This is probably the oldest life size representation of a pharaoh in existence. In the front wall of the chamber are two holes through which the tourist can view a copy of the statue, seated exactly where and as the original was found. It is believed that through these two peepholes the dead king in his image-form was still in touch with the living world and its affairs.

The mortuary temple itself is almost a complete ruin; the remains of the outer wall are only just discernible. From this temple an entrance leads into the tomb, which is not open to the public. The narrow passage leading to it can be entered as far as an iron door, which shuts off the interior.

The Southern Tomb

The Southern Tomb (4) lies south of the Step Pyramid. From the outside it looks like a mastaba. Although scholars have been able to solve many of the riddles about ancient Egypt, many things still puzzle them including this tomb. Some claim that it was built for a royal foetus or a child, or for the king's internal organs (liver, lungs,

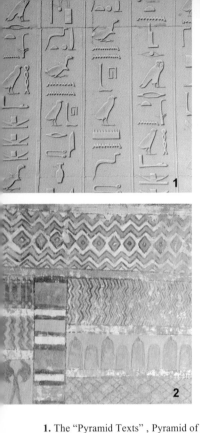

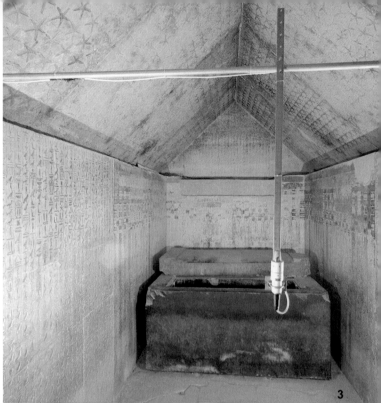

1. The "Pyramid Texts" , Pyramid of Unas, Saqqara.
2. The decoration of the burial chamber in the Pyramid of Unas, Saqqara.
3. The burial chamber in the Pyramid of Unas, Saqqara.
4. The pyramid of Unas.
5. Head of Pharaoh Userkaf (45 cm), founder of the Fifth Dynasty, sculpted in schist. The eyebrows are elongated. The statue was found at the sun temple at Abusir in 1957. Userkaf reigned from 2498 to 2491 BC. Here the Pharaoh is wearing the Red Crown of Lower Egypt. It is very rare for Old Kingdom sculpture to represent a Pharaoh wearing the crown of Lower Egypt; Egyptian Museum in Cairo. Userkaf became Pharaoh by marrying the half-sister of his predecessor Shepseskaf, who might not have had any sons to inherit the throne. Userkaf had no royal blood and nothing is known about his background. His reign was short because he did not come to the throne as a young man.
6. The ruins of Userkaf's pyramid at Saqqara. The pyramid was damaged in antiquity. The funerary temple was located south of the pyramid. In its courtyard stood a colossal statue of Userkaf. Only the head escaped damage and is now in Cairo Museum.

stomach and intestines). Another claim is that it was intended as a symbolic tomb for King Djoser instead of building one in Abydos. Osiris, lord of the underworld was buried in Abydos and hence it was regarded as a holy site, and was visited by pilgrims from all over the country. Kings of the Archaic Period, all has two tombs built, one in the north at Saqqara and another in Abydos. The argument about the symbolic purpose of the Southern Tomb becomes stronger when we consider that there is little doubt that the *mastaba* at Beit Khalaf near Abydos belongs to Djoser.

The Southern Tomb was discovered in 1927. It consists of two parts; the upper is a *mastaba*-like structure and could easily be seen from the court in front of the Step Pyramid. The lower part is hewn into the base rock to a depth of 28 metres, and was reached by a steep stairway also cut out of the rock from west to east. This goes down to a doorway and then is followed by another stairway leading to the burial chamber lined with Aswan granite. This was closed up with a plug very similar to that used to close the Step Pyramid's burial chamber. After going through the burial chamber, another stairway on the east side leads to a set of lower chambers. In one of them there is a relief of King Djoser wearing the White Crown of Upper Egypt and running in the sed-festival. The relief is surrounded by turquoise coloured faïence similar to that found in the burial chamber of the Step Pyramid. In addition to this chamber there were several others all decorated in a similar style. Much of it had fallen down, but has been restored to its original place. It was attached to the wall with a thread passing through holes at their back similar to sewing. A lot of pottery was found in these rooms, this also very like that found in the burial chamber inside the Step Pyramid.

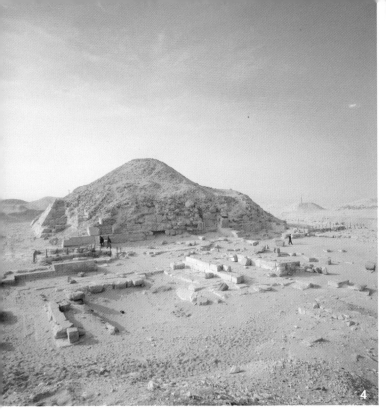
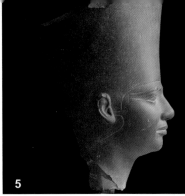
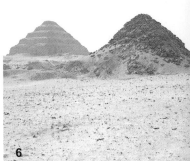

The *sed*-festival was a ritual celebrated in the 30th year of the king's rule during which he renewed his authority. In the ceremony he was represented running to prove his fitness to rule the country, and across the country's borders to symbolise his domain. Then, he was re-crowned as king of Upper and Lower Egypt. It is believed that the *sed*-festival was a very old tradition that was celebrated by Pre-dynastic rulers.

Pyramid of Unas

This lies about 120 metres to the southwest of Djoser's Step Pyramid and was built in 2475 BC. A visit to the interior is of great interest and should not be missed. From the entrance on the north side, a passage, once enclosed by three gates of granite, leads down a slope. To the right of the vestibule lies the burial chamber with the granite sarcophagus of the king. Noteworthy is the roof of this chamber which tapers as it ascends.

The walls of the burial chamber and the central room are completely covered with hieroglyphic writing, dealing with the soul's passage to the hereafter; most of these are spells, but there are also prayers for the king. The entire collection of such spells calculated to help the deceased on his difficult journey by magic, is known as "The Pyramid Texts" and comprises some 700 spells found in the various pyramids, some 200 in the pyramid of Unas alone. They are also alluded to as the Pyramid Texts and are among the most ancient religious or quasi-religious texts, which have come down to us. In the Middle Kingdom it was known as the 'Coffin Texts' and in the New Kingdom as the 'Book of the Dead'. The old tombs in the vicinity of the pyramid are Persian.

These texts are the best references about religious beliefs in the Old Kingdom. They inform us about the king's afterlife, and give us many references to ancient Egyptian mythology. One text reads:

> This Unas comes to you, O Nut,
> This Unas comes to you, O Nut,
> He has consigned his father to the earth,
> He has left Horus behind him.
> Grown are his falcon wings,
> Plumes of the holy hawk;
> His *ba* has brought him,
> His magic has equipped him.

Nut, the sky goddess, welcomes Unas in the afterlife with the following words:

Make your seat in heaven,
Among the stars in heaven.

Another spell asks the gods for their help. Shu, the god of the air is called to lift the king up while Nut holds the king's hands. Then the king climbs up to the sky on a ladder:

Hail, daughter of Anubis, above the hatches of heaven,
Comrade of Thoth, above the ladder's rails,
Open Unas' path, let Unas pass!

Sometimes the king asks a celestial ferryman, to take him across the water that separates the earth from the sky:

Awake in peace … …
Sky ferryman, in peace, …
Nut's ferryman in peace,
Ferryman of gods in peace!
Unas has come to you
That you may carry him in this boat in which you carry the gods.

In case the ferryman rejects him, the alternative solution is found in the form of Thoth, god of wisdom. Thoth is shown as an ibis:

If you fail to ferry Unas,
He will leap and sit on the wing of Thoth,
Then he will ferry Unas to the other side!

Now the king asks to be united in eternity with his father Ra, the sun god:

Ra Atum, your son comes to you,
Unas comes to you,
Raise him to you, hold him in your arms,
He is your son, of your body, forever!

The Pyramid Texts were found in the pyramid of King Unas, the last king of the 5th Dynasty. They were also found in the 6th Dynasty pyramids of the Kings Teti, Pepi I, Merenre and Pepi II. All these pyramids were erected towards the end of the Old Kingdom, but scholars think that the Pyramid Texts date to the Archaic Period or even earlier.

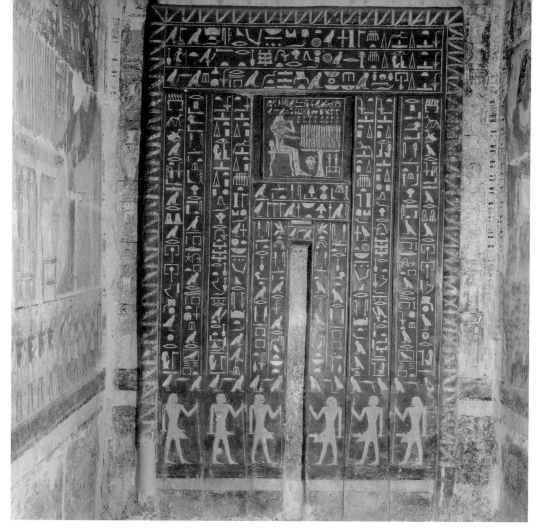

Above : False door in the tomb of Mehu. The remarkable feature here is that the false door is painted dark red to imitate granite. The hieroglyphs, written in yellow, form a sharp contrast to the red. The colours are the original and are in excellent condition. In the frame in the middle Mehu is seated and eating the funerary meal *skhet* meaning field of offerings.
Right : The hieroglyphic script records the names, types and quantities of offerings that the deceased wanted in the netherworld. It was believed these offerings would materialise there.

Rock-cut tomb of Mehu

Mehu was a vezier during the reign of Pepi I, 6th Dynasty, *c.* 2300 BC. The tomb consists of four rooms and a courtyard. The rooms are painted with scenes of hunting and fishing in the swamps. The original colours are almost completely intact. The offering chamber has paintings of offerings and shows Mehu watching a performance of dancing and four harpists. Then follows a chapel decorated with high relief offering scenes. The colour of the background is dark blue-grey with a beautiful false door painted dark red.

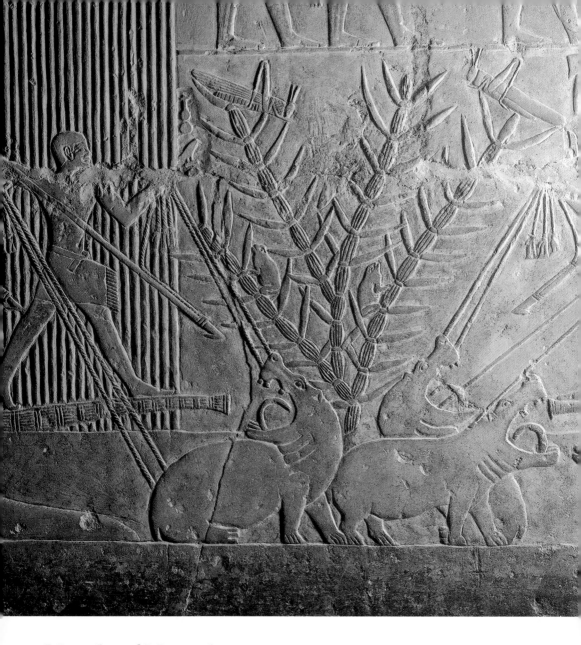

Mastaba of Mereruka

Mereruka, also called Meri, was Grand Chamberlain to the pharaoh. His mastaba lies northeast of the Step Pyramid and not far from the dilapidated pyramid of Teti. The tomb, 40 metres by 24, was built sometime at the beginning of the 6th Dynasty (*c.* 2345 BC) and was discovered in 1893.

It consists of 32 chambers and passages in all, 21 of which belong to Mereruka himself, while six rooms on the east, to the right, are dedicated to his wife Hertwatetkher and five others to his son Meri-Teti.

On the right hand side of the vestibule Mereruka himself is shown painting the three seasons as deities. In the first room are paintings of Mereruka, his wife and their son; scenes showing fishing in the reed swamps follow. In a room in his home Mereruka sits listening to his wife playing the harp; male and female dancers perform before them. In another room there are representations of offerings for the dead. There is a sacrificial chamber with six columns; on the north side is a niche for the statue of Mereruka. There are pictures of domestic animals, ships, funeral rites, wailing women and sacrificial offerings on the walls.

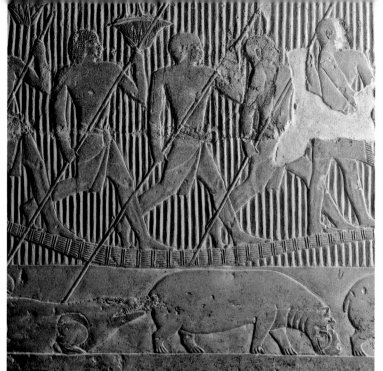

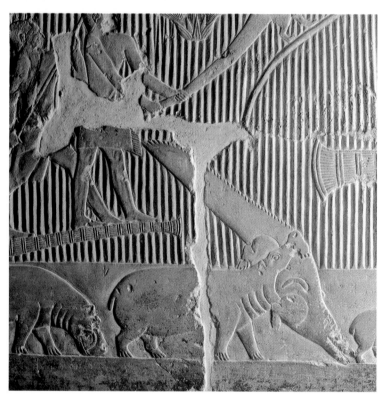

Facing Page : Mastaba tomb of Mereruka, 6th Dynasty *c.* 2345 BC, Saqqara.

A hippopotamus hunt in the marshes of the Nile. The animals turn their heads towards the hunters, who fire arrows at them. The ancient Egyptians regarded the hippopotamus as a representation of the god Seth, symbolising the evil and wickedness in the world. They considered killing the hippopotamus as a symbolic subduing of evil. Hence, the tomb owner would not be harmed as he entered the afterlife.

Left : an excellent high relief of a female hippopotamus giving birth while a crocodile attacks the newborn calf. The quick movement of the crocodile is depicted by a double drawing of its feet.

Below : This scene is a continuation of the last register. Here the hippopotamus is taking revenge by attacking the crocodile and lifting it out of the water, while fishermen watch from their papyrus boat.

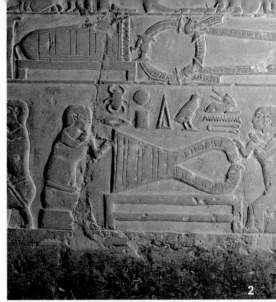

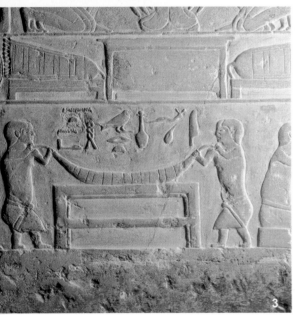

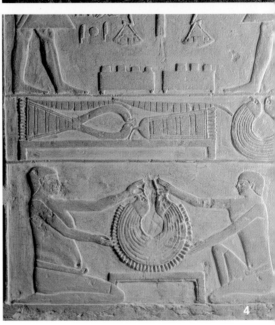

Mastaba tomb of Mereruka, 6th Dynasty *c.* 2345 BC, Saqqara.

A series of registers showing goldsmiths.

Clockwise from top left: 1. The scribe records the weight of the gold. The various weights of the balance are placed in a box below.

2. Two dwarfs work on a gold necklace with chisels.

3. Two dwarfs blow the melted gold. The hieroglyphic script records that one dwarf is telling the other : "He is very happy with you". They were actually talking about a colleague. In another register the text reads "Blow well, as I have taught you to do."

4. Making the final touches to the finished product. It is interesting to note that dwarfs were preferred as goldsmiths, since their short fingers allowed them to do meticulous work. It was also thought they could not run away with the gold. If they did, they would have been easily identifiable. The text in this register reads "You start shaping the piece ".

114

Serapeum

About 600 metres west of Ti's *mastaba*, about five minutes' walk, is an underground gallery containing the tombs of the sacred Apis bulls, discovered in 1851 by the French archaeologist Mariette. The Apis bull was thought by the ancient Egyptians to be the living manifestation of the god Ptah, who had his own temple at Memphis. The sacred Apis bull (special markings were a black hide and a face with a white blaze) was embalmed after death and buried with great ceremony in a special tomb. The oldest of these date back to the 18th Dynasty.

The Apis vaults, which the tourist visits today were inaugurated by Psammetichos I (26th Dynasty, 663-609 BC) and were enlarged by the Ptolemies. The total length of all the passages hewn from the rock is 342 metres. They are 3 metres wide and 5 high. The main gallery is 200 metres long. Apis was assimilated with Osiris after death and was then called Osiris-Apis (*Ozer-Nape* by the ancient Egyptians; *Oserapis* by the Greeks). During the Ptolemaic period Oserapis was equated with the Greek god of the underworld, Serapis, and since that time these catacombs have been called the Serapeum, or Serapaion.

The entrance is on the east (1), and from there one goes straight to the first intersection (2) and then turns left to reach the Great Gallery (3). Right and left of it are the 8 metre high chambers with the sarcophagi in which the mummified sacred bulls were placed. Nearly all these sarcophagi were carved from solid blocks of black granite. The 24 still standing in their original positions are each some 3 metres high, 4 long and 2 wide, and weigh, it is thought, between 60 and 70 tons. The sarcophagus which stands last on the right (4) is the most remarkable. There is an easy access to it by means of some steps. Behind the sarcophagus another flight leads to its upper edge; the cover or lid, as in most sarcophagi, is shifted a little to one side. On the way down one turns into a side passage (5) which leads back to the intersection (3) and the exit.

Pyramid of Sekhem-Khet

Not much is known about Sekhem-Khet; he is though to have been a successor of Djoser, and to have died in 2643 BC. His pyramid is to the southwest of Djoser's Pyramid and is an unfinished step pyramid of the 3rd Dynasty.

The enclosure wall of white limestone was 550 metres long north to south, and 200 east to west. On the north side there is a path with parts of the first enclosure wall, which are extraordinarily well preserved, thanks to the fact that the pharaoh had them covered up during his reign as he was intending to build another wall further north. The pyramid, most of which is under the sand, covers 120 square metres and is only some 6 metres high. The entrance is discernible in a shaft on the north side. From this spot a tunnel about 7.5 metres long leads to the burial chamber, 40 metres underground.

Mastaba of Ptah-hotep

Ptah-hotep was a judge of the High Court, *vizier* (minister) and a close friend of King Isesi Djed-Ka-Ra Isesi of the 5th Dynasty. From the entrance (1) the way goes straight to a corridor (2) with a half finished relief, whose condition gives us some idea of the artist's technique in carrying out this type of work. From there we turn to the right into the square pillared hall (3) with four columns. At the southeast corner, to the left, a door leads through an antechamber (4) into the sacrificial chamber of Ptah-hotep (5). This room contains some of the most beautiful reliefs surviving from the 5th Dynasty, with the colours still well preserved. On the ceiling are depictions of palm trunks, and in the entrance door, scenes of servants carrying offerings of fish and birds. On all four walls are depicted scenes from the daily life of the tomb owner. On the north wall we see (a) Ptah-hotep freshly clothed for the day, seated on a chair surrounded by his favourite dogs, while an attendant holds a monkey. Before him are harpists and singers, and seated officials awaiting his orders; in the bottom row are musicians, harpists and flautists with their conductor who is clapping the rhythm. On the west wall (b) to the left and right are false doors. On the right side the facade of the palace is depicted, without any inscription. On the left are two portraits of Ptah-hotep; in the right hand one he is in a temple and in the left, he is being carried in a litter. Between the two false doors are priests taking part in sacrificial scenes and in the lower tiers, slaves carrying various offerings. On the south wall (c) Ptah-hotep is seen at a meal and there is a scene showing sacrificial animals and servants with offerings. The most important and artistically perfect pictures in the mastaba are on the east walls (d), which are divided into two big scenes, each of which is shown in seven rows. Left: Ptah-hotep on an inspection trip to the countryside. Above: herdsmen are driving animals through a lake in which crocodiles are visible, labourers are pulling papyrus plants and bundling them into sheaves. The second row depicts: boys at play. The third: vineyard scenes, peasants are gathering grapes, watering the vines, pressing the ripe grapes and treading out the juice. The fourth: hunting scenes in the desert. The fifth: fish being gutted and spread out flat. The sixth: working on nets. The seventh: sham fighting between three boat crews. Behind is a boat with the artist himself who sculptured the reliefs: he has included many things from the tomb owner's daily life. In the second scene on the right, Ptah-hotep is contemplating the presents and tithes from the villages of the North and the South. Above: a file of youths is bringing a young prisoner before their master. Second and third rows: hunters displaying their captures, a caged lion and a leopard, gazelles, a cage of hares and hedgehogs. The fourth: shepherds with their flocks. The fifth onwards: rural scenes. In the sixth, oxen are being paraded before their owner; below this is a display of poultry.

From the sacrificial chamber one must return to the pillared hall (3) and from there to the sacrificial chamber of Ptah-hotep's son Akhet-hotep (6), which is also decorated with scenes from daily life. On the west wall is a false door with a sacrificial tablet.

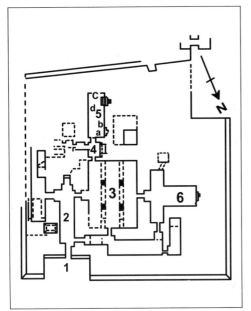

Mastaba tomb of Ptah-Hotep, end of 5th Dynasty *c.* 2380 BC, Saqqara.
1. A favourite pastime among the fishermen of the papyrus rafts was mock fighting.
2. The relief shows typical boat building.
3. The relief shows a typical bird farm. Bird farming was common in ancient Egypt. Certain bird species were symbols of particular deities. The ibis, for example, was a representation of Thoth, god of wisdom and learning, as its bill dipping into water resembled the dipping of a quill pen into ink. The ibis is represented in this relief on the left, and in the lower row on the right. The bird in the middle is a quail, which does not represent any deity. In the centre are flocks of geese and ducks.

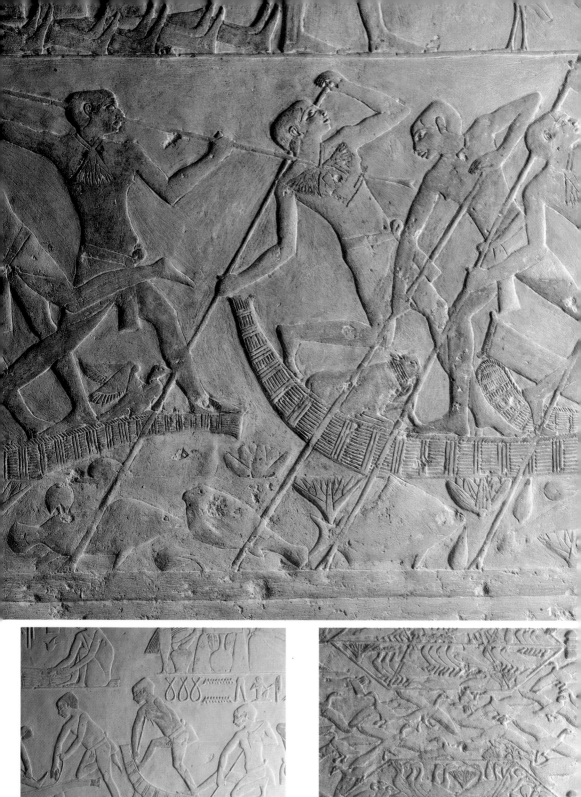

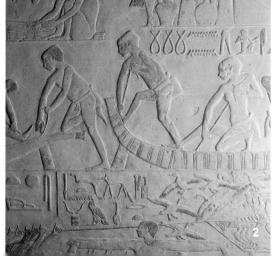

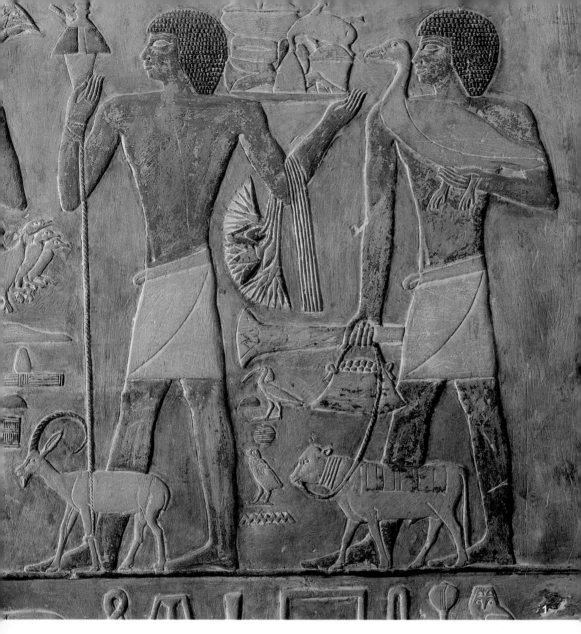

Mastaba tomb of Ptah-hotep, end of 5th Dynasty *c.* 2380 BC, Saqqara.

1. An excellent high relief still retaining its original colours. The man in the foreground is carrying offerings of a fowl on his shoulder and holding a lotus plant. With his other hand he leads a gazelle tied to a rope. The man at the rear carries a goose and papyrus, and leads a small calf by a rope.

2. An excellent high relief of a hunting scene. A lion attacks a cow, which urinates in fear. The top register depicts a scene of gazelles, including a suckling fawn. The bushes in the background still retain their original green colour. The lower register depicts salted fish.

3. A typical hunting scene, showing dogs attacking gazelles while other gazelles look on. The bush still retains its original green colour. In the top right register is scene depicting a wild rabbit.

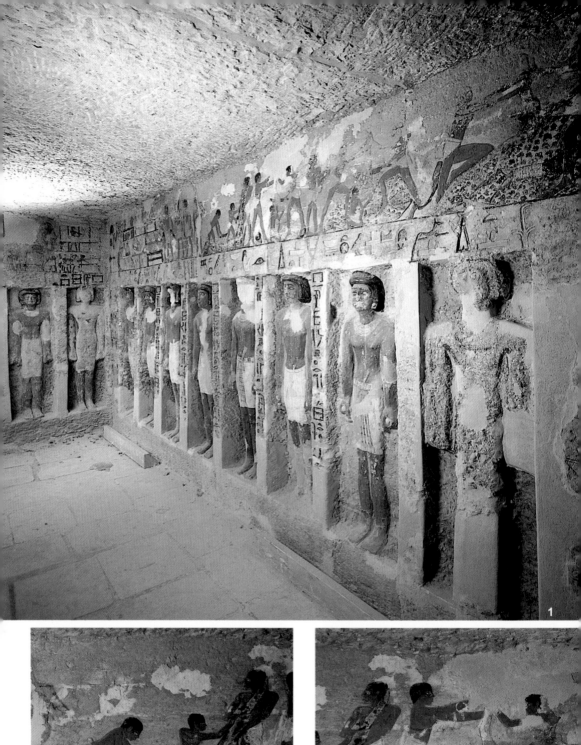

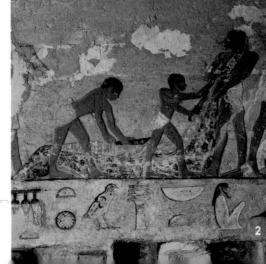

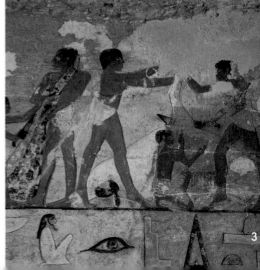

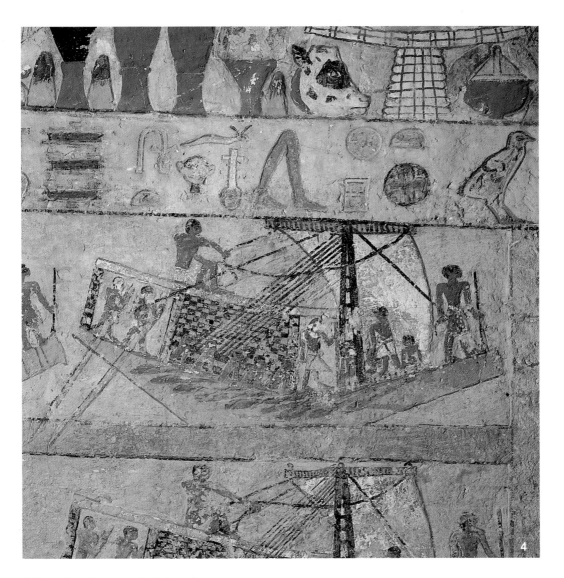

4

1. Ten rock-cut *ka* statues of relatives of Irukaptah standing in their niches receiving offerings. The middle register has a drawing of the funerary formula known as *htp di-ni-sw*. The upper register has a scene from the daily life of a butcher.
2, 3 & 5. Drawing of animals being slaughtered.
4. Drawing of sailing vessels in the Nile.

Rock-cut tomb of Irukaptah known as the Butcher's Tomb

Irukaptah had the title "Head of Royal Butchers" during the 5th Dynasty, *c.* 2300 BC. The tomb has numerous drawings of animals being slaughtered. The drawings still retain their original colours. Ten stone statues of family members lay on the east wall of the tomb. Similar statues can be seen in the Giza cemetery. At the rear end of the tomb we find drawings of sailing vessels.

Mastaba of Ti

Visitors who wish to see only one of the private tombs of the nobles should see the mastaba of Ti, the biggest and most beautiful of the tombs of private individuals at Saqqara. It was cleared in 1865 by Mariette and contains the best narrative wall reliefs of the Old Kingdom. Ti was a high court dignitary towards the end of the 5th Dynasty (c. 2350 BC).

The tomb is entered from the north; first there is a small vestibule with two pillars (1) decorated with portraits of the tomb's occupant. From here the big hall (2) lies ahead where offerings for the dead were presented. Some of the 12 pillars are ancient, some are later restorations; the original roof has been replaced by a wooden one.

In the north wall is an opening to the so called *serdab*, a chamber in which the statues of the deceased once stood (3). In the middle of the pillared hall is a stair (4) leading to the burial chamber (5), with a niche and an empty sarcophagus. (This part is not open to the public.)

To the right, in the southwest corner is a passage (6), which, like the following rooms, is richly decorated with a variety of scenes from the daily life of Ti. The rich Lord Ti was anxious that all, absolutely all, that had occurred around him in his life should also surround him in death. On the right of the passage is a false door for his wife Neferhotopes. On the walls are depicted servants with all kinds of offerings.

A second door leads to another passage with pictures of sacrificial animals, statues of Ti, which are being carried to the tomb on sleds, and representations of Ti in a boat, on the right wall. Above the door Ti and his wife are seen in a boat in the middle of a papyrus thicket. On the right, before the mortuary chamber, is a side chamber (7) with coloured reliefs in a very good state of preservation of servants bringing offerings. The mortuary chamber (8) is 7 metres high, 5 long and 4 wide, with pillars in the middle. The walls are decorated with reliefs: to the left of the entrance, Ti with his wife is inspecting the gathering of the harvest, to the right of this, shipbuilding scenes, shown in such detail that the construction of Nile vessels 4,500 years ago can still be clearly followed.

On the north wall, amid pictures of the river and the Delta marshes, is a wonderful scene of Lord Ti sailing among the papyrus swamps. This is one of the most beautiful reliefs in Saqqara. Up among the flowers and buds of the papyrus plants are numbers of birds, while below, in the water, are fishes and hippopotami; Ti stands on his

boat. In front of him is a smaller craft whose crew are aiming spears at the hippopotami, one of whom holds a crocodile in its great mouth. To the left of this remarkable picture we see Ti bird-catching in the Delta, and fishing scenes; below, 36 peasant women are bringing offerings. On the right (from above downwards) papyrus gathering, boat building, a flogging, and some rustic scenes: ploughing, treading in the seed, homecoming.

In the west wall are two false doors, a symbolic entrance to the kingdom of the dead. Between the doors sacrificial scenes are depicted. On the south wall are, left, pictures of Ti with his family, in the middle Ti and his wife, varied with representations of game, cattle and poultry. On the right Ti is seen seated at table.

Behind the south wall of the mortuary chamber is another *serdab* (9) in which a series of statues once stood. Most of these were already broken when discovered; the only one in a good state of preservation is now in the Egyptian Museum in Cairo. This chamber cannot be entered but can be seen through an opening in the wall.

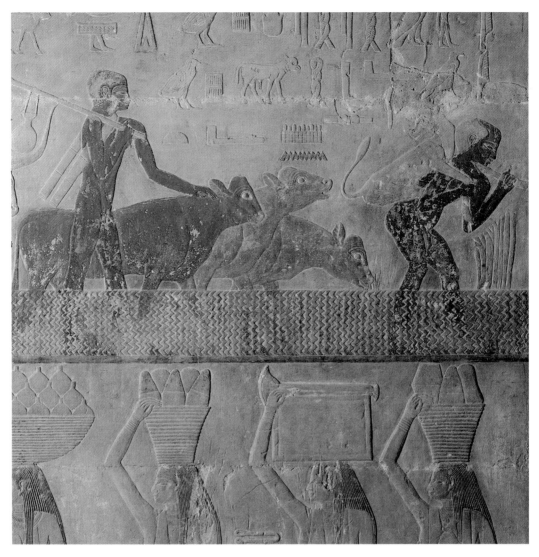

A man carrying a new-born calf on his shoulder while crossing a canal. The calf looks back towards its mother who follows and hence also the rest of the group of cattle, mastaba of Ti. The water is represented in a transparent mode enabeling us to see through and recognise the animals' and pesant's legs. In the text on top the pesant shouts to the calf "Don't shout your mother will feed you soon". The maan carrying the calf has a big tummy probably he was suffering from Bilharzias which is an infection of a parasite wide spread in Nile waters.

What the Sands Conceal...

In the city of the dead at Saqqara there are, besides the monuments already spoken about, a number of pyramids, among them those of Teti (Phiops) I; Mer-ne-rê, and tombs including those of Kagemni, the Mastaba el-Faraun, the Persian tombs, and also the ruins of early Christian churches, such as the church and monastery of St. Jerome. All these have not so far been mentioned, so that the visitor's attention would not be drawn to too many things at once, but was concentrated on the most important and complete remains in this region. Research is still continuing at Saqqara.

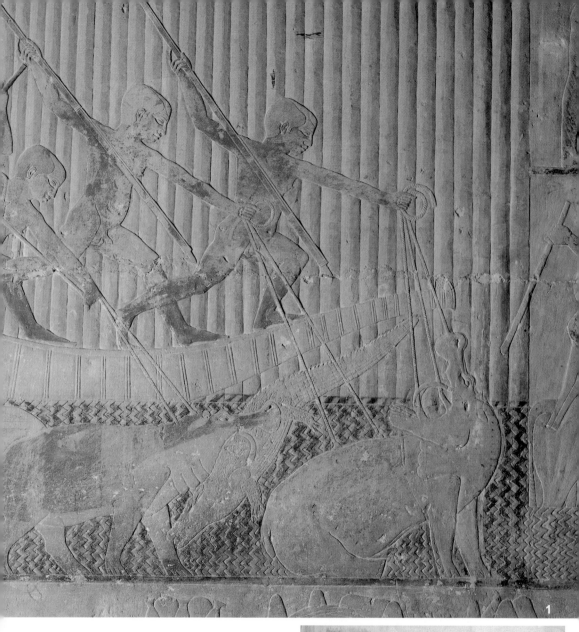

1. Two men shooting a hippopotamus during a hunt, and a hippopotamus crushing a crocodile.
2. Window of the serdab with a statue of Ti behind the wall. This serdab is not accessible but can only be seen through the window.
3 & 4. Scenes from daily life.

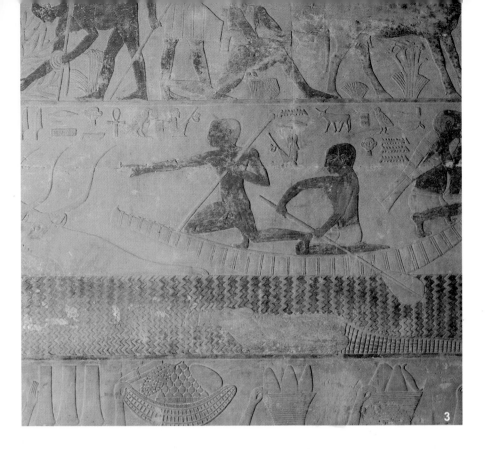

3

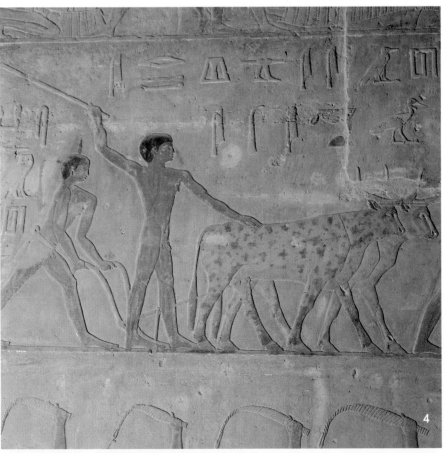

4

125

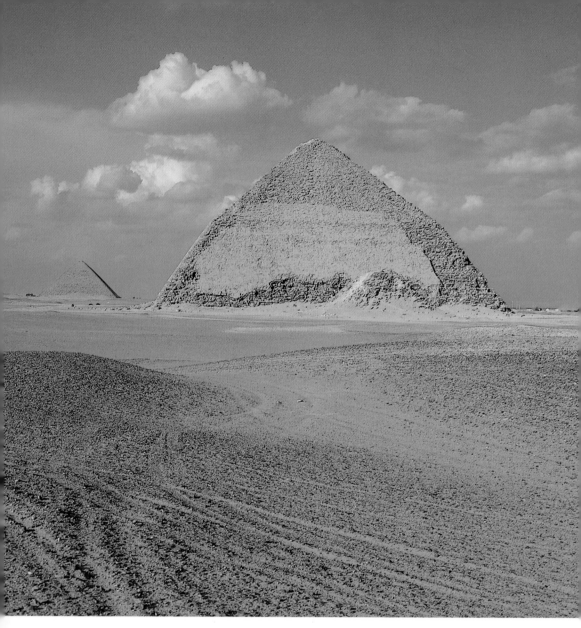

Above : Snefru abandoned the royal necropolis at Meidum and chose the new site of Dahshur. He is the only Pharaoh who built four pyramids. It has been calculated that he used 3.7 million cubic metres of construction material. The slope of the lower part of the Bent Pyramid is 54° 31′13′′ to a height of 49 metres, and then becomes 43° 21′.

Along the southern face of the Bent Pyramid is a small satellite pyramid which still retains some of its original limestone casing at the base. The entrance is still approachable though a passageway that reveals only sand and debris. Inside this pyramid is a prototype or miniature Grand Gallery, that is, a corbelled sloping chamber that leads to the burial chamber. This design

innovation demonstrates the evolution of pyramids in the Old Kingdom as this concept would later appear in grander form in the Great Pyramid of Cheops.

Facing page : The western face of the Bent Pyramid at Dahshur. The original limestone casing is the best preserved of all pyramids. This pyramid gives the best idea of the sparkling brilliance that the pyramids of Egypt had before their casings were stripped away. Mostly these casings were removed and used to build Cairo houses.

The Bent Pyramid at Dahshur

Snefru also built the Bent Pyramid and the Northern or Red Pyramid at Dahshur. The Bent Pyramid was planned from the beginning as a true pyramid, with its sides measuring 188.6 metres and with an original height of 101 metres. Its stone casing is the best preserved of all the pyramids of Egypt. The angle of the slope is 54° 31′13′′ up to a height of 49 metres, and then it becomes 43° 21′. The change of the sloping angle gives it its name of the Bent Pyramid.

Archaeologists explain the change in the sloping angle by speculating that it was too steep to continue, and the centre of weight of the core masonry stones would have made the structure unsound. Another explanation is that the builders may have felt that the stone casing was unstable and would fall out. Whatsoever, cracks were discovered in the passage leading to the upper burial chamber. The builders tried to repair the damage by filling it with plaster. This might have been a strong reason for the builders to reduce the pyramid's slope. This modification resulted in reducing the weight of the upper part of the pyramid, thereby reducing the load on the chambers and passages that had started to crack.

The Bent Pyramid is unique not only in its shape but also in having two separate entrances, one situated roughly in the middle of the north face about 12 metres above the ground, the other on the west face. This last entry is the only known exception to the rule that all pyramid entrances lie on the north face. The west entrance was opened by Ahmed Fakhry in 1951. Each entrance leads to a separate chamber; the north to a subterranean chamber, the west to a chamber at ground level and a little to the southeast, above the other. The corridor at the northern entrance has a slope of 25° 24′ and is 79 metres long and leads to a small chamber with a corbelled roof 12.5 metres high. Then immediately following comes the subterranean chamber, measuring 6.2 metres from north to south and 4.9 from east to west with a height of 17.1. Its corbelled roof with 15 courses looks very impressive. At the top, it is only 1.6 metres long and 0.3 wide. A narrow passage starting from a height of 12.6 metres on the south wall reaches the chamber at ground level. This passage is roughly hewn, and it looks as if it was cut later by ancient robbers. Both chambers have similar walls and ceilings with a corbelled roof. The interesting feature about this second chamber is that it has various cedar wood beams fixed between the walls. They were in a stunning state of preservation when discovered by Perring and Vyse in 1839. These beams must have been part of a cargo that Snefru imported from Lebanon. At first sight one would think these were a kind of a raised platform for workmen, but the conclusion reached by surveyors and other archaeologists was that this could not have been their function. When Perring and Vyse first entered the pyramid they found some white limestone blocks among the beams. This arrangement of white limestone blocks and wooden beams is still a mystery.

To the south of the Bent Pyramid is a satellite pyramid, probably belonging to Queen Hetepheres I. However, some scholars think that this small pyramid was for the burial of the pharaoh's viscera or for his *ka*. The interesting feature about it is that its entrance is at ground level, first through a descending passage and then an ascending passage to the burial chamber. The ascending passage has a corbelled roof approximately 7 metres high, a miniature version of the 'Grand Gallery' in the Great Pyramid of Cheops. Next to the satellite pyramid south of the Bent Pyramid, Fakhry found a large Stela bearing the name of Snefru.

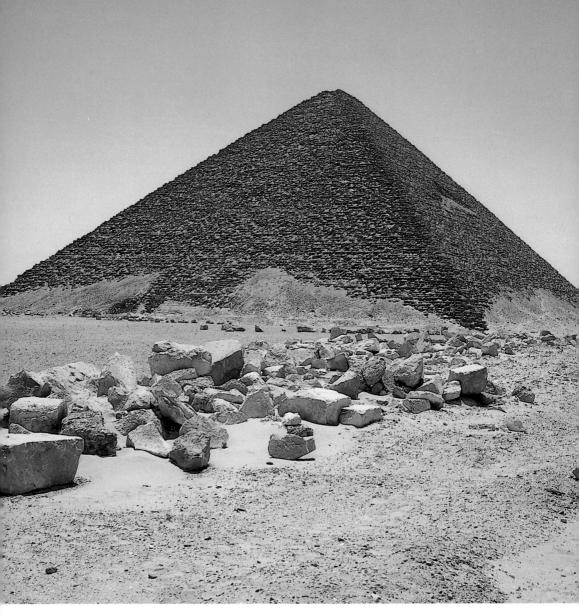

The Northern Pyramid at Dahshur is the first true pyramid, with its slopes rising at a gentle angle of 43° 36′ instead of 52° which became the standard angle of later pyramid's face inclination.

The Northern Pyramid at Dahshur

The oldest true pyramid is the Northern Pyramid at Dahshur, a short distance from the Bent Pyramid. Although earlier in date than the Great Pyramid it is not much smaller in size, the base measuring 220 metres and the height 105. The sides have a slope with a horizontal of 43° 36′, which is nearly equal to the slope of the upper part of the Bent Pyramid (the base of Cheops Pyramid measures 232 metres, and its side has a slope of 51° 51′14.3′′ to the horizontal). The slope is much less than most other pyramids, and gives it a more or less flattened appearance.

The entrance of the pyramid through the north face is 28 metres above the ground, and descends at an angle of 27° 56′ (the angle of descent of the sloping passage in Cheops Pyramid is 26° 18′ 9.7′′). The corridor, 60 metres long, leads to three chambers. All these have corbel vaulted roofs. The first two antechambers are nearly identical in size and form. Each of them measures 10 metres in length from north to south, 3.6 in width and 12 in

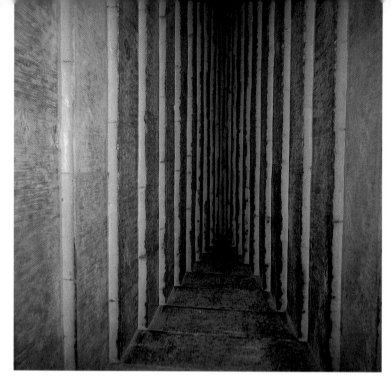

The first antechamber has a magnificent corbelled roof built in 11 steps and reaching a height of 12 m.

height. The second antechamber lies exactly below the apex of the pyramid. An opening 8 metres up in the south wall of the second antechamber leads to the burial chamber, which is 9 metres in length from west to east and has a width of 4.2 metres. Its corbelled roof is 15 metres high. The floor of the chamber was removed in antiquity to a depth of 4 metres. The walls have been blackened by fire and the torches of ancient thieves and visitors. This is the first burial chamber to be aligned from west to east. In all 3rd Dynasty pyramids and also the previous two pyramids of Snefru, the burial chambers were aligned from north to south.

The pyramid has no inscriptions, and it was a mystery to find out which pharaoh was its builder. Several small clues made archaeologists come to the conclusion that its builder was Snefru. Snefru's name was also found written on a casing block at the north eastern corner of the pyramid. However, inscriptions of this order are sometimes inaccurate. In 1905 Ludwig Borchardt saw another such inscription at the edge of the cultivation dating from the reign of Pepi I of the 6th Dynasty. It was a decree from Pepi I exempting the priests of the 'two pyramids of Snefru' from some taxes. No sarcophagi or remains of a mummy were found in any of Snefru's pyramids.

Approximately 400 metres east of the pyramid are the remains of a vast 4th Dynasty necropolis. This has been excavated by Dr. Rainer Stadelmann, head of the German Archaeological Institute. He also excavated the ruins of the Northern Pyramid's mortuary temple, which was not completed at the time of Snefru's death.

At the close of this section on Snefru's pyramids I am sure the reader will ask the question: "In which of the three pyramids was Snefru buried?" Many archaeologists share the opinion with Ahmed Fakhry that Snefru was buried in the upper chamber of the western gallery of the Bent Pyramid. However, Stadelmann thinks that Snefru was buried in the Northern Pyramid, in spite of the fact that the complex was not finished at the time of his death. It is hoped that further research with modern scientific tools will reveal many more surprises.

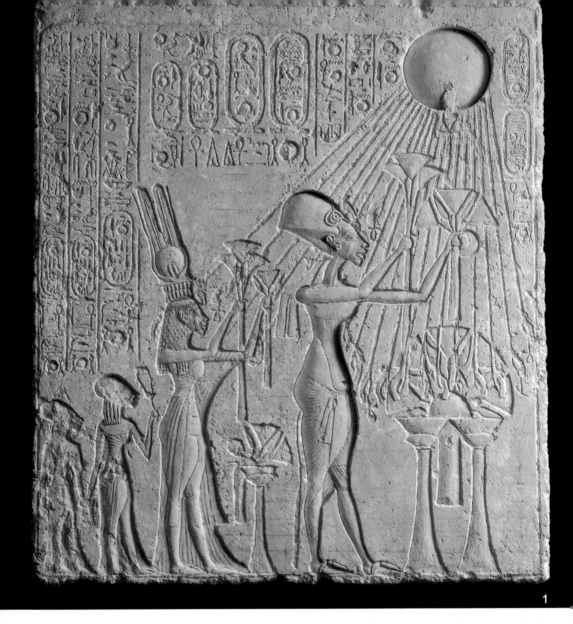

1

1. Panel with adoration scene of the Aten.
18th Dynasty, reign of Akhenaten, 1350 - 1333 BC.,
Tell el-Amarna, Painted Limestone, H. 53 cm, W. 48 cm,
D. 8 cm, The Egyptian Museum in Cairo.
This panel was found in the rubble blocking the royal
tomb of Akhenaten. Its function within the funerary
monument is not clear. The scene represents the royal
family, Akhenaten, Nefertiti, and their daughters
Meritaten and Meketaten, worshipping the god Aten. On
the surface between the figures, one can see traces of a
red grid used by the artist to execute the decoration of
the tomb. The solar disc is placed in the top right corner,
with rays terminating in small hands, some of which are
holding the signs of *was* (prosperity) and *ankh* (life).
The rays of Aten pass behind members of the royal
family and in front of the offering table. The contents of

the offering table are almost completely obscured by the
rays of the solar disc.
The pharaoh is wearing the blue crown, adorned by the
uraeus; his skirt, partly plaited, shows his knee. The
queen is wearing a wig, a diadem surmounted by two
horns, a sun disk, and a tall feather; her long, transparent
robe reveals her body. Their daughter Meritaten is
holding her sister with her right hand and her sistrum in
her left hand, the figure of Meketaten is damaged.
The inscriptions includes the names of the family and the
titles of the pharaoh and queen.
2. Head of Nefertiti, painted limestone, 18th Dynasty,
reign of Akhenaten, 1350 - 1333 BC, Tell el-Amarna.
3 & 4. Fragment of a painted floor,
18th Dynasty, reign of Akhenaten, 1350 - 1333 BC, Tell
el-Amarna.

Monuments of Upper Egypt

Tell el-Amarna

Akhet-aten was founded during the New Kingdom by Amenhotep IV - Akhenaten (1350-1333 BC). It lay on the east bank of the Nile near what is now Tell el-Amarna (*tell* means "hillock"), named after a Bedouin tribe. The capital was for a short time transferred here, in Middle Egypt, but his successor, Tutankhamun, lost no time in restoring it to Thebes.

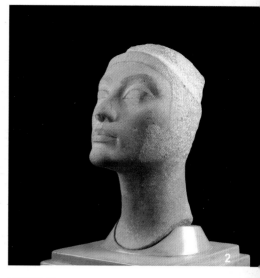

Akhetaten, "the Horizon of the Aten", was built as a city of the god after Amenhotep IV broke with the polytheistic religion centred at Thebes around Amun-Ra. He changed his own name, containing the name of Amen, to Akhen-aten, "Pleasing to the Aten", and renounced the worship of Amun-Ra, replacing it with the sole worship of the Aten, the sun disk. The 17 year long reign of the ruler known as the "heretic king" is one of the strangest in all Egyptian history; it was disastrous for the stability of the Egyptian empire but fascinating from a purely human point of view.

In the centre of the City of the Sun, nearly 15 kilometres east of the Nile, was the great temple of the Aten of which few traces remain. All that is known is that it was 735 metres long and 277 wide. In the hillside are to be found more than 24 rock tombs, many of them unfinished. They are remarkable for the intimate and familiar domestic scenes shown on their walls, depicting the royal family, drawn with much greater artistic freedom in conception and execution than ever before. Hitherto such subjects had been treated in a strictly stylized and rather dry manner. Noteworthy also is the frequent appearance of the sun disk, whose rays terminate in hands.

The most important tombs are in the north, those of Huye, who was in charge of the female section of the royal household, and Meri-Ra, the high priest of the sun. The tomb of Huye is the biggest of this group and contains informative and interesting inscriptions, and wonderful reliefs. One of the most beautiful of these pictures shows the king in a chariot leaving his palace on the way to the temple of the sun, followed by the queen and princesses. Another impressive scene is that of the royal couple and the princesses sacrificing to the sun.

Many of the tombs in the southern group were never completed. Excavations were begun by the German Oriental Society under Ludwig Borchardt in 1907, but were interrupted by the 1914 -1918 war. The most important finds were the bust of Nefertiti, wife of Akhenaten, and the Tell el-Amarna Tablets, which Prof. Erman comments on as follows: *"This find has preserved for us a part of the Egyptian State Archives. They are the letters which the Asiatic potentates and the Syrian and Palestinian vassals addressed in cuneiform script to the Pharaohs Amenhotep III & IV. These clay tablets, now in the Berlin Museum, give us an insight into the political conditions and diplomatic relations of the days as no other documents do"*.

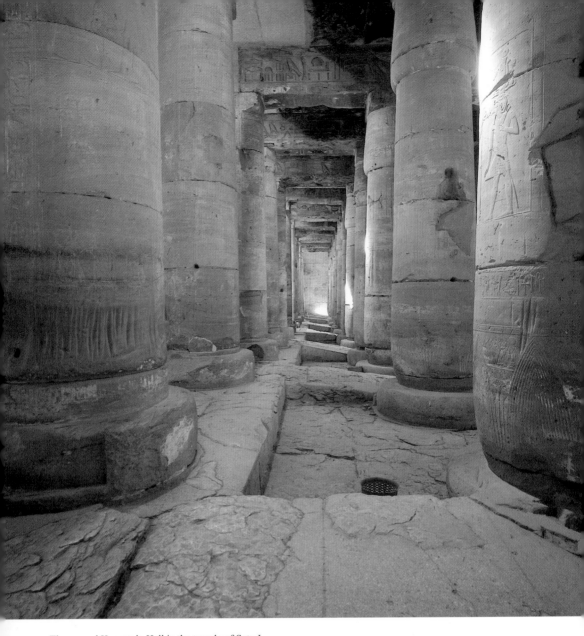

The second Hypostyle Hall in the temple of Sety I,
Abydos.

Abydos

Abydos is on the west bank of the Nile, about 10 kilometres southwest of el-Baliana railway station. It is reckoned to be one of the most ancient towns in Egypt. Tombs of the 1st and 2nd Dynasties have been found there, and it was regarded as a holy place where the tomb of Osiris, god of the underworld, was worshipped. It is no accident that one of the greatest centres of the Osiris cult was developed at Abydos. Here an ancient cemetery deity, the jackal shaped Khentamentui, the "First of the Westerners", is at home; he whose name was often coupled in prayer with that of Osiris till at last the two were fused into a single deity Osiris-Khentamentui.

Old accounts say that Abydos was once a large town, but the most important part remaining is the city of the dead on the edge of the desert. On approaching it along the embankment road, the visitor passes through the village of Araba and comes to the tombs of the New Kingdom. Here stand the temples of Sety I and Ramses II, which should be studied in detail. The necropolis of the Old Kingdom once lay to the northwest of them, and still further northwest, Middle Kingdom tombs. Northwards lies the sanctuary of Osiris (Kom el-Sultan) and south of the old fortress Shunet el-Zebib; nearly 3 kilometres west of the temple of Sety I, is the necropolis Omm el-Ga'ab, with the tombs of the kings of the earliest dynasties of the Old Kingdom and the sacred tomb of Osiris.

Temple of Sety I

Most Egyptian temples are built to the same ground plan which I will explain later in this book, but the temple of Abydos deviates from it completely; the forecourt and pylons which lead up to its main entrance are destroyed, but the interior of the temple is wonderfully preserved and still deeply impresses the visitor. Seven chapels, all side by side (e - d V) form the centre and core of the structure, and each of these must be regarded as a special sanctuary. The sanctuaries were roofed with rounded arches cut from stone blocks, just like the large stone sarcophagi with their covers hollowed out on the inner side, intended to represent the starry heaven that curves over the world and the dead. At the farther end of each, a hollow niche may be seen where a statue of the divinity once stood, and in the doorpost the holes to which door hinges were fixed, are still visible. In each of these sanctuaries a great god was worshipped. In the centre one was Amun (a), the great god of Thebes; to his left were Haramachis, god of Heliopolis, Ptah of Memphis, and Ra, the sun god (e - g); to his right the Triad of Osiris, Isis and Horus (b - d). Seven doors, all walled up but for one (e - d, III) led into the temple through the two vast pillared halls, which must be passed through (III and IV) to reach the sanctuary. In the first hall, the ceiling was supported by 24 columns, and in the second, which was larger and finer, by 36. In the former there were four, and in the latter 6 groups of six, and the ways left open between these groups of columns led straight up to the door of the sanctuary, as did those between the outer columns and the wall. The ancient visitor who approached the chapel of Amun through the centre opening saw to the right and to the left and wherever his eyes might turn, nothing but pictures and inscriptions about Amun, while anyone approaching the sanctuary of Osiris between the rows of pillars to the right, saw nothing but those that referred to the ruler of the underworld. Similarly each of the ways leading up towards the seven vaulted chapels at the further end of the second great hall was richly decorated according to the same principle. The common people were prohibited from visiting the sacred halls. None, but the highest priests and the king might enter the inner sanctuary, while the processions waited in the outer hall, and looked with prayerful fear at the ceremonies performed in the vaulted chambers. No song, no music of flute or harp, might ever be heard in this temple, which was erected as a cenotaph, or honorary monument, by Sety I. probably on the site of a more ancient sanctuary. The body of Sety lies in Thebes; but his name was to be preserved near the head of Osiris in Abydos, with those of his forefathers. Also here in Abydos he could receive, under the auspices of the god with whom his spirit was united, the reverence and sacrifices of his descendants. The mummy was probably brought to Abydos, and placed in front of the holy of holies. The space behind the seven sanctuaries was the scene of much preparation; and this seems to have been most indispensable for the services performed in the chapel of Osiris, since it is only from that one chapel that a door leads into the hall with the ten columns adjoining it at the back (VI), with several rooms connected to it. On the columns and walls of both the great halls the pharaoh is represented either bowing forward to pour out a libation to the gods, burning incense, or kneeling to receive their gifts. These representations are in low relief, executed with unsurpassable care in a fine grained limestone. Sety's face is always a true portrait and is not in any way idealized; the similarity to his son Ramses II is very strong. Every sculpture from this period bears the stamp of fine workmanship. Sety lived long enough to see the completion of the general planning of his cenotaph in the rough, as is seen by the wooden braces in the form of swallows' tails, which were intended to strengthen the connections of the stone blocks, all of which are marked with his name. On the other hand, he must have left the larger portion of the work of the interior decorations of this magnificent temple to his successor; and the way that son conducted himself in

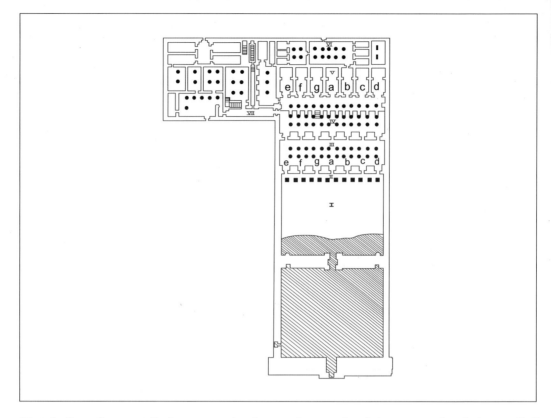

this task of recording events for future generations is set out in a great inscription, preserved on the inner wall of the antechamber (II).

Mariette is credited with having cleared this temple of sand. We owe the discovery to one of the most important of all documents concerning ancient Egypt to Professor Duemichen. It consists of the long series of names of all the legitimate and acknowledged kings who ruled over Egypt up to the time of the builder of this temple King Sety. This list of kings was found in one of the south side chambers (VII). Sety, with his son and successor, stands before this list. The father sacrifices to them with incense while the son approaches with songs of praise. Another similar list was found by Cailliaud in 1822 among the ruins of the cenotaph, which Ramses II had built for himself to the north of his father's. He got most of the costly building materials - granite, alabaster and limestone from Mokattam. This list, which is now in the British Museum, contains 22 names, of which only 16 are legible. A longer inventory has been found in Saqqara, with 31 perfect cartouches, and only three damaged. But the list discovered in Sety's temple contains 76 cartouches, beginning with Menes, the first king of the 1st Dynasty and ending with Sety himself. The immense importance of this monument is in delineating the long catalogue of early monarchs who ruled Egypt into one unified list. Akhenaten was omitted because of his so-called heresy. Hatshepsut also, because being a woman she had no legitimacy to the throne. Another list of pharaohs has been written by Manetho, a native of Sbennytus (now Semmenood). He was a learned priest who drew up the list for Ptolemy II-Philadelphus, who wanted to learn about the early history of the land which he ruled. The original book has been lost except for a few fragments. As for his list of kings, it was preserved by Christian historians.

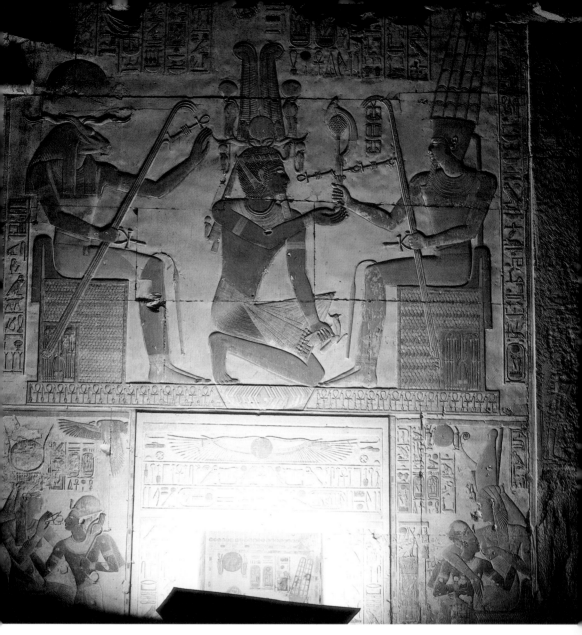

This relief is on the western wall of the Second Hypostyle Hall. Sety is kneeling before the god Amun Ra. The king wears the *henu* crown which is associated with this god, conferring legitimacy on the king to rule Egypt. The crown consists of the *nemes* and the crown of Amun known by its ram's horns and two feathers. The body of Amun is blue symbolising the sky. Sety holds the *rekhyt* bird with his left hand, showing that the people of Egypt are under his rule. His right hand is raised to receive from Amun Ra the *khepesh* mace and curved battle axe, denoting his victories in battles. The *ankh* sign on the *khepesh* is pointing towards Sety's face. In the text the god pledges to give Sety: "All the foreign lands under thy feet". The overall meaning of this is to denote that the king cares for the well-fare of his people, while the weapons handed to him by the god symbolise restoring Egypt's empire in the east, which was the king's first priority after the troubled era of the monotheistic pharaoh Akhenaten. Behind Sety is a rare representation of the god Ra-Herakhty as a ram-headed man, crowned with a solar disk between his horns. The god is holding in his right hand the sceptre of *djed*, a symbol of stability and continuity, which in touching the king passes on its attributes to him. Sety is wearing the composite crown, which consists of two tall feathers and a pair of images of the goddess Wadjet. The crown is the symmetrical sign of his sovereignty over the two lands of Egypt. The relief at the bottom right is that of the goddess Mut suckling Sety. This scene is a masterpiece in its expression of tender emotion. The goddess with her head tilting a little down towards the king is shown holding her breast close to the king's mouth. The latter is represented as a young child wearing the *khepresh* Blue Crown and holding the goddess's left arm. The way she is holding her breast is very realistic. Mut is wearing the *pschent* crown. The vulture goddess Nekhbet is folding her wings around Mut's head, symbolising the protection she gives to goddesses. In the lower left scene, the goddess Isis-Hathor is handing the king the emblems of life and prosperity. The king here is also represented as a small child and is holding in his right hand the sceptre of *heka* to emphasise his legitimacy to rule Egypt. The purpose of this register is to show the goddess as the spiritual creator of the king. The meaning of 'Isis' is the throne, hence he receives from her the legitimacy to rule Egypt, and the meaning of 'Hathor' is the house of Horus, which gives him a divine dimension.

135

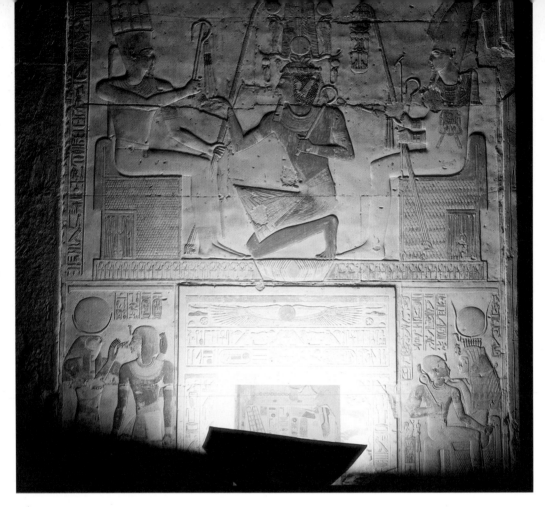

Above : This relief is on the western wall of the Second Hypostyle Hall. Sety is shown wearing the divine headdress kneeling in front of the god Amun Ra, who is giving him the crook, the flail and the *ms,* which consists of three fox skins tied together, a symbol of rebirth in the netherworld. The god Osiris is shown seated behind the king giving to him the most important insignias, *the was* sceptre of prosperity, the *Djed* pillar of stability and the *ankh* sign of life.

The lower relief on the right *(facing page)* shows the king as a child sitting on the lap of the goddess Isis. Her right arm is resting on his back while she pulls his face towards her with her left hand to kiss him. Sety is wearing a pendant, a symbol of protection. This role of the child on Isis's lap denotes he is the god Horus, the child of the Osiris myth. Behind Sety his title in the hieroglyphic inscription says: "The strong bull rising in Thebes". Isis is represented as the great mother of the god: *wr mut ntr.*

In the scene at the bottom on the left, the god Khonsu is represented as a falcon-headed man wearing the crowns of the full and the crescent moons. The god is holding the emblems of life and prosperity before Sety's face.

136

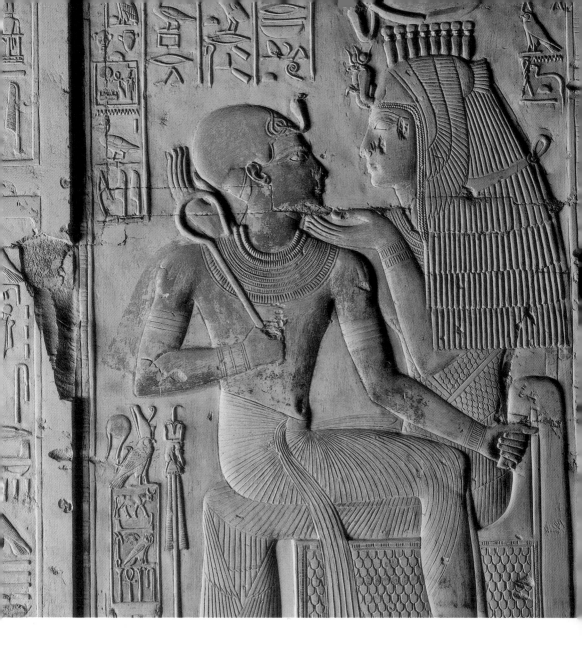

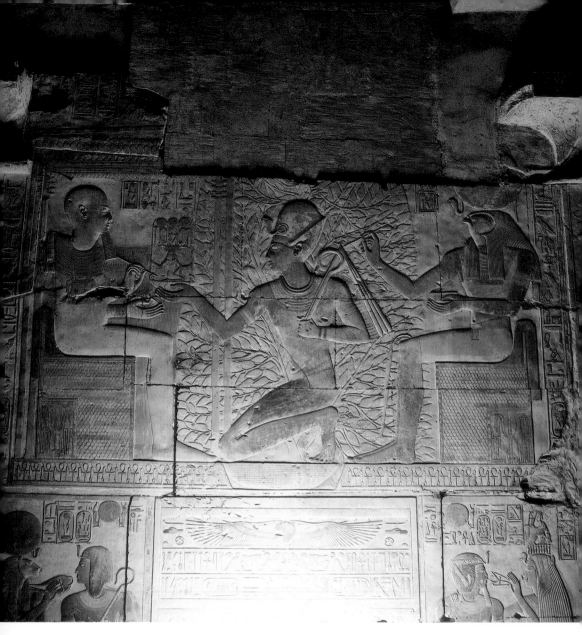

This relief is on the western wall of the second Hypostyle Hall. Here Sety is kneeling beside a sycamore tree. The god Ptah is shown seated on a throne inside his shrine giving the king the *nhh* emblem of millions of years or immortality, in the form of a kneeling man holding a palm branch in each hand. The god Ra Herakhty is seated on his throne behind Sety and is writing the king's name on the leaves of the sycamore tree. The sycamore tree was regarded as sacred; on each of its leaves its bears the name of previous kings of Egypt. It was an honour for every king to write his name on its leaves. The sycamore tree has a long life span that can exceed a 1,000 years.

In the lower left scene the goddess Hathor is handing the emblems of life and prosperity to the king. She is wearing a rarely seen crown, consisting of a falcon with half extended wings sheltering two *uraei*, wearing the crowns of Upper and Lower Egypt. In the bottom left relief Sety is standing in front of the goddess Sekhmet, who is holding her *menat* necklace out to the king. This necklace was considered a sign of protection.

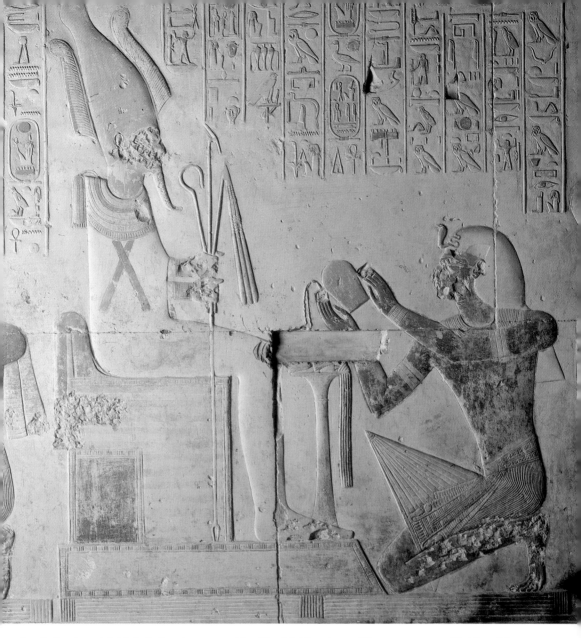

Sety before the god Osiris in the latter's sanctuary. The title of Osiris written as Khentamenty, means 'the First of the Westerners', and has its in roots in the Archaic Period. Khentamenty, a dog-like animal, was the local god of Abydos. Osiris who was mummified, is considered the first human who defeated death. The king is pouring beer into a pot to Osiris, which was a daily ritual in the temple. Beer was considered the favourite drink of the gods.

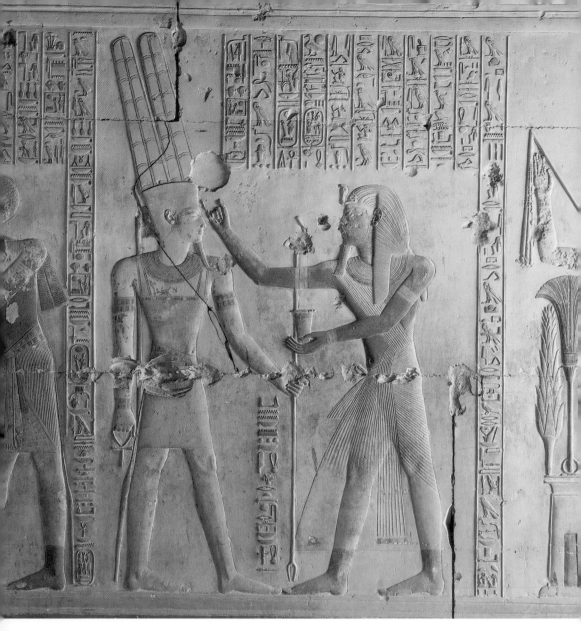

Sety before the god Amun Ra in the latter's sanctuary. Sety is wearing the white linen robe of a ceremonial priest. It is worth noting the excellent quality of this carving. The king's legs and thighs appear through the robe rendering it somewhat transparent. The king is painting the god's eye with *kohl* eyeliner and in his other hand he is holding the *kohl* pot. This was also one of the daily rituals of the temple. The benefit of *kohl* was to protect the eyes from dust and the glare of the sun's rays.

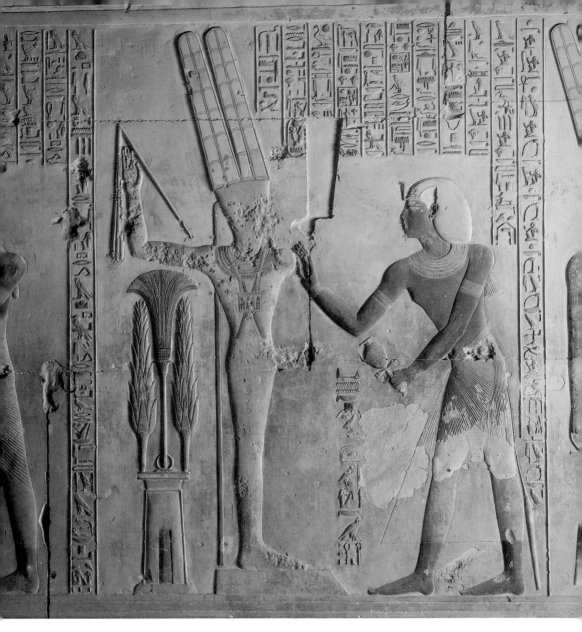

Sety before the god Amun Ra in the latter's sanctuary. Strangely here Amun Ra is represented as the ithyphallic god Min wearing the feathered crown. In the text the god is saying to the king: "I shall give you immortality". In the relief this immortality is conferred by touching the king's shoulders. Behind the god, a lotus flower is placed in the middle of two sections of latticed framework. It is known that the lattice pattern denoted the fertility of Amun-Ra. Sety is holding a vase filled with Nile water, which was used in the purification ritual.

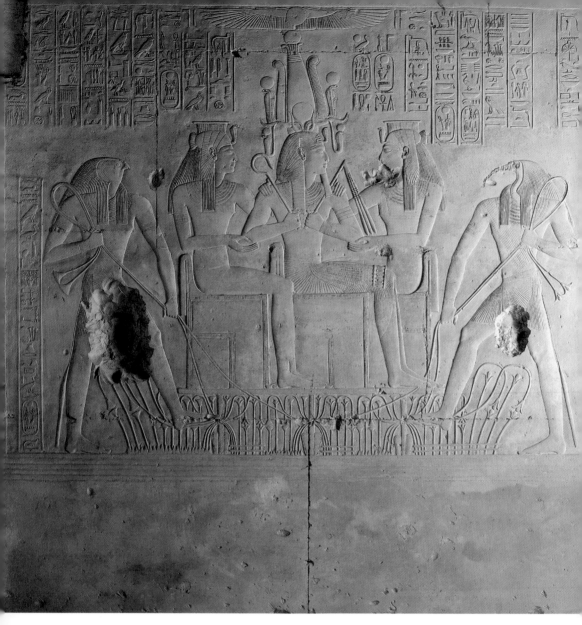

This high relief in the sanctuary of Sety is excellently carved. The king wearing the *atef* crown is seated between the goddesses Nekhbet of Upper Egypt and Wadjet of Lower Egypt. He is holding in his right hand the *ms* insignia symbol of rebirth, and in his left, the *heka* sceptre symbol of authority. These two symbols gave him rebirth and the authority to rule over Egypt even in the afterlife. The gods Thot and Horus are attaching the *sematawy* sign, consisting of the lotus (symbol of Upper Egypt), and papyrus (symbol of Lower Egypt), as a symbol of the unification of the two lands. The papyrus and lotus are intersected by a sign denoting lungs and heart, meaning the king gives breath and life to the country. The combination of the *nemes* and the *atef* crowns may signify the royal aspect of the son of Ra and Isis. The goddess Nekhbet, to the right of the king, is depicted with her legs behind the king while Wadjet is shown with hers in the foreground. The reason for that is that it was a rule in Egyptian art to show the pharaoh in his totality with nothing concealing the body.

142

Top right : The boat of Amun Ra in his sanctuary. Ram-headed figures are standing at the prow and stern. They are emerging from bouquets of lotus flowers. The rams have two sets of horns, one curved and the other horizontal. A solar disk is resting on the horizontal pair. A large bouquet placed at the front of the boat has the *ankh* sign at its centre.

The base carrying the boat has four figures of Sety, all with their hands raised. The first depicts Sety as a priest, while in the other three he is wearing the pleated kilt and the blue crown of war. Sety is represented four times pointing in the four cardinal directions, denoting his rule over the whole world.

This *wserhat* boat was used only during the processions of the *opet* festival. During this festival, the statue of the god Amun was carried from Karnak to Luxor on the *wserhat* boat. The shrine in the middle of the vessel is partly veiled because the Amun statue was placed there. It was the custom never to let the public see this statue.

The celebration of the *opet* festival took place in the second month of the *akht*, the inundation season. It was linked to the prosperity brought by the Nile. The festival lasted between 40 - 49 days.

Bottom right : The sanctuary of the god Ra-Herakhty. The seated god Atum is the evening form of Ra. The former is surmounted by the sun disk thus representing the midday form of Ra. The beetle *khepri* carved inside the disk, represents the early morning form of Ra. The verb *khepri* means self-birth. The ancient Egyptians observed that the scarab beetle emerged from balls of dung; that is why they associated it with the process of creation.

Sety burning incense in front of the god Horus in the sanctuary of
Sety. He is holding in his left hand a jar filled with water, which
he is pouring into a pot in front of Horus. The pot is decorated
with a pair of blue lotus flowers. Horus holds in his right hand the
was sign of prosperity and well-being, and the *ankh* sign of life.

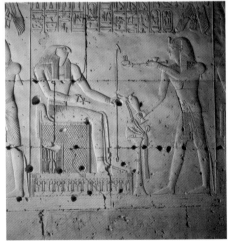

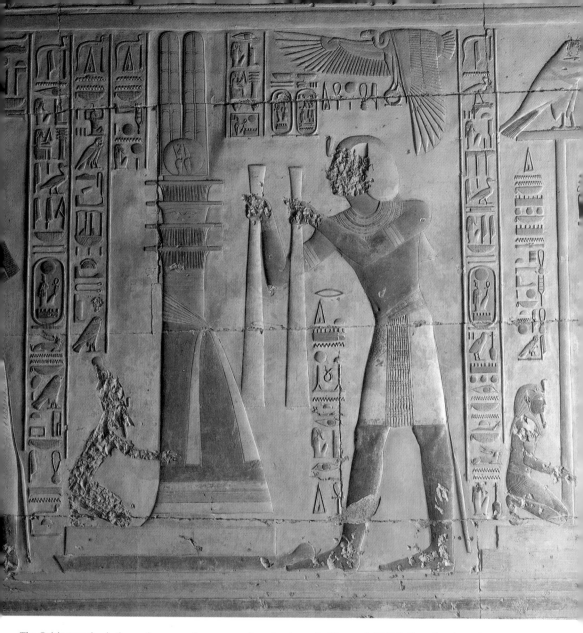

The Osiris complex is the modern name for a group of sanctuaries and a Hypostyle Hall dedicated to the god Osiris. It is only accessible through the sanctuary of Osiris. This complex was systematically defaced by early Christians, who chiselled out the faces, hands and feet. The purpose of removing the faces was to destroy the identity of the persons or gods being represented, and the mutilation of hands and feet was to render the gods incapable of harming those who had committed these crimes. This is the second of two scenes showing the ceremony of erecting the *Djed* pillar. Here the D*jed* is upright, with its lower part covered by a garment bound by a white girdle. Sety is offering two pieces of cloth resembling the bands of mummification to the *Djed* pillar. The hieroglyphic text reads: 'I give cloth to Osiris, may he live a long life'. Here the text perfectly describes the scene.

The *Djed* pillar dates to the Pre-dynastic Period and symbolises stability. It was mainly associated with the gods Ptah and Sokkar, and the Memphite theology. The association with Sokkar was extended to include Osiris, also god of the dead in the Heliopolis Creation Myth. Eventually the *Djed* pillar became a symbol of Osiris. The celebration was held from the last day of the month of *Kihok* for 25 - 30 days, and probably took place in Memphis. Here the king celebrated the erection of the *Djed* pillar and hence the resurrection of Sokkar and Osiris. Another explanation of the *Djed* pillar, from the Book of the Dead, is that it is a spine or backbone, and therefore defines stability.

Sety in front of the god Osiris and the goddess Isis. Osiris is seated on his throne in his usual mummified form. He holds the *heka* crook symbol of kingship, the *was* symbol of prosperity, and the *ms* symbol of resurrection. Sety wearing the *nemes* headdress is offering the god incense, which stimulates the circulation of the blood and hence aids resurrection. With his left hand, he is offering the god a jar of wine. Isis wears the Hathor crown known by its two cow's horns surrounding the sun disk. When Isis wears the Hathor crown she actually becomes Hathor and assumes her role as goddess of the sky. Isis is touching Osiris in a protective manner referring to the Osiris Myth. The hieroglyphic text behind Sety reads: 'Protection and life cover him forever like Ra'.

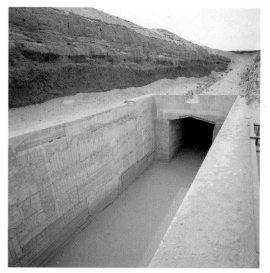

Top : The Kings List from the temple of Sety I: *Egypt, Descriptive, Historical and Picturesque* by Georg Ebers, Leipzig 1879.
Above left: An inscription showing a soldier emptying a box full of hands that have been cut off. This could have been a method for counting the number of fallen enemies in battle. Mutilation of dead enemy soldiers was a commonplace in antiquity.
Above right: The Osiron was discovered in 1909 by one of Flinders Petrie's assistants and cleared of sand in the 1920's. It has continuously puzzled scholars. Because the name of Sety I was inscribed on the ceiling of one of the rooms, it was thought that he was the builder. The Osiron is now attributed to the Old Kingdom due to its simple style. The name of Sety I might be due to restorations that he had done. Sety never made claims that he had built the monument.
The entrance of the Osiron lies to the north of the temple of Sety I. Meren-Ptah, the grandson of Sety I had the western wall inscribed with funerary text from the Book of Gates. On the eastern wall he inscribed the Book of the Netherworld. These both describe the night journey of the sun through the netherworld.

Temple of Ramses II

This lies to the northwest of the temple of Sety and can be reached by foot in a few minutes. It is in a very dilapidated state but should, nevertheless, be visited. The upper walls have all fallen down but the layout is still clear; when complete the temple must have been a grandiose edifice. Some of the reliefs and coloured paintings are still very well preserved.

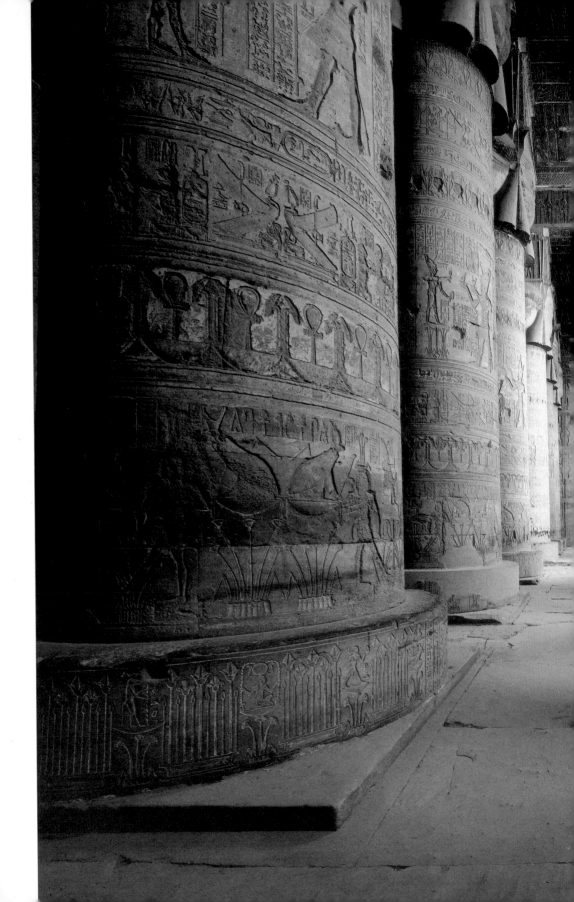

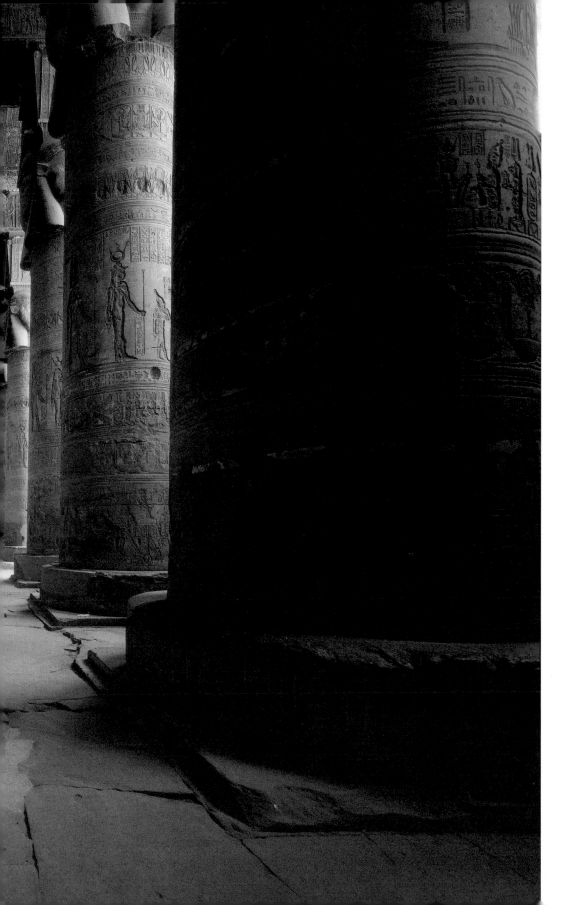

Dendera

The temple of Hathor at Dendera enables us to become acquainted with the planning of an Egyptian temple, and to almost be observers of the worship of this goddess. The first building plan was made under Cheops, builder of the Great Pyramid. The temple continued to be used till the end of the Old Kingdom, and then in the Middle Kingdom till the 12th Dynasty. In the New Kingdom, Tuthmosis III undertook its restoration. Then during the course of the centuries it fell into ruin and it had to be rebuilt by Ptolemy VIII and was completed by Emperor Tibereus, whose name we find in some of the series of hieroglyphs, which cover the subterranean chambers. His successors and the Roman emperors down to Trajan continued to add to its interior decorations and inscriptions. The building may, nevertheless, be regarded as an example of an ancient Egyptian temple. Its ground plan agrees exactly with that which was always adopted at the time of the pharaohs. As regards the interior, no other temple is in a more perfect condition than this. The walls decorated with gold and the inner chambers with glorious colours, the doors of brass, and the door-posts and bolts overlaid with gold, and the sacred vases made of precious metals and stones.

The construction of the temple begun at the sanctuary, the holy of holies, the innermost core and centre of the whole structure (I); then the chambers, and passages and rooms adjacent to the sanctuary were built. In front of the holy of the holies came, first, two small halls (1 and 2) with side chambers, then a spacious hall (II) with a roof supported by six pillars; this opened into three rooms on each side, and, in front of all, the vast hypostyle hall (III) with 24 pillars, was erected last. A straight flight of steps and a winding stairway both led to the roof, on which there were six rooms. A high wall made of mud bricks surrounded the temple. Its purpose was not only to exclude the general populace from setting foot on sacred ground, but even from catching a glimpse of it. It is difficult to believe, but it is confirmed by many inscriptions, that the temples of Egypt were open only to a small number of the elite, and were absolutely impenetrable to the common people. It is also proved that construction and maintenance costs made heavy claims on the resources of the people. Commoners were only permitted to watch the great processions from the temple highway when the god was carried abroad. On certain festivals they were admitted to the forecourt of the temple to offer gifts and prayers. The interior of the sanctuary might be entered only by three levels of priesthood, and even these were forbidden to penetrate beyond the door which led from the great hypostyle hall (III) into the smaller pillared hall (II). This hall was called "the hall of the presence of her majesty". The statue of Hathor was shown only to these elite. It was made of solid gold and precious stones. The

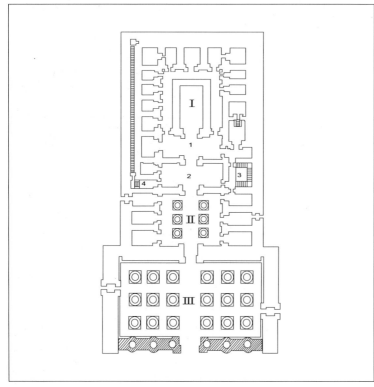

Previous page :
The Hypostyle Hall has 18 columns whose Hathor-headed capitals are represented on each of the four sides. The heads with women's faces and cow's ears carry the façade of the temple. These two forms represent the sistrum, which was a musical instrument related to Hathor, because she was also responsible for musical festivals and the quality of music. This Hypostyle Hall was built by the Emperor Tiberius 14 – 37 AD and was called *wskht-khnt,* meaning the front hall.

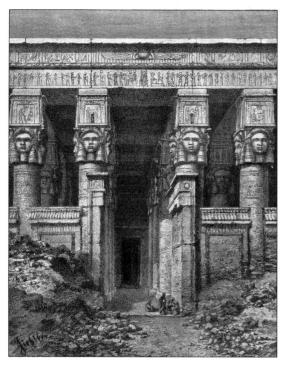

selected few gathered during great festivals at the door leading to the second hall, to catch a glimpse of the goddess.

The temple's ground floor contained 27 rooms, and several corridors, which can be arranged into five groups: 1) "the Great Hall of Heaven" (III), 2) the small pillared hall of the presence of the goddess, and the two halls behind it (II 2 and 1); 3) the holy of holies (I), 4) the 22 chambers surrounding this and its antechamber; 5) the steps leading to the roof (3 and 4). Each of these rooms was dedicated to a special use; bearing some reference to the gods of the temple. Inscribed calendars inform us of all the festivals held there, and other records tell us, which were the princes who finished each chamber of the sanctuary. Even the darkest corridors are covered from top to bottom with pictures and inscriptions in high relief. This shows that the priesthood paid the same honour to the Ptolemies and the Roman emperors as they had formerly to the earlier pharaohs. However, the sculptures in this and the other temples of the same period are not to be compared with those we admired so much in the tombs of the Old Kingdom and in the temple of Abydos, for their simplicity of style.

Top left : The Great Court of Heaven, Dendera: *Egypt, Descriptive, Historical and Picturesque* by Georg Ebers, Leipzig 1879.
Top right : Cleopatra from an Egyptian perspective: *Egypt, Descriptive, Historical and Picturesque* by Georg Ebers, Leipzig 1879.
Above: Cleopatra, from a Greek coin: *Egypt, Descriptive, Historical and Picturesque* by Georg Ebers, Leipzig 1879.

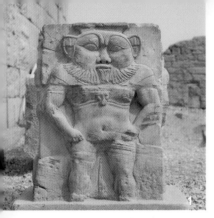

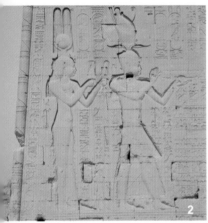

All the walls of the temple are covered with inscriptions. Among these are records of Cleopatra and Cæsarion her son by Cæsar. The reader sees here the portrait of this famous woman as rendered by an Egyptian sculptor; and may compare it with that shown on a Greek silver coin.

On the external walls of temples from the Ptolemaic period, as in those of the temple at Dendera, we see lions with their foreparts projecting from the wall, possibly intended to carry away excess rainwater. They were most certainly first invented in Lower Egypt where heavy storms were more frequent, and then introduced into the almost rainless provinces of the south to which Dendera belongs. They also refer to the zodiacal sign of the lion as the bringer of the inundation.

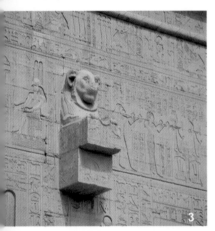

1. The god Bes is represented in the form of a dwarf. He was the god of joy and dance because dwarfs were brought from Africa to perform dances for the gods and kings. A quotation from ancient Egyptian literature says: 'Dances of dwarfs rejoice hearts of gods'. Bes was also a protector god for pregnant mothers at the time of delivery; therefore he is often shown in birthing houses. Also due to his strange shape he was much represented in magic texts. Probably this god originated from Punt.

2. Relief of Cleopatra VII. her son Cæsarion and Ptolemy XIV before the goddess Hathor (not shown). This is the only known relief of Cleopatra and Cæsarion in an Egyptian temple. Ptolemy is wearing the *pschent* crown, which consists of the *hdjt* White Crown and the *dshrt* Red Crown. His head is also surmounted by a horned crown. Cleopatra holding a sistrum in the shape of Hathor and Amun, is offering incense. The purpose of this relief on the outer wall of the temple was political propaganda for Cleopatra's son to become the future king. It was a tradition in Greco-Roman temples to depict the king and queen as the same size, while in ancient Egyptian temples the queen was usually not shown on the outer walls of the temples, and if she was shown she was usually much smaller in size.

3. Tefnut, goddess of humidity, the daughter of Geb and Nut, is a member of the Great Ennead of Heliopolis. She is usually represented as woman with a lion's head. Here her role is to protect the temple from heavy rainfall. Big storms were regarded as one of the forms of Seth, god of evil. Tefnut is shaped like a drain spout to collect excess rain water from the ceiling. The combination of lions' heads in water fountains has continued in Europe up to the modern day.

4. The remains of the sacred lake surrounded by a fence. A stairway leads down to the water at each of the four corners of the lake. Here in this picture we see two of them. The waters came from groundwater beneath the lake. The purpose of the sacred lake was to enable the priests to purify themselves before entering the temple. The priests' residence lay behind the sacred lake. Its remains can still be seen today. The waters of the sacred lake symbolized Nun the primeval ocean. In the far background we can see a small niche where the Hathor statue was kept. Festivals took place around the lake, and one of these festivals was the sacred marriage between Horus, god of Edfu and Hathor, goddess of Dendera.

5. The Roman birth house.

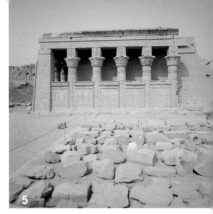

6. A relief outside the Roman birth house represents the Emperor Trajan (98 - 117 AD) offering a mirror to the goddess Hathor and Horus-Behdety, who was the god of Edfu temple. This ritual meant 'giving life', because a mirror reflects light. This also symbolized offering the sun and the moon, because the mirror disk had the shape of the sun and was placed on a base with a crescent shape. Hathor herself was connected to the sun cult as one of her titles is *npt-nbt,* mistress of the sky, from whence the sun shines. Her head is surmounted by the sun disk placed in the middle of two horns. The first appearance of this ritual was in the Late Period.

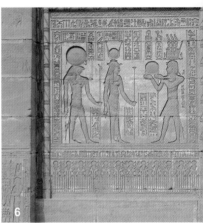

7. This register is also on the outer wall of the Roman birth house. The Emperor Trajan is making an offering to Hathor, who is suckling her son Hr-Ihy. Trajan wears the *dshret* Red Crown of Lower Egypt, and is offering her some cloth. Behind Hathor stands (another image of) her son Hr-Ihy, which means the musician; he is represented with a side lick and a finger in his mouth to indicate childhood. This child god played a big role in the concept of the divine birth, because he connected the idea of divinity to the king's birth, which was also a divine event.

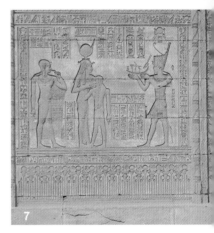

8. The remains of a Coptic church from the fifth century built of mud bricks. It lies next to the Roman birth house. A vulture is carved at the center of the shrine, the niche has floral motifs with the cross in the middle. Next to the cross are the Greek letters alfa and omega symbol of creation and resurrection.

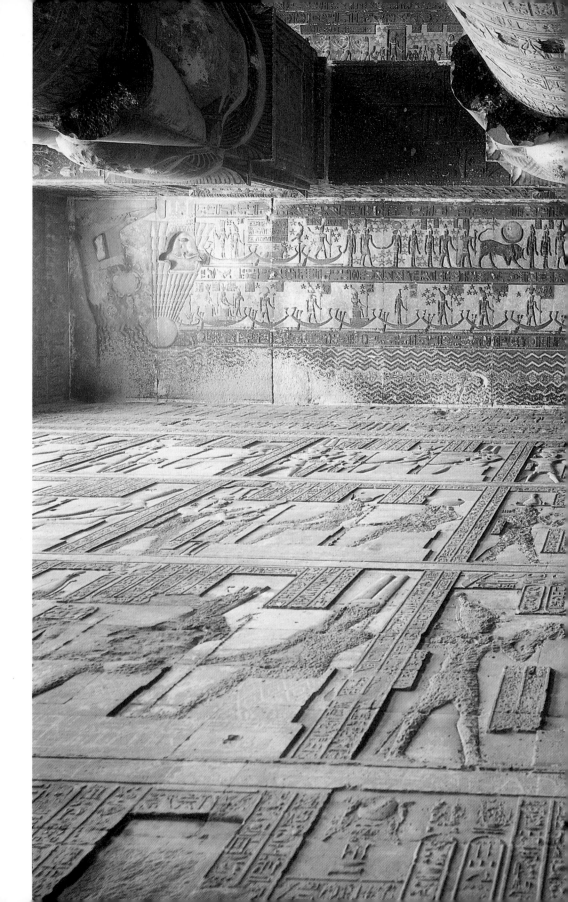

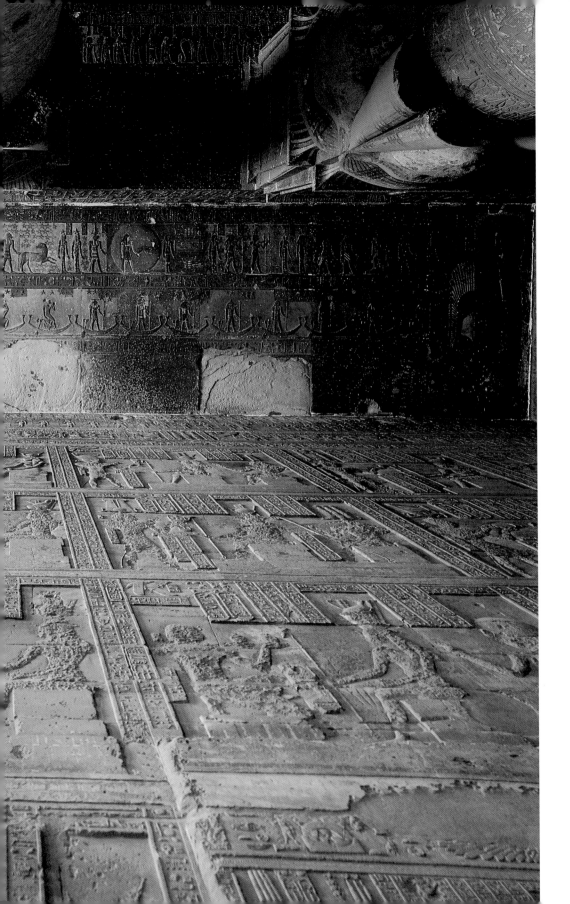

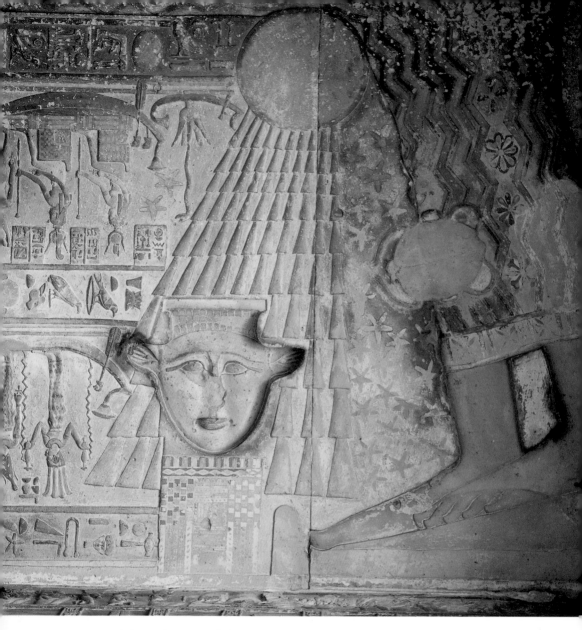

Previous page and above : The astronomical ceiling describes the daily birth of the sun. Nut the sky goddess is stretching her body across the ceiling to imitate the vault of the sky. Her blue body is filled with stars painted in yellow to denote the night sky. Wavy lines on her body represent the water where the solar boat would sail. At dusk she swallows the sun disk which travels through her body to be born at the dawn of the next day, as shown here. The rays of the newborn sun illuminate the head of Hathor represented as a woman's face with cow's ears, and there is also a small model of the temple, carved below her head. One of Hathor's titles is *nbt-npt*, mistress of the sky. On an upside-down boat next to her head, is the star of Sothis shown both as a man and a woman. The first appearance of Sothis marked the beginning of the inundation season *akhet*. The rise of Sothis had been known since the Archaic Period, and was first mentioned on an ivory tablet of King Djer in the 1st Dynasty. The seated man in the other boat represents Orion, the constellation of the great bear. The neighbouring Orion was considered to be the husband of Sothis.

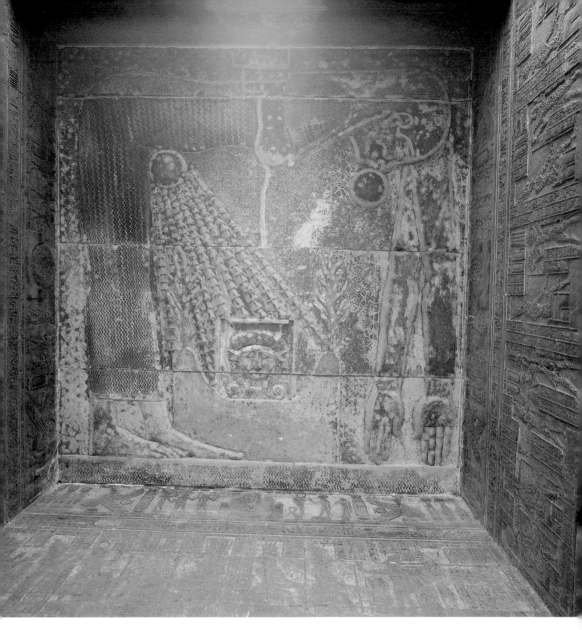

A relief from the ceiling of the *wabet* room, which means the pure chapel. This is on the upper floor. It shows the goddess Hathor giving birth to the sun. The number of rays emanating from the sun is nine as in hieroglyphics nine means *psjet*, which also has the meaning 'to rise'. The sun's rays fall onto two mountains each topped by a sycamore tree. In the middle between the two mountains, Hathor's framed face appears. The sycamore tree was related to the goddess because one of her titles was *nbt-nht*, mistress of the sycamore.

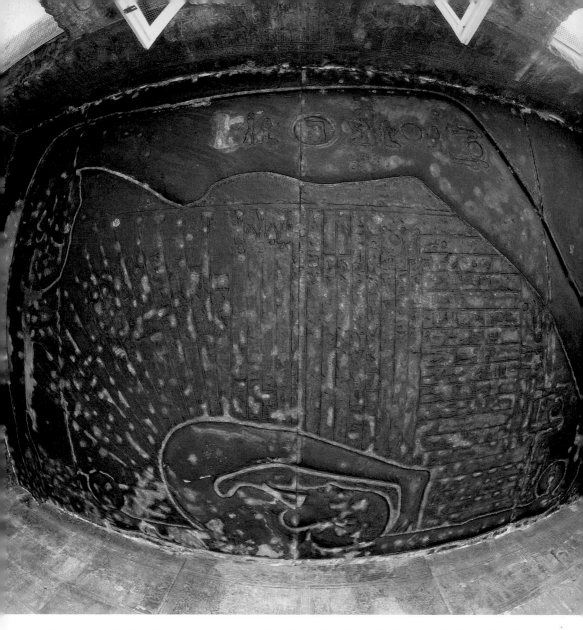

An astronomical ceiling from a room on the upper floor. It probably refers to the theology of the Great Ennead of Heliopolis. The upper figure is of Nut, goddess of the sky and the lower is Geb, the earth god. Their separation marked the beginning of the creation of the world.

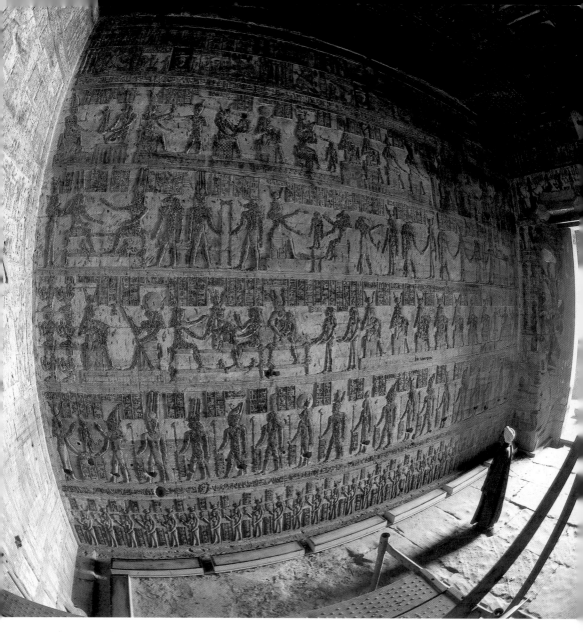

A fisheye picture inside the Roman birth house. These reliefs relate to the divine birth of the king.

Thebes

The Eastern Bank of the Nile

Luxor stands on the site of ancient "hundred gated" Thebes. The queen of winter health resorts is how Egyptians describe it; all praise its mild climate, shimmering light and perpetual sunshine. It may confidently be stated that a journey to the Nile Valley which does not include a trip to ancient Thebes (Luxor) is only half a journey.

Here stood the imperial city of Amun, later called Thebes, which for more than 1000 years ruled over the Egyptian empire. It first appeared in Egyptian history at the beginning of the 11th Dynasty *c.* 2100 BC when, after a century of anarchy, a family of provincial *nomarchs* gained power and established themselves at the site of the future capital. Besides its political and religious eminence, Thebes was also an important market. It controlled the routes to the gold mines in the Nubian mountains, and collected imports from Sudan, such as gum, ostrich feathers and gold dust.

However, the time of the city's greatest glory did not come until the 18th Dynasty, about 500 years later, and it is chiefly the remains of this and later periods that the visitor to Thebes sees to-day. In the 18th Dynasty, when the great warrior kings who ruled from Thebes vied with one another in foreign conquests, rich tributes flowed into the city, enabling her monarchs to build those gigantic temples and monuments of which Champollion wrote:

... No people, ancient or modern, has conceived the art of architecture on a scale so sublime, so great, so grandiose as the ancient Egyptians. They conceived like men a hundred feet tall, and the imagination which, in Europe, soars high above our portals, stops short and falls powerless at the foot of the one hundred and forty columns of the hypostyle hall of Karnak.

Champollion was one of a long succession of scholars, travellers, learned and ignorant, simple plunderers or scientific excavators who visited Thebes. Even in Roman times it had become a 'showplace', but in the last three centuries it has attracted more attention than any other site in Egypt. Here some of the most romantic discoveries have been made, the finding of the 36 royal mummies at Deir el-Bahari in 1881, and the opening of the kings' tombs in the Valley of the Kings, and the discovery of the intact tomb of Tutankhamun. In fact so intimately is the site linked with great discoveries that the little town of Luxor has acquired great fascination. There is not only the appeal of the place itself, but its remote antiquity, the splendour of its temples on the east bank, and the mystery of that vast city of the dead on the western hills.

It is important to remember that in ancient times there were two cities of Thebes. On the east bank of the Nile was the city of the living with the royal palaces, noblemen's houses and the temples of Amun and the lesser deities. On the west bank was the city of the dead, for here, as at Memphis, the dead were believed to inhabit the west. On the east side the town is still dominated by the great complex which takes its name from the modern village of Karnak. Here in ancient times dwelt Amun-Ra, king of all the gods. Amun, who from the Middle Kingdom onwards became the state god of Egypt, was originally an unimportant local god. But when a Theban family rose to rule Egypt, the Theban gods rose with them and soon he was identified with the other great solar deity, Ra of Heliopolis, his name being changed to Amun-Ra. He also had affinity with Min, the ithyphallic god of fertility, whose home was at Coptos, a town to the north of Thebes. The modern English word semen is derived from Min. Amun's wife was the goddess Mut and their son was the god Khonsu, both of whom had their temples adjoining his at Karnak. More usually Amun is represented as a man wearing the royal *uraeus* or cobra on his forehead and crowned with two plumes. Sometimes however, he is shown with the head of a ram, and a goose also seems to have been closely associated with him. Amun-Ra was the supreme god having the title 'King of the Gods'. He took over the attributes of Ra, the sun god, with his solar barque in which he crossed the heavens by day and the underworld by night. During the latter journey he united with Osiris, lord of the dead. His priesthood attained tremendous political power, rivalling that of the king himself, since the pharaoh's right to the throne depended on his being accepted as the son of Amun. The queen was 'the divine consort'. The importance of Karnak as the home of the king of the gods explains why generations of pharaohs contributed to building and enlarging its temples.

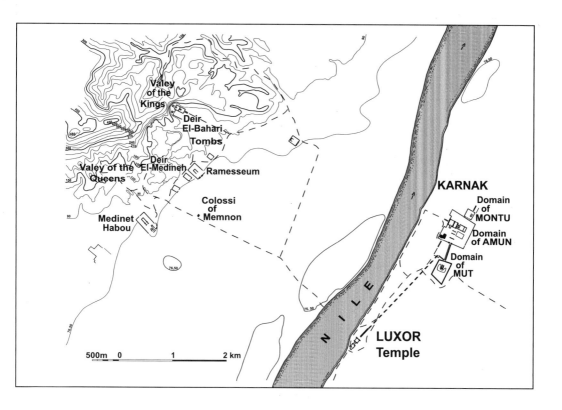

The Temple of Luxor

The temple of Luxor lying close to the edge of the Nile was first excavated by Gaston Maspero in 1884; Daressy and Legrain continued with this work later. In the northern part stands the mosque of Abu el-Haggag (A), under which part of the temple ruins are thought to lie hidden.

Luxor Temple belonged to the temple area of Karnak and was originally a chapel for the celebration of the new year feast. Amenhotep III had this temple erected on the remains of an old sanctuary dedicated to the god Amun, his wife Mut and their son, the moon god Khonsu. It was originally 208 metres long and 54 wide. Amenhotep IV (Akhenaten) not only transferred the capital to Tell el-Amarna, but also defaced the effigies and names of the old gods in the temple of Luxor. It was only under Tutankhamun, his successor that the temple was restored and its area enlarged. Ramses II also extended the building, adding pylons and embellished the edifice with mural reliefs. The final temple compound was 260 metres in length.

Before going into the temple it is worthwhile to view from the roadway outside, the pylon (B) at the north end built by Ramses II. Of the original six statues of the king only three remain, two seated, 23 metres high, and one standing. The walls of the pylon were decorated with reliefs, now much damaged, showing battle scenes from the wars of Ramses II against the Hittites. The inscriptions under the reliefs describe the combat in poetical terms. The central portal is badly damaged. Only one of the two pink-coloured granite obelisks is still standing; the other was taken to Paris at the time of Napoleon and erected in the 'Place de la Concorde' in 1833. North of the pylons are some ram-headed sphinxes of the old Sphinxes' Avenue leading from Karnak; these were unearthed about 100 years ago.

The pylon court of Ramses II (1) is 56 metres long and 50 wide. It has been only partially cleared on the west and south, since the white mosque of Abu el-Haggag was built into the court itself. Originally it was surrounded by papyrus columns, 74 in all, with closed capitals.

In the northwest corner (C) is the chapel built by Tuthmosis III and restored by Ramses II. On the walls of the great court (1) are reliefs and inscriptions: sacrificial scenes and words of praise addressed to the gods, mostly from the time of Ramses II. On the south side are statues of Ramses II, over 6 metres high, one carved in black granite, the others in red granite. To the south lies a colonnaded passage (2) leading to the great pillared court (3) of Amenhotep III. Its seven pairs of papyrus columns are 11 metres high with open capitals and heavy

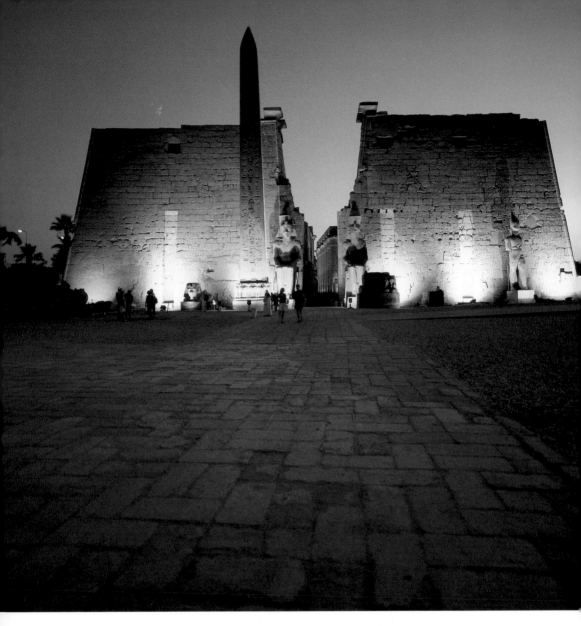

Above : The pylon of Ramses II, in antiquity it supported four huge flag masts. A pair of pink-coloured granite obelisks stood in front of the pylon. Now only one of these obelisks is still standing; the other was taken to Paris at the time of Napoleon and erected in the 'Place de la Concorde' in 1833. Six colossal statues of Ramses II also in front of the obelisk.

Facing page : Statue of Ramses II.

architraves, which originally supported the superstructure; they are still well preserved. The wall designs describe the feast of the new year when the sacred barques of the divinities of Karnak were brought up the river to Luxor Temple for the ceremonies, and returned to Karnak in the evening.

From the pillared hall of Amenhotep III the way leads south into the vestibule of the temple proper (4), consisting of 32 papyrus bundle-style columns, four pillars in four rows on each side. In the rear wall (south) is a door originally giving access to a small hall, which was later converted into a Christian church (5).

From the vestibule, via the eastern side, one goes out to the so-called birth chamber (6), decorated on the west wall with scenes in relief of the birth of Amenhotep III, and on the south wall with scenes connected with the king's accession to the throne.

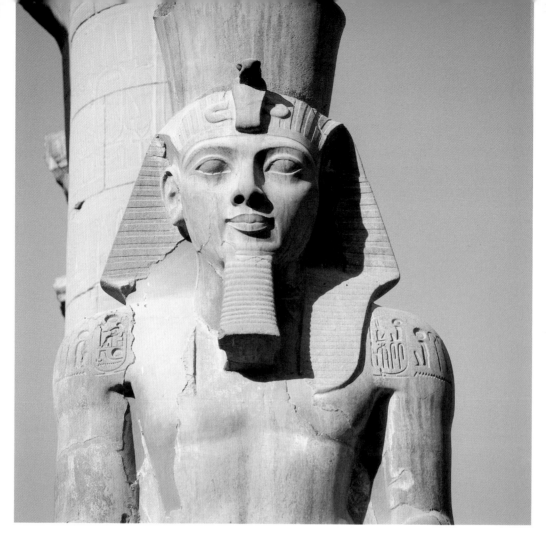

Further south is the sanctuary of Alexander the Great (7), which is entered from the east side: a chapel with representations of Alexander before the god Amun. The further temple chambers afford nothing of interest, but behind them one can see the innermost sanctuary. Originally an avenue of human-headed sphinxes led from the temple of Luxor northwards to the temple area of Karnak; part of this avenue is still standing at Karnak.

The temple of Luxor had two main elements. The main one was the celebration of the *Opet* festival. The 2.5 kilometre long sphinxes' alley connecting Luxor and Karnak supports the argument that the two temples held joint celebrations. This festival was held yearly after the second month of the inundation and lasted for 27 days. It was an extravagant and pompous occasion in which the god's barque sailed from Karnak to Luxor and back again. Among those in the procession were dancers, musicians and people from various walks of life. During the reign of Hatshepsut, the festival involved walking to Luxor and sailing back to Karnak. The Luxor temple symbolised the creation of the world, and is supposed to have been built on the primeval hill. Lord Amun-Ra made the return to Luxor to celebrate this day marking the creation of the world. This denoted a sort of cyclic renewal of the earth. The divine barque of Amun-Ra was moored in the southwest corner of the hypostyle hall, while those of Khonsu and Mut were in the south corner.

The second feature of Luxor Temple was related to the divine nature of royalty. Luxor was the place where the king was united with his divine *ka*. Before his crowning, the king was equated with mortal men, but with the coronation he became divine in nature. The festival at Luxor was the annual renewal of the divinity of royalty. For this occasion the *ka* statue was brought to Luxor, and in special rituals the king and his *ka* statue became divine. When the ceremonies were over, they emerged from the temple together and were greeted by the crowds waiting outside. This delicate balance between the king's divine and human nature was maintained throughout the 3000 years that the pharaohs ruled Egypt down to Alexander the Great.

The colonnade of Amenhotep III, consisting of 14 columns with open papyrus capitals. The height of each column is 21 m.

An exciting discovery of 21 statues occurred in 1988 in the hall of Amenhotep III. Some of the statues still in a perfect condition are now displayed in Luxor Museum.

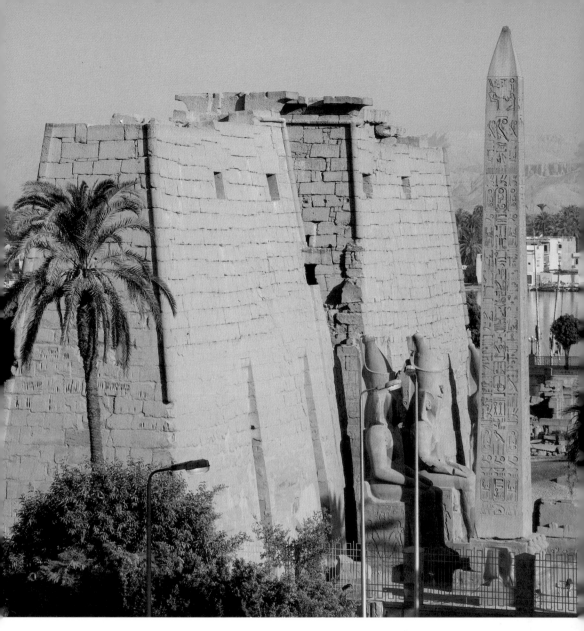

First pylon of Ramses II, Luxor Temple.
The war at Kadesh is depicted on the outer
walls of thee pylon. The obelisk standing
belongs to Ramses II. It marked the
celebration of the *heb-sed*.

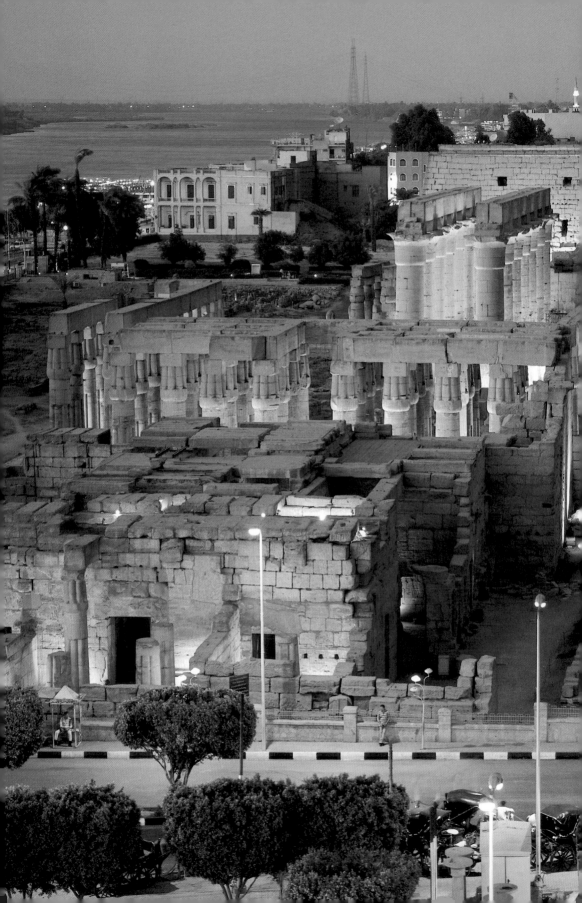

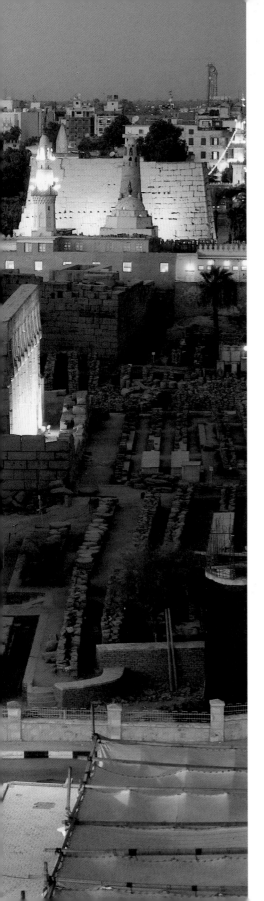

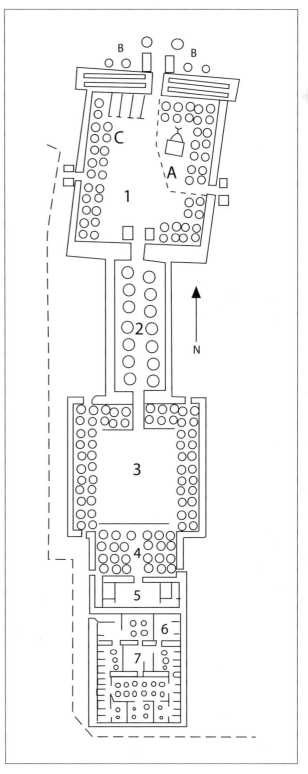

The Luxor Temple.
From the entrance the ground level slopes upward till
reaching the highest level at the holy of the holiest, shown
here in the foreground.

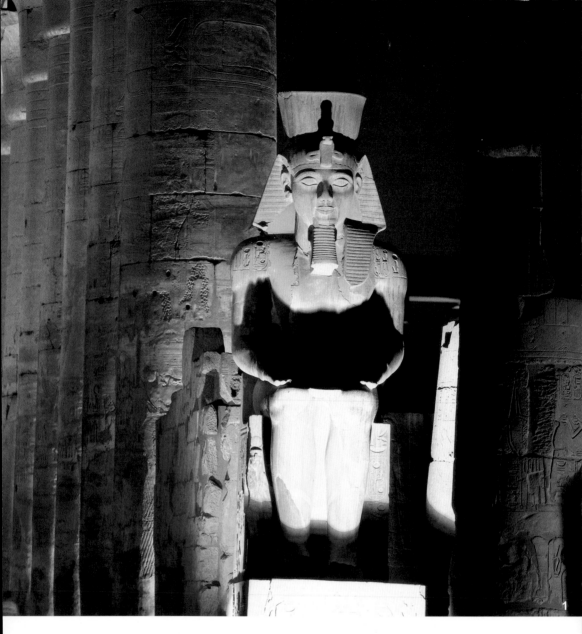

1. Colossal statue of Ramses II next to the entrance of the colonnade. His titles are written on the shoulders. The coronation name "Ra-mss" is written on his left shoulder. It means "the born of Ra". The *niswt-bity* title *stp maat n-Ra* "let the justice of Ra's spirit be sustained" is written on his right shoulder. It is a characteristic in the art of the Rameside period to represent faces with a little smile.

2. Abu el-Haggag mosque in the foreground, with the colonnade built by Tuthmosis III. A recent study related similarities between the Opet festival of Amun-Ra and the annual feast of the birthday of Abu el-Haggag...

3. The colonnade and the rear view of the pylon of Ramses II.

4. The Abu el-Haggag mosque built on an elevated level of the Ramesside court.

5. The colonnade built by Tutankhamun.

6. Colossal statues of Ramses II at the entrance to his pylon.

7. The third antechamber or shrine of Alexander the Great.

8. Abu el-Haggag mosque: *Egypt, Descriptive, Historical and Picturesque* by Georg Ebers, Leipzig 1879.

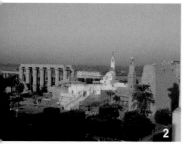

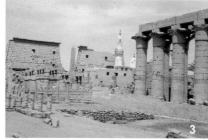

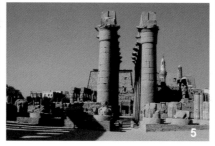

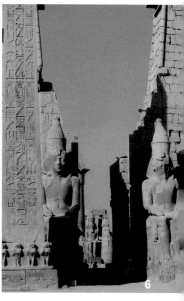

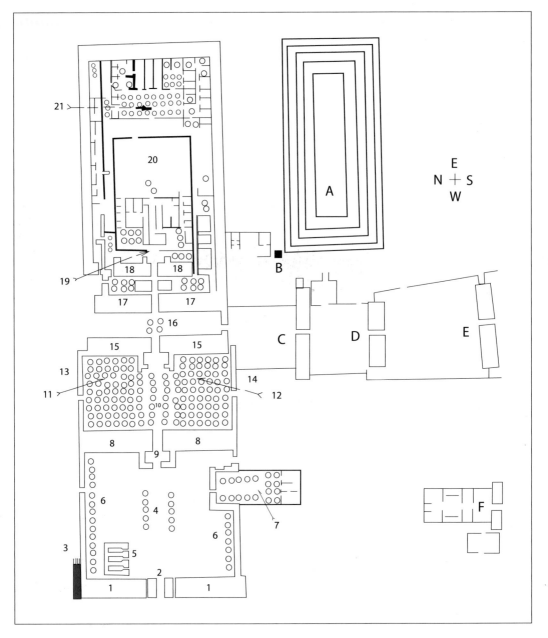

Temple of Karnak

1. First Pylon
2. Entrance
3. Stairway
4. The great court
5. Temple of Sety II
6. Colonnades
7. Temple of Ramses III
8. Pylon of Ramses II
9. Forecourt of Ramses's II Pylon
10. The Great Hypostyle Hall
11. Northern section of the Great Hypostyle Hall built by Sety I

12. Southern section of the Great Hypostyle Hall built by Ramses II
13. Relief of Sety I battles
14. Relief of Ramses II battles.
15. Pylon of Amenhotep III
16. Obelisk of Tuthmosis I
17. Pylon gateway of Tuthmosis I
18. Two antechambers of Tuthmosis III
19. Pylon gateway of Tuthmosis III
20. Middle Kingdom Temple
21. Temple of Tuthmosis III

Karnak, the Great Temple of Amun

Anyone who has ever stood before the great tombs of the pharaohs at Giza will carry away from his visit memories of the gigantic dimensions of the sky-pointing pyramids; the sight of the temple of Karnak will, in its turn, engrave upon his mind an image of vastness and monumental massiveness, unequalled in all the ancient monuments of Egypt. Karnak is a city of temples, the largest of which is the temple of Amun, considered an object of wonder even in the ancient world.

An avenue of ram-headed sphinxes erected by Ramses II leads to the main gateway. The pylon (1) forming the chief entrance (2) is from the Ptolemaic period; though never completed it is the most grandiose of the temple gates of Karnak, 129 metres wide, nearly 43 high and 15 long. On the north side of the pylon a stairway (3) leads from the outside to the upper platform, whence a good general view of the temple's layout can be seen; to the west is a splendid prospect over the Nile Valley. The great court (4) behind the pylon is, with a width of 100 metres and a length of 83, the biggest of all the temple courts in Egypt. It dates from the 22nd Dynasty (945 – 715 BC). To the left of the entrance is the temple of Sety II (5). Of the three chapels only that dedicated to the god Khonsu (right) is still more or less complete. Here we see Sety II before the barque of Khonsu.

To the right and left sides of the court are colonnades (6) of which the right-hand one, that on the south side, is broken by a temple of Amun built by Ramses III (7), 52 metres long. It is a perfect example of a classically designed and perfectly executed sanctuary, carried out to the original plan without the modifications so often made during the construction of ancient monuments from pharaonic times. At the entrance, which has its own pylon, are two effigies of Ramses III. In the court stand eight columns on each side, together with gigantic statues of the king. The walls of the court show reliefs of the god Amun, and on the inner face of the pylon are pictures of Amun presenting Ramses III with the symbols at his jubilee.

From the court we reach the vestibule and then the pillared hall containing eight columns, followed by three chapels: in the middle that of Amun; on the left that of his wife Mut, and on the right that of their son Khonsu. In each chapel, Ramses III is represented at a sacrificial ceremony before the barque of the deity.

From the temple of Ramses III one comes to the pylon (8) erected by Ramses II. Before the entrance there is a forecourt (9), 16 by 16 metres, flanked by two huge statues of Ramses II in rose-coloured granite; the right-hand one is well-preserved while of the other only the lower limbs remain. Through the gateway of the pylon, 29 metres high, which was restored during the Ptolemaic period, one reaches the great hypostyle hall (10). Here there are 134 sandstone columns arranged in 16 rows covering an area of about 6000 square metres. The central avenue is extraordinarily impressive since its 12 papyrus columns with open capitals are higher than the rest, being 21 metres tall. The other pillars are papyrus bundle-style columns with closed capitals standing about 16 metres high, the centre of the whole structure thus being higher than the rest. The columns in the avenue have a length of about 16 metres and are about 3 in diameter, while the capitals alone measure over 3 metres. The shafts of the columns and the walls of the hall are ornamented with reliefs of kings, sacrificial offerings, royal cartouches and inscriptions: in the northern part, is Sety I (11) and in the southern portion Ramses II (12). The names of Ramses I, III, IV, VI and VII also appear. The outer walls of the hypostyle hall can be reached through lateral doors leading outside; on these walls are depicted historical war scenes: on the northern face (13) the victories of Sety I over the Libyans; on the southern (14) the victories of Ramses II over the Hittites.

The east side of the hypostyle hall ended in another pylon (15), built by Amenhotep III but now in ruins. In the court between the two pylons (16) were formerly four obelisks, two of Tuthmosis I and two of Tuthmosis III. Only the 23 metre high obelisk of Tuthmosis I is still standing; with its fellow it once formed the entrance to the temple proper. The pylon gateway (17), erected in the time of Tuthmosis I, is badly damaged; it leads to a columned hall in which on the left, a 29 metre-tall obelisk of Queen Hatshepsut carved from red Aswan granite, still stands. The queen had this obelisk erected in the 16th year of her reign; it is not only the most prominent object in the area but also the tallest obelisk left standing on Egyptian soil. Its inscriptions bear witness to the greatness and might of the queen. In the niches of the hall are statues of Osiris.

A pylon gateway (18), also built in the reign of Tuthmosis I, leads to two small antechambers constructed by Tuthmosis III. The court of Tuthmosis I with statues of Osiris and 16-sided columns, extends on both sides. From here we come to the last and smallest pylon gateway (19) erected by Tuthmosis III and now in a very bad condition. On its remaining walls can be distinguished pictures of the towns and peoples, which were subjugated by Tuthmosis III. Behind this pylon lies the first Hall of Annals, with two granite pillars each showing the symbols of Egypt, to the left the papyrus of Lower Egypt and to the right the lily of Upper Egypt. Besides these there are huge statues of Amun and the goddess Amunet, from the time of Tutankhamun.

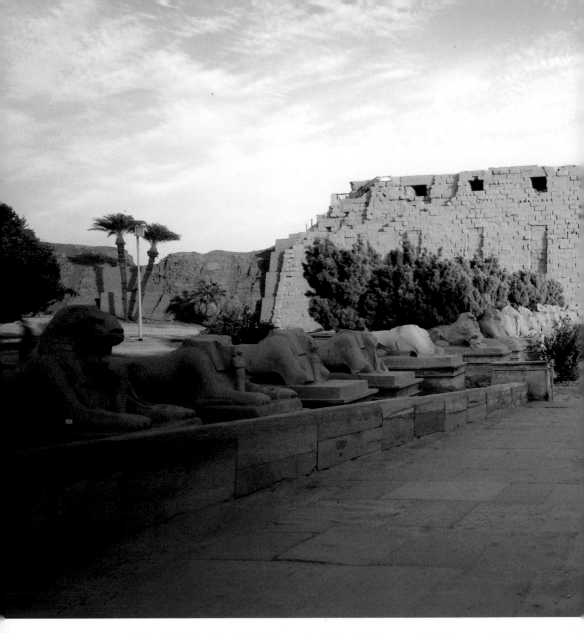

Above : A panoramic view of the First Pylon built by Nectanebo I of the 30th Dynasty with the Avenue of the Sphinxes in the foreground. Each of the sphinxes has a ram's head on a lion's body. The ram as a symbol of fertility was the sacred animal of the god Amun. A small figure of the pharaoh Ramses II is placed between the paws of the lion to protect him and for him to be reborn in the afterlife from the flesh of this powerful animal. The number of complete sphinxes remaining is 33 in the southern row and 19 in the northern. The First Pylon consists of two towers; each has two sloping sides on which were affixed flags and royal signs during religious ceremonies. The Pylon symbolises *akht,* the horizon. The horizon was demonstrated as the sun disk between two mountains. Here the two mountains are represented by the two towers of the Pylon, and the sun disk by the god's statue inside the shrine.

Right : The remains of the Avenue of the Sphinxes also show the ram-headed statues with King Ramses II. This road extended as far as the Second Pylon; some Egyptologists believe that it probably went as far as the Third Pylon built by Amenhotep III. The purpose of the three- kilometre long avenue was to connect Luxor and Karnak, and it was used essentially during the *opet* festival.

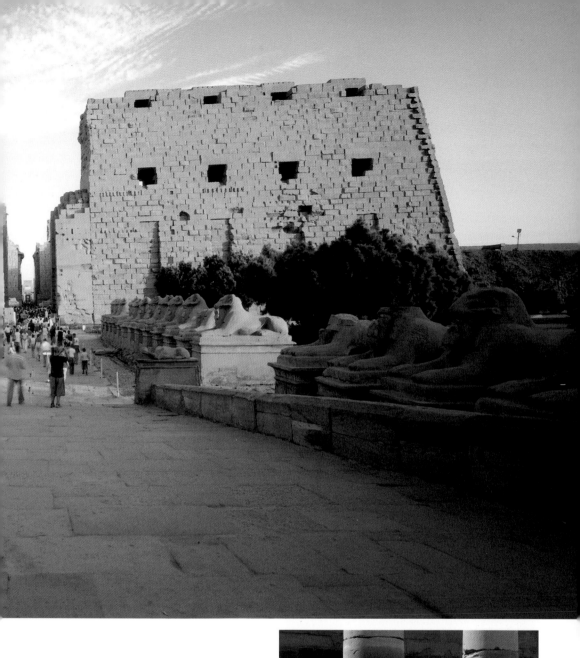
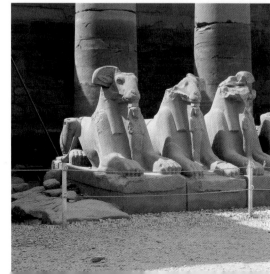

The court of Tuthmosis III stretches right and left, and straight ahead stands the two-roomed granite chapel in which was kept the sacred barque. On the walls are coloured reliefs of sacrifices to Amun, priests carrying the sacred barque in procession, and other themes connected with religious ceremonies. On either side of the granite chapel are the rooms of Queen Hatshepsut, in which the names of the queen have been effaced and replaced by those of Tuthmosis II and III. To the east is the oldest temple from the Middle Kingdom (20) of which only a few traces remain. Still farther east is the great temple of Tuthmosis III reached through the portal on the right. The big state hall (21) is 44 metres wide and 16 long, with 20 great columns and 32 rows of pillars. The middle portion is higher than the sides and the columns differ in form from other ancient Egyptian columns. They bear a resemblance to tent poles, as if the state hall was originally intended to represent a sort of ceremonial tent.

In the chamber on the southwest of the state hall the "Karnak List of Kings" was found, one of the five documentary tablets, which have handed down to us the names of the kings of ancient Egypt. This contains the names of 62 sovereigns and is now in Paris. On the left of the hall (north side) are three chapels, and to the east three rooms almost in ruins. Outside the enclosure wall built by Ramses II, on the east side there is a funerary temple of Tuthmosis III.

The Sanctuary of Ptah

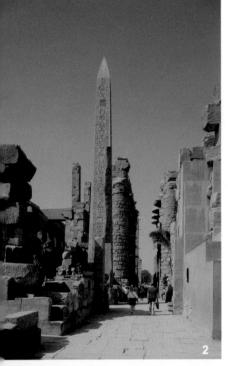

To the north of the great temple of Amun lie further buildings, such as the Northern Temple area, surrounded by a brick wall with the temple of the war god Montu, built by Amenhotep II, and the Ptolemy temple to the west of it. The sanctuary of Ptah is more important; it was erected by Tuthmosis III for the tutelary god of Memphis and later added to by the Ethiopian ruler Shabako and some of the Ptolemaic kings. The sanctuary of Ptah is reached by a road branching off at the north exit of the great hypostyle hall of the temple of Amun.

From the Temple of Amun to the Temple of the Goddess Mut

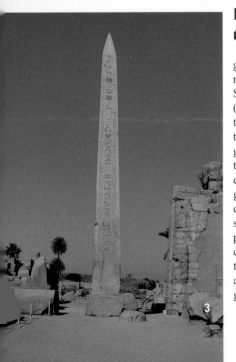

Between the temple of Amun and the Southern Temple area of the goddess Mut, are several sanctuaries and other buildings largely in ruins. To the south of the enclosure wall of the temple of Amun lies the Sacred Lake (A), and near the northwest corner is a huge granite scarab (B) dedicated to the sun god by Amenhotep III. West of the scarab is the pylon gateway (C) erected by Tuthmosis III; it can be reached from the middle court of the Amun temple. On the north side are enormous granite statues of kings from the Middle and New Kingdoms. Towards the south stands another pylon (D), the oldest gateway still remaining, erected by Queen Hatshepsut. Its north face bears reliefs with scenes of gods and sacrifices, while on the south face Amenhotep II is shown campaigning against his enemies. Of the seated statues of kings on the south side of the pylon, that of Amenhotep I is well preserved. The next pylon (E) was built by Horemheb. On the eastern wall of the following court are reliefs of Horemheb. The wall is broken by the protrusion of a temple of Amenhotep II. From the exit pylon of Horemheb, the eastern avenue of sphinxes is reached, leading directly to the temple of the goddess Mut.

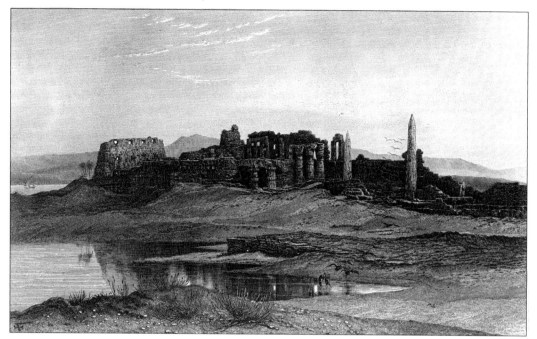

1 & 4. Avenue of ram-headed sphinxes leading to the first pylon at Karnak. The ram-headed sphinx is a representation of the god Amun.
2. The obelisk of Hatshepsut is in a perfect state. This obelisk was not ruined by Tuthmosis III because it has a religious significance. What he did is that he enveloped it with a high tower.
3. The obelisk of Tuthmosis I was built to commemorate his *heb-sed*.
5. Drawing of Karnak: *Egypt, Descriptive, Historical and Picturesque* by Georg Ebers, Leipzig 1879.

Temple of Khonsu

This temple can be reached by turning west after the last pylon gateway. The sanctuary (F) was dedicated to the Theban moon god, Khonsu, the son of Amun and his wife Mut, who was venerated particularly as an oracle god. The building of the temple was begun under Ramses III and continued by Ramses IV and XI. Through a gateway one reaches the avenue of sphinxes built by Ramses XI leading to the pylon gateway, nearly 20 metres high, 32 wide and 11 metres long. The four depressions in the wall were for flag staffs; the reliefs show sacrificial scenes. In the court, to right and left, is a double row of papyrus columns with closed capitals. From the court one comes north to the vestibule with 12 columns and then to the pillared hall. In the middle of this hall are four papyrus columns with open capitals, and on either side two papyrus columns with closed capitals, eight pillars in all. The wall pictures show Ramses XI, the last of the Ramesside kings, in sacrificial scenes. The barque of the god once stood in the chapel, which follows to the north. Behind the gallery, still to the north, is a small hall with reliefs of Ramses IV and the Emperor Augustus.

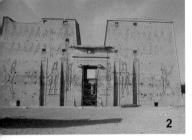

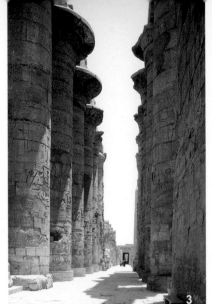

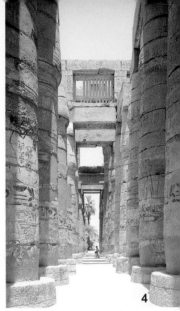

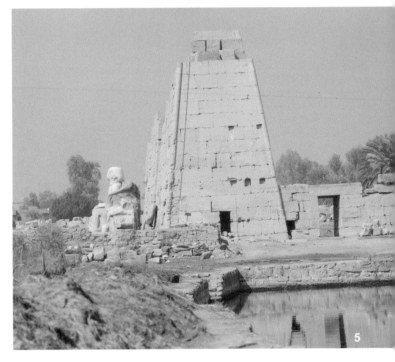

1. Temple court of Ramses III surrounded on three sides by Osiris-style statues of the king.

2. The first pylon of the temple of Khonsu.

3 & 4. The Great Hypostyle hall is one of the emblems of ancient Egypt. It consists of 134 columns, with open papyrus capitals. Each column has a circumference of about 15 metres. The middle row was built by Amenhotep III, who planned it as a simple colonnade leading to the sanctuary of Amun This row is higher than the side columns. It is this difference in height that created the subtle play of light and shadow inside.

5. Eighth pylon of Tuthmosis II and Hatshepsut.

6. The sacred lake dug by Amenhotep III. The lake was full of swams, because it was a sacred bird of Amun. The main purpose of the lake was ablution before entering the temple.

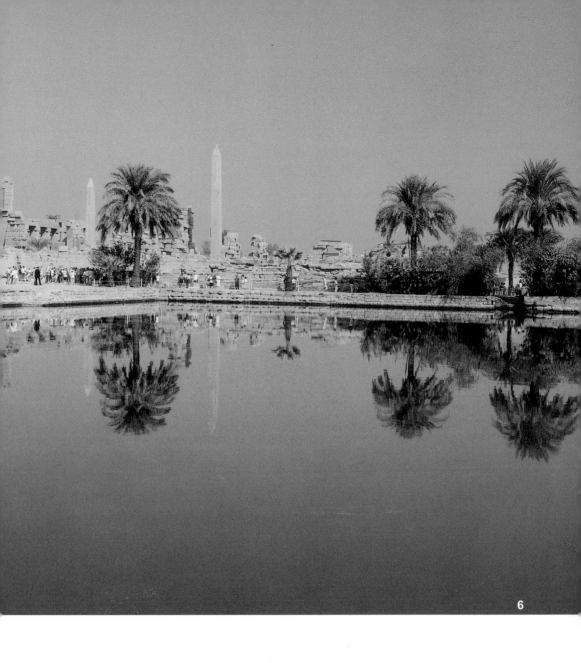

6

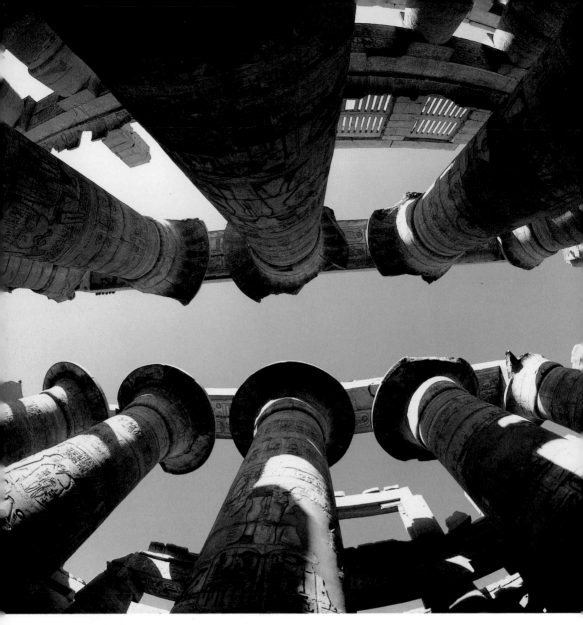

The Great Hypostyle Hall is composed of 134 columns arranged in 16 rows. The columns have papyrus-crown capitals. The height of each column is around15 metres not including the base. King Amenophis III had 12 of these erected, while Kings Sety I and Ramses II added the other 122 columns. The hall is enclosed by a wall, which has small window openings to let in light and air. The Great Hypostyle Hall is one of the marvels of New Kingdom architecture. It never fails to inspire visitors as even we in modern times feel dwarfed in comparison to the achievements of the ancient Egyptians. Here one can grasp the concept of immortality in art through a civilisation.

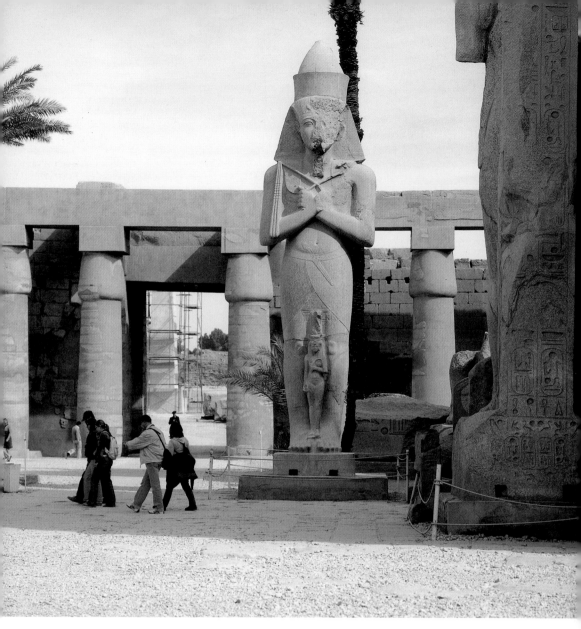

This statue of Ramses II is sculpted out of granite and is in perfect condition. Here the king is depicted with one of his daughters probably *Pnt-ant,* standing between his feet. The king wears the *pschent* crown which is composed of the Crowns of Lower and Upper Egypt; he is holding the *heka* sceptre symbol of authority and the *ms* sceptre symbol of rebirth. The statue is colossal in size, which was the tradition in art of the Ramesside period. This statue has been abrogated first by King Ramses VI from the 20th Dynasty who had his name carved on the base, later King Panijm from the 25th Dynasty added his name.

1 - 4. Reliefs from the temple of Tuthmosis III. This temple was called *akh-mnw*, meaning the beautiful monument. Inside there is a hall called the Botanical Garden, the reason being that its walls are decorated from top to bottom with plants, trees, animals and birds. King Thuthmosis III had brought the originals from *Rtnw* (Syria) following his campaigns there, to plant them in the temple's garden as an offering to the god Amun. We can claim that Tuthmosis III was probably the first to establish a zoo and a botanical garden in the ancient world. Some of these plants are real, others appear mythical. There are about 175 different species of flora depicted; some were already known in Egypt, while other exotics are seen for the first time in this temple. Among them are the pomegranate, caper, chrysanthemum and the Egyptian plum. The garden also had a religious connotation, because the maintenance and order of the garden symbolised the order and balance of the universe.

5 & 6. The remains of a group of statues of Tuthmosis IV standing between two gods, in the temple of Tuthmosis III. It is mentioned in his title: *mn kheprw-Ra* meaning "May the forms of Ra be established". On the base of the statue: *nb-was, nb-ankh* meaning 'Lord of prosperity' and 'Lord of life' is written. During the early Christian years, this statue was reworked into the shape of a cross. The hieroglyphics were damaged except for one word *djet*, meaning 'eternity' because 'eternity' belonged to the Christian faith as well.

7. This relief from the temple of Tuthmosis III shows Queen Hatshepsut, (completely eradicated), standing between the gods Thot on her right and Horus on her left. According to the Osirian legend both Thot and Horus were in charge of purifying Osiris, to give him new life. The water of purification was supposed to be brought from the First or Second Cataracts. The water here takes the form of the *ankh* symbol of life. The two gods are standing on a cushion which contains the *was* symbol of prosperity and the *ankh*. Both the names and images of the queen were completely vandalized by Tuthmosis III as part of his revenge for preventing him from becoming ruler of Egypt for many years. According to Egyptian mythology, the deceased cannot profit in the afterlife from offerings without his or her name or shape being preserved. This was the revenge that appealed to Tuthmosis III with regard to his stepmother Hatshepsut .

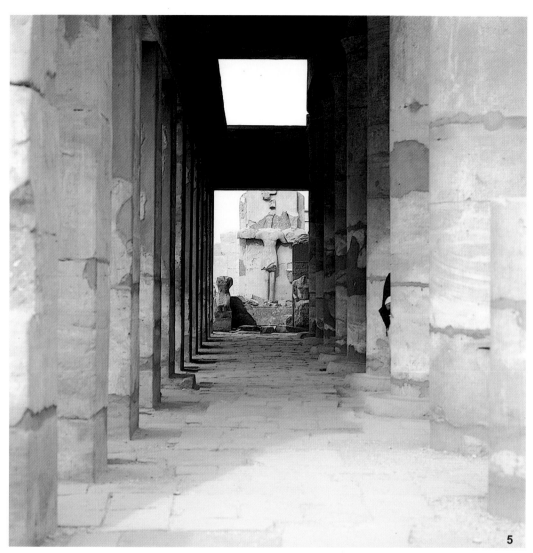

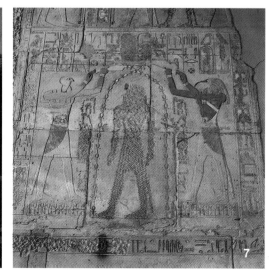

1. Part of an obelisk belonging to Queen Hatshepsut as we can see her title *Mat-ka Ra*, meaning the spirit justice of the Ra. At the top of the obelisk there is a child probably Tuthmosis III, kneeing in front of her. So it is one of the rare moments where she permitted Tuthmosis to appear in the same relief. Hatshepsut erected many obelisks, two of them in Karnak temple. In her funerary temple in Deir el-Bahary she also told the story in text and reliefs of the transportation of the two obelisks from Aswan to Luxor. Obelisks were often erected to commemorate the *sed* feast, which was celebrated every 30 years to renew the king's authority and show him as fit to rule the country.

2. The façade of the temple of Khonsu. This temple was dedicated to the god *Khonsow pakhrd* meaning the child god Khonsu; this deity was incorporated with the moon and therefore was usually represented with a crescent above his head. The word *khonsow* means in hieroglyphics: "The one who crosses the sky" referring to the moon's monthly cycle. The god Khonsu was part of the triad of Thebes, which consisted of Amun, the father, Mut, the mother and Khonsow, the son. The Pylon's entrance was built by King Panjem (1070 - 1055 BC), whose image is carved on the Pylon's registers, making offerings to different deities.

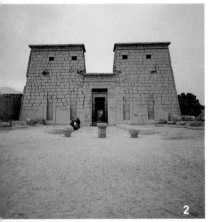

3. A title of Sety I from the Great Hypostyle Hall; it shows the name of Sety I: *sa Ra Sethy, Imn mry, mry Imn Ra*, meaning the son of the sun, Sety the beloved of Amun Ra. The colours are the original ones and appear as if but recently painted.

4. On the rear wall of the Great Hypostyle Hall Ramses II inscribed his victory in the battle of Kadesh in the fifth year of his reign then again in the 21st year of his reign. Carved here is Ramses II pulling with a rope the Hitite captives. Below stands goddess Wasset of Thebes shown as a triumphant city, she is also pulling two lines of enemies. For each fallen city a captive is represented carrying its name. Here we can read Aka, Beïth Sham and Yenem. The cartouche has the form of an Asian fortress. It was customary for the king to offer the war captives to Amun-Ra.

5. The statue of the goddess Sekhmet found in the temple of Ptah. The goddess here is represented as a woman with a lioness's head. She was the wife of Ptah in the triad of Memphis and mother of Nefertum. The word *Sekhmet* meant "powerful", she was considered the daughter of the god Ra as was mentioned in the mythology of the "Destruction of humanity", where the god Ra was so aged after creating human beings, that his daughter Sekhmet the "Eye of Ra" became aggressive towards humankind and decided to exterminate all mankind. The people asked the god Thot what to do so he told them to offer wine to pacify her; thus she was calmed and returned to her normal nature. She is represented here wearing the sun disk above her head and holding a sceptre of papyrus in her hands to denote her origins in the Delta. This statue was recently restored because the local people damaged it in the 19th century by breaking it into pieces to prevent it from harming their children !

6. This sycamore tree stands in front of the temple of Ptah. The sycamore tree was worshipped in ancient Egypt as a symbol of eternity because of its long life cycle. The cult of the goddess Hathor was associated with this tree as one of her titles was *nbt-nht*, meaning mistress of the sycamore especially in the Memphite region. The remains of this tree have been found at many archaeological sites including the Deir el-Bahari temple. The wood was used to make sarcophagi as it is flexible and can be easily shaped.

7. A relief of Sety I inside the Hypostyle Hall. He is shown in the right accompanied with goddess Hathor who is introducing him to Amun seated on his throne and holding the *was* sceptre, behind him goddess Mut is standing wearing the double crown. She is the only goddess shown with the double crown. Her title *Mut wrt nbt pt* meaning the great mother mistress of the sky is written next to the crown. Here Sety is surmounted by the *nemes* headdress with the *uraeus* on his forehead and is wearing the *shndyt* kilt. Hathor is offering sistrum with the cow-shape form of her face and a bunch of lotus to Amun. This scene originally belonged to Sety I but usurped by Ramses II who carved his title *wsr maat-ra stp-n-ra* the justice of Ra is powerful, chosen of Ra.

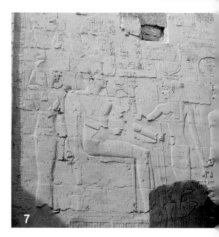

8. A relief of Ramses II also in the Hypostyle Hall, he is represented on his knee infront of Amun, and behind him goddess Sekhmet and Amun are giving him the insignia of the *heb-sed.* Neith, goddess of war is standing behind Amun and is touching his shoulder. As the king receives the *heb-sed* insignia he gets as well the justification to rule Egypt for millions of years.

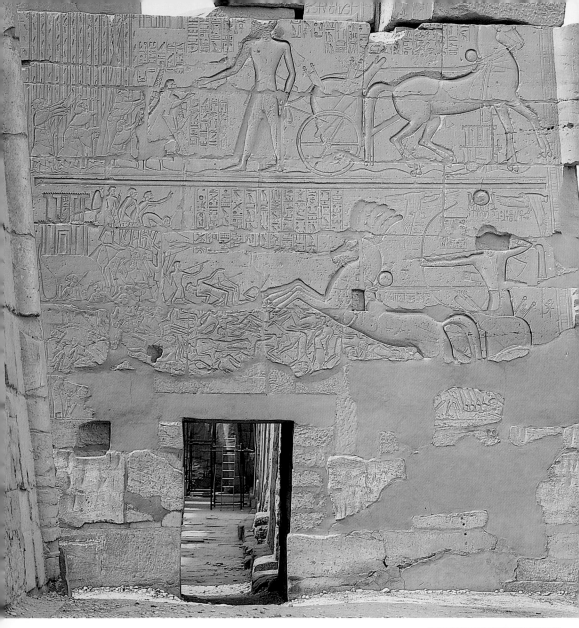

Above : A relief from the northern external wall of the Great Hypostyle Hall of Sety I. It shows Sety I riding in his chariot holding a bow and arrow in his hands and with an arrow's holder on his shoulder. Fallen enemies are shown beneath his horse's legs in an abject condition running back to their fortress, which is represented as Asiatic in style, trying to save themselves and their comrades from the hell of battle. Also two cedar trees are carved close to the fortress. The artist wanted to show a feature of the Asian landscape. We know that King Sety I had led a campaign in the first year of his reign to regain the lost cities of Beith-sham,Tyre and Amour in Asia . The purpose was to challenge the Hittite's rule in Mesopotamia.

Right : King Sety is represented wearing the *nemes* royal headdress and the *wadjit*, the cobra which is spitting fire into the faces of the enemy. The king here is represented as the triumphant warrior, holding in his right hand the dagger of *khepsh* symbol of victory. There are two rows of captive prisoners depicted during his return to Thebes. The war passes through three phases; first, the king is fighting the *shasow–beduin*; second, the taking of Mount Carmel where he regained some cities like Beith-shaïl, Yenem and Sour; third, the return of the triumphant warrior king. The wars of the king in Palestine, Syria and against the Hittites, are carved on the eastern part of the wall while the wars against the Libyans are on the western.

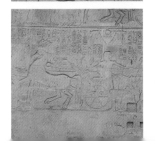

184

The granite statue of a scarab is situated at the northwest corner of the sacred lake and depicts the lifecycle of the daily resurrection of the beetle from the morning sun. On the base of this statue King Amenhotep III is shown kneeling and offering wine to the god Atum. Probably this statue was in the funerary temple of Amenhotep III, and later when this temple collapsed, it was removed from the west bank of the Nile to Karnak.

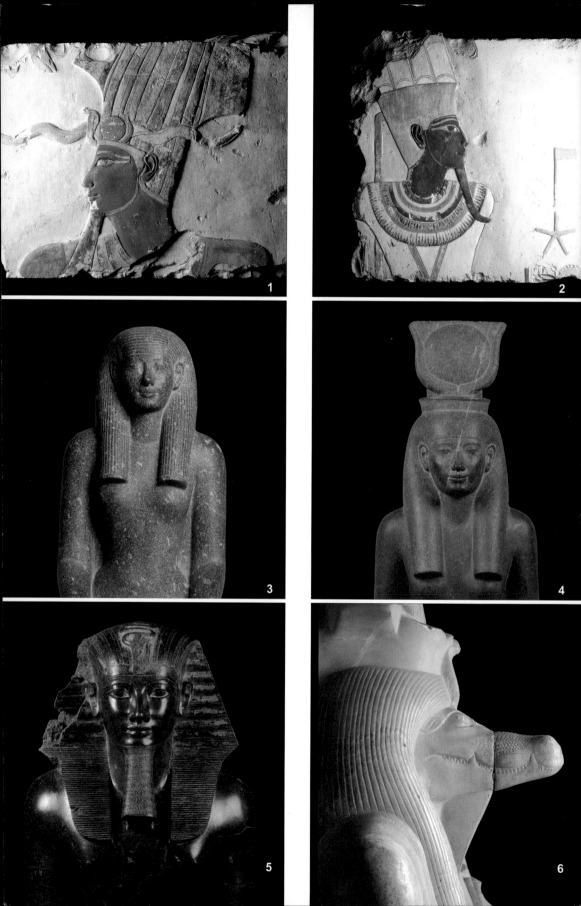

1

2

3

4

5

6

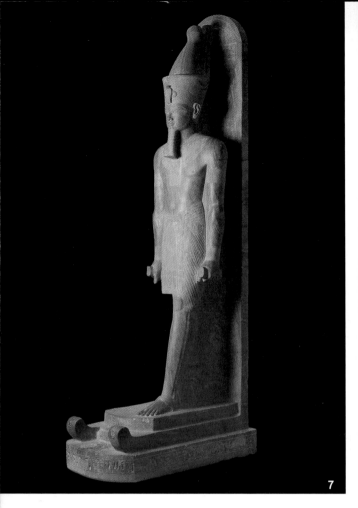

7

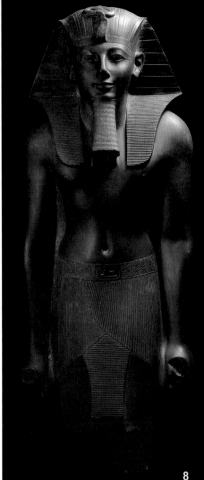

8

9

Luxor Museum

Luxor museum is a relatively new museum having been established in 1975. On display are around 300 pieces of sculpture mainly from the New Kingdom. The modern museum building lies on the corniche, and the display and lighting of the pieces shows them to their best advantage.

All the masterpieces discovered in the Luxor Temple cachette in 1988, are on show in the museum. A new section was opened in 2004. Its main theme is "Egypt's military might during the New Kingdom". The newly displayed artefacts came mainly from the Cairo Museum, these are: a victory Stela of Kamose, the mummy of Ahmose I, a schist statue of Tuthmosis III, a ceremonial chariot, an alabaster statue of Sety I, Ramses IV grasping a prisoner, a prisoner and two colossal heads of the goddess Sekhmet.

1. Tuthmosis III wearing the *Atef* Crown. **2.** Relief of the god Amun. **3.** Statue of the goddess Iwnet. **4.** Statue of the goddess Hathor. **5.** Statue of Tuthmosis III. **6 & 9.** The god Sobek with Amenhotep III. **7.** Statue of King Amenhotep III represented on a sledge. **8.** Standing statue of Tuthmosis III. **10.** The god Amun identified by his double plumed headdress, seated behind Horemheb.

10

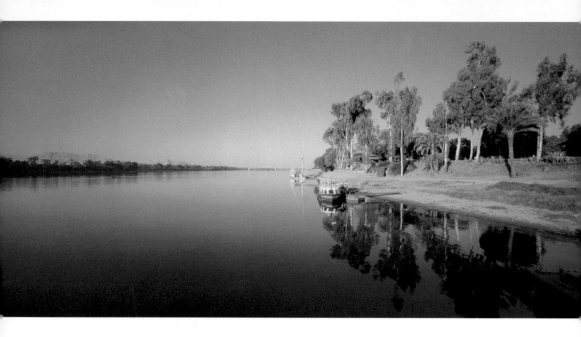

West Bank of The Nile

The Necropolis of Thebes, City of the Dead

All the buildings of Luxor are on the east bank of the river. Westward on the opposite shore a broad plain of fertile land extends for a width of about 2 kilometres until it meets a range of limestone cliffs with peaks reaching up to 350 metres. For us they have an impressiveness which is unparalleled anywhere in the world. For within them they received the embalmed bodies of 70 generations of Egyptians. Kings and queens, princes and nobles and citizens lay within their shadow. The painted and sculptured tombs reveal a detailed picture of the daily life of this most ancient of civilizations.

Some of these tombs are from the Middle Kingdom, but the majority date from the New Kingdom onwards. Unlike the Old Kingdom tombs previously described in the form of a *mastaba*, these take the form of deep galleries and chambers hollowed out of the mountainside. In the hillside facing the Nile are the tombs of the nobles. The kings were buried in an isolated valley on the western side of the mountain, the famous 'Valley of the Kings'.

Although this was the region of the dead it also supported a large community of the living. Here lived the mortuary priests responsible for guarding and maintaining the tombs, conducting the funerary rites and making regular ceremonial offerings. Here also lived the quarrymen, who were constantly excavating new tombs, the draughtsmen who decorated them, and the makers of the funerary furniture.

Near Medinet Habu, south of the necropolis, the remains of the workmen's village have been excavated. It housed the men who worked on the great tombs of the 18th and 19th Dynasty kings. Here are the foundations of scores of small compact mud houses, built along regularly spaced streets. Their occupants may not have been allowed to cross the river to Thebes but had to live near their work. A track leading from the village over to the Valley of the Kings can still be traced.

Today most of the nobles' tombs are empty with their reliefs scattered in museums and private collections around the world, after being illegally removed from them. From the time that ancient Egyptian artefacts acquired a high market value, these tombs have been ruthlessly robbed by the local population, particularly from the village of Sheikh Abd el-Qurna, which is on the site of the necropolis. For a description of these tombs approximately 200 years ago there is no better guide than the description of Belzoni, who visited Thebes in 1816 when this gruesome trade was flourishing.

Of some of these tombs (he wrote), many persons could not withstand the suffocating air, which often causes fainting. A vast quantity of dust rises, so fine that it enters the throat and nostrils, and chokes the nose and mouth to such a degree that it requires great power of lungs to resist it. This is not all; the entry or passage where the

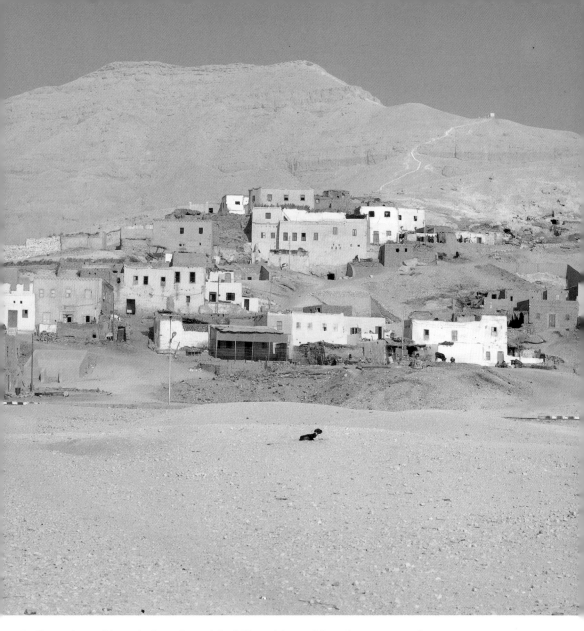

bodies are is roughly cut in the rocks, and the falling of the sand from the upper part of the ceiling of the passages causes it to be nearly filled up After getting through these passages, some of them two or three hundred metres long, you generally find a more commodious place, perhaps high enough to sit. But what a place of rest! Surrounded by bodies, by heaps of mummies in all directions; which, previous to my being accustomed to the sight, impressed me with horror. The blackness of the wall, the faint light given by candles or torches for want of air, the different objects that surrounded me to converse with each other, ...

After the exertion of entering such a place.... nearly overcome, I sought a resting place, found one and contrived to sit; but when my weight bore on the body of an Egyptian, it crushed like a band-box; I naturally had recourse to my hands to sustain my weight, but they found no better support; so that I sunk altogether among the broken mummies, with a crash of bones, rags and wooden cases, which raised such a dust as kept me motionless for a quarter of an hour, waiting till it subsided again. a passage about twenty feet in length, and no wider than that a body could be forced

Facing page : Nile at Thebes.
Above : The village of Qurna.

through. It was choked with mummies, and I could not pass without putting my face in contact with that of some decayed Egyptian; but as the passage inclined downwards, my own weight helped me on; however I could not avoid being covered with bones, legs, arms and heads rolling from above. Thus I proceeded from one cave to another, all full of mummies piled up in various ways, some standing, some lying, and some on their heads ...

Fortunately the days of unrestricted plunder and exploitation are over. Fortunately, too, not all tombs were ruined by ruthless antiquity hunters, but survived until the days of modern scientific excavation. The first pioneers were Garis Davies, Flinders Petrie, George Raisner, Marriette and Howard Carter.

The city of the dead on the west bank comprises the following:

A. The tombs of the Kings; the Valley of the Kings in the extreme west and the Valley of the Queens in the extreme south of the necropolis.

B. Tombs of the Nobles, on the edge of the desert.

C. Mortuary temples of the Kings between the mountains and the valley.

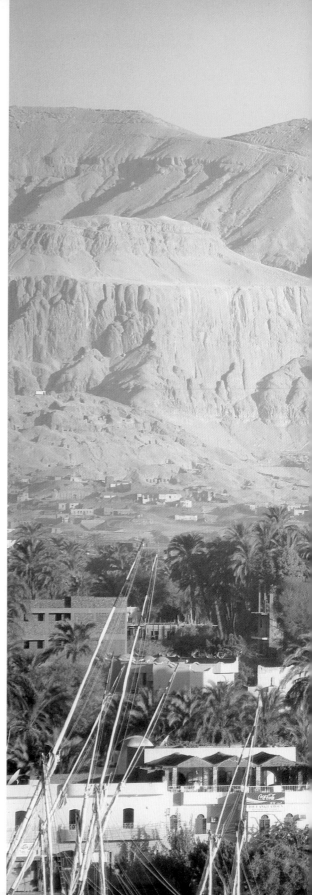

The west bank of Thebes with the temple of Hatshepsut in the background, photographed from the east bank.

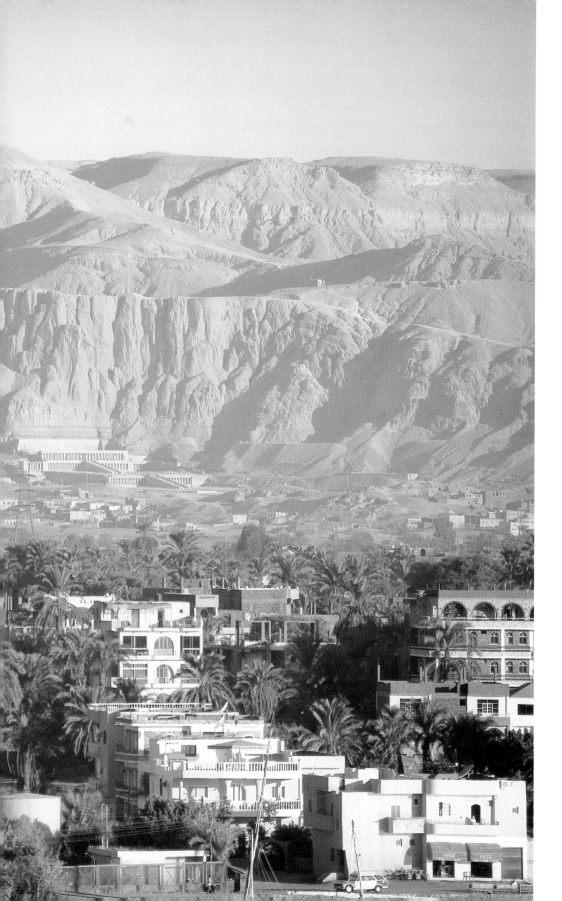

Valley of the Kings

The Valley of the Kings has drawn more visitors than any other monument in Egypt except for the Giza Pyramids. The last pharaoh to be buried there was laid to rest 3000 years ago. A thousand years later it had become a showplace. Greek and Roman tourists carved their names on it. Medieval hermits made homes in its empty tombs. Eighteenth century adventurers probed it, and 19th century archaeologists crossed it from end to end. Yet it kept the greatest of all its secrets until the 1920's of the 20th century.

Until the 18th Dynasty, the Theban kings seem to have been buried on the eastern side of the mountains. They still adhered to the pyramidal form for their tombs, but the pyramids had shrunk to mere pigmies 20 metres high, with the mortuary chapel closely adjoining. No doubt they were robbed as were those of their predecessors, and it was this which led the pharaohs to seek to conceal their sepulchres.

The chief difficulty was that it had always been considered necessary to build the mortuary chapel as near the tomb as possible, so that the *ka* could have easy access to it from the burial chamber. As the mortuary chapel could not be concealed, its presence naturally gave away that of the tomb. It took the Egyptian mind over 1000 years to recognise this fact and respond to it. The first pharaoh to break with tradition was Tuthmosis I, the third king of the 18th Dynasty, but it cannot be known whether the idea was his or that of his architect Ineni. This was the man who never swore in his life, we quote his tomb inscription "I attended to the excavation of the cliff tomb of His Majesty alone, no one seeing, no one hearing ... I shall be praised for my wisdom in after years ... ". The site chosen was approached by a narrow valley road which winds round the north western end of the necropolis and then turns southward before issuing into the royal valley. "Although only separated from the teeming life of the Nile valley by a wall of cliffs, it seemed to be an infinitely remote and unearthly, sterile, echoing region of the underworld or a hollow in the mountains of the moon." Even today, when at the height of the season the valley teems with visitors, it never loses its mystery, and in the evening, when the last tourist has left, the eternal residence of the kings returns to its old silence and majesty.

From Tuthmosis I onwards through the 18th, 19th, and 20th Dynasties, king after king had his tomb carved out of the valley's cliffs, and as the years passed each pharaoh tried to make a more magnificent sepulchre than his predecessor. At first the chief aim was concealment. The tombs of the early 18th Dynasty kings, Tuthmosis I and III, Amenhotep II and Queen Hatshepsut were sited in remote, mysterious recesses. The entrances were inconspicuous. But when it became evident that even these precautions were not enough to stop the thieves, aided as they probably were by corrupt officials and police, secrecy was abandoned. In the 19th Dynasty the Ramesside kings opened up their tombs boldly on each side of the valley road, tunnelled out long broad galleries, which descended for hundreds of feet into the heart of the mountain, and relied for the protection of their bodies on concealed burial chambers, and massive granite sarcophagi. Meanwhile on the other side of the cliffs, facing the Nile, rose the great mortuary temples of the kings whose bodies lay in the valley: the Ramesseum, the temples of Sety I, Amenhotep III and Hatshepsut's terraced temple at Deir el-Bahari. The spirits of the dead kings now had to pass through the mountain wall in order to receive the temple offerings, but this, apparently, was no longer considered an obstacle.

There must have been a time when more wealth, both in value and in artistic craftsmanship, was stored in this desolate valley than in any other spot in the world; but it is highly improbable that it lasted for very long, or that all the treasures of a single dynasty remained intact at its close. Scheme after scheme failed in turn; the gigantic pyramids of the Old Kingdom, the elaborate maze of passages of the modest pyramids of the Middle Kingdom, all proved powerless against the tomb robbers.

After the 20th Dynasty no more kings were buried in the royal valley. Under the weak government of the later Ramesside kings, tomb robberies became even more frequent, as we know from a papyrus describing the trials of some of these robber gangs. Eventually the valley, most of its tombs stripped and empty, was abandoned. The might of the pharaohs, respect for the dead, fear of the gods, had all proved less powerful than mankind's eternal lust for gold.

The Greeks and the Romans came; their historians Strabo and Diodorus of Sicily, visited the valley, set down their careful observations, and went away. Some of their more careless contemporaries also came, and left their scribbled remarks, such as "I, Philastrios, the Alexandrian, who have come to Thebes, and seen the work of these tombs of astounding horror, have had a delightful day". When Christianity came to Egypt, the Copts built their monasteries nearby and some Christian hermits lived in the tombs themselves. Throughout the centuries the name of the valley survived, though now changed into Arabic, the *Biban el-Moluk*, the 'Gate of the Kings'.

In the 17th and 18th centuries, European travellers reached Thebes and the royal valley. Among them was Richard Pocoke, who ventured here in 1745, and "viewed these extraordinary tombs of the kings of Thebes with the utmost pleasure". A century later with the decipherment of the hieroglyphs, the newly awakened interest in ancient Egypt, brought a succession of antiquity hunters to Thebes, and sooner or later most of them dug in the valley. Among them, of course, was Belzoni, who in 1817 discovered and cleared a number of tombs, including that of Ay.

Mentuherkhepeshef, Ramses I and Sety I. All had been completely stripped in antiquity - coffins, mummies, funerary furniture had all disappeared. But in opening the tomb of Sety I, the great 19th Dynasty warrior king whose empire reached from the Fourth Cataract of the Nile to the sources of Jordan, Belzoni revealed what is undoubtedly the most magnificent tomb in the valley. After opening the tomb he spent 12 months making drawings and wax impressions of the paintings and reliefs. This act ruined the original paintings stripping them of their colours. The copies he took to England and with them produced a replica of the tomb which was displayed in Piccadilly, London, in what was called the Egyptian Hall. He also took the fine alabaster sarcophagus of the pharaoh with beautiful reliefs from the Book of Gates and it too was exhibited for some months before being sold to Sir John Soane, who placed it in the Soane Museum, Lincoln's Inn Fields, where it can be seen to this day.

Today when we visit Sety's tomb, it no longer appears "as if just finished" as it did to Belzoni. His destructive copying methods, in addition to the torches of thousands of 19th century visitors have begrimed the colour and sheen of its mural paintings, but the grandeur of the whole concept remains unparalleled.

The rulers who are buried in the Valley of the Kings reigned in the 18th, 19th, & 20th Dynasties from 1580 to 1085 BC. Contrary to the practice of the pharaohs of the Old Kingdom, who raised pyramidal structures, these tombs were cut deep into the living rock and closed up after the mummy had been laid to rest.

The rock tombs generally follow the same plan: three corridors, one after the other, lead to the burial chamber itself; at the side of the first corridor are small side chambers and at the sides of the second and third corridors, rooms for the funerary equipment. The walls and pillars of the tombs are usually decorated with inscriptions and religious scenes and motifs.

Sixty-four tombs are known to exist in the Valley of the Kings, but most of them are either in ruins or inaccessible. There are 17 tombs which can be visited, though some of them only by special permit. In the following pages we list the most significant.

Decoration of the Royal Tombs

The Night Journey of the Sun

Decoration in the Valley of the Kings is dominated by two themes. First, the king praying and offering before the gods, and second, a description of the netherworld with illustrations and text describing the books of the underworld. These books are the *Amduat* 'What is in the Underworld', the Litany of Ra, the Book of Gates, the Book of the Divine Cow and the Ritual of the Opening of the Mouth.

The ancient Egyptians believed that the earth was flat and hence arose the question: where does the setting sun go to in the west? They believed it went to the realm of the dead, and hence the west bank of the Nile belonged to the dead and so all the tombs were located in the west. As the setting sun descended into the netherworld, it moved backwards in space and time to rise again in the east the next morning. The lord Ra accompanied the setting sun, and because barges were the only form of transport in antiquity, they used the sun barge for the night journey. Ra was the god of the living, while Osiris was the god of the dead. During the night journey Ra and Osiris united and formed a single entity "Ra goes to rest in Osiris, and Osiris goes to rest in Ra" (from chapter 17 of the Book of the Dead).

The ancient Egyptians defined a year as 365¼ days. This was divided into 12 months of 30 days each, plus a month of 5 days. They defined the week as 7 days. The day was divided into 12 hours of day and 12 hours of night. The hour was the smallest time unit as they had no minutes or seconds. I n the books of the underworld, the night journey is divided into 12 chapters, which represent the 12 hours of the night. Vertical borders define the chapters, and each is divided into 3 horizontal registers. After 12 hours of darkness the sun was reborn next morning and with it the resurrection of the blessed dead. In the netherworld there was no differentiation between the gods and the dead. Those who crossed the threshold of death, moved freely among the gods. As the residents of the underworld were the souls or *ba* of the dead, those who were dammed had to be held accountable for their

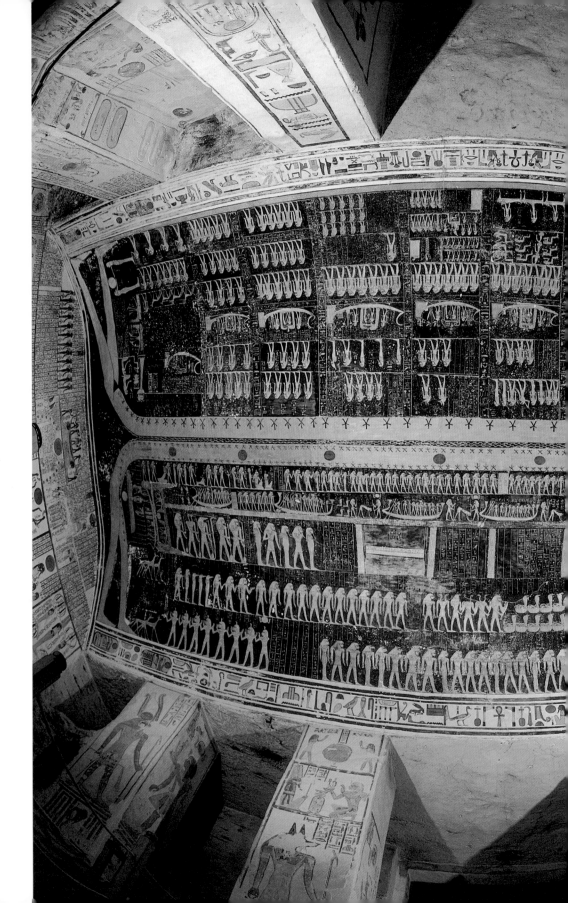

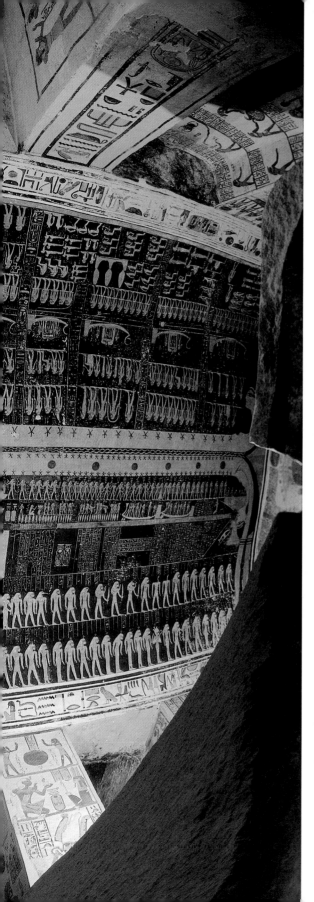

Tomb of Ramses VI, KV9, 20th Dynasty, reign of Ramses VI 1141 - 1133 BC.

A fisheye picture of the astronomical ceiling of the burial chamber with the sky goddess Nut elongating her body to imitate the vaults of heaven. She is represented twice, first, in the "Book of Days" in the upper register and second, in the "Book of Nights" in the lower register.

In the "Book of the Nights" the new born sun is represented as Khepri with two wings who is received by Isis and Nephtys with god Shu lifting the whole scene. Shu is shown staanding on the solar boat. In the first register gods are receiting hymns of the journey. They are represented across the whole scene. Below them is a register showing nine boats with deity passengers hunting Apophis the evil serpent, which attacked the sun in its night journey and tried to prevent its rise next morning. The next three registers describe the twelve hours of the night journey.

In the "Book of the Day", top register, Isis and Nephtys are also receiving the new born sun shown left. The remaining registers are a collection of star deities and constellations. In one of the myths Nut was cursed by Ra who deprived her from giving birth. Thoth intervened and made peace between Ra and Nut, then she gave birth to the 360 days of the year, later she won five more days.

195

evil deeds on earth. In the first hour of the night, the sun god was accompanied by Ptah, the opener. He was also joined by two groups composed of nine baboons who sang as he entered the netherworld. They communicated with the sun god in a language that no human could understand, only the gods and the dead knew this language. Also accompanying the sun god were 12 goddesses personifying the 12 hours of the journey. It is nowhere mentioned whether the barge sailed upstream or downstream. But we think that because the barge moved back in time and space it must sail upstream. Four men pulled the barge when rowing was not sufficient to move it. According to the Book of Gates, four men were depicted pulling the barge. By their costumes we know that they are the souls of dead men. The idea is that when all the inhabitants of the netherworld saw the sun barge approaching with Ra on board, they united their forces and helped in moving it towards its goal. Not only men and gods helped the barge, but also the animals associated with Seth, the *uraeus* and snakes. A shrine guarded by snakes was situated in the middle of the barge. The sun god Ra was represented as a ram-headed man. His horns surmounted by the sun disk, which illuminates the darkness of the netherworld. At the first gate of the underworld, the god was transformed into a ram, as *ba* (spirit) also meant ram. The purpose of this transformation saying that the god enters the netherworld as a *ba* spirit and aims to be united with his body there. All the inhabitants of the underworld aspired to accompany the sun on its night journey to be reborn from the depths of the earth the next morning. The barge that carries the millions through the currents of the netherworld was called the 'Barge of the Millions', and was occupied by all those who had ever existed. The 'way opener', the god Upuaut sat in the bow of the barge. His role was to ease the way of the journey. The cow goddess Hathor was the only female deity among the passengers. Another of these was Seth, and his presence represented conflict. Since he was the murderer of Osiris, they could not be in the same place in the underworld. However, Seth was an indispensable and powerful member of the barge, as his role was to confront the evil Apophios. The dilemma was solved by imprisoning his *ba* in the barge and hence his body could not be resurrected. Seth is often shown in the bow attacking the wicked Apophios snake with a spear, an early representation of the dragon killer. Horus sat in the stern, his purpose to steer the barge. Maat was defined as mass, balance and righteousness, and her presence in the netherworld meant that the deceased would stay within the safe structure of creation, and be under the law of the strong. Maat was represented in a dual form, which was a sign of her presence both in the real world and the underworld. The judgement of the dead took place in the hall of judgement. It was the fate of all the deceased to have his or her heart weighed against a feather of Maat. The result of the judgement was resurrection for the blessed and punishment and expulsion from existence for the dammed. Therefore, next to both the Maat goddesses, another god stood with a knife in his hand to stab the dammed, in the last hours of the *Amduat*. Next stood Osiris as king of the netherworld, he was represented in his usual mummy-form body wearing the White Crown of Upper Egypt. Sekhmet took part in the punishment of the dammed, since she was the goddess who carried the myth of the destruction of mankind, bringing death and devastation to the world. The dammed were thrown into the "Lake of Fire", which had an offensive smell. The waters were guarded by cobras spitting fire from their mouths.

Tombs of the Ramesside period show the night journey occurring in the body of the sky goddess Nut, who swallowed the setting sun in the evening and gave birth to it the next morning. The representation of the goddess Nut was semicircular to express the idea of the vault of the heavens. Her body was completely covered with stars, Nut was in fact, the embodiment of the sky. Hence the ancient Egyptians correlated the depth in space that stretches in all directions, with the depth of unconsciousness in ourselves. As on the other hand, rays of light emitted by the sun were correlated to consciousness. In the title of the *Amduat* depth is defined as the 'hidden chamber'.

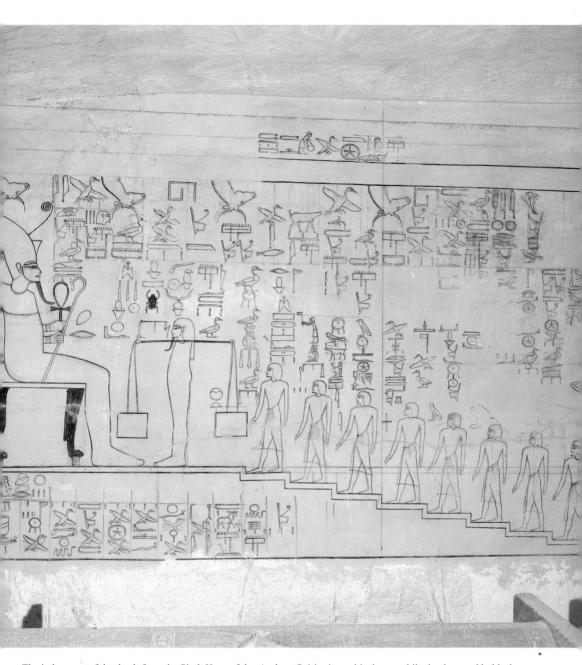

The judgement of the dead: from the Sixth Hour of the *Amduat*. Osiris sits on his throne while the deceased holds the scales. Nine of the dead go up the stairs towards the scales, tomb of Horemheb.

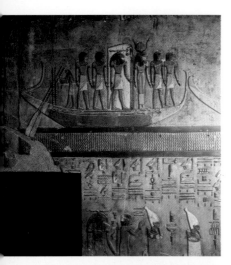

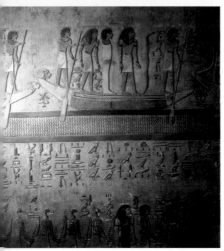

Above : Details from the Second and Third Hours of the *Amduat.*

The Tomb of Sety I (1291 – 1278 BC) KV 17

The tomb of Sety I was discovered by Belzoni in 1817. From the time of its completion the tomb remained intact for 3000 years waiting to be ruined by Belzoni. It is heartbreaking to see its state today and read Belzoni's description " ... with painted reliefs as beautiful and fresh as on the day they were completed ...". As mentioned earlier, Belzoni prepared a model of Sety's tomb that was put on display in London, in the summer of 1821. The method Belzoni used to copy the painted reliefs took off the original colours as he pressed wet paper on them, leaving it until it dried and then pulled the copy from the walls. In addition he removed the stones from the entrance, hence nothing prevented flash floods from entering the tomb. This is exactly what occurred; an abundance of rainwater entered the tomb and seriously damaged the first chambers. Also the candles and torches of 19th century visitors emitted black smoke that obscured the original colours. In addition some reliefs were hammered away by Champollion and Rosellini, and other adventurers in the 19th century.

The best photographs of the tomb were done by Harry Burton between the years 1921 and 1928. He took 222 pictures on 8 X 10 inch glass plates. In taking these he did not use any sort of artificial light, but employed natural sunlight directed with the use of various reflectors. What a monumental task! These glass plates are now in the Metropolitan Museum of Art in New York city.

Sety's I mummy, found in the Deir el-Bahari cachette in 1881, is the most lifelike of all the mummies in the Egyptian Museum.

The tomb of Sety I is decorated with the *Amduat*, Litany of Ra, the Book of Gates and the Book of the Divine Cow. Prior to Sety I, decoration was found only in the burial chamber, well shaft and vestibule. Sety I changed this tradition utterly, his tomb was decorated from the entrance onwards to the burial chamber. All subsequent kings followed the new scheme. Sety's burial chamber was the first tomb to be decorated with an astronomical ceiling showing some of the constellations, and a calendar with 36 groups of stars into which the night sky was divided by the ancient Egyptians.

Ramses I, founder of the 19th Dynasty, ascended to the throne as an old man and ruled for only one year dying at the age of 70. His son Sety inherited the throne to become Sety I. Shortly after his accession, he marched his army to Syria and re-established Egyptian rule to a point north of present Lebanon, where he was halted by the Hittites. Still his limited victory returned the majority of Syrian territory to the Egyptian domain. Back in Egypt he was victoriously received, and the Egyptians felt that the catastrophic era of Akhenaten has gone forever, and that the country was on its way back to assume its imperial role. Many reliefs were chiselled on the outer wall of the great hypostyle hall of Karnak temple. Here, for the first time, the battlefield was illustrated with hundreds of soldiers involved in combat.

Everywhere in Egypt, Sety I restored the worship of Amun. He built a grandiose temple in Abydos dedicated to Osiris and to the spirits of the previous kings of Egypt who were buried in the royal cemetery close by. He also completed the great hypostyle hall at

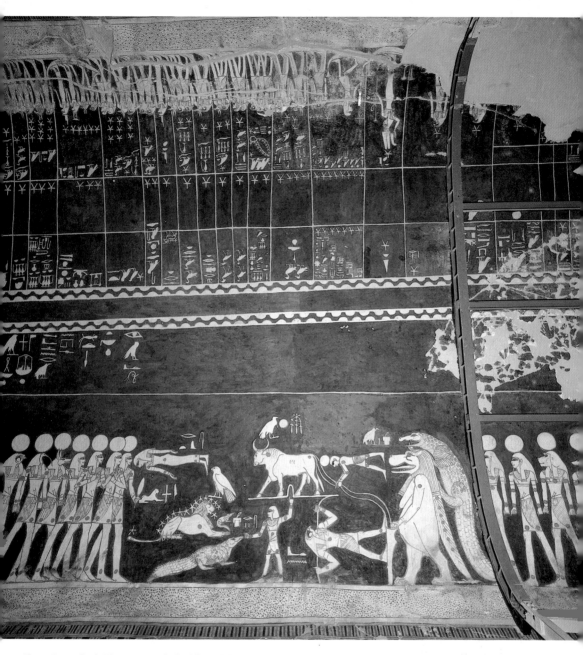

Above & overleaf : The astronomical ceiling of the burial chamber painted with stars and constellations. This is the first dome-shaped ceiling in the Valley of the Kings. Also the whole tomb is carved in high reliefs and painted while the ceiling is only painted. The upper registers are Decans stars and constellations. The drawings of the other side are constellations of the hippopotamus and crocodiles that may refer to the northern sky. The purpose of the drawing is to help the *ba* of the deceased to ascend to the heavens. Our knowledge to-day cannot give a precise explanation for these type of drawings.

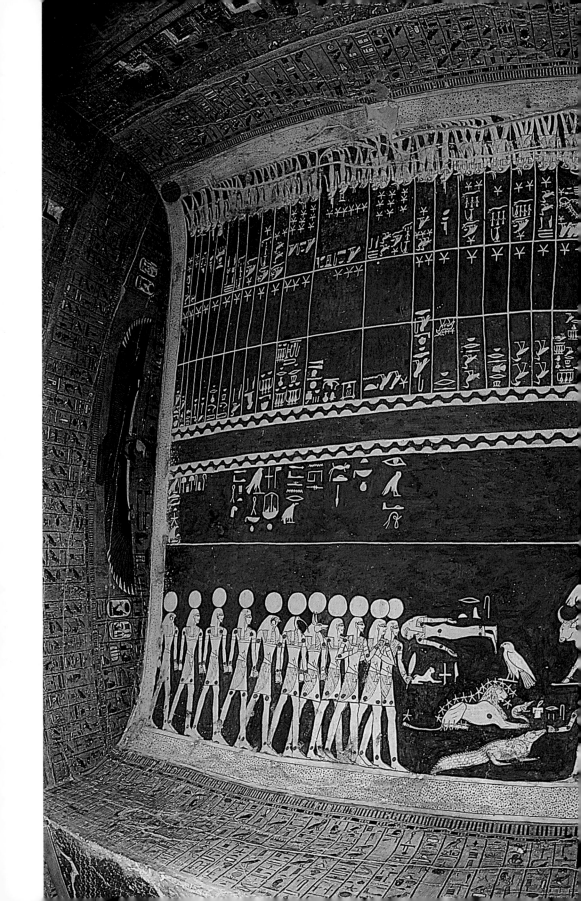

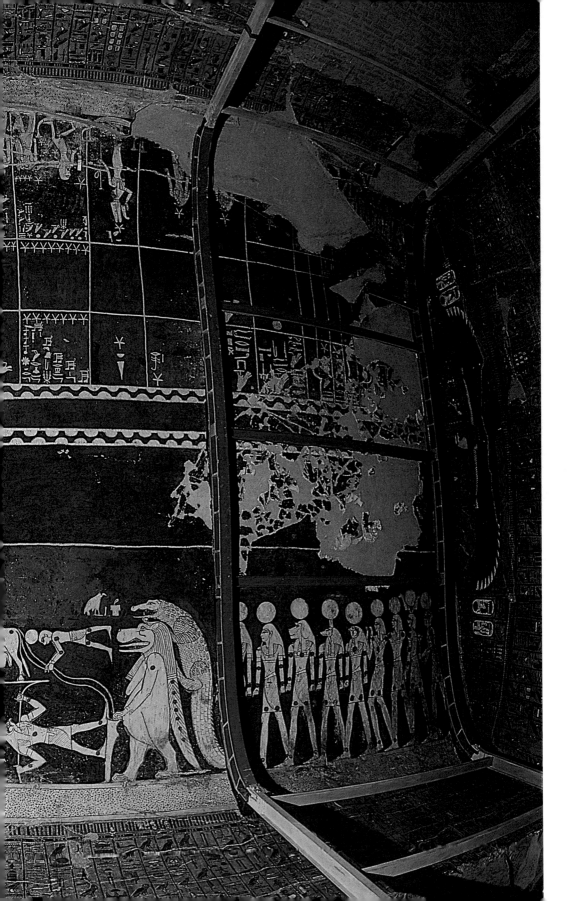

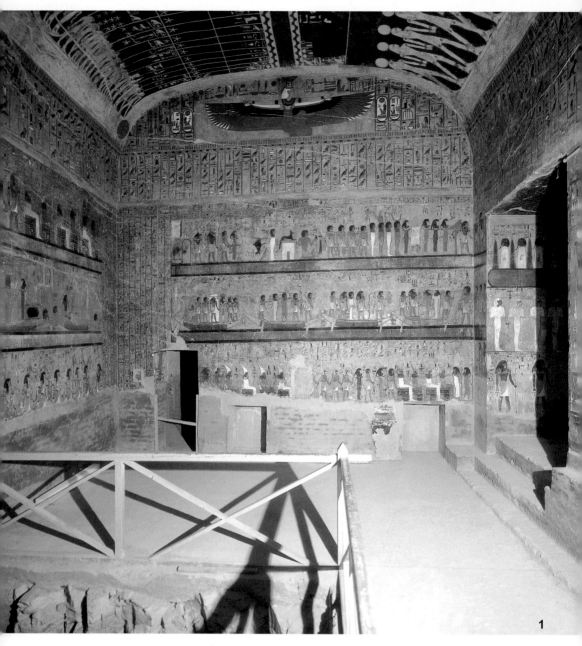

1

1. Burial chamber, looking north, with decoration of the Second and Third Hours of the *Amduat*.
2. Relief of the priest Iwnmutef.
3. The Sixth Hour of the Book of Gates, with Sety and Horus before Osiris and Hathor.
4. The beginning of the Third Hour of the Book of Gates.
5. Detail of the solar barge of the sun god.
6. The Sixth Hour of the Book of Gates.

Karnak. It is the biggest hall that has survived from antiquity, covering an area of approximately 6000 square metres and having 134 pillars.

His mortuary temple was built on the western side of Thebes beside the Valley of the Kings. In the valley itself he built a magnificent tomb that extends over 100 metres into the rock.

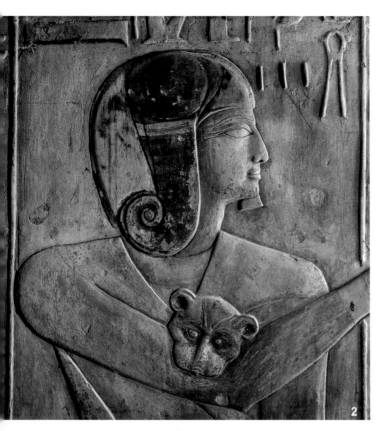

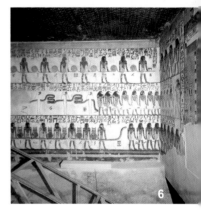

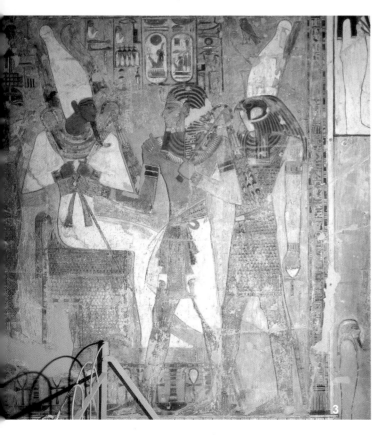

203

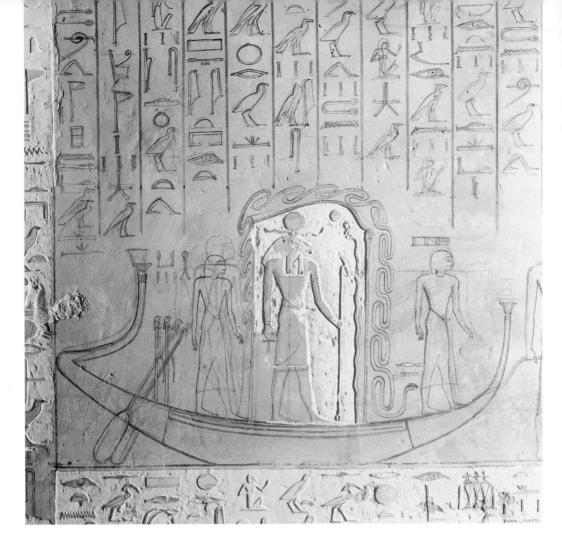

The Tomb of Horemheb (1321 – 1293 BC) KV 57

The tomb of Horemheb was discovered by the English archaeologist, Eduard Ayrton in 1908. It is one of the best preserved in the royal valley. The innovation here is that it has no 90 degrees turn compared to previous tombs. This new style was adopted by his descendents. The first four chambers were left undecorated with rough walls and no plaster. The well shaft is the most beautiful room. The drawings show the king making offerings to various gods and goddesses. The ceiling is painted dark blue with golden stars. Another new contribution is that he had the paintings done in high relief, instead of painted on flat surfaces which had been done hitherto. This is the first tomb to have decorations from the Book of Gates, all previous ones had decorations from the *Amduat*, but these are incomplete.

The sarcophagus is carved from red granite with low reliefs painted yellow. On each of the corners is a goddess stretching her wings in a protective manner. The four goddesses are Isis, Neith, Serqet and Nephthys. The king died before the tomb decorations were finished.

Horemheb, a strongman, who was commander-in-chief of the army, seized the throne when King Ay died and legalized his accession by marrying Nothemmut, the daughter and heiress of Ay, and sister of Nefertiti. Gradually during his reign the remaining Aten worshippers were denounced as 'heretics', and the late Akhenaten became the archenemy. The temples of Aten were destroyed and Akhenaten's name was erased. Since the heresy had really begun, when Queen Tiye had pushed her husband Amenhotep III into the background, and had assumed the regency of Egypt, Horemheb now decreed that all the years from that date to his own accession should be erased; and thus though he actually reigned 24 years he was credited with a reign of 59, so as to cover the blank period.

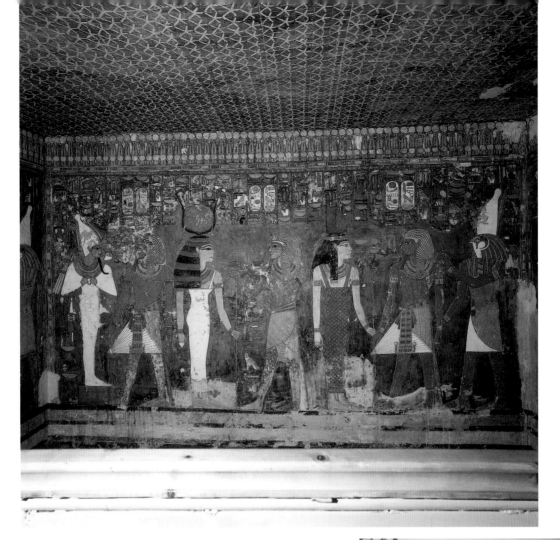

Facing page : Example of an incomplete relief. Here only the sun god Ra has been carved while the other gods are only painted in outline. The god behind Ra has been redrawn several times to adjust both his size and position. Also on the left and bottom, only some of the hieroglyphs have been carved. After the plaster had been smoothed, the draughtsmen make the drawing in red ink, then corrected with black ink. The next step would be the carving and finally the painting in colour.

Above : Relief in the well-shaft chamber showing Horus before Horemheb who is offering to goddess Hathor, Isis and Osiris. The remarkable feature in this drawing is the striped dress of Hathor.

Right : Four men are pulling the sun barge, and the sun god Ra is standing in a shrine.

His tenure of the throne marks the period of Egypt's recovery from the disasters unwittingly brought upon the country by Akhenaten's hopeless dream. He led an Egyptian army into Syria once more, and managed to re-conquer a little of the lost ground, and he also carried out a campaign in the Sudan. Some of the many new laws enacted by him are on record; and the remains of his many buildings at Karnak, Luxor and elsewhere, show his efforts to restore Egypt's former grandeur.

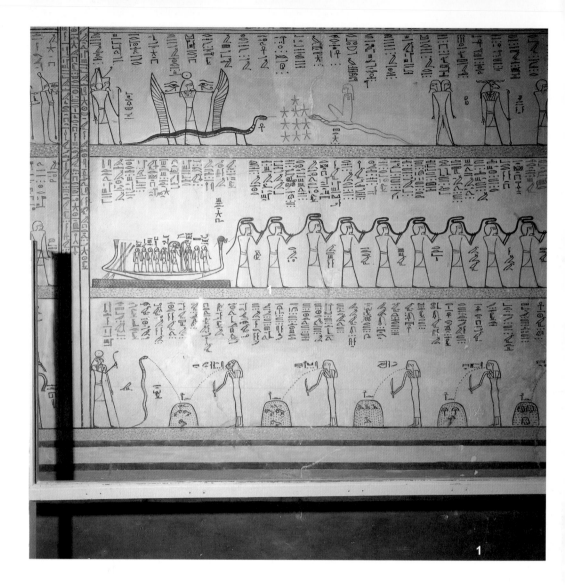

The Tomb of Amenhotep II (1453 – 1419 BC) KV 35

The tomb of Amenhotep II was discovered in 1898 by the French archaeologist Victor Loret, but was robbed in antiquity. However, when he entered it he found many broken pieces of funerary furniture and wooden boats. Amidst one wooden boat he found a mummy. It was that of the king's son Webensennu, who had died during the king's lifetime. The mummy of Amenhotep II was also found intact inside its sarcophagus. Now it is on display in the Egyptian Museum in Cairo. In one of the side rooms, Loret found many royal mummies including those of Tuthmosis IV, Amenhotep III, Merenptah, Sety II, Siptah, Setnakht, Ramses IV, V and VI. All were removed to the Egyptian Museum in Cairo.

The tomb has a well chamber 6.5 metres deep. Scholars first explained that the purpose of this was to trap thieves or to prevent rain floodwaters from reaching the burial chamber. But the acceptable explanation now is that it was a symbolic tomb for Osiris.

The burial chamber is rectangular in shape and has six columns with drawings of Amenhotep II before Osiris, Anubis and Hathor. These were the most important deities in the netherworld. The first pair of pillars have the drawings of Osiris, the second of Anubis and Hathor, and the third of Hathor only.

The walls of the burial chamber were decorated with a complete version of the *Amduat* drawn in red and black ink. A vertical border separates each of the 12 chapters and these are divided into three horizontal registers.

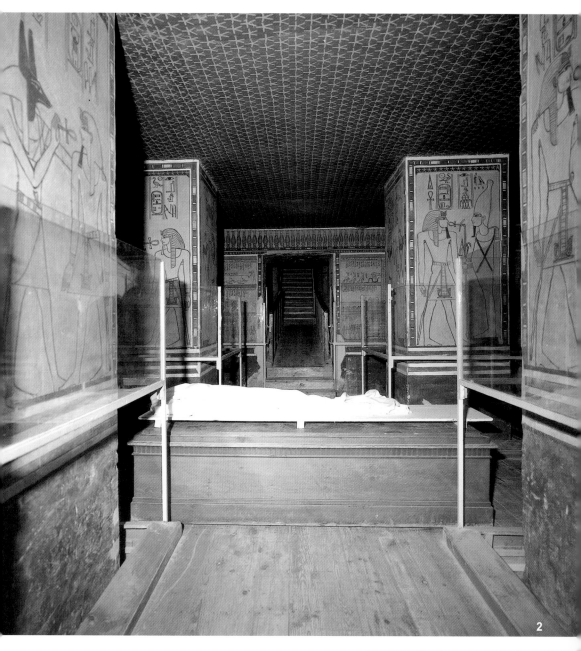

2

1. Scenes from the *Amduat*.
2. Overall view of the burial chamber showing the six pillars.
3. The ceiling and frame decoration.

The ceiling is 10 metres high and painted dark blue with golden stars. The sarcophagus is cartouche-shaped, and carved from quartzite painted brown to look like granite.

Amenhotep II started his reign as sole pharaoh in 1453 BC. He had ruled as joint pharaoh with his father for 18 months prior to this. He was a good looking young man known for his exceptional physical strength. Soon after he was crowned, he took his forces to Syria to crush an uprising that had started when the news of the death of Tuthmosis III was reported

3

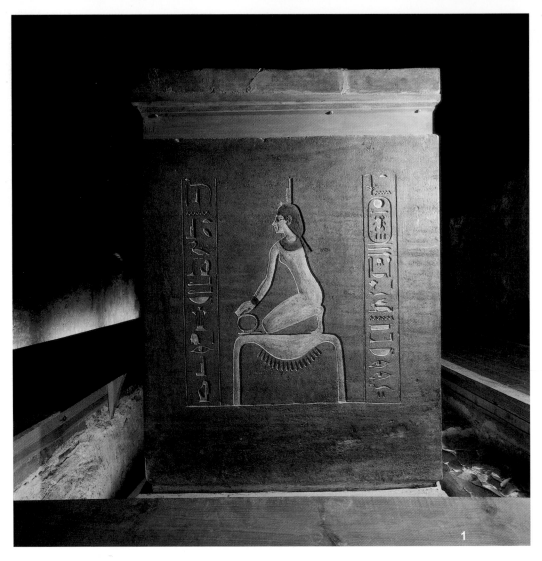

there. In one of the battles he fought alone against a Syrian officer, whom he at last killed. The commemorative palette states the following: "His majesty raised his hands above his eyes to examine the horizon. Then his majesty saw some Asiatics galloping their horses towards him. Now his majesty was armed with his weapons. Then his majesty beat down their swords, and killed them with his spear, and carried off the body of the officer, his span of horses, his chariot, two bows, a case full of arrows and a shield".

Much building occurred during his reign while immense wealth was accumulated all over the country. Temples were decorated with large quantities of gold. Amenhotep II died in 1419 BC, and was buried in the Valley of the Kings. Prior to him four pharaohs were secretly buried there, they were Tuthmosis I, II, III and Hatshepsut.

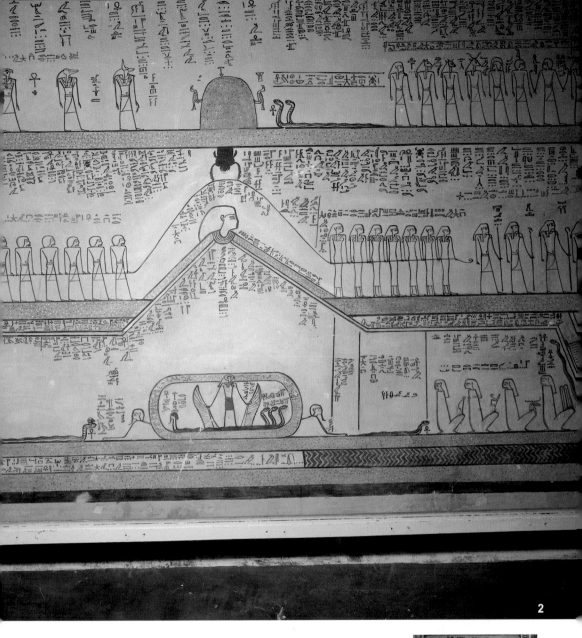

2

1. The cartouche-shaped sarcophagus.
2. The Fifth Hour of the *Amduat*. Ra's solar boat is towed across the mound of Sokar, which symbolises the tomb of Osiris, hence flanked by his two sisters, Isis and Nephthys, in the form of kites. The tow rope of the boat is held by the scarab Khepri denoting the rebirth of Ra from the night, in the form of the scarab beetle. The entrance of the mound is guarded by four heads spurting flames. Emerging from a mound of sand on the back of Aker, the double-headed, leonine earth god, is the primeval representation of Ra. The hawk-headed Sokar grasps the two ends of a venomous snake with a human head at one end and three snakes' heads at the other. Below the evil Sokar lies the "Lake of Fire" a place of punishment.
3. Drawing of Amenhotep II before Anubis, on one of six pillars.

3

1

The Tomb of Tuthmosis III (1504 – 1450 BC) KV 34

The tomb of Tuthmosis III was discovered in 1898 by the French archaeologist Victor Loret. The entrance lies in a recess in the rocks approximately 20 metres above the valley floor. This ingenious site is concealed naturally and in addition rains and floods had piled up debris that further hid the tomb. Today the entrance is reached via a steel stairway, but at the time the tomb was built the stairs were built of mud brick. From the top of the stairs one has a beautiful panoramic view of the royal valley. The entrance points to the north and the burial chamber lies on an east-west axis. The burial chamber is not rectangular but oval in shape, 15 X 9 metres and has four side chambers; their purpose was for the funerary offerings. The well chamber is an innovation to the previous tombs. The sarcophagus is carved of quartzite painted brown. Tuthmosis's mummy was found in the Deir el-Bahari cachette and is now displayed in the Egyptian Museum in Cairo. The walls of the burial chamber were decorated with a complete version of the *Amduat* drawn in red and black ink. The hieroglyphs are written in a cursive script. The two columns of the burial chamber have only a short version of the text of the *Amduat* without any drawings. Only the burial chamber was decorated.

Tuthmosis III was a great warrior, and often described as the most competent pharaoh that Egypt had produced. His personality can be felt from his mummy and also from his many statues. He had a strongly built body, was 165 centimetres tall, and was obviously a man of enormous energy.

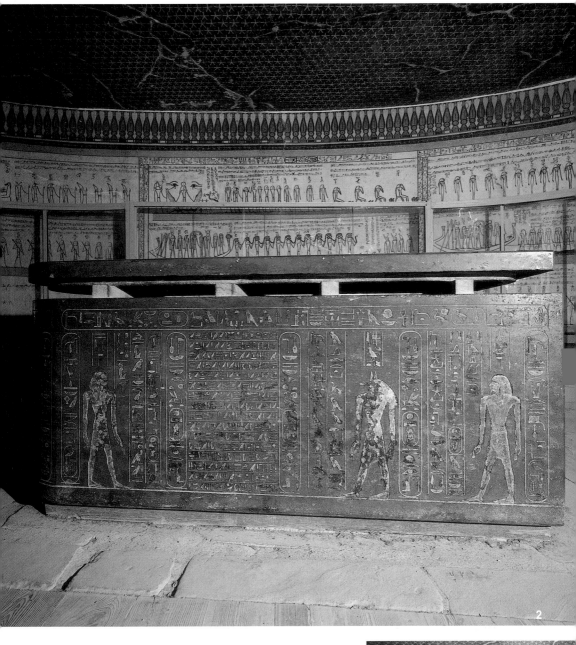

1 & 3. The burial chamber with the sarcophagus in the foreground.
2. Isis suckling Tuthmosis III. Her breasts emerge from the branches of a sycamore tree.

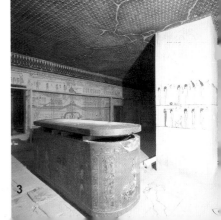

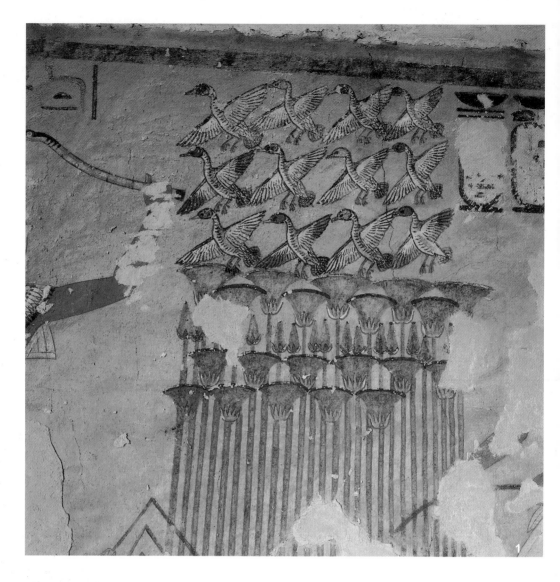

The Tomb of Ay (1325 – 1321 BC) WV23

The tomb of Ay lies in the western fork of the valley. This region is isolated compared to the eastern side that is always teeming with tourists. It is so desolate that one has the feeling of being a million miles away. There are over 58 tombs in the eastern section as opposed to only four in the west. Ay was buried in this tomb, but we are not sure whether the tomb was originally built for him. It could have been built for Tutankhamun or Smenkhkare. The granite sarcophagus was smashed to pieces by ancient tomb robbers. It was restored by the Cairo Museum and has now been returned to the tomb.

Tutankhamun died without heirs and the throne passed to his nearest male kinsman, Ay, the father of Akhenaten's Queen Nefertiti. Tutankhamun's wife made a bid for the throne herself by entering into correspondence with the king of the Hittites, the rising power in the land of Syria: she said that her husband had died, that she had no children, and that if she were to marry the son of the Hittite king she would make him pharaoh. Nothing came of these negotiations, however, and the elderly Ay reigned for four years, during which he made himself a tomb in the desert ravine in which Amenhotep III was buried, but has left few other remains of his activities.

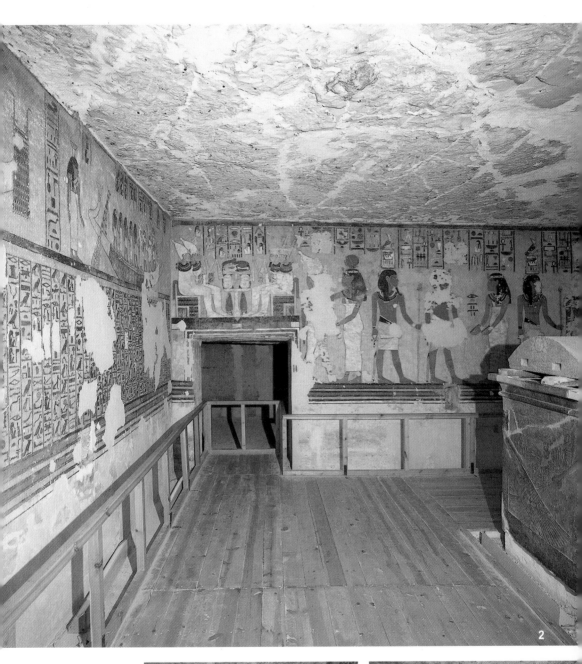

1. Ducks in papyrus marshes. This drawing is unique in a king's tomb, because such scenes of daily life are more usually found in nobles' tombs. The number of ducks here is twelve, which coincides with the number of day and night hours.
2. Overall view of the burial chamber.
3. Twelve baboons in the north wall of the burial chamber.
4. Nephthys behind the sun barge.

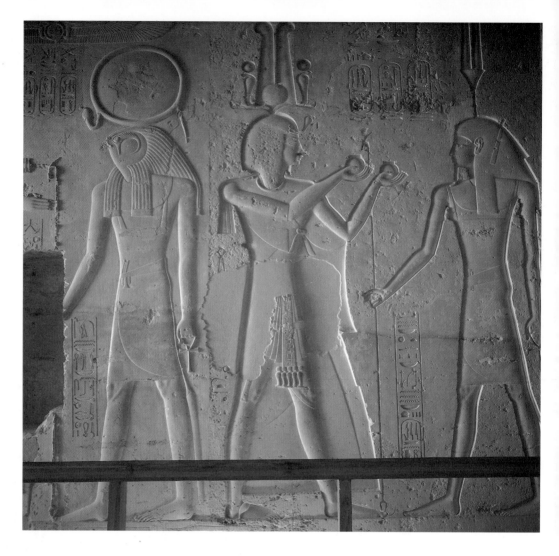

The Tomb of Siptah (1193 – 1187 BC) KV 47

The 125 metre-long tomb was hewn in poor quality rock. The entrance corridor has low reliefs of the Litany of Ra. Then 74 reliefs of the solar deity are listed on the walls. These are followed by scenes from Chapter 151 of the Book of the Dead. Here Anubis is shown standing next to a mummy lying on a bed. The next corridor has decorations in a poor state from the fourth and fifth hour of the *Amduat*, which were ruined in antiquity. The red granite sarcophagus is still in the burial chamber. His mummy found in the cache of the Amenhotep II tomb is now in the Egyptian Museum in Cairo.

Merenptah was succeeded by his son Menmaere Amenmosis, who legitimised his accession by marrying his sister Tausert; but after a reign of about a year he died, whereupon Queen Tausert was married to a younger brother, a cripple with one leg shorter than the other, who was crowned under the name Siptah. The real power, however, was in the hands of Tausert, who was supported by a great statesman named Bey, just as Queen Hatshepsut of the 18th Dynasty had been supported by Senmut. Bey was highly honoured by the queen and he was allowed to make a tomb for himself in the Valley of the Kings. Siptah, however, died after a reign of only six years, and another brother, Sety II ascended the throne.

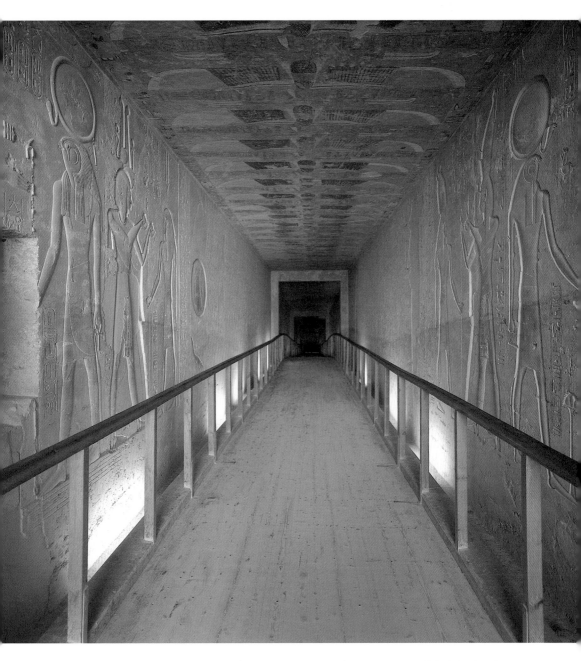

Left : Low relief of Siptah and
Ra-Herakhty.
Above : View of the tomb from the
entrance.

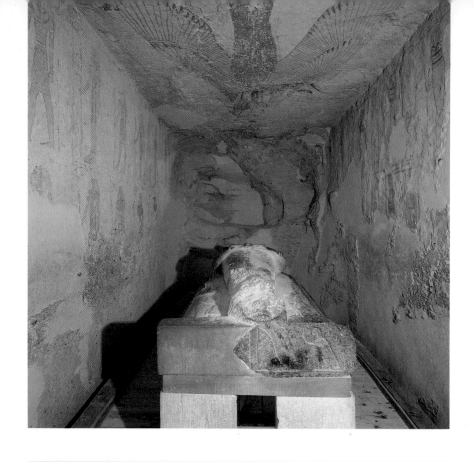

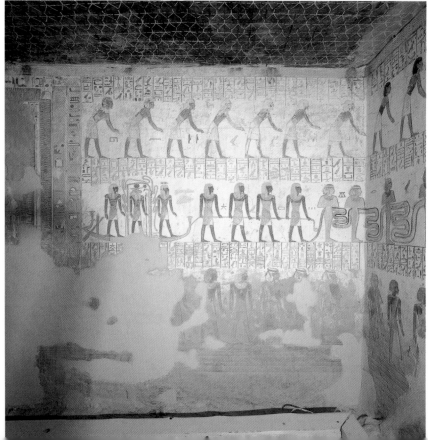

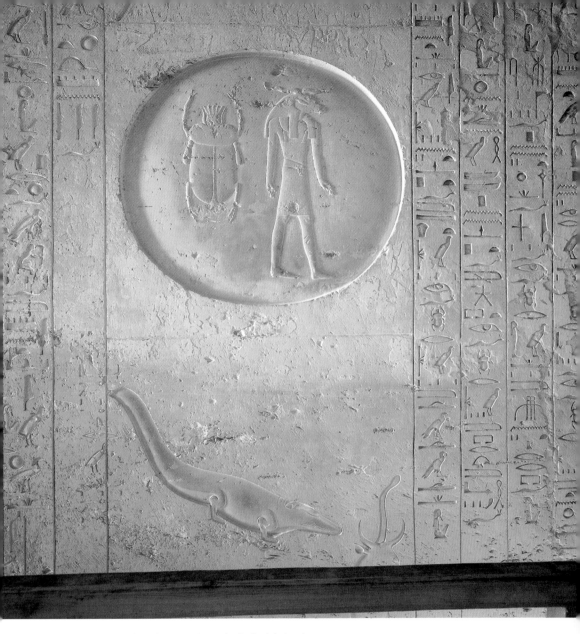

Facing page top : The red granite sarcophagus in the burial chamber.

Facing page bottom : The journey of the sun god in the netherworld. Ra stands inside a shrine in the solar-barge, guarded by a snake. The barge is pulled by four men.

Above : The Title of the Sun Litany.

From the time of Sety I, the entrance of the royal tombs was decorated with reliefs of the evening form of the sun god represented as a ram-headed man, and the early morning form with the head of the scarab Khepri. Khepri represents the self renewal of the sun every morning. Both are shown inside the sun disk. The scarab became the most popular amulet of ancient Egypt. The serpent above (not shown in the picture) and the crocodile below the sun are evil powers fleeing the triumphant god.

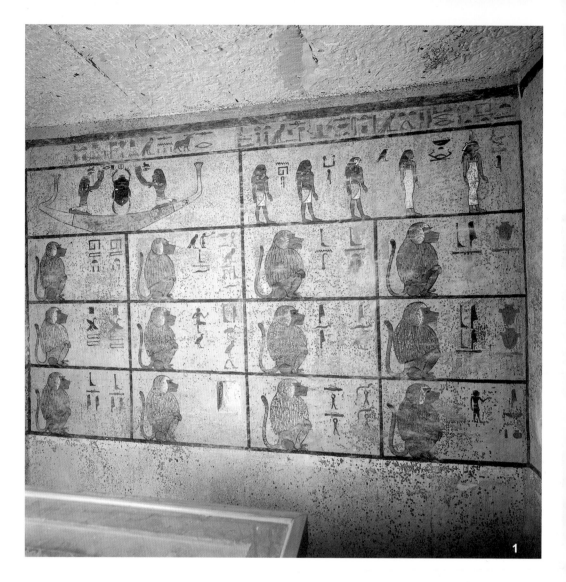

The Tomb of Tutankhamun (1334 – 1325 BC), KV62

The world famous tomb of King Tutankhamun is the smallest of the kings' tombs; it was discovered in 1922 by the English archaeologist Howard Carter. It was found to be richer in treasures than any other tomb hitherto discovered, since it had never been looted by grave robbers, even in ancient times.

Howard Carter was working for the wealthy 5th Earl of Carnavon, who had received a concession to excavate in the Valley of the Kings, and who not infrequently shared the labour of digging; however, at the time when the tomb was found, he was in England. For five years the archaeologist had been searching fruitlessly for what he was sure must be there; on November 5th, 1922 he had his reward. Quite near the tomb of Ramses VI he came upon a step, then a sealed door. "It was a soul-stirring moment for an excavating team." Later Howard Carter wrote of this hour when he was confronted with the treasures of the burial chamber: "Surely in the whole history of excavation nothing so wondrous had been seen as was now revealed to us by the light of an electric torch".

Tutankhamun was nine years old when he came to the throne. At the beginning of his reign, when his name was still Tutankhaten, he lived at Tell el-Amarna where Akhenaten had established a new city for the worship of the Aten. But the young king, who was the second successor to Akhenaten, in obedience both to public opinion and to the priests of Amun, re-established the royal residence in Thebes, and at the same time changed his name to Tutankhamun.

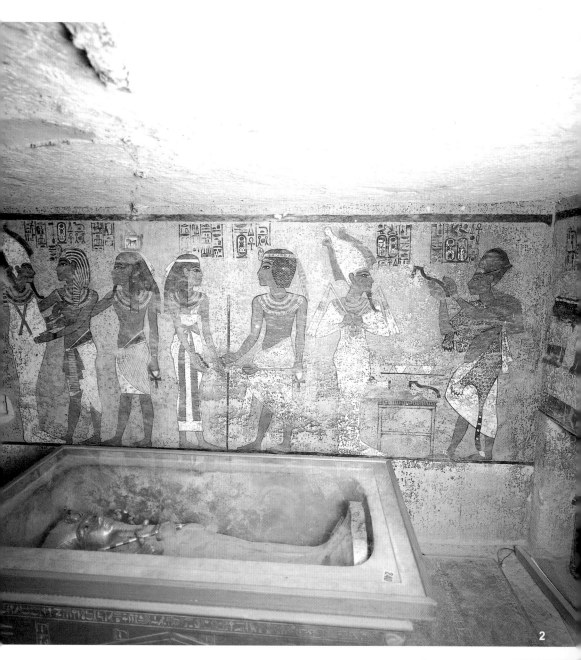

1. The First Hour of the *Amduat* with twelve baboons and the early morning representation of the sun god Ra as a beetle. Below is the outer coffin made of gilded wood. It is placed inside the sarcophagus. The mummy of the king is still inside the coffin.

2. Overall view of the burial chamber, with the sarcophagus and coffin. The wall decoration is very similar to that in the tomb of Ay.

The left side of the wall decoration shows Tutankhamun and his *Ka* before Osiris, the next scene shows Tutankhamun before Nut and then Osiris.

3. The outer gold coffin of the king.

Whether Akhenaten or the steward of the Royal Harem was his father is not definitely known. He was in any case the son-in-law of Akhenaten, since it is known that he was married to the princess Ankhesenaten, or Ankhesenamun, a daughter of Akhenaten. After a reign of nine years Tutankhamun died at the age of 18.

Never before had a tomb been found so packed with treasures; most of them can now be seen displayed in the Egyptian Museum in Cairo. From the entrance of the tomb 16 steps lead down to a passage about 8 metres long, which was closed by a sealed door at the further end. Then one enters the antechamber, the biggest room in the whole tomb; a door on the left gives on to a side chamber for the funerary equipment. To the right (north) was another sealed door in front of which stood two life size statues of the king, now in the Egyptian Museum in Cairo; the door also has now been removed. The visitor goes up to a balustrade and looks down upon the golden coffin lying in its sarcophagus in the burial chamber below. When the king was buried, his mummy was placed in the innermost of four coffins of cedar of Lebanon entirely covered with gold. Howard Carter found the mummy wrapped in its 16 layers of linen; it still lies in the innermost coffin ... "For at least 3300 years the body of the young pharaoh, issue of that strange family of Akhenaten of Tell el-Amarna, had rested there undisturbed."

The Valley of the Queens

In the Valley of the Queens, lying at the southern end of the necropolis of Thebes, there are about 70 tombs of queens, princes and princesses of the 19th & 20th Dynasties. Most of them are either unfinished or undecorated. Excavations in this region were undertaken at the beginning of the last century by a group of Italian archaeologists under Schiaparelli. The four most important tombs, of which the tourist should see at least two or three, are:

Queen Nefertari
Nefertari was the wife of Ramses II. Her tomb contains some very fine reliefs, with the colours still bright and clear; the representations of the queen herself are outstandingly good.

Queen Titi
Titi was the wife of one of the Ramessides, but it is not definitely known which one. The vestibule and a long corridor lead to a chapel, with further rooms to right, left and rear. Pictures of the queen before the gods decorate the walls, and in the chapel are vividly coloured paintings of gods and demons.

Prince Amunkhopeshfu
The prince, a son of Ramses III, died at the age of 12. There are some very beautiful wall reliefs in his tomb, showing his father Ramses III presenting his little son to the gods of the netherworld.

Prince Kha-em-weset
This prince was also a son of Ramses III and an officer of the royal guard. His tomb contains a number of fine coloured reliefs; in the first room one shows the prince and his father before the gods, and in the corridor we see the father and son at the entrance to the netherworld.

The Temple of Deir el-Madina

This 3rd century BC temple was begun by Ptolemy IV-Philopator and is dedicated to two goddesses: the sky goddess Hathor, and Maat, the goddess of justice. It lies about 1 kilometre from the Ramesseum and is built of stone blocks, but is smaller and more delicate in construction than any of the other temples here. Through a gateway one enters an open court with two pillars; from here we come to the vestibule with three chapels behind it. Above the entrance to the central chapel (left) on the left wall, the judgment of the dead is shown, presided over by Osiris, god of the underworld; Horus, and Anubis weighting the heart of the departed on the scales, while the god Thoth writes down the court's sentence. Above are the 42 judges of the dead. In the central chapel and that on the right, the dead man stands before the gods. In early Christian times this temple was for some time a monastery.

Tombs of the Nobles

The tombs of the nobles at Sheikh Abd el-Qurna, nearly all of the 18th Dynasty, are covered with wall pictures which afford us a great deal of information about the life of ancient Egyptians 35 centuries ago. Though generally spoken of as tombs, they are in reality funerary chapels sometimes giving the impression of being ceremonial halls. In most cases there is a broad hall first, then a passage leading to a niche in which once stood the

statues of the dead owner. There are over 300 such rock tombs or chapels but most are now in ruins. Instead of the reliefs with which royal tombs were chiefly decorated, these are embellished with wall paintings on a white background. The visitor should see at least three of these tombs, preferably those of Nakht, Menne and Ramose. Anyone with more time at his disposal will not regret a visit to some of the others as well.

The principal tombs of the nobles are: Nakht, an Overseer of the Royal Granaries; Menne, Steward of the Royal Estates under Tuthmosis IV; Ramose, a *vizier* under Akhenaten; Khaemhet, Chief Overseer of the Theban granaries; Senufer, Prince and Chief Overseer of the Stores of Amun.

Name	Office
Nakht	Overseer of the Royal granaries
Menne	Steward of the Royal Estates under Tuthmosis IV
Ramose	vizier under Akhenaten
Khaemhet	Chief overseer of the Theban granaries
Senufer	Prince and chief overseer of the Stores of Amun
Enne	Prince and royal scribe under Tuthmosis I
Horemheb	General under Tuthmosis IV
Userhet	Teacher and scribe
Nefer-hotep	Priest under Horemheb
Amenemhab	Officer and judge in the royal court
Rekhmire	vizier under Tuthmosis III and AmenhotepII

Tomb of Nakht

This tomb is only a small one but contains many fine paintings, whose colours remain fresh and bright. Particularly remarkable is one of a blind harpist and three dancing girls, who are also playing musical string instruments and a flute. There are also sacrificial scenes showing Nakht and his wife, and in other paintings we see them at the dining table and amid scenes of country life, such as working in the fields, harvesting, fishing and hunting birds.

Tomb of Menne (or Menena)

The tomb of the steward of the estates of Tuthmosis the 4th, of the 18th Dynasty, is one of the most interesting of all. The mural paintings, still well-preserved, are of great artistic merit. It will be noticed that the eyes in pictures of Menne are generally scratched out; this was done by a personal enemy in revenge. He believed that by blinding the figure of the deceased the latter would not be able to enjoy the marvels of the Netherworld.

In the first room on the right, Menne and his wife are seen before the offerings. Opposite are funerary ceremonies. On the left wall of the entrance Menne is seen inspecting the domains; among other scenes is, above, a fine picture of surveying; it is to be noticed that the units of measure have been obliterated by enemy in order to prevent the deceased from knowing the extent of the lands. On the narrow wall to the left Menne and his wife are seen sacrificing to Osiris. In the corridor following are pictures of the funeral ceremony. On the left wall is the journey to Abydos, the sacred place with the grave of Osiris; this is followed by pictures of Menne before the tribunal of Osiris, where his heart is being weighted. Opposite are hunting scenes in the marshes and swamps. At the end of the corridor is a niche for the memorial stone of the deceased and his wife.

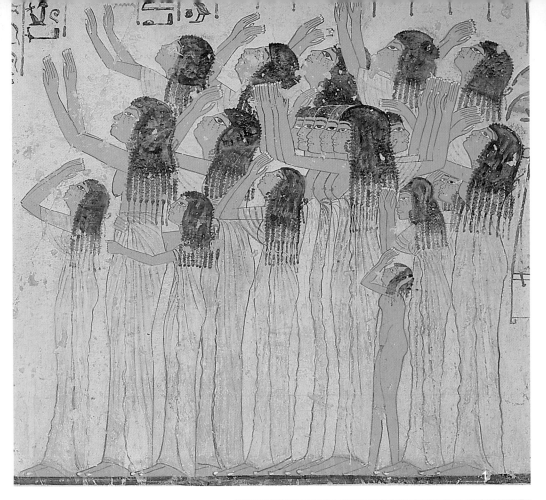

Tomb of Ramose

Ramose was *vizier* under Tuthmosis the 4th, afterwards the "heretic king" Akhenaten, who introduced the cult of the sundisk in place of polytheism. The tomb, in which some of the pictures are executed in relief and other painted on the walls, representing sketches of great historical significance.

There are very few tombs except those in Tell el-Amarna showing worship of the sun-disk. In the first pillared hall, there is an expressive representation of the funeral procession in which we see the willing women reminiscent of the professional mourners still to be seen in village funeral processions in Egypt today. On the east side Ramose and his wife and relatives are seen partaking of a repast. The most remarkable picture of all is on the western wall: Akhenaten and his wife, Ramose in outline only, and the king's bodyguard; above the group is the sun-disk with its long rays terminating in hands.

1. Tomb of Ramose TT55.
2 - 5. Tomb of Amenemonet TT 277.

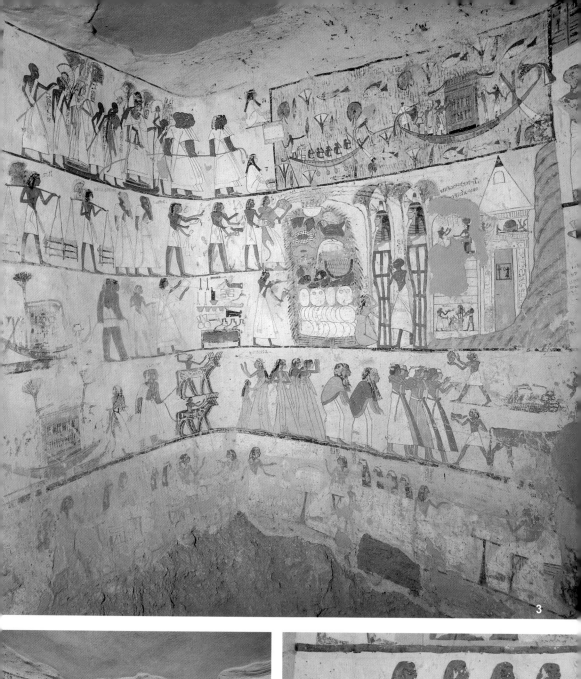

3

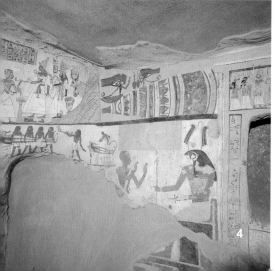

4

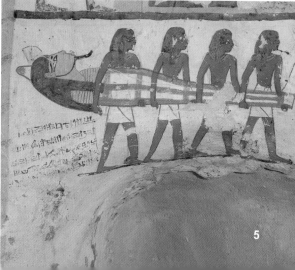

5

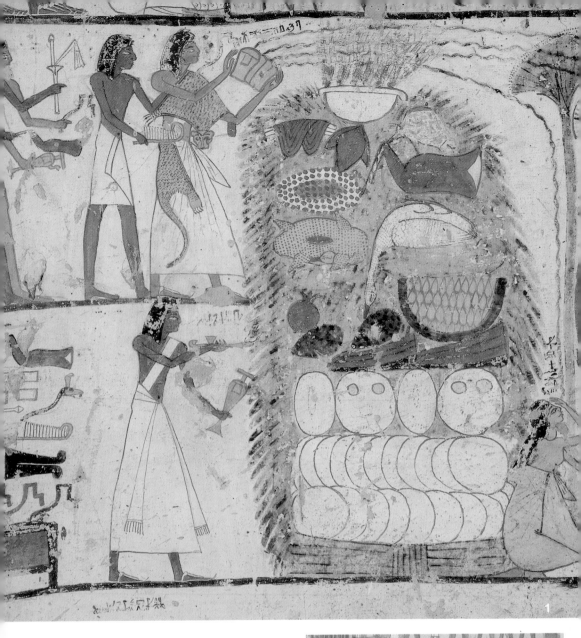

1. Tomb of Amenemnet TT 277.
2 & 4. Tomb of Pairi TT 139.
3. Tomb of Huwi TT54.

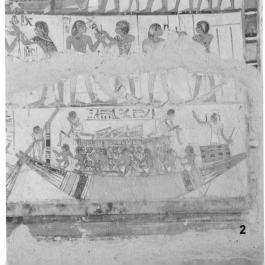

The Mortuary Temple of Sety I

The temple, dedicated to the god Amun, was planned and begun by Sety I towards the end of his reign (1278 BC) as a mortuary temple for himself and his father Ramses I, but it was not completed. It was not until the time of Ramses II that is was finished and beautified with some very fine reliefs and inscriptions.

Though the pylon and courts are in ruins the place of worship itself, 45 X 52 m still exists, with the hall containing 6 papyrus pillars, the inner sanctuary, the cult-chamber of Ramses I (left) and some side chambers. The cult-chamber of Ramses II (right) has suffered much damage. The temple measures 124 X 162 m.

1. The portico with 10 papyrus bundle-shaped columns.
2. The roof with coloured paintings.
3 & 4. Workers during the excavations.
5. View inside the temple.
6. Alabaster statue of Sety I, Luxor Museum.
7. Columns of the hypostyle hall.

On Foot to Deir el-Bahari

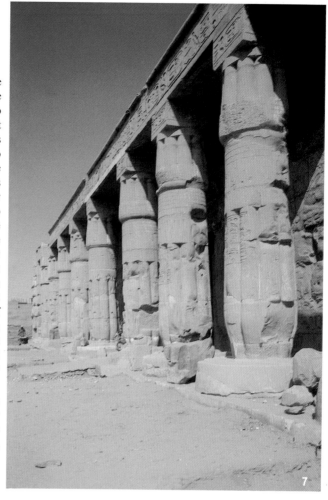

After a visit to the Valley of the King the visitor should go on to Deir el-Bahari; if the exploration of the tombs has proved too exhausting the trip can be made by car but the path over the heights of the mountains is so impressive and beautiful that it is a pity to miss the experience of going on foot. The walk takes only thirty to forty minutes; it is advisable to have someone point out the way from the small rest-house opposite the tomb of Tutankhamun. The steep ascent can be somewhat tiring but on the height, where the path is good, there is an unforgettable view over the naked, rust-red mountains and the overwhelming loneliness of the valley. Care should be taken on the way down on the east side : it is imprudent to hurry. The view of the Nile Valley from the summit, and even more on the way down, overlooking the Temple of Deir el-Bahari with the steep and massive mountain rising behind it, is deeply impressive.

Deir el-Bahari, Arabic for "the Northern Monastery", is so-called after a monastery which was built in the 7th century in the temple area of the temple of Queen Hatshepsut. There are two sanctuaries (terraced temples) at Deir el-Bahari : the Great Temple of Hatshepsut of the 18th Dynasty, and, south of it, the mortuary temple of King Mentuhotep of the 11th Dynasty, more than 550 years older than the queen's temple.

The Temple of Queen Hatshepsut

This temple, dedicated to the cult of "the beautiful and gifted" Hatshepsut and her family, differs in plan, style of architecture and decoration from all other temples in Egypt. It is more graceful, pleasing and certainly less oppressive, freer in its style, than the monumental and massive buildings of the previous periods. It is worth noticing that it was a woman who finally broke through the established tradition of temple architecture.

The temple was dedicated to the god Amun but it contained also chapels for the god of the dead, Anubis, and for Hathor, the tutelary goddess of the Theban necropolis. There are few buildings remaining anywhere in which the struggle for power within a family can be so clearly traced as in this temple. Queen Hatshepsut (1498 - 1483 BC) had built it, but in every place on its walls and pillars where her lineaments or her name appeared, her features and her appellations have been chiseled out and effaced. It was her step-son Tuthmosis III who thus satisfied his hatred and wreaked his vengeance on his co-regent.

Much of what happened at the beginning of the 18th Dynasty is a mystery. All that is known for certain is that while Tuthmosis I was still living, dynastic quarrels had broken out among his children, Hatshepsut and Tuthmosis II (also spouses), and with Tuthmosis III (son of Tuthmosis II by another queen), and that all three reigned by turns. Tuthmosis I himself had come to the throne only in virtue of his marriage to Ahmose, a princess of an old Theban royal line; the sole legitimate issue of the union was a daughter, Hatshepsut. J.H. Breasted, in his "History of Egypt" gives a detailed account of these highly complicated family affairs and also discusses the

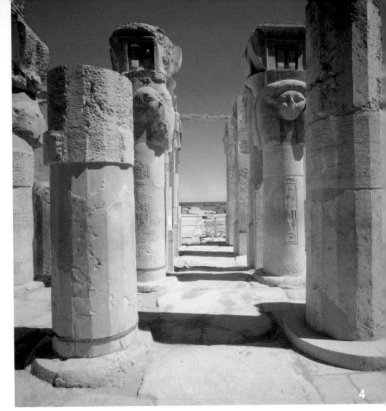

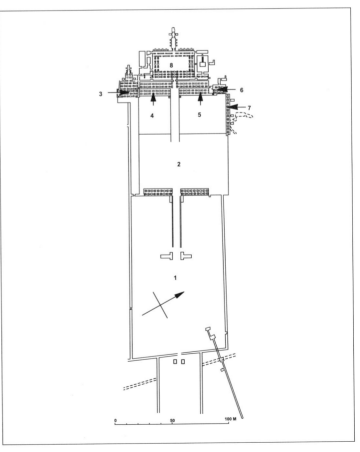

Right : The Temple of
Hatshepsut.
1. Lower court. 2. Middle terrace.
3. Shrine of Hathor. 4. Portico of
Punt. Portico of Birth. 6. Lower
shrine of Anubis. 7. North
colonnade. 8. Upper terrace.

influence of the priestly castes and factions, so that the quarrels and shifts of power, although dating back 35 centuries, have in many instances a contemporary ring.

Tuthmosis II and Hatshepsut reigned for about 14 years. After his death, Hatshepsut acted as co-regent for the young king Tuthmosis III, but "before long her party had become so powerful that the king was seriously handicapped in his decisions and finally even pushed into background; changes crept into the customs and protocol of the court, adapting them to what was befitting the rule of a woman".

Hatshepsut began to build her own temples and to promptly fulfill the duties of her office with the greatest energy; she is the first outstanding of whom we hear in Egyptian history. Her partisans had appropriated to themselves the key posts : from *vizier*, chief treasurer and high priest of Amun downwards, the whole machinery of government was in their hands. It stands to reason that the wealth and probably the very lives of all these men were closely bound up with the queen's primacy. They therefore took special care that Hatshepsut's position should continue to be acknowledged, and tried in every possible way to prove that she had been predestined to the throne by the gods themselves from the beginning.

In her temple at Deir el-Bahari, long rows of reliefs were engraved on the walls, representing the birth of the queen. Here, all the particulars of the old governmental fiction, showing the ruler as the actual child of the sun-god, were pictured in detail. So contrary to custom, however, was the introduction of a female in such a connection; the artist who carried out the work followed immutable tradition to the letter and the new-born child is depicted as a boy, the introduction of a girl-child at this point would have done too great violence to age-long convention. The reliefs also show how Tuthmosis I summoned Hatshepsut and recognized her as queen, and that he prayed for his daughter's reign. By such representations efforts were made to overcome the prejudice against a woman occupying the throne of the Egyptian kings.

Hatshepsut, as mentioned above had a masculine-like character. Therefore, it was not strange for her to be represented in male's clothes, and insist on having male titles such as king instead of queen, and the words 'he' were used instead of 'she'. Actually we don't know wether these initiatives are hers or she was influenced by the nobles. Because these nobles made fortune from their alliance with Hatshepsut, their chief interest was that she keeps the throne.

When at last Hatshepsut died - no one knows exactly how or of what she died - Tuthmosis III was again sole ruler. The majority of partisans fled and those who did not take to flight certainly were punished. Tuthmosis III had stood too long in the shadow of the mighty woman who was not only his aunt, step-mother and mother in law, but also co-regent, and who had proved herself, through the considerable following she attracted, to be the stronger character. After years of suppressed hatred, Tuthmosis III gave free reign to his spirit of revenge. In all contemporary documents, even in the tombs and on all statues, her name and her effigy were chiseled out. The mutilated monuments stand till

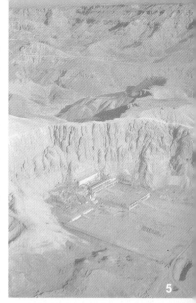

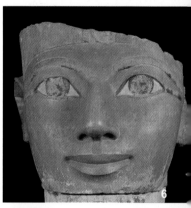

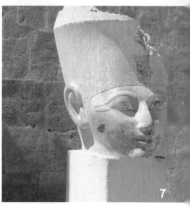

1. Shrine of Hathor. 2. High relief of soldiers in the Hathor shrine. 3. High relief of soldiers in the Punt Hall.
4. Capitals of the Hathor Temple. 5. Aerial view of the temple of Hatshepsut with the Valley of the Kings in the background. The architect and overseer of the Temple of Deir el-Bahari was Senmut. Here we should recognise the fact that Queen Hatshepsut gave this great man the opportunity of building this unique and beautiful temple which glorified both of them.
6. Head of Hatshepsut, She had a masculine character. Therefore, it was not strange for her to be represented wearing men's clothes, nor to insist on taking male titles such as king instead of queen, and using 'he' instead of 'she'. This head is now in the Egyptian Museum in Cairo.
7. Head of Hatshepsut in the Upper Terrace.

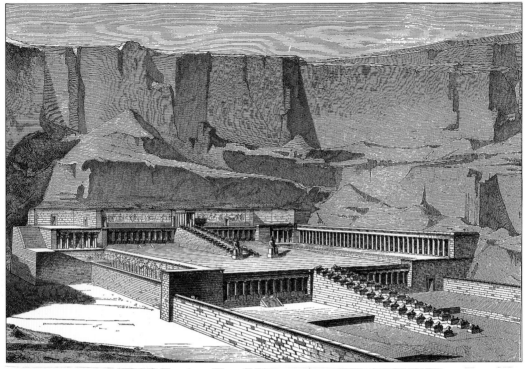

Top: Drawing of the temple of Hatshepsut: *Egypt, Descriptive, Historical and Picturesque* by Georg Ebers, Leipzig 1879. *Above:* Capitals at the Hathor Temple.

this days as eloquent. Witnesses to the great king's revenge, but in Hatshepsut's noble temple at Deir el-Bahari her fame still lives.

The temple is composed of three widely-spaced terraces, the highest of which is up against the slope of the mountains. The queen conceived it as a pleasure garden of Amun, and regarded its terraces as myrrh-terraces of the Land of Punt, where the gods had a rest. In the plain an avenue of sphinxes led up to the terrace, but hardly any traces of it now remain and the lowest terrace also is in ruins. In the middle an incline leads up to the second terrace from the wide open court. On either side of incline, slightly raised, are two halls, each supported by 22 pillars; on the right, the Birth Hall, on left, the so-called Punt Hall.

On the walls of the Birth Hall are scenes portraying the birth of the queen; part of this is very good work, but everywhere the picture of Hatshepsut has been chiseled out. The picture of her mother, Ahmose, is particularly good. At the northern end of the colonnade two steps lead into a vestibule with 12 sixteen-sided columns. The reliefs are noticeable for the freshness of their colouring. Here also the figures of the queen are effaced. On the west wall Hatshepsut is shown during a sacrificial ceremony; on the left, before the sun-god Amun; on the right, before Anubis, the god of the dead. The chapel of Anubis, standing behind this wall, consists of three chambers, on whose walls the queen is seen before the gods. Tuthmosis II is shown on the eastern wall of the second chamber.

The visitor now returns to the middle incline and from there to the south colonnade, the so-called Punt Hall. The walls are covered with reliefs of a naval expedition which Hatshepsut, in obedience to an oracle of Amun, dispatched to the Land of Punt. The reliefs, though partially destroyed, are among the most interesting of their kind in Egypt. They immortalize the incidents of the voyage and the

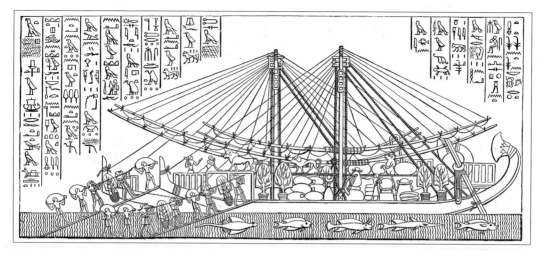

Trip to Punt on the walls of the temple of Hatshepsut: *Egypt, Descriptive, Historical and Picturesque* by Georg Ebers, Leipzig 1879.
Members of the expedition are shown loading the vessel with goods of Punt among these are the sycamore trees, baboons and other species of apes, musical instruments, myrrh and incense. The text on the left side states the various goods and the sycamore tree, and the text on the right reads : "... no one has brought such goods prior the king (Hatshepsut)".

experiences of the navigators in the far and fabled Land of Punt, which then lay at the end of the known world : obviously that Red Sea coast which we now know as the coast of Somali. On the right side of the hall, on the north wall, the queen, de-faced, is seen under a canopy. Opposite, on the south wall, are huts and palms beside the water : a village in Punt where the queen's envoys are being received by a prince. The rear wall (west) shows Egyptian vessels being loaded in Punt, pictures of homeward voyage, of the trade-goods and of the nobles before their queen. Following upon these we see the queen dedicating the treasures from Punt to her god; the weighting of precious metals; the counting of incense-trees; Tuthmosis III before the bark of Amun and Hatshepsut before Amun. At the south end of the Punt Hall, corresponding to the Anubis chapel on the north side of the temple, was the chapel of Hathor, tutelary goddess of the Theban necropolis. A few of the 16 sided. columns and some of the Hathor columns (pillars with the head of Hathor) can still be seen. At the second hall is the three-chambered chapel. In the second are some very fine reliefs, among others, that of Hatshepsut (her features effaced) sacrificing to the Hathor-cow.

We must again return to incline which leads to the upper court (the third terrace); the great pillared hall which stood behind the granite gateway is destroyed. To the right (north) is a vestibule containing a niche; to the west is a court with an altar dedicated to the sun-god Ra-Harakhte; in the north wall an opening leads to a chapel. Crossing the upper terrace towards the left, on the south side, one reaches the sacrificial hall, decorated with reliefs and destined for the cult of the dead queen. It is still well-preserved, whereas the other rooms are in ruins. A granite portal in the middle of the last temple wall was leading to the inner sanctuary consisting of three chambers, now all destroyed.

Mortuary Temple of Mentuhotep

This sanctuary, also built in terraces, lies just to the south of Hatshepsut's and dates from the 11th Dynasty (2060 - 1785 BC) Although it is held to be the oldest temple in Thebes it is in such a ruinous state as hardly to be worth visiting, in view of the abundance of other tombs and temples in better repair.

Above: Red Sea fauna depicted on the walls of the Punt Portico. **1.** This is probably a juvenile Batfish *Platax* sp.
2. Surgeonfish **3.** Marine turtle **4.** Squid **5.** Lobster **6.** Scorpion fish *Scorpaenopsis* sp. **7.** Cornet fish *Fistularia* sp.
8. Triggerfish *Balistapus* sp.
9. High relief of soldiers at the Hathor shrine. The soldiers accompanied the expedition of Punt to protect its members. They are carrying the goods of Punt.
10. Pharaoh Nebhepetre Montuhotep, Middle Kingdom, 11th Dtynasty, 2061 - 2010 BC, Egyptian Museum in Cairo. Montuhotep, considered to be the founder of the Middle Kingdom, ruled the country for more than 50 years. When Montuhotep came to the throne, Egypt was in anarchy. His authority was shared with local leaders and noblemen. To consolidate his authority he claimed that he was sent by god as "the herdsman of the land" who will provide for the prosperity of his people, as a shepherd looks after his flocks.
His sandstone Osirian statue was found in a cenotaph dug below the courtyard of his funerary monument at Deir el-Bahari in Thebes. It was discovered accidentally as Howard Carter was passing over a covering slab with his horse causing it to give way, horse and rider falling into the tomb. To this day the tomb is called 'Bab el-Hossan' (the tomb of the horse). The statue had been wrapped in a linen cloth and had been painted black just before it was buried. The statue represents Pharaoh Montuhotep sitting on a stool, wearing the Red Crown and a short white dress.

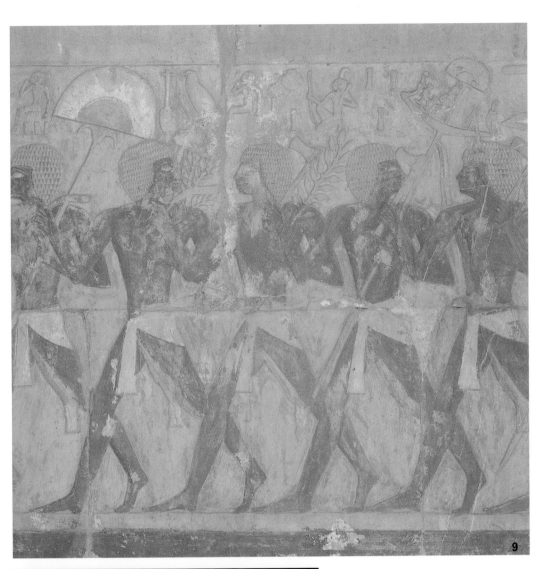

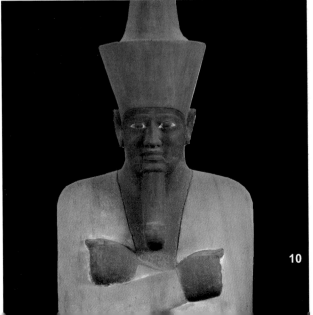

233

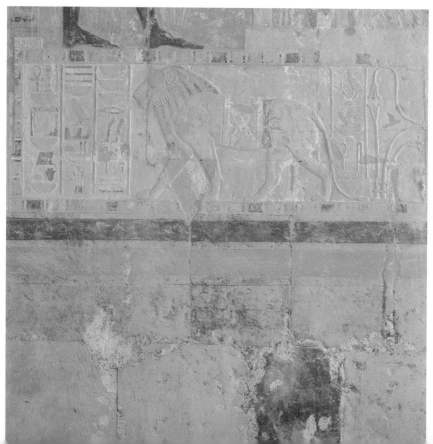

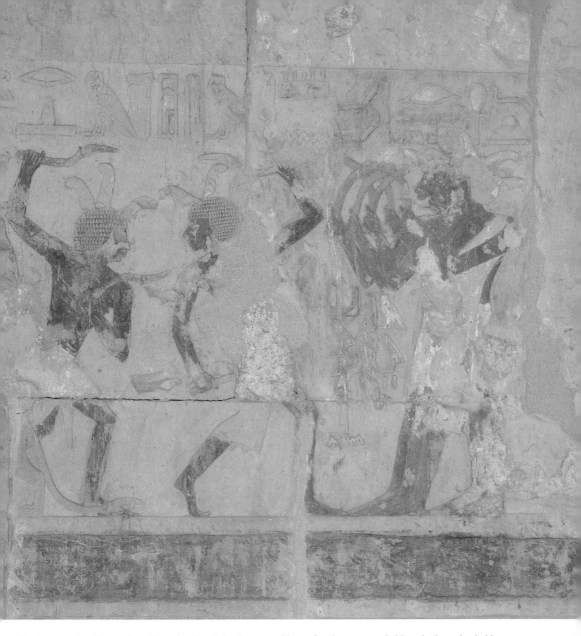

Facing page top: Scenes from Punt showing its landscape and huts of natives approachable only through a ladder, probably to protect them from wild beasts and also to be away from the ground that is constantly washed by rain showers. The whole village lies on the sea shore therefore the water drawing in the lower part of the scene.

Facing page bottom: Relief of two lions, with the *sematawy* sign in-between; only one is shown here, middle colonnade, north. The two lions represent god Aker, the lion not shown is a demonstration of 'yesterday' and the lion shown here is a demonstration of *duat* 'tomorrow'.

Above : Dancers and musicians at the Hathor shrine holding boomerang. Originally the boomerang tool was used in hunting and later adopted by dancers. Their heads is surmounted by feathers, originally wore by hunters in prehistory. The two feathers then developed as a mark of hunters. The conclusion is that this dance or ritual stems from prehistory.

1. The Ramesseum photograped from the hills of Qurna.
2. Battle scene from the Ramesseum: *Egypt, Descriptive, Historical and Picturesque* by Georg Ebers, Leipzig 1879.
Ramses II is represented standing in his chariot and fighting the Hitites alone in the battle of Kadesh. Below the chariot
we see the Ornate river full of fallen enemies and enemy soldiers trying to rescue them. This type of drawing is a
characteristic of the Ramesside period. The meaning of the drawing could be interpreted as the pharaoh putting order to a
chaotic world.
3. Head of Ramses II from a colossal statue.
4. Aerial view of the Ramesseum.

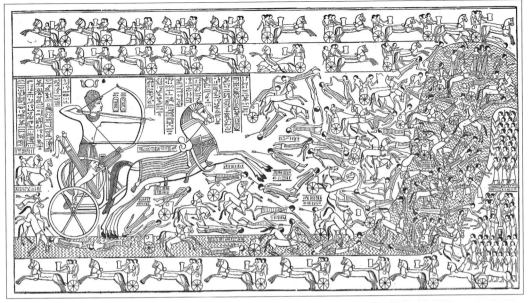

2

The Ramesseum

This great mortuary temple dedicated to the god Amun was built by Ramses II (1279 - 1212 BC), the mightiest king of the 19th Dynasty. It was about 270 m in length, but today, standing on the fringe of the arable land fifteen minutes' walk from Deir el-Bahari, it is only a heap of ruins.

On the east side, facing the Nile, is a pylon nearly 70 m wide an 24 m high, but rather dilapidated on the outer face. On the inner face are still well-preserved scenes of the king's wars against the Hitites. The first court is also in ruins; on its western side lies the colossus of Ramses II, hewn from a single granite block, but now prone and broken into three pieces. It was the biggest statue in the whole Egypt and weighted over 1000 tons. Its principal measurements are : height 19 m; width across the shoulders, 7m; length of index finger, over 1 meter; width of foot, 1.25 m. On both upper arms are engraved the name of Ramses II in hieroglyphics. It is said that it was the Persian king Cambyses who ordered the statue to be broken.

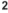

3

The second court is also in a rather ruinous state. On the inner wall, to the right of the gateway, are more reliefs of the wars against the Hitites; the king in his chariot towers above all other warriors. A double colonnade once surrounded this court with figures of Osiris; the fragments of four of them can still be seen. Two granite colossi of the king once stood before the entrance to the vestibule, but they are now destroyed.

4

The vestibule leads to the great hypostyle hall, parts of whose central court remain. In the small colonnaded hall, lying to the west, eight columns, with closed capitals, still stand. On the walls are pictures of Ramses II and on the ceiling astronomical figures can still be seen. Four of the pillars of the colonnaded hall which follows are extant.

A few hundred meters southwest of the Ramesseum stands the "German House," established by the Emperor Wilhelm II to lodge the German Egyptologists working at Thebes.

After his death of Sety I, his son Ramses, 16 years old, ascended to the throne and became Ramses II. Tuy mother of the young King Ramses II was not the Queen-consort of Sety I, although she still was a princess of royal blood.

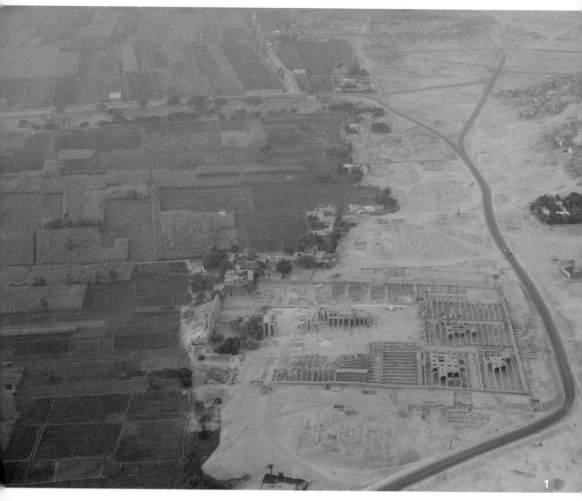

Somehow he was able to surpass his elder brothers and inherit the throne. In a talk-show he once said his father has always intended to inherit him the throne, and had made him commander-in-chief of the army when he was ten years old ! He further said that he was consulted in matters concerning the state before he was 16 ! In fact, Ramses II had a vigorous and showy personality, and he was rather idle.

At the beginning of the 18th Dynasty the Egyptian considered their rule over Syria as a sort of occupation, and the Syrians were regarded as subordinate. Hence there was little cultural interaction. Then slowly these ideas starded to fade, and Ramses II viewed Syria as part of Egypt. Many Syrian princes and officials made their residence in Egypt. As members in the Egyptian court, many Syrian princess, had influence in its orientalization. The large number of *hareem* in Ramses's court is another sign of its orientalization. It is for certain that Ramses was related by marriage to many local rulers in Syria. For instance Ramses II named his favourite daughter Bint-Anath. This is certainly a Semitc name and not an Egyptian name. The significance of this becomes aparant by the fact that this daughter was the legitimate heiress to the throne.

Ramses spent only the winter months in Thebes and the rest of the year in a city that he founded in the eastern Delta. He named the city 'Per-Ramses' meaning 'The house of Ramses'. He established also in the Delta another city that he called 'Per-Atum' meaning 'The house of Atum'. Also the city of Tanis, a few kilometers away, flourished and grew in importance.

Ramses II undertook vast construction projects all over Egypt. He contributed with immense buildings to Luxor and Karnak temples. He also built his mortuary temple, the Ramesseum, in the Thebian necropolis.

238

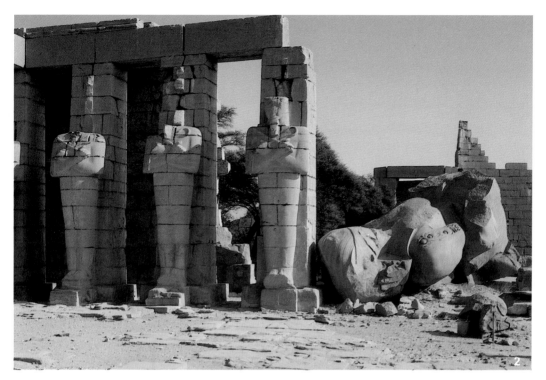

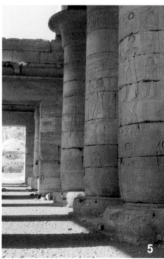

1. Aerial view of the Ramesseum.
2. The second court of the temple with the Osiride pillars.
3 - 5. Colonnades of the second court and the remains of the colossal statue of Ramses II, its original length was 19 metres, and it weighed 1000 tons.

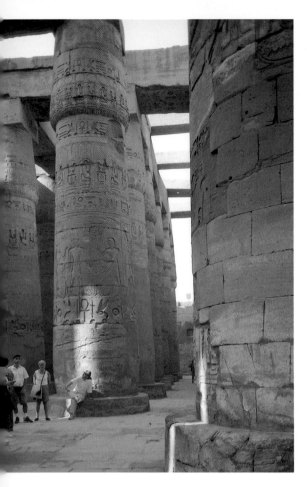

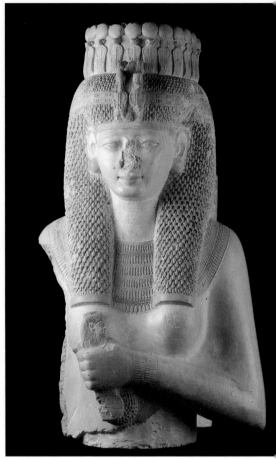

Above left: Hypostyle hall of the Ramesseum.

Above right : Bust of Queen Merit-Amun, wife of Ramses II, found in the Ramesseum and now in the Egyptian Museum in Cairo. Merit-Amun was a daughter of Ramses II whom he married after his queen consort Nefertary had died.

Facing page : Ostracon of a political caricature, a cat herding geese; found at Deir el-Medina, 19th - 20th Dynasty, limestone, 10.5 X 12.8 cm, Egyptian Museum in Cairo.

Ancient Egyptian artists used ostraca (broken pottery and limestone flakes) to draw pictures. Here on this ostraca, a cat acting as a goose-herd stands on its hind paws and drives a group of geese forward. Themes like this one in which animals act out the roles of humans might have been the earliest and safest way to criticize the weak political situation and rising corruption at the end of the late New Kingdom. They show the lack of trust people had in their rulers, as the role of animals are reversed with cats serving mice. Equivalent epigram would be for instance, "If the guard is himself the thief, what happens ?"

The Village of Deir el-Medina

The Village of Deir el-Medina was known in ancient Egypt as *Ta Set Ma'at*, 'the Place of Truth'. The village measures 5100 square metres. The houses were built of mud bricks and stone. The village had only one entrance. During five centuries of the New Kingdom this was the home of sculptors, stone masons, draftsmen, carpenters, painters, goldsmiths and architects. These were builders of the Valley of Kings and mortuary temples. The village was abandoned after the collapse of the New Kingdom, and it slowly became covered with sand until it was discovered 2000 years later. In the 19th century many natives of Qurna did illegal excavations, and as a result thousands of artifacts were robbed. Only in the second half of the 20th century the antiquities department did excavate thesite. Many ostraca was discovered in the village dealing with political caricature and the daily activities of the artists such as love notes, marriage contracts and complaints. These finds are very precious as they give us insight of the daily activities and corruption three thousand years ago.

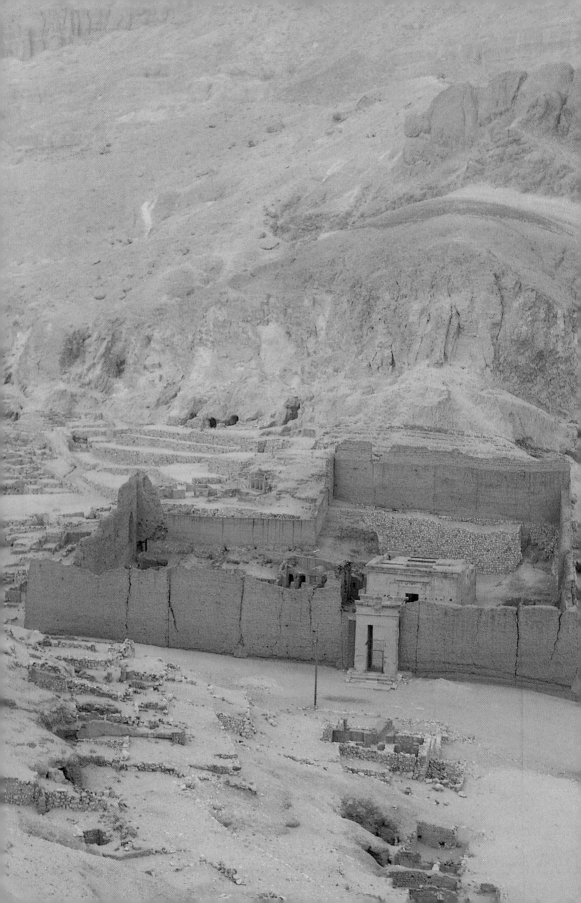

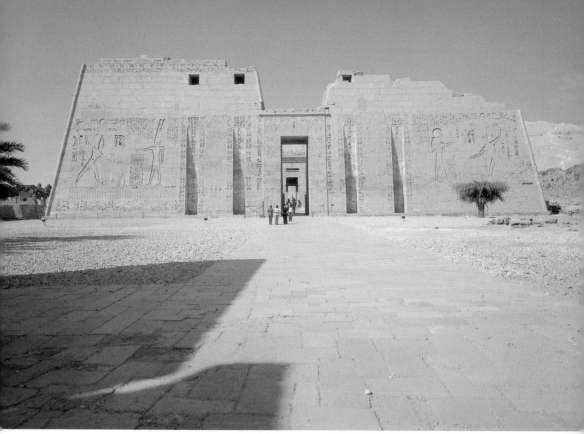

Medinet Habu

The temples of Medinet Habu lies at the extreme south end of the Theban necropolis, about 15 or 20 minutes from Deir el-Madina. The name means "town of Habu" and refers to the Christian village which grew up there in the fifth century of our era.

Like the temple of Sety I at Qurna, the temple of Hatshepsut at Deir el-Bahari and the Ramesseum of Ramses II, the sanctuaries at Medinet Habu are mortuary temples. There are four constructions in all:

1. Pavilion of Ramses III (1182 - 1151 BC)

2. Mortuary Temple Queen Amenerais (700 BC)

3. Great Mortuary Temple of Ramses III.

4. Mortuary Temple of Tuthmosis III (1504 - 1450 BC)

Pavilion of Ramses III

This pavilion was built under the influence of Syrian architecture and is reminiscent of those castle-like fortresses so often stormed by Ramses III during his campaigns in Asia Minor. The pavilion was intended as an entrance to the great temple lying further.

In the pictures showing the construction an outer wall with two guardhouses is observable. Behind it is a crenellated fortress wall, 19 m high, into which are built two great towers. Inside this wall is a court narrowing to a gateway at the end. The reliefs depict the warlike deeds and the victories of Ramses III, and the king slaying his enemies before the gods.

Left: Aerial view of Deir el-Madina.
Top: Pylon of Ramses III at Medinet Habu.
Above: Temple of Medinet Habu.

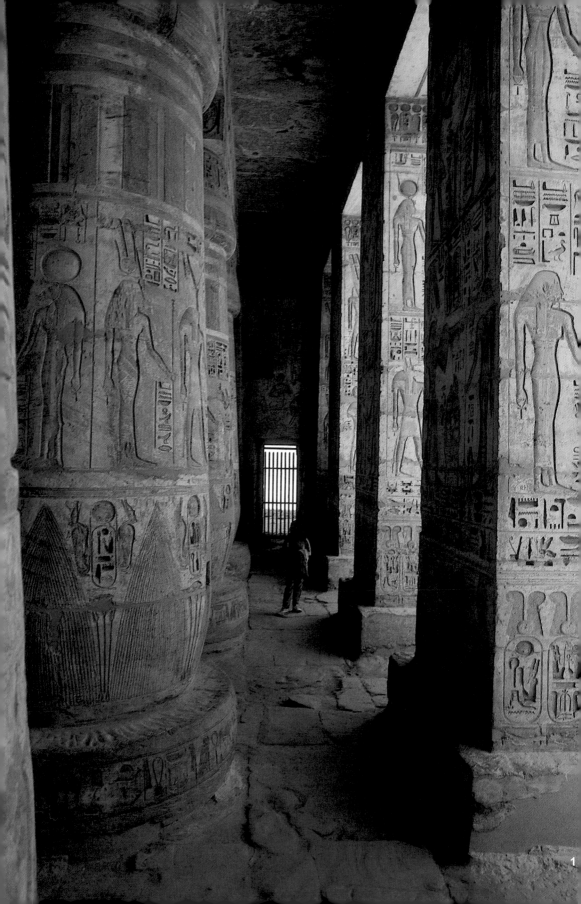

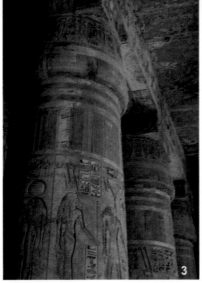

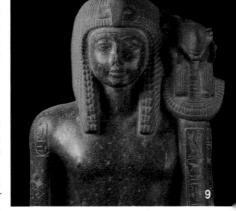

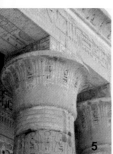

Mortuary Temple of Queen Amenertais

This lies on the west side of the court, between the royal pavilion and the great mortuary temple of Ramses III. Queen Amenertais was the wife of the Ethiopian king Pi'ankhi, who reigned in about 700 BC. The temple is not large and only consists of a four-pillared hall and the sanctuary. The wall pictures are of the queen before the gods.

Mortuary Temple of Ramses III

This temple, dedicated to Amun, is better preserved than its prototype, the Ramesseum. On the outward face of the first pylon (1) are scenes showing Ramses's III victories over his enemies, and in the entrance gateway (2) are reliefs of the king before the gods.

In the first court, left (3), is a row of eight papyrus columns with open capitals (A), on the right, a row of pillars (B) on which statues of Osiris once stood; these are long since destroyed. War scenes illustrating the king's victories decorate the walls.

On the second pylon (4) on the left, Ramses III is seen leading his captives before Amun and Mut. On the right are victories over the enemies from Syria who threatened Egypt. The second court (5), measuring 42 m by 37 m, is surrounded by colonnades; to right and left are columns with closed capitals and both east and west are

1 & 3. Columns and porticoes of the second court. 2. First pylon. 4 & 5. The south colonnade of the first court.
6. Ramses III smiting the enemy, carved on his palace. 7. Prisoners of war, carved on the second pylon.
8. Drawing of the vulture goddess Nekhbet inside the temple of Ramses III. These are the original colours.
9. Ramses III as a standard-bearer of Amun, found in the Karnak Temple cachette, now in the Egyptian Museum in Cairo.

245

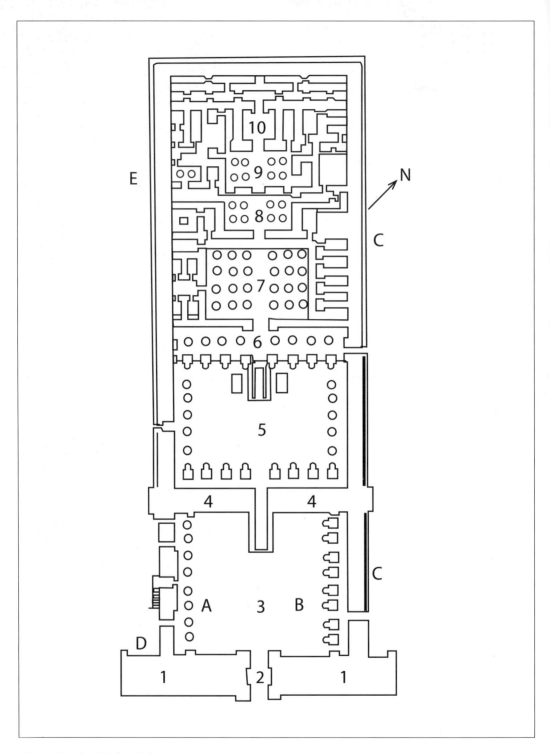

Above : Temple of Medinet Habu.
Facing page : Temple of Habu from *Egypt, Descriptive, Historical and Picturesque* by Georg Ebers, Leipzig 1879.

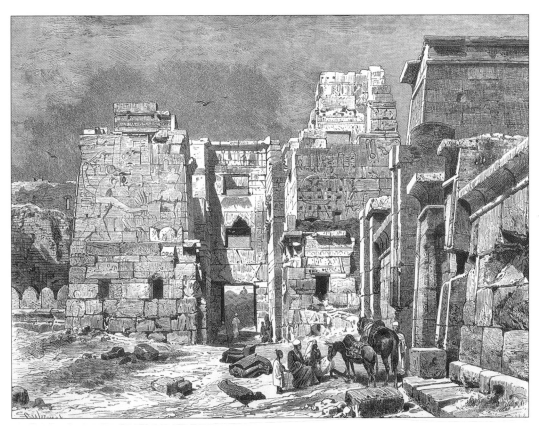

eight pillars with statues of Osiris. On the walls are scenes showing the accession ceremonies and the heroic deeds of the king.

On the west is a terrace (6) whose rear wall shows the king before the gods, with the princes and princesses below. The hypostyle hall (7) once contained twenty-four pillars supporting the ceiling, but it is now almost in ruins. The hypostyle hall is followed by three smaller halls (no. 8 & 9 with eight pillars each and no. 10 with four pillars) but here again everything is in ruins. The chambers to the right and left of the hypostyle hall were temple treasuries. The outer walls of the temple are decorated principally with scenes of the king's victories (C). On the south side (D) are hunting scenes and on the same side, towards the west (E), is a calendar with the mention of the offerings for the different feasts.

Mortuary Temple of Tuthmosis III

This temple, northwest of the pavilion of Ramses III, dates from the 18th Dynasty. It was begun under Queen Hatshepsut and Tuthmosis III but was completed only after the queen's death, when Tuthmosis III was reigning alone.

After the destruction under Akhenaten, Horemheb and Sety I had the temple restored. In the time of the Ramessides and the Ptolemies, additions and enlargements were made toward the west, with the result that the original layout is hard to trace.

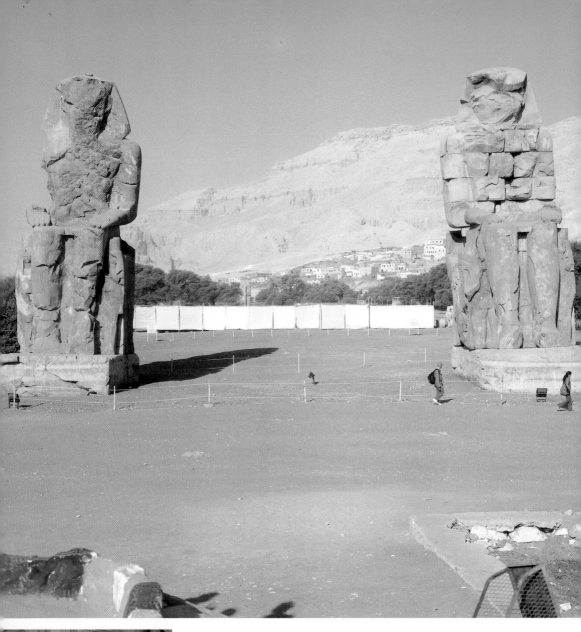

The colossi of Memnon, are said to have been 23 metres in height; the legs alone are about 7 metres long and the feet over 3 metres. In Hellenistic times, the figures were though to represent Memnon, who was slain by Achilles before Troy.

The Colossi of Memnon

North-east of Medinet Habu, among fields of clover and beans, one comes upon the two gigantic seated sandstone figures of Amenhotep III, which once guarded the entrance to the mortuary temple of the Pharaoh who was all powerful from 1386 to 1349 BC.

The vast halls of this temple are totally destroyed. But their remains make such a huge mass, that we are justified to think that this temple must have exceeded all others in size and extent. On the side where it stood numerous fragments of building and statues are strewn on the soil, and on the spot, which perhaps was the sanctuary, lies an enormous stone engraved with hieroglyphics, which tell us how rich and splendid the interior of this building must have been. In front of its main entrance stood those two gigantic statues. What a magnificent sight this building must have been, with these colossal statues, seated on the throne. On the sides we may still see the figures of the mother and wife of the king. Each statue is over 15 m high, and was still higher before the crown fell from their heads. The width at the shoulder is 6.7 m, the length of their feet is 3.2 m. It has been calculated that each statue must weigh about 1280 tons. The northern statue is the most famous one. It is the vocal colossus of Memnon, which, in the time of Cæsars, was thought as well worthy of a visit by the Roman or Greek traveller in Egypt as the great Sphinx or the Pyramids. In the year 27 BC part of this statue was broken away by an earthquake. Since that time it is said that every morning shortly after sunrise it emitted certain sounds, the nature of which are unknown to us. Traveller called it a song. In Hellenistic time the figures were though to represent Memnon, who was slain by Achilles before Eos. The legs of the statues are covered with Greek inscriptions, commemorating the names of the visitors, and feelings with which it had inspired them. The most ancient visitor is from the eleventh year of Nero; the longest is a poem written by the court poetess Balbilla on the occasion of her accompanying Hadrian on a visit to Thebes.

The portion of the colossus that has been damaged in the earthquake was restored under Septimius Severus by building it up with blocks of stone, and this caused the sounds to cease. Hence it seems that the vocal phenomenon was genuine. It appears to have resulted from the action of the rays of the sun, which even at its first rising are very powerful. When striking on the broad inclined surface of the broken part of the wet statue with the dew of the night expanded rapidly with a ringing noise. This explains why the sound ceased when the broken part was cemented.

The embankment road passing the Colossi of Memnon leads back to the bank of the Nile. Before leaving the spot, the visitor should take a last glance back towards the enigmatic mountains of the desert, yellow and barren, at sunset quickly darkening from a bright golden glow to deep violet, and towards that utterly lonely world which for more than three thousand years has been the empire of the gods and the dead Pharaohs. Surveying the awe-inspiring field of ruins we remember that this whole gigantic necropolis, which even today bears such mighty monuments, must once have been crowded through its whole extent with the houses of priests, officials, artists, artisans, workmen and laborers, the many people connected with temple service, the embalming and the burial of the dead: a capital of death, buildings, tombs and living inhabitants all preoccupied solely with death.

Esna

Temple of Khnum

Esna is one of the most important towns on the west bank of the Nile. A few miles further south on the east bank stands the village of el-Kab, with the remains of the ancient town of Nekheb.

Any one who has seen the fine hall of the temple will genuinely admire it. The chief sanctuary of this temple was dedicated to the triad Khnum. The Greek called Esna Latopolis, from the fish *Latus*, which was held particularly in this town. The approach is through a narrow closed alley and then going down a flight of steps. When we reach the hypostyle hall we shall be amazed at the extent of its grandiose style while we admire the sculptors who covered every inch of this vast space with pictures and inscriptions. The roof is supported by 24 columns. All the capitals are different, but all formed on the same type; a large flower-bell surmount the column, each decorated with some details of plant-growth as palm branches, grapes, bunches of dates, and the stems of some water-plant.

The inscription in the Hypostyle mentions the name of the Roman Emperor Decius (250 AD). It is one of the last inscriptions ever written in hieroglyphic. Also carved on the walls is a calendar of the festivals and processions held in Esna.

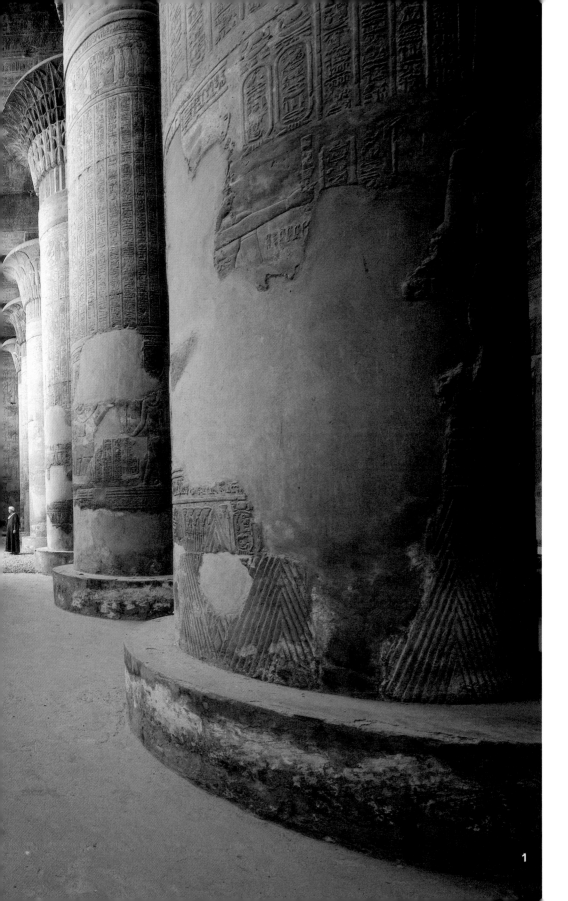

1. The Hypostyle Hall is supported by 24 columns arranged in six rows. Each column is approximately 14 metres high. The façade has an intercolumnar wall, which connects the front columns comparable to those at Dendara temple. Along the top of the façade are small windows that allow light and air into the Hypostyle Hall. It was built in the first century AD during the Roman period. The Emperors Clausios (AD 41-54) and Vespasian (AD 69-79) had the majority of the Hypostyle Hall built, and the decoration was carried out during the third century AD. Decuis (AD 249-251) was the last Emperor who contributed to the building of the temple.

2. The temple of Esna.

3. The use of the lotus is overabundant in this temple, which helps us to imagine that we are in the marshes of the Delta or at the moment of the world's creation. The lotus is linked to regeneration and the solar cult.

4. The most outstanding thing about the Hypostyle Hall is that all the columns and their capitals are different. Every capital features botanic patterns. For instance, one of the 24 capitals is composed of three rows of the lotus plant, and on the second and third rows there is a leaf. The reliefs contain many details of the structure of the plant itself. This can be noticed at the edge of every capital where nestled between two leaves there is a tiny representation of a lotus plant. The Egyptian sacred lotus is *Nelumbo speciosa* is an aquatic plant. Its seedpod is an indication of the solar cult, and it contains three black seeds in the middle. It is quite interesting to observe the three holes in the centre of the seedpod at the edge of the capital. At the bottom of each capital there is a cylinder of vertical lines, which are supposed to imitate the roots of the lotus in the water. The lotus grew in the marshes of the Delta, rising about 30 centimetres above the water's surface.

5. This column has the most delicately decorated capital formed with the use of two main motifs. Vine leaves and palm fronds are artistically arranged alongside each other. The species of palm which is represented on this capital is the date palm *Phoenix dactylifera*, which grows abundantly in the neighbourhood. The palm branches are carved vertically with their date clusters hanging to the side. The palm tree refers to regeneration because each branch denotes a new month. The word month in hieroglyphics is written using a palm branch as its sign. A vine with bunches of grapes is shown between the palms. The branches of the vine are red, which is a typical colour of the wood. The grapes and leaves are carved in a natural form, contrary to the canons of Pharaonic art. This free style is typical of the Greek and Roman influence. The vine is portrayed in a dynamic way, which was one of the features of Egyptian art during the Roman period. Here we can observe a moving away from the more orthodox style of Egyptian art. At the bottom of the capital there are three rows featuring leaves, which imitate the branches of palms. Egyptian wine was the favourite drink of the Roman emperors.

6. This capital has papyrus plants represented vertically with faint traces of colour still remaining. The details of the papyrus are clear, with the petals and the stems looking almost too real. A vertical leaf stands as a separator between each papyrus plant. At the bottom of the capital there is a cylinder of vertical lines in imitation of the plant's roots. And below that another, which simulates the water in the marshes of the Delta. It therefore became the symbol of Lower Egypt. The papyrus, which grows in Egypt, is the *Cyperus papyrus*; it reaches about four metres in height. Its stems have a triangular shape and therefore it was related to the sun cult. In general temple inscriptions and rites are related to the theory of the regeneration of the universe and solar cosmology as a whole.

7 & 8. These are two more examples of botanic capitals, the first representing a lotus shape **(7)**, and the other **(8)** palm fronds. These two motifs have been represented before in other capitals, but in more intricate detail. Here we see the lotus capital with a plain edge unlike **(6)** and **(5)**, which had an image of a small lotus. **(8)** is more simplified than **(5)**. In the **(8)** capital the branches are represented vertically, one by one with no intersecting vines. The presence of these capitals with their theme of vegetation gives the impression that we are in a garden. The religious purpose of the capitals was to symbolize the first primordial marshes from whence the universe emerged.

9 & 10. This capital has a simplified version of the lotus pattern. It consists of three rows of lotus plants with the largest at the top. The whole capital takes the form of a lotus plant with four flower petals surrounding the capital itself. Furthermore, in the centre of every petal, a blue lotus plant of the *Nymphaea* species is shown. Here it is depicted as open to symbolise the sunrise. The Egyptians had observed that this particular species of lotus opens shortly after sunrise and closes again at midday. In scenes in private tombs, women are often shown smelling a lotus flower as it is very sweetly perfumed as well.

11 & 12. The columns of the temple's façade; they are connected by an intercolumnar wall. The capitals again take the lotus form but the decoration and motifs are different. Both bear slight traces of blue colour. The first 18 columns are inscribed with descriptions of various festivals such as the feast of "Lifting the sky", "The wheel of the potter", related to Khnum, "The voyage of the goddess Neith from Sais", and "The conflict of Ra with mankind".

13 - 15. These three capitals have papyrus and lotus motifs, as do three more of the rest of the others.

16 & 17. These columns have lotus capitals. Mythical botanical specimens can be found among the real plants. By doing so the artist mixed reality with imagination, which makes quite an attractive theme.

18. This is a beautiful representation of a mythological plant with the main theme depicted as palm fronds. The flowers and leaves are painted in yellow, red and blue. The colours themselves have symbolic meanings. For example blue refers to Nun, the primordial water. In other circumstances blue refers to the sky.

19. A very impressive crown; the main element is the lotus but represented in mythological mode, the flowers hang to the side with the spirals ending in colours of green-blue, yellow and red.

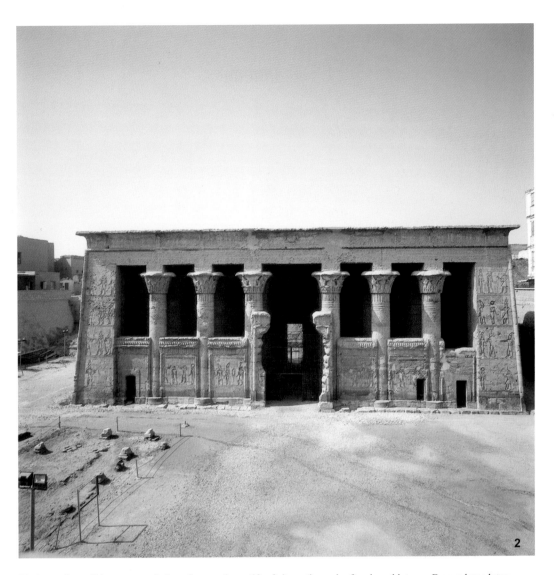

2

20. A very beautiful crown consisting of two main motifs of alternating palm fronds and lotuses. From a large lotus emerge five thin long stems, three with open flowers and two with closed buds. The five open and closed flowers alternate, starting and ending with an open bloom. As is well known, the lotus flower opens at sunrise and closes at midday, and this flowering lasts three days, hence the three open and two closed flowers simulated the life cycle of the lotus flower. The ancient Egyptians associated the opening of the lotus at dawn with the sunrise, and therefore it became a symbol of regeneration and eternity. In the lower row, tall and short lotus flowers alternate as they occur in nature. Among the lotus we find also the *hkr* plant, which was used from Archaic times as a decorative element. It is found also in the southern tomb of the Pharaoh Djoser.

21. A column at the corner of the Hypostyle Hall with a capital composed of three motifs, a date palm, a vine and a lotus. Dates and grapes are represented at the lower end of the capital with triangular designs acting as separator between them. At the top, open and closed lotus flowers with thin long stems alternate.

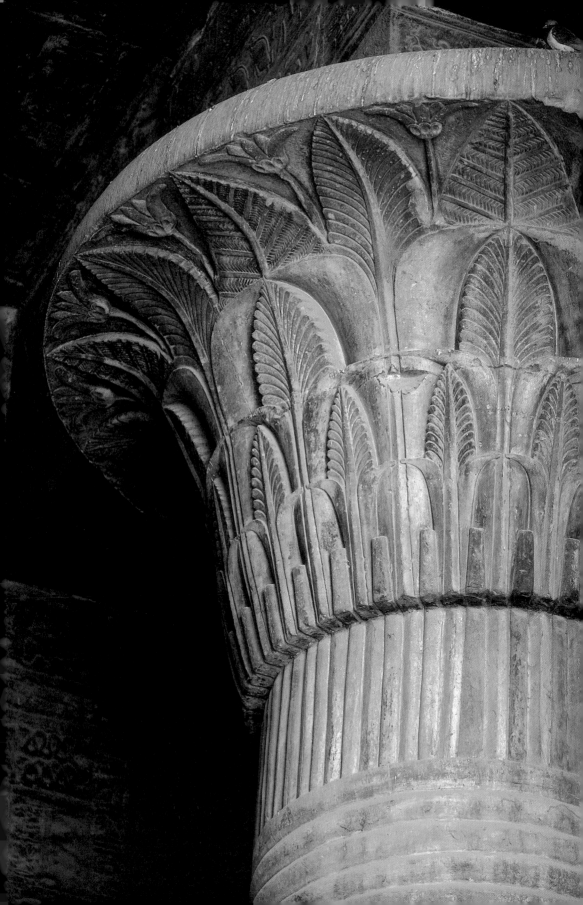

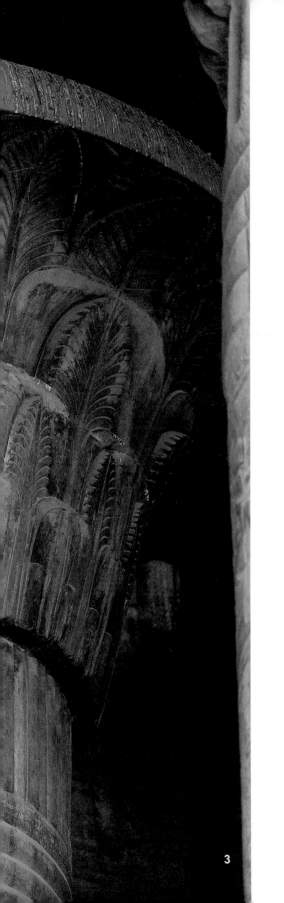

3

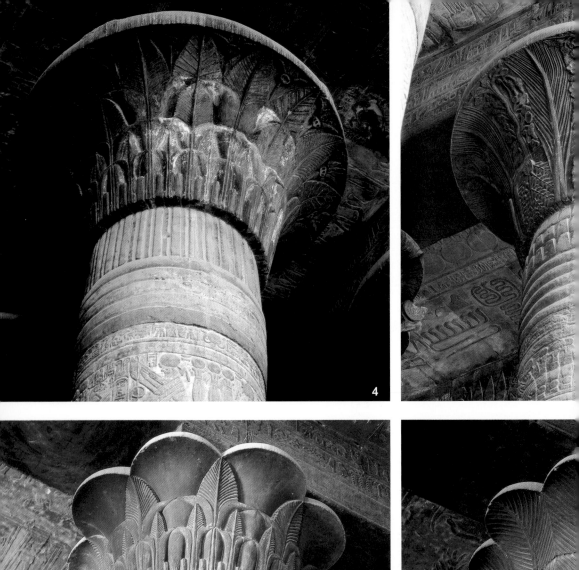

4

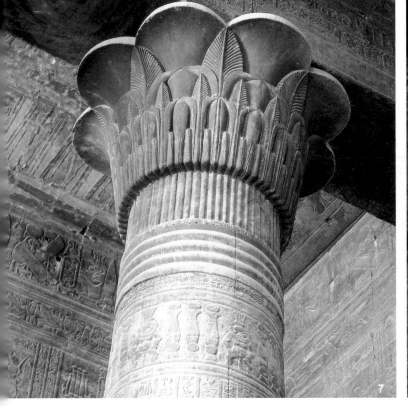

7

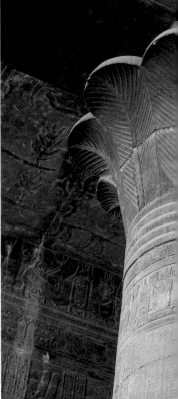

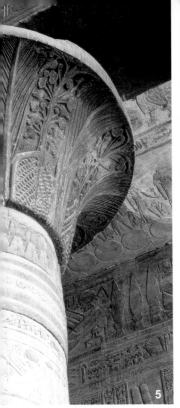

5

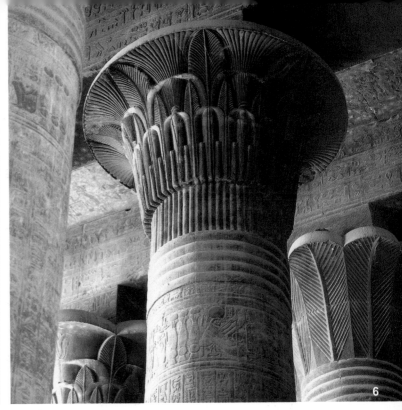

6

8

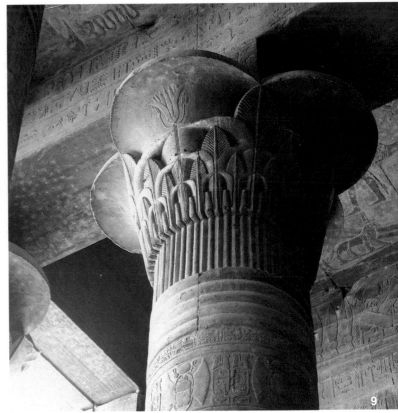

9

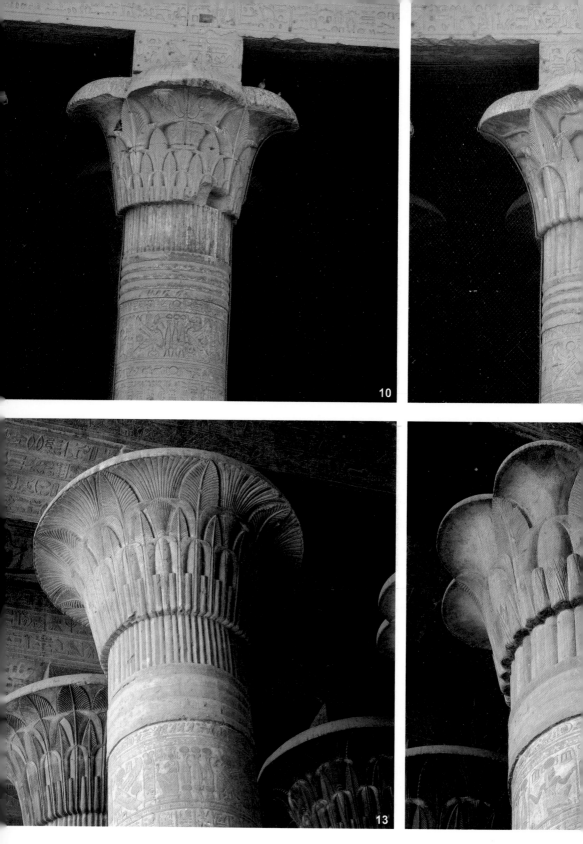

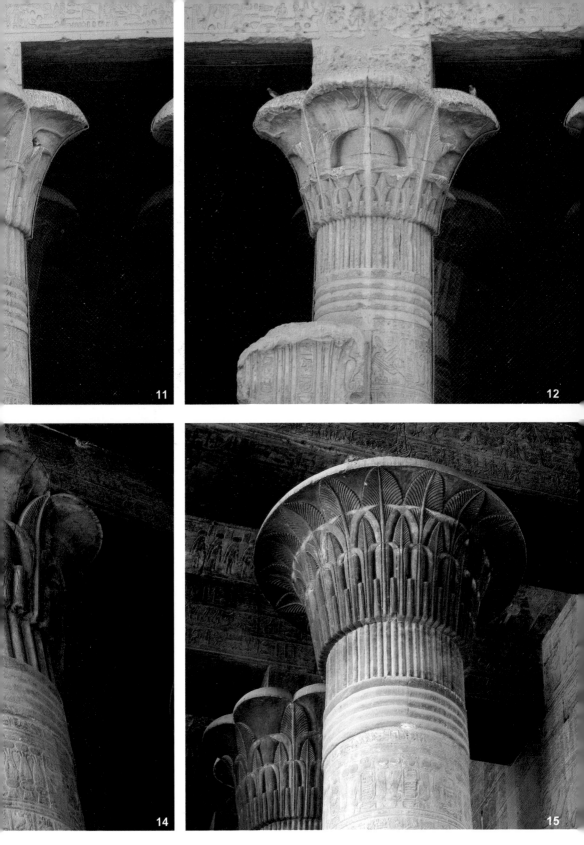

11 12

14 15

259

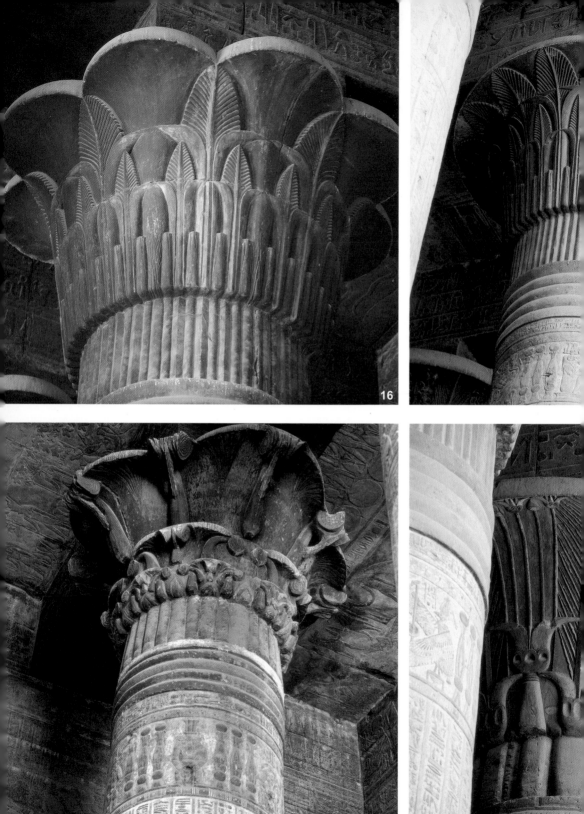

16

19

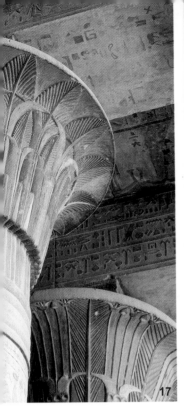

17

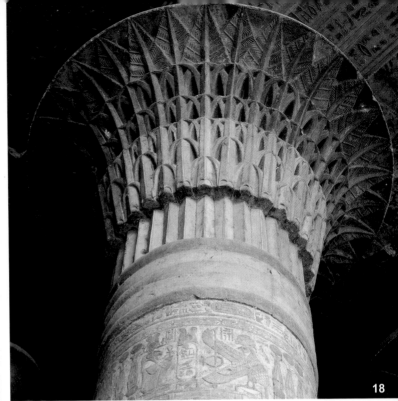

18

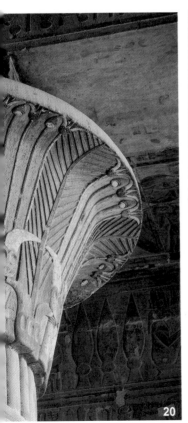

20

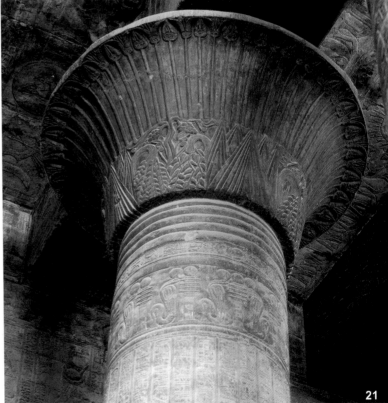

21

261

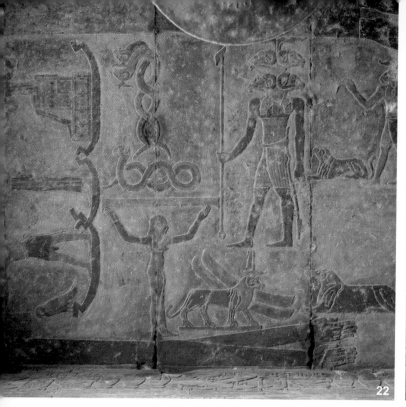

22

22 & 23. Shown here are various scenes from the ceiling. The temple is dedicated to Khnum and his wife the goddess Neith, his female counterpart in the triad of Esna. Many of the hymns and feasts are very well depicted in this temple. This particular scene shows one of the feasts belonging to Neith. At first glance it looks too mythical, a stretched out human body with elongated arms and legs. The hands are on one side while the feet are on the other side of the scene. Neith, represented as a small figure, is shown lifting the sky during the feast of the "Lifting the sky". This celebration took place on the first day of the month in the season of *prt*, the winter. Three snakes are placed above the sky, one of them is falcon-headed and the other two are ram-headed with horns. Khnum is represented by two pairs of rams' heads; he is holding a sceptre and is represented in the Roman form of a warrior. Three divine vessels carry Neith and the king wearing the White Crown of Upper Egypt. In front of Neith there is a mythical anthropomorphic animal with a lion's body, a ram's head and two pairs of wings. This mythical animal referred to the four winds coming from the four cardinal points. This animal representation unknown in conventional ancient Egyptian art was introduced by the Romans after they conquered Egypt. To the right of this register is a crocodile-headed lion and behind it is the representation of a female hippopotamus that might be the goddess Tawaret. The reason for the presence of so many crocodiles and snakes as well, is that the goddess Neith was "The mother of snakes and crocodiles", and she was often also called the "Mother of Sobek". In the other two scenes there are also many snakes, one of which has two human heads, another a falcon's head and the third a crocodile's head. The snakes depicted in a disordered manner, were related to one of Esna's festivals where they celebrated Neith as a saviour of the newborn sun by carrying her children the crocodiles and serpents, across the water. Neith was also connected to the supernatural as it was she who created the universe by reciting seven magic words. In conclusion, the whole scene relies on an enigmatic cryptographic system to protect the Egyptian culture from the foreign invaders.

24. The ceiling has mythological drawings showing forms unknown in standard Egyptian art. Among them is a swan with four wings, a lion with a human head wearing a strange headdress. The gods Thot and Horus are standing on the lion's back. An ape is seated in front of a snake with a falcon's head.

25. Part of the ceiling from the northern wall of the Hypostyle Hall. It shows a scene from the hymns and liturgy of the god Khnum, the main god of the temple, together with other deities like Neith, Tefnut, and Menkhit. The writing method is mysterious and it is a very difficult task to decipher it. The priests and scribes did this on purpose. Due to the fact that they were being occupied by Greek and Roman invaders, they switched to an enigmatic and complicated system of inscriptions to protect their identity and religion. The scene here is cryptographic consisting of many anthropomorphic creatures such as a ram-headed man identified with the god Khnum, a crocodile–headed man corresponding either to the god Sobek or the deity Sjema-nefer, the son of the triad of Esna. The triad of Esna consists of Khnum, the father, Neith,

262

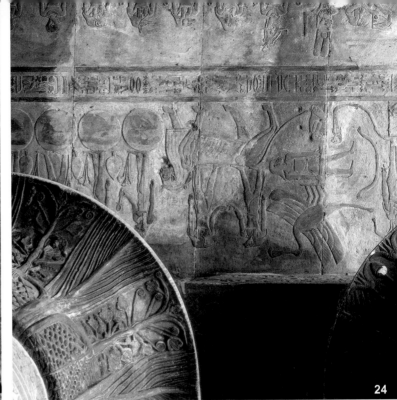

the mother and Sjema-nefer, the son. The inscription here represents one of the festivals that took place in winter or *prt*, on the tenth and eleventh day of the month, which was characterized by the occurrence of the procession of the god Khnum accompanied by the solar disc, and the appearance of Thot, Shu, and Tefnut. Recently the French Egyptologist Serge Sauneron attempted to explain the cryptographic meaning of the ceiling; his theory as to why there are so many drawings of animals that the Egyptian worshipped was that they were venerated because they were created by the gods, but the animals themselves were never divine.

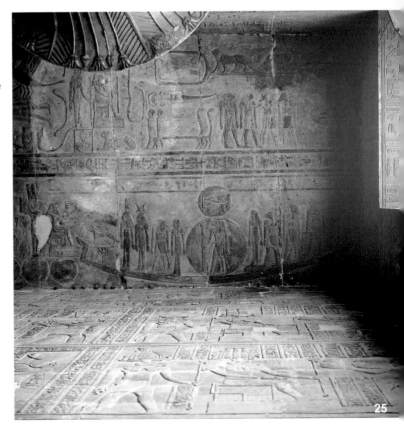

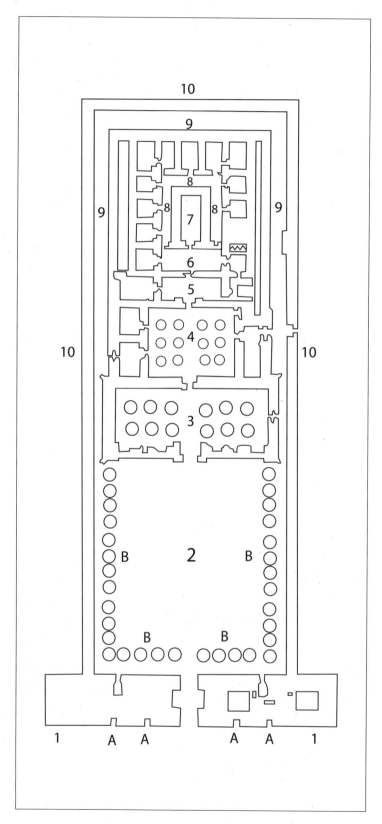

The temple of Edfu.

Edfu

Temple of Horus

Edfu, the Apollonopolis of the Ancient Greeks, lies half-way between Luxor and Aswan, nearly 100 km south of the former. A visit to Edfu to see the marvelous temple of Horus is strongly recommended. No other monument in Egypt remains in such a perfect state of preservation as the temple of Edfu, dedicated to Horus. The temple itself, with the inner sanctuary, was begun by Ptolemy III, Euergetes I (246 - 221 BC) in the year 237 BC and finished 90 years later under Euergetes II, though the kings reigning between (Philopator and Philomator) had contributed to its construction. The vestibule, the colonnaded court and the pylon were added only in the last century BC.

The pylon (1) is decorated with reliefs of King Neos Dionysios before the gods and in scenes of fighting, and still bears on the right and left of the entrance gate the four depressions (A) where the flag poles were placed. The first court (2) is surrounded on the south, west and east sides (B) by colonnades, 32 pillars in all with fine flower and palm frond-capitals. On the walls are large reliefs showing Ptolemy Soter II before the gods. Two doors, to the right and left of the entrance gate on the inner side of the pylon, lead to stairs enabling the visitor to climb the pylon by 242 steps and have a wonderful panoramic view of the temple and the Nile scenery from the summit. From the court (2), further north, we come to the vestibule (3) with 12 pillars. On the left is a great falcon with a double crown, and on the walls, reliefs showing King Euergetes II sacrificing before the gods. In the east wall (right) is a door leading into a passage going round the temple (9), decorated with reliefs and inscriptions. On the east side of the passage is a stairway to the nilometer. From the vestibule we go straight to the hypostyle hall (4) with 12 pillars with flower-capitals. This is followed to the north by the first ante-chamber (5) and from here are the stairs leading right and left to the roof. By the second ante-chamber (6) we reach the inner sanctuary (7) decorated with wall-reliefs of Philopator before the gods. All around the inner sanctuary runs a corridor (8) reached from the second ante-chamber, from which open 10 chambers which were reserved for cult ceremonies. On the outer side of the enclosure wall (10) are inscriptions giving details concerning the building of the temple.

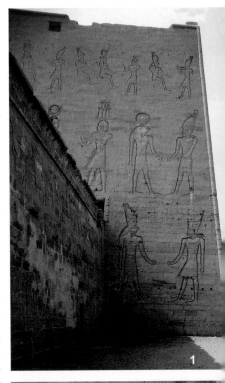

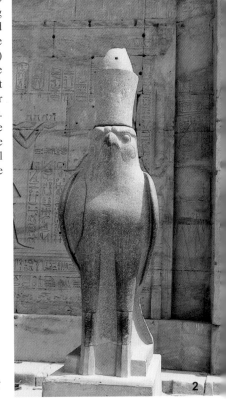

1. Rear view of the first pylon.
2. Black granite statue of the falcon god Horus wearing the double crown of Upper and Lower Egypt.
3. First hypostyle hall viewed from the forecourt. The hall has three rows of six columns.
4. Columns with flower capitals.
5. Wide court of the libations.

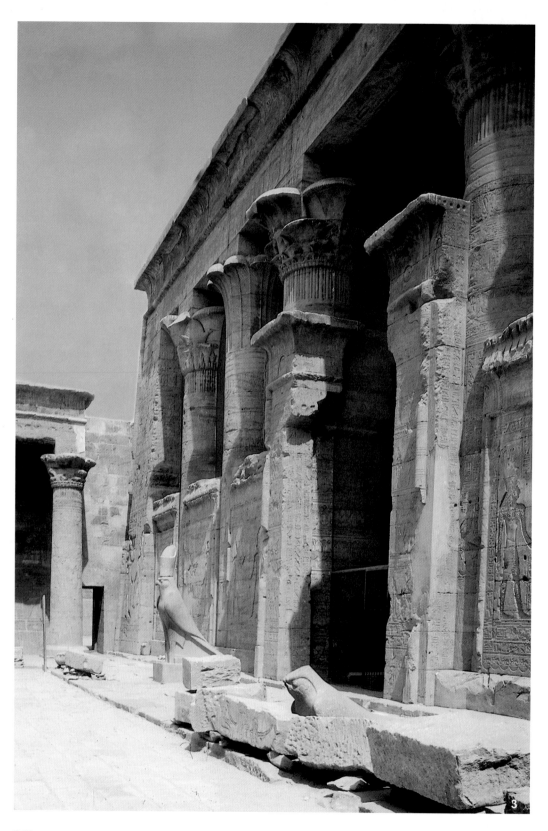

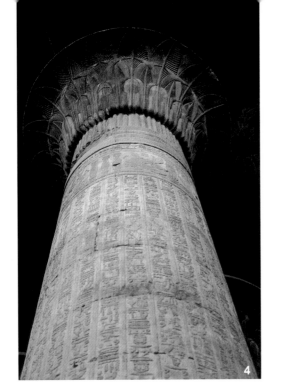

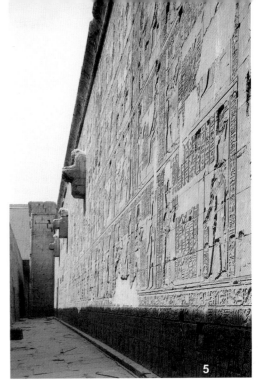

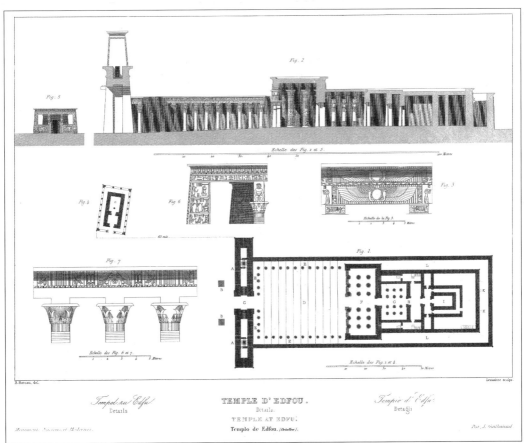

TEMPLE D'EDFOU.
Details.

TEMPLE D'EDFOU.
Details.

TEMPLE AT EDFU.

Templo de Edfou. (Detalles).

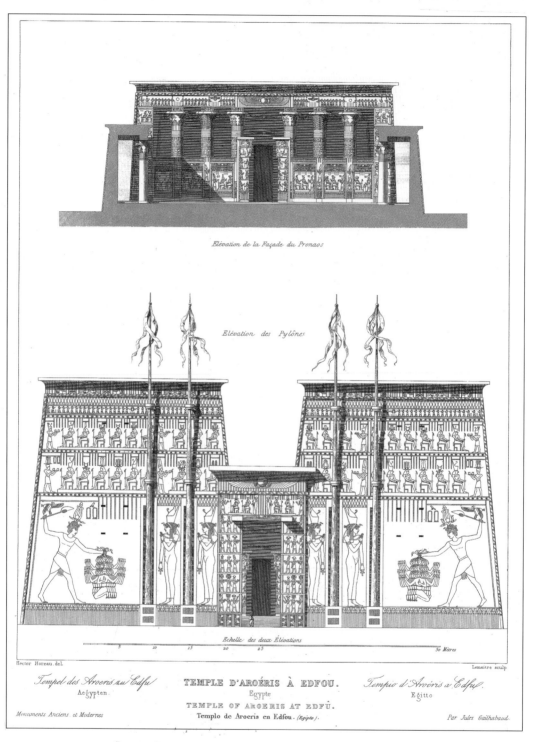

Elévation de la Façade du Pronaos

Elévation des Pylônes

Echelle des deux Elévations

5 10 15 20 25 50 Mètres

Hector Horeau. del. Lemaitre sculp.

Tempel des Aroeris zu Edfu TEMPLE D'AROÉRIS À EDFOU. Tempio d'Aroéris a Edfu
Aegypten. Egypte Egitto

 TEMPLE OF AROERIS AT EDFU.

Monuments Anciens et Modernes Templo de Aroeris en Edfou. (Egipto). Par Jules Gailhabaud.

Above & previous page : The temple of Edfu.
Facing page : Temple of Kom Ombo from *Egypt, Descriptive, Historical and Picturesque* by Georg Ebbers, Leipzig 1879.

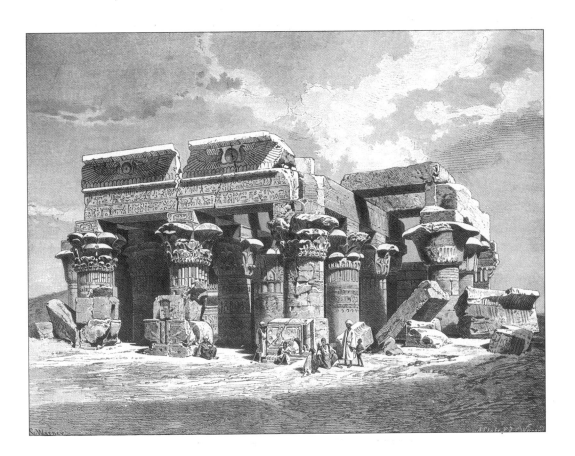

Kom Ombo

Kom Ombo, "Hills of Ombo", is on the east bank of the Nile, 160 km south of Luxor. In the Ptolemaic Period it was the starting point for an important caravan-trade with Nubia and Ethiopia. To-day it is still important, but for its sugar-cane and cotton plantations. The excursion to visit the temple of Kom Ombo is best undertaken from Aswan, 45 km away by car.

Anyone who wants to see an oriental market should see Daraw just over 5 km south of Kom Ombo. A most interesting camel market is held there.

The two tutelary deities of the town were the crocodile-headed Sobek, especially venerated in Fayum and Ombos, and Haroëris, the god of the morning sun. The temple dedicated to these two divinities dates back like the temples at Dendera and Edfu to the Ptolemaic Period (2nd Century BC). Three rulers contributed to its building or to its decoration: Ptolemy IV Philopator (181 - 145 BC.), Ptolemy VIII Euergeyes II (145 - 116 BC) and Neos Dionysios (80 - 52 BC). Some of the pictures in the court and on the outer walls were added by Roman emperors, including Tiberius. As it was a double temple each god had his own sanctuary : on the left (north) Haroëris, on the right (south) Sobek. The layout resembles that of the temple of Edfu, but is unusual in that the entrances and doors are double and that each divinity has its own chapel.

The pylon is in a bad state of repair as are also the colonnades enclosing the court on three sides (16 pillars). On the low east wall, leading to the vestibule, there are, on the right, pictures of the king Neos Dionysios with falcon-headed Horus, ibis-headed Thoth and crocodile-headed Sobek. On the left wall these scenes are repeated but with the falcon-headed Haroëris instead of Sobek.

In the vestibule stand 10 pillars with palm frond and flower-capitals, and on the wall are fine well-preserved reliefs showing the king, Neos Dionysios, before the gods. In the ten-pillared hall following are pictures of Euergetes II with the gods.

The three ante-chambers which succeed each other towards the east contain beautiful mural pictures. Adjoining the third ante-chamber are a chapel of Haroëris on the left and one of Sobek on the right. The rooms

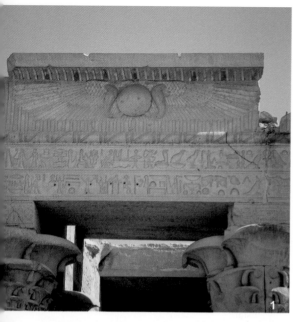

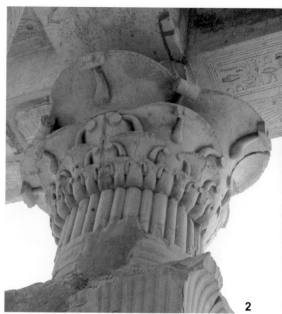

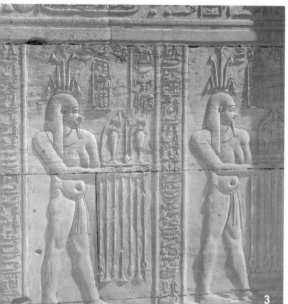

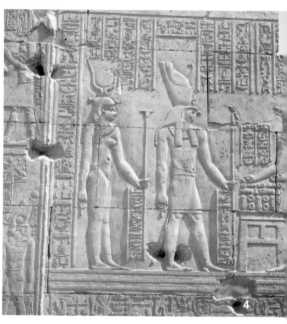

1 & 2. Capitals from the second hypostyle hall.
3 & 4. High reliefs in the vestibules.

behind the chapels are reached by the passages inside the enclosure walls which branch off on the right and the left from the vestibule. There are in places first sketches, outline drawings for reliefs which were never sculptured. From the bank of the Nile in front of the temple a fine view over the river and the surrounding country is to be enjoyed.

Aswan

Aswan is the southern frontier of Egypt. The region is characterised by granite boulders that rise in the water stream replacing the dark yellow Nubian sandstone. The inhabitants are dark-skinned Nubians, who have their customs and language. Their houses have a peculiar shape. The Bisharian, also from African origin, but are not considered Nubians are mostly nomadic and work in camel trade. They inhabit the desert and are not found in the Nile Valley. The Bisharian are known as trouble makers and are fierce fighters. Their territory is separated from their tribal relatives, the Ababda, about 40 km north of Aswan at Darau. Also at Darau caravan routes open out into the south-eastern desert at the place where in early days the chief market of the nomadic Beja was held. Darau is the border between the arabic speaking and the Nubian speaking population.

Two ancient names denote special importance in this region . They are : Elephantine, the name of the northern most island at the First Cataract opposite modern Aswan, and Syene, "the market", a settlement on the Eastern bank. The name 'Elephantine' does not stem from elephants who roamed the region in predynastic times, but because it was a commercial centre for ivory, the most important commodity in the trade with the south. The principal ancient town was on the island and it also acted as a fort for the Nubian nome. Because the Nubians had no divine symbol, they were regarded as outsiders in the ranks of the Egyptian nomes. As the town was on an island it had no walls. It consisted of houses packed closely together all around the temple. Black granite boulders marked the beginning of the cataract. The ram-god Khnum, 'Lord of the Cataract' ruled over the new flood waters. The Famine Stela, of King Djoser lies on the island of Sehel, south of Elephantine immediately facing the beginning of the principal cataract area. Divine myths were eager to seek the sources of the Nile. The Nilometer at Elephantine, the most southern in Egypt, still has its fame. It was established near the temple on the island facing Aswan. Moving the border southward gave the opportunity of observing the flood higher up the river and hence earlier.

The divine triad of the temple of Elephantine consisted of Khnum and two goddesses, Anukis whose bright coloured feather head-dress gives her a sort of barbaric look; and Satet, 'the One from Sehel' who wears a crown with antelope horns.

On the island of Sehel there are few ancient remains apart from hundreds of rock-inscriptions, mostly at the southern end of the island. The inscription recall the kings, viziers, high priests and army officers who pass at the island on their way to military campaigns in the south or to the quarries and gold mines. The neighbourhood around the cataract, stretching out deep into the desert is full of inscription left by ancient travellers. It is like a "visitors' book" in which adventurous men recorded their observations and names. Among them are many names recorded also in the turquoise mines in Sinai or in the quarries of Wadi Hammamat. The history of the cataract and of the surrounding country is written in these inscriptions and in the texts in the tombs of the nomarchs of Elephantine who, from the 6th Dynasty onwards, had made their tombs in the cliffs by the riverside at Kubbet el-Hawa with its wonderful view across the river.

These great men regarded themselves as natives of that region although they had grew up in the capital and had their first employment at the court there. Isi is one of these men who, in the reign of Teti (2345 - 2333 BC), was sent to be nomarchs in the neighbouring nome of Edfu. He was a great lord who had the title of vizier and he was regarded with great astonishment by the local people of Edfu. After his death he was revered as a 'living god'. His son Kar was also sent by King Merenre (2283 - 2278 BC) to Edfu 'as the representative of My Lord at the head of all the chief men in the whole of Upper Egypt'. This man called himself 'Master of the secrets of all secret words that come out of the narrow doors at Elephantine'. At the time he was responsible for all the problems of the southern provinces in respect to both the river and the land. They equipped the caravans and were responsible also for their fitting out the ships that sailed through the Red Sea to Punt. King Merenre himself had inspected the frontier, as the inscriptions in the cataract area tell us. Under him and his successor Pepi II (2278 - 2184 BC) a man named Harkhuf held office in Elephantine. He too had the title of 'Overseer of Upper Egypt' and also 'Overseer of all Deserts of Upper Egypt who set terror to Horus in the foreign lands'. He was not engaged in true military campaigns, his duty was to avoid confrontation and to agree the chiefs to supply willingly the raw materials. He did not achieve his aim without trouble and often force had to be used.

The areas reached by these expeditions can only be guessed by the ancient Nubian place names. From this inscription we know that Harkhuf was away from Egypt for seven months. He regarded as a great achievement that he was able to acquire a real dwarf, a 'dancer of the gods', from the 'land of the dwellers of the horizon'. The young King Pepi II was so excited by this news that he issued a special decree ordering that exceptional precautions should be taken to ensure the safety of this rare man.

Nile at Aswan

Map labels:
ROCKSTOMBS
ST. SIMEON'S MONASTERY
KITCHENER IS
Nile
MAINSTATION
Aswan
ELEPHANTINE I.
MUSEUM
NILOMETER
CATARACT HOTEL
GRANITE QUARRIES
UNFINISHED OBELISK
STATUE OF RAMESES

① Former Assuan Dam
② Isle of Philae
③ Dam Sadd el Aali
④ Kalabscha temple

0 1 2 Km

Expeditions were not always peacefully. One of the last officers of Elephantine had to search for the body of his father Mekhu who was killed in one of these expeditions. In doing so he waged war against these lands. To die in a foreign country and for the body to be lost was a disaster for the ancient Egyptian. It was not for vain that in the Story of Sinuhe of the 12th Dynasty reference is made to a burial in a foreign country with barbaric customs as being one of the strongest arguments that led the hero to return to Egypt from Asia.

The goods that were imported from Africa were in demand throughout all ages of ancient Egypt. These were : ivory, animal skins, spices, ostrich feathers. In exchange Egyptians gave unguents, honey, textiles and glass. Goods were transported on donkeys, a convoy would consist of 300 animal. Permanent trading centres were not set up in remote regions during the time of the Old Kingdom. A trading centre existed in Kerma at the Third Cataract during the Middle Kingdom. Now we know that the Fourth Dynasty quarries of diorite were 60 km north west of Abu Simbel. The beautiful statue of Chephren was sculpted from this diorite as well as paving stones of Cheops's mortuary temple. This quarry is in the vicinity of the caravan route of 'Darb el-Arbaeen'. In the times of Cheops and Chephren the leaders of the expeditions did not dare to commemorate their own names in inscriptions even in the most remote regions of the desert. This was done out of respect to the king's majesty.

The Mentuhotep family of Thebes requnquered Lower Nubia about 2100 BC. This time, however, they faced severe resistance, and excessive force was used. Senusert I and III conquered Lower Nubia as far as the Second Cataract and secured it with linked forts. The fort of Elephantine was the most northern in line. In the New Kingdom Aswan lost its character as a border town.

The material wealth of ancient Egypt was due to the gold mines in the Eastern Desert and Nubia. An inscription of Ramses II at the entrance of Wadi Alaki shows the new measures to increase production. His father Sety I concentrated his efforts to the Barramiyah mine, Ramses II turned his attention to that of Wadi Alaki. It is clear that unfavourable reports were presented to him critisising the losses in a waterless desert. The king is quoted "Much gold is in the desert of Alaki but the way into there is miserable beyond measure because of lack of water. Whenever some of the workmen go there to wash gold, only half their number reach it, for they die of thirst on the way, together with their donkeys. They cannot find water to drink on the way there or back. One therefore gets no gold in this desert because of the lack of water." Old wells had dried up and water had to be brought from a distance on donkey back.

The quarrying of stone after gold mining was the second most important activity to the market at Elephantine. The quarrying of granite was of a very ancient origin. In fact, granite did not involve real quarrying as was done with limestone from Turra. For granite it was a question of working individual rocks lying on the surface of the ground. The granite was obtained not far away from the banks of the Nile. Huge quantities of granite were used in the mortuary temples of the Old Kingdom. However, the greatest achievements in the working of stone were the monolithic obelisks made by the pharaohs of the 18th Dynasty. Senusert I, the conquerer of Nubia, with his obelisk nearly 22 m in height at Heliopolis achieved a record, which Tuthmosis I with his two obelisks at Karnak could not beat. However the greatest obelik still lies unfinished in a quarry. It was planned to reach a height of 42 metres with an estimated weight of 1168 tons. Then the height was modified to 31 metres which is still heigher than the 29 metres obelisk of Hatshepsut at Karnak. Probably it dates to Tuthmosis III.

Aswan & Round About

Aswan is Egypt southernmost winter resort, attracting travelers from all over the world. The population is composed of Nubians, Egyptians, Bisharin and Sudanese.

The ancient quarries south east of Aswan are famous. It was from them that the Pharaohs brought the granite they needed for their sarcophagus in the pyramids or for the construction of temples.

The scenery at Aswan is fascinating. It is one of the bright, cheerful spots, if not the brightest. Moreover a wonderfully healthy and agreeable climate, without rain or mist, the purest desert air. It can be well understood why nature lovers come here.

Elephantine Island

An island 5 km long lies in the middle of the Nile, opposite to the Old Cataract Hotel. It is reached by boat from the river bank and a very pleasant sail may be enjoyed round the whole island. West of the landing-stage are the remains of the temple built by Trajan, erected on the ruins of older temples of Tuthmosis 3rd and 4th and Ramses II. Nearby is the nilometer used in old times, because the annual level of the Nile flood has always been of vital interest to the country's prosperity. It consists of a well in which the water rose to exactly the same level as in the main river. On the walls are Greek and demotic markings from which could be seen whether the water level insufficient, adequate or excessive. At the southern end of the island are the last traces of the former town of Elephantine.

Near the nilometer is a museum containing four rooms: in the first : pre-historic finds from about 4000 BC.; second room : finds from the Old Kingdom Period, about 3000 BC.; third room : Middle and New Kingdom finds, 2060-1085 BC.; fourth room : the Greco-Roman Period. Most of the exhibits were found near Aswan and in Nubia.

From the Elephantine Island one can be rowed across to Kitchener's Island, renowned for its charming gardens and many kinds of tropical and Indian trees, where a delightful stroll is afforded.

Tombs of the Nobles

These are rock-tombs cut into the face of the cliffs on the west bank of the Nile nearly opposite the north end of Elephantine Island. They were built by princes and nobles living there and in the neighboring district during the Old and Middle Kingdom.

The most important are: the tomb of Mekhu of the 7th Dynasty, with a hall with three rows of six rather roughly-hewn pillars; the tomb of Prince Sirenput, one of the best of the tombs of nobles of the 12th Dynasty; the tomb of Prince Pepi Nakht; the tomb of Prince Serenpitwa, governor of the South in the 12th Dynasty. Some of the relief are in bright pleasing colors. A pleasant view can be enjoyed from the mouths of the tombs.

Monastery of St. Simeon

This lies on the west of the Nile on a hill in the desert about three quarters of an hour's walk from the river bank opposite Aswan. The monastery is known locally as "Anba Soma'an."

It was dedicated to Anba Hadra, a local saint who lived in the 5th century. The monastery itself dates from the 8th century and was restored in the 10th, but abandoned as long ago as the 13th century through lack of water and because it was frequently attacked by roving bands of nomads.

As one of the most complete of the remaining Coptic monasteries of the Middle Age it is well worth visiting.

The Granite Quarries

These are south of Aswan and can be reached in twenty minutes. They are of considerable historical interest since from them the Ancient Egyptians obtained the granite needed for temples, colossi, sarcophagi and obelisks.

There is still something of a practical working atmosphere clinging to them; it is hard to realize they have been silent so long. Of special interest is the unfinished obelisk which was hewn out of the living rock on three sides, but cracked before it could be excavated completely. It well illustrates the method of working on and cutting out these monoliths. The obelisk measures about 28 m, the width of each side is about 3 m at the base. To cut the monolith from the rock on the fourth (under) side, a simple but high practical method was employed.

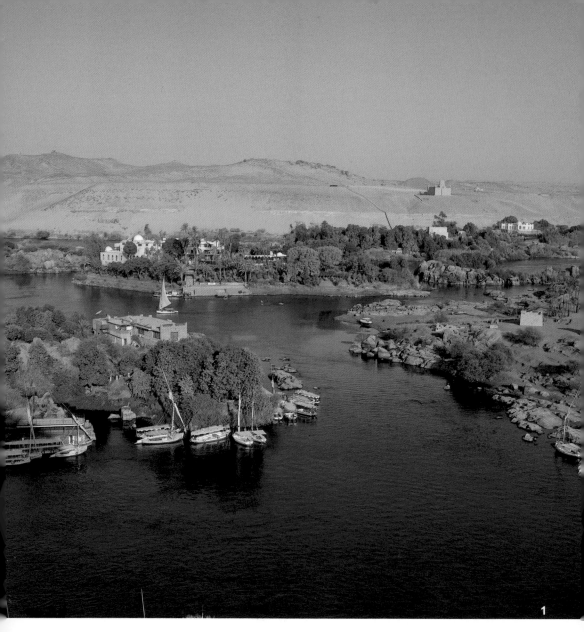

1. Nile at Aswan, photographed from the Cataract Hotel.
2. Scenes from Kitchener Island.
3 & 4. Monastery of St. Simeon. It is a large, strong building, half monastery, half fortress, and has been abandoned by the monks in the 13th century. The monastery is surrounded by a wall 7 m high. The monks lived in the north tower, in the upper storeys. The church was covered by a vaulted roof, carried by columns. In the church are the remains of a fine fresco of a Byzantine style, which had drawings of Christ and 24 saints. In a small rock-cut chapel at the foot of the stairway the walls are covered with drawings of Apostles. Everywhere on the walls of the church we see grafiti in Coptic and Arabic. The coptic text usually is prayers to God. About 300 metres to the east of the monastery lay the ancient cemetery.

Holes were drilled where the side was to be separated from the rock and wooden pegs were driven into them. Water was then poured on the line of pegs.

South of the first quarry lies a second where round-hewn blocks and other specimens of uncompleted work may also be seen. From the heights there is an impressive view of the surrounding country.

The Bisharian Village

This is a Bedouin settlement about 15 or 20 minutes' walk east of Aswan. The Bisharin are a Hamitic race related to the Red Sea and the Nile. The Bisharin are dark-skinned, uncommonly slim and are considered somewhat rugged; they are proud and differ from the inhabitants of the Nile valley in both customs and language. The men wear their hair in a thick fuzzy mop and the women dress theirs in numerous little oil-soaked plaits. The Bisharin are reputed excellent trackers.

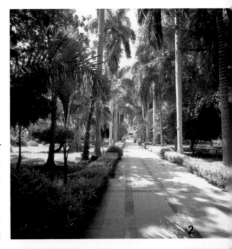

The Island of Philæ

The name "Philæ" is the Greek version of the ancient Egyptian *Pilac*. On the island, 445 m long and 150 m wide, are a number of sanctuaries built during the period from the 25th dynasty till the time of the Emperor Hadrian.

The chief temple is dedicated to the goddess Isis and her son Harpocrates. On the south side is a pylon, 43 m wide and 17 m high, behind which lies the first court, enclosed on two sides by small buildings, that on the west being the birth-chapel. The second pylon lies behind this first court and is 32 m wide and 13 m high; then follows the temple of Isis, consisting of a court, a vestibule, smaller antechambers and the inner sanctuary.

The walls are covered with reliefs on both sides, showing kings of the Ptolemaic Period and Roman emperors at sacrificial ceremonies. Other important buildings include the temple of Hathor east of the temple of Isis; the Kiosk, considered the finest building on the island (south-east of the temple of Hathor); the Arch of Hadrian, west of the Arch of Isis; the temple of Harendotes, north of the Arch of Hadrian; ruins of the temples of August, in the north part of the island.

In atiquity pilgrims travelled from all over Egypt to this spot. Their goal was the sanctuary of Isis and the tomb of Osiris. Ancient travellers to Egypt claim to have seen on the island granite slabs having the names of Amenhotep II, Amenhotep III and Tuthmosis III. Nothing of these had survived to modern times. There is no doubt that there were temples here from very early times at least from the 12th Dynasty. To-day the oldest building on the island dates from King Nectanebo II (360 - 343 BC) who was last pharaoh to rule Egypt. All other buildings date from the Ptolemaic period. The Roman emperors enlarged some of the existing buildings. An ancient cult regarded Philæ as one of the burial places of Osiris, hence, the soil of the island was considered divine and only priests were allowed to step on the island. During the Greek and Roman era the deities worshipped on the island were Ra, Osiris, Isis and the rest of the Great Ennead. In Ptolemaic times great number of

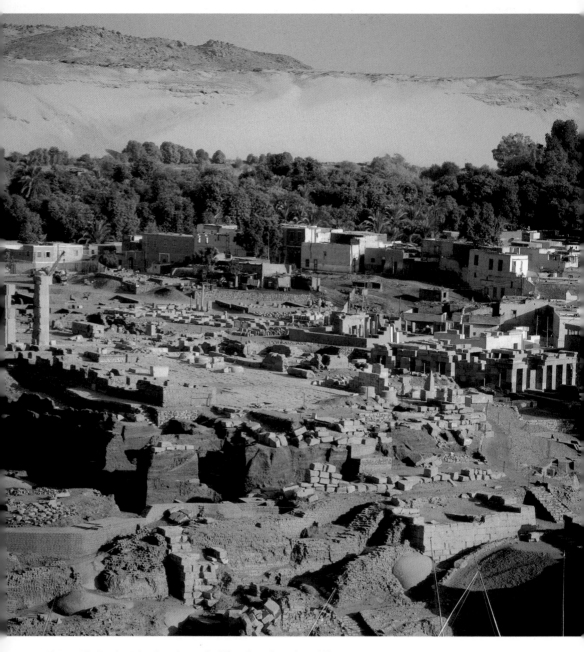

Above : Elephantine Island can be reached by a ferry from the public gardens. It has a museum and other monuments located on the south of the island. The museum has a section for artefacts from the Pre-dynastic and Archaic periods. The collection includes slate palettes, pottery, ornaments of stone and ivory, and jewellery. In another section, the visitor can see the mummy of a sacred ram, a statue of Tuthmosis II, alabaster vessels, shabtis, scarabs and jewellery. Also worth seeing are the mummies of two priests and their wives, dating to the Greco-Roman Period. Another site to be visited on the island is the famous nilometer.
Faacing page : The Island of Philæ from *Egypt, Descriptive, Historical and Picturesque* by Georg Ebers, Leipzig 1879.

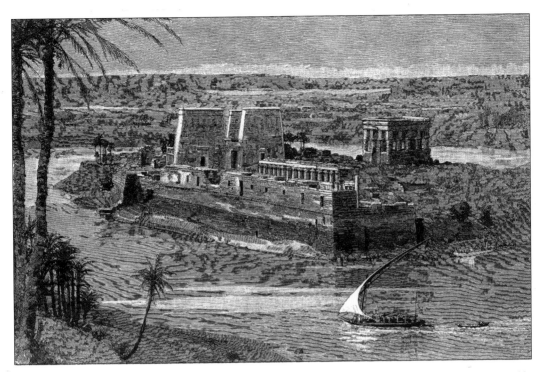

Greek pilgrims came to the island to worship Osiris, later the Roman pilgrims came in great numbers to worship Isis.

The centre of the temple of Isis was built by the Ptolemaic kings, and further enlarged and decorated by Roman emperors down to Diocletian who visited Philæ personaly.

The Greek deity equivalent to Osiris was Serapis. The Egyptian priests accepted this new god because he was immediately linked to their ancient god. The introduction of the new god was made during the reign of Ptolemy Soter, and as time passed the worship of both gods became identical, and Philæ became one of the most holy shrines. Rich tributes were received in the island.

In 22 BC Philæ and Aswan were seized by the Meroitic Queen Candace, who was later defeated by the Romans. In 250 AD the Blemmyes followed the example and raided all of Upper Egypt. In the region of Deoclitian (284 - 305 AD) the Blemmyes invaded the neighborhood often, and the emperor made an agreement with them in which he gave them Nubia provided they guarantee safe caravan routes with the south. In this era Christianity had spread in Egypt, and was penetrating into Nubia. But the worship of Osiris and Isis continued in Philæ. In AD 380 Theodosius the Great issued a decree forcing people into Christianity, and a year later he ordered some temples to be converted to Christian churches, and the rest to be shut. In spite of these decrees worship of Osiris continued on Philæ until the reign of Justinian in AD 527. Nubia was converted to Christianity about AD 540 and a few years later Emperor Justinian sent a force to Philæ with the order to destroy the worship of Osiris and Isis. Statues of Osiris and Isis were taken to Constantinople; then nothing is known about what happened to them. Then the temple was closed and all the priests were thrown into prison and then executed, and all the gold was confiscated, and the Nubians were all forced to convert to Christianity. The beautiful hypostyle hall was turned into a church with the inspirations and pictures on its walls being plastered over with Nile mud, for the eyes of the faithful to be preserved from polution. Later on, a seperate Coptic Christian church was built, but nothig from it remains to-day. From a Coptic inscription discovered in 1902 and now in the Egyptian Museum in Cairo, we know that a church dedicated to the Virgin Mary existed at Philæ in the first half of the eight century. The inscription tells us that in the year 439th of the Martyrs (AD 723), a man named Joseph, son of Dioscurus, placed an altar in the sanctuary.

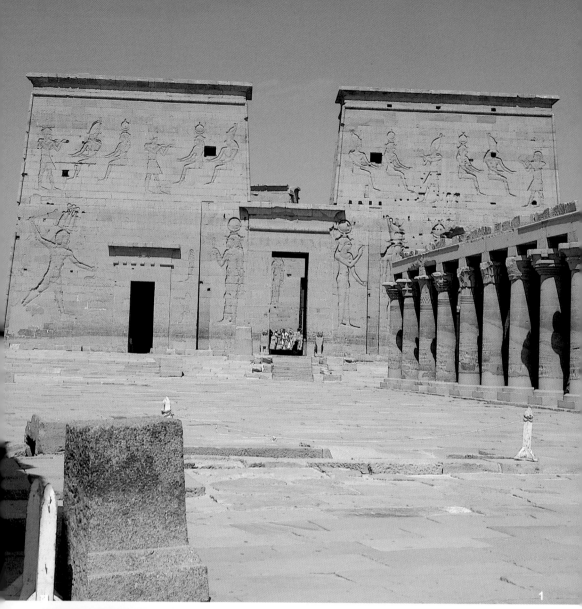

1. The First Pylon at Philæ built by Ptolemy XII.
This scene is typical to the ancient Egyptian art showing the
pharaoh smiting the enemy of Horus. Isis is carved along the flanks
of the entrance. The Pylon is in a good state of conservation. A
door in the west tower (left) leads to the birth house of Ptolemy VI.
In the first register in the left tower the king is talking to Horus of
Buhen saying "Be happy, protector of your father, your enemies lie
dead beneath you" Horus replies "I shall give you power against
your enemies". The text next to Isis are hymns dedicated to her
saying "O Isis golden one who illuminates the Two Lands with
your beams and fills the earth with gold dust (sun-ligh)". It was
common for temples in the Ptolemaic Period to be covered with
gold leaves.
2. Symbols of Christianity on the walls of Philæ.
3. The Temple of Isis from *Egypt, Descriptive, Historical and
Picturesque* by Georg Ebers, Leipzig 1879.
4. Ptolemy XII making offerings to the gods.

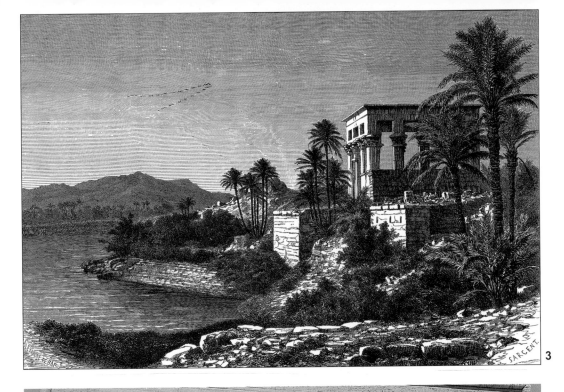

3

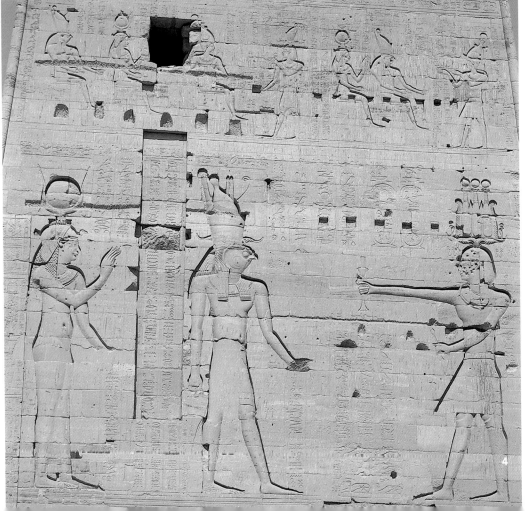

4

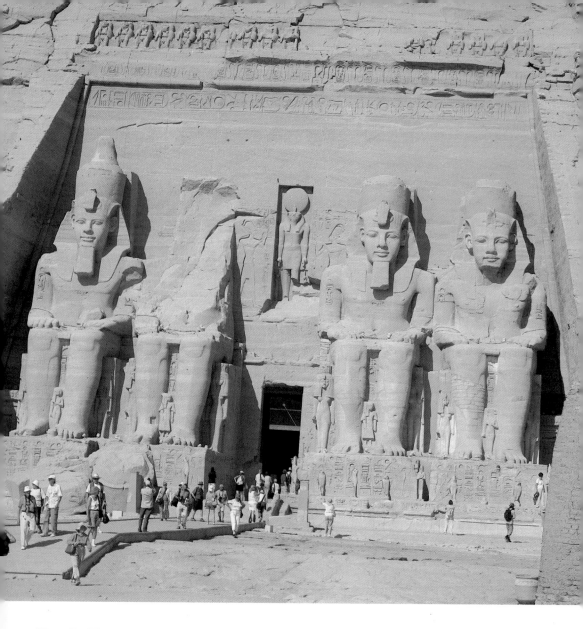

Rock Temple of Abu Simbel

This sanctuary, built by Ramses II and dedicated to the four gods, Amun-Ra of Thebes, Ra-Harakhte of Heliopolis, Ptah of Memphis and Ramses II himself as a god, is the biggest and most important in Nubia and one of the most magnificent memorials of Ancient Egypt.

The temple is cut sheer out of the sandstone mountain, and its location was chosen with great precision so that twice a year (in February and October), the first rays of the rising sun illuminate the innermost wall of the sanctuary and the seated statues of the four gods there. Before the entrance are four colossi of Ramses II, each 22 m high. Standing between their feet, and also to right and left of the figures, are smaller statues of members of the royal family. A visit to this remarkable temple, carved from the living rock, is most rewarding. Its total length is 54 m; first one comes into a big hall, 16 m, with 8 columns and huge statues, 11 m high. In the middle of the ceiling are hovering vultures, and constellations right and left of them.

The walls are decorated with reliefs; on the left (south) the king before different deities, on the right (north), battle scenes during the Hittite wars. Eight chambers open to right and left from the hall and ahead is a further hall, with four pillars. From here there are three openings into another hall, whence 3 rooms lead. The middle one

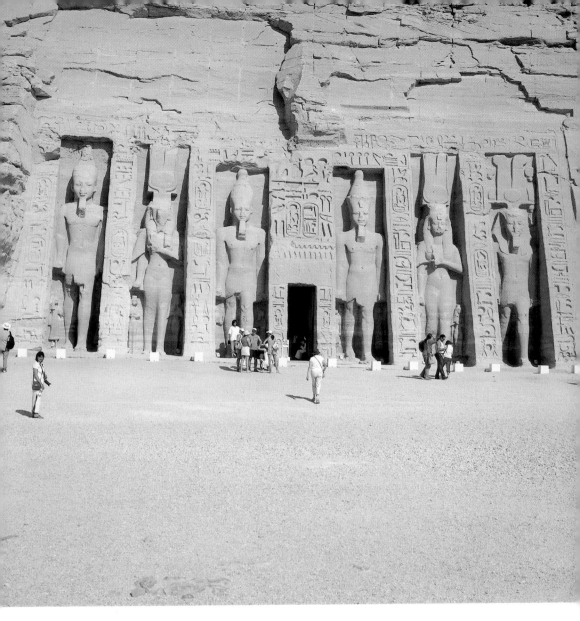

Facing page : The temple of Abu Simbel, with the four gigantic statues of Ramses II guarding Egypt's southern border. The colossal size of the statues demonstrates Egypt's political presence in Nubia.

The top freeze is represented with seated baboons cheering the sun rise. Baboons are related to the solar cult as they were also carved on the obelisks praising the sun-rise. The next freeze consists of the titles and cartouches of Ramses II. The *niswt-bity title stp maat n-Ra "let the justice of Ra's spirit be sustained"* Above the entrance a small statue of Ra Herakhty shown as a falcon-headed man is placed in a niche. The king is carved on both sides making offering to the god. The small statues at the feet of colossal statues of Ramses are of his wives and daughters.

Above : Guardian statues, four depicting Ramses II and two of his wife Nefertari, standing in niches in the middle of each side. The entrance of the queen's temple, located a few hundred feet north of the king's shrine.

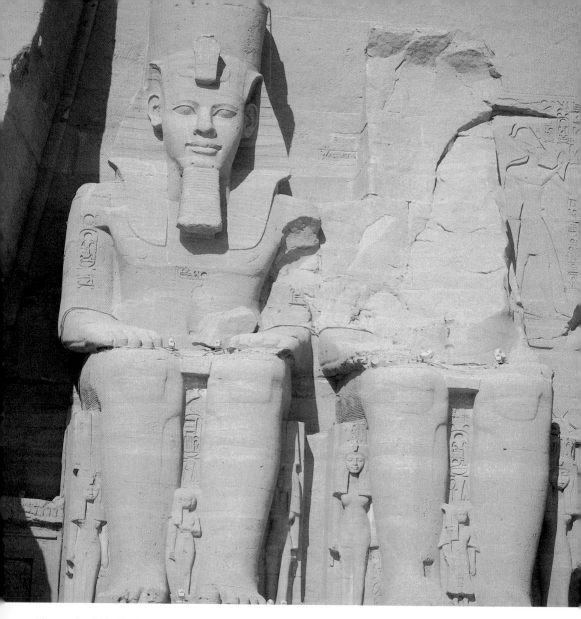

The temple of Abu Simbel.

is the inner sanctuary, with a place carved out of the rock for the sacred bark. On the rear walls are figures of the god Ptah, of Ramses II and of the gods Amun and Ra-Harakhte. Near the great rock-temple to the north is a second temple, also built by Ramses II, and dedicated to the goddess Hathor and to Nefertari, the king's wife. Anyone visiting Abu Simbel should not fail to see the smaller temple also.

A dramatic reconstruction intended to save the vast temple complex at Abu Simbel from inundation, was begun in 1964 and completed in 1968 as the rising waters of the Nile started to accumulate behind the Aswan Dam. The huge temple of Ramses II was cut away from the cliff, sliced into movable blocks and reassembled on nearby high ground about 60 m above the old water level. The small temple of Nefertari was also reassembled on top of the hill.

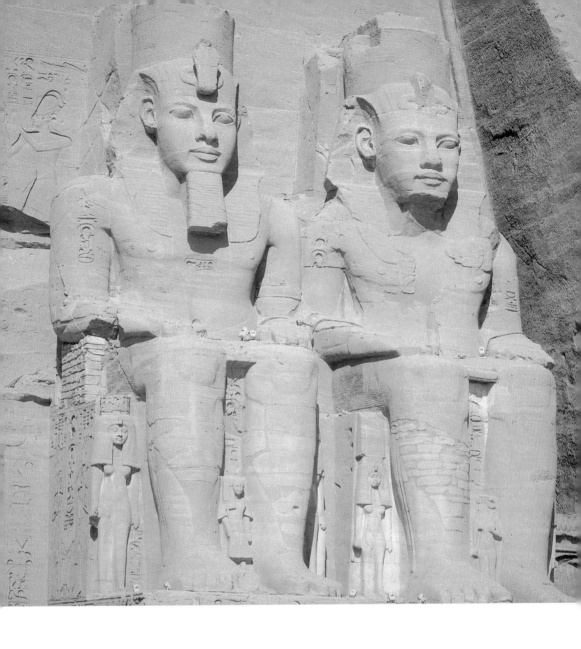

Glossary

Akht: the inundation season. It starts from middle of July and lasts to the middle of November. It could also mean horizon.

Akh-mnw: name of the festivals' hall built by Tuthmosis III in Karnak.

Amduat: the netherworld a corpus with a conventional name "The book of *Amduat*" or "The book of what is in the netherworld". This book was inscribed on the walls of the New Kingdom royal tombs and detailed the twelve divisions of the netherworld corresponding to the twelve hours of the night. Its main theme was the journey of the sun through the netherworld and its rebirth next morning.

Amulets: the origin of the verb means "to guard" or "to protect", confirming that the primary purpose of these personal ornaments was to provide magical protection for the wearer. It was worn by ancient Egyptians at every level of society, both in life and the hereafter. The amulet's shape, the material from which it was made, and its colour were crucial to its meaning. For example lapis lazuli was the colour of the dark blue, protective night sky; green turquoise and feldspar were like the lifebringing waters of the Nile. Green jasper was the colour of new vgetation, symbolizing new life; red jaspar and carnelian were like blood, the basis of life.

Ankh: is a hieroglyphic symbol of life. Recent explanation of this hieroglyphic sign indicates that it may refer to the front of a sandal. In the Christian era it was linked with the cross.

Atef: is a composite crown consisting of the White Crown of Upper Egypt with two feathers aside. Its main use was in religious feasts.

Ba: is the soul in ancient Egyptian belief. It was demonstrated by a bird with a human head.

Book of Gates: a collection of funerary text which was inscribed in the royal tombs of the 18th Dynasty. It contains a detailed view of the netherworld and is more complex than the *Amduat*. The name is a reference to the 12 gates that symbolise the 12 hours of the night and are carefully described in this work.

Book of the Dead : a collection of spells, many descended from the Coffin Texts and Pyramid Texts which was used by private and royal individuals during the New Kingdom. Personally inscribed papyrus rolls contained one of the many versions of this collection of spells with the deceased's name inserted in the text at certain points.

Djed: is a pillar symbolising stability and continuity. It was associated with the Osiris resurrection and stems from pre-history.

Djet: means stability, and was associated with kings and gods.

Dshrt: red color, and also refers to the desert meaning the "Red Land".

Duat: tomorrow.

Harmachis: Greek name for the hieroglyphic *hr-m-akht* meaning "Horus in the horizon"

Heb-sed: a feast celebrated by the king at the 30th anniversary on the throne to renew his authority for ruling the country.

Hdjt: white colour, it also refers to the White Crown of Upper Egypt.

Henu: is a type of crowns related to Amun, worn by kings but more often by queens.

Hkr: is a floral decorative element that stems from the Archaic Period.

Heka: is a scepter hold by kings and deities, it is a sign for authority and rightness.

Hr-Ihy: is a god child in the triad of Dendera his father is Horus of Edfu, his mother Hathor.

Htp- di-ni-sw : is a canonic form of offerings, must be recited before making the offerings (offering formula).

Ka: is one of the basic elements that compose the human being in the Egyptian mythology, it is the vital power or the double of the person. In modern terms could be referred to as personality.

Khat: is one of the elements of the human being, it refers to the body.

Khentamenty: is the local god of Abydos meaning "first of the westerns" i.e. "first who was dead and entered the realm of the dead in the west".

Khepsh: is a sword of victory, given by Amun to the triumphant kings.

Khepresh: is the Blue Crown, known as "war crown".

Khepri: is a god represented with a beetle head symbolising the new born sun in the morning.

Khonsu Pakhrd: meaning Khonsu the child, it represents the son in the triad of Thebes where Amun is the father, Mut the mother.

Litany of Ra: New Kingdom royal funerary text composed in the 18th Dynasty and is contemporarily to the *Amduat*. It acclaims the sun god Ra under 75 different forms and also praises the king in the form of different deities.

Mastaba : Arabic name for a 'bench'. Name given to Old Kingdom tombs with a rectangular shape. It was used for both royal and private individuals.

Mat-ka-ra: is the coronation name of Queen Hatshepsut meaning "The soul of Ra".

Menat: is sacred collar offered by kings and gods, which was a sign of protection.

Mes: a verb meaning birth. It is also a royal insignia, used by kings and deities and consisting of three fox skins.

Mn-nfr: is the hieroglyphic name for Memphis, meaning "The stable monument". Memphis, the first capital of unified ancient Egypt was established by King Narmer *c.* 3200 BC.

Mn -kheprw-Ra: the coronation name of King Tuhotmosis IV. It means "The everlasting are the manifestations of Ra".

Mut-wrt-nbt-pt: a title used for goddesses, meaning "The great mother, the mistress of the sky".

Nbt-nht: one of the titles belonging to Hathor, which means "The mistress of sycamore".

Nbt-pt: one of the titles of Hathor, as she was related to the sky; Hathor itself means "The house of Horus".

Nbty: one of the five royal protocols of the ancient Egyptian monarchy. It means "The one who belongs to the two ladies 'Nekhbet' and 'Wadjit' the archaic goddesses of Upper and Lower Egypt.

Nemes: is the royal headdress consisting of a wig with *uraeus* in the forehead.

Netery-khet: the Horus name of the first king of the Third Dynasty Djoser, meaning "The divine body".

Niswt-bity: a title of the Egyptian protocol of kingship, it means "The king of Upper and Lower Egypt".

Opet: one of the most important festivals, at which the statue of Amun was carried from the temple of Karnak to the temple of Luxor. It took place in the second month of *akhet*.

Pschent: derived from the Greek, it means the Double Crown consisting of the White Crown of Upper Egypt and the Red Crown of Lower Egypt.

Psdjet: means nine as a number and at the same time refers to the Ennead deities of the Heliopolitain theology.

Pyramid Texts: the oldest known religious text in the world. It was inscribed on the walls of the inner chambers and passages of 5th and 6th Dynasty pyramids. The aim of the texts was to ensure the successful entry of the deceased king into the afterlife. This theme was continued later in the Coffin Texts and the 'Book of the Dead' for commoners. The Pyramid Texts was divided into chapters known as spells.

Rtnw: is the hieroglyphic name for the area of Syria-Palestine Upper *Rtnw* is northern Palestine and Lower *Rtnw* is Syria.

Sekhmet: a goddess represented with a lion-head and female body. She is the mother in the triad of Memphis, Ptah being the father and Nefrtum the son.

Sematawy: a sign of unification of Lower and Upper Egypt. It consists of lotus and papyrus combined by a heart and throat.

Shasw: a hieroglyphic name of Bedouins who lived in Sinai, Syria and Palestine.

Shawabti: a small figure of statues placed in the tomb as funerary servants to undertake tasks such as agriculture.

Shndiyt: a royal kilt worn in offerings scenes and statues as well.

Ta-set-Maat: means "The place of truth" it refers to the "Valley of the Kings".

Uraeus: is a royal ornament of cobra placed on the forehead to protect the king by throwing fire against enemies.

Wabet: means the pure chapel in the temple of Dendera. It has a magnificent astronomical ceiling.

Wdjit: the cobra goddess worshiped in the Lower Egyptian town Buto.

Was: scepter held by kings and gods which is considered a sign of prosperity.

Wserhat: is a divine boat used in *Opet* festival where the statue of Amun was carried on shoulders by the priests.

Wskht-khnt: means "the front hall" of the temple of Dendera. Is was not considered a real part of the temple because it was accessible to the public.

Index

nome 97
Northern or Red Pyramid 127, 128
Nubia 31 - 34, 281
Nubian sandstone 20
Nubians 71
Nun 21, 56, 69
Nut 54, 57, 61 - 62, 66, 99, 109, 156, 158, 195 -
 196

O

oasis of Amun 35
Old Cairo 21, 23
Old Cataract Hotel 25
Old Kingdom 21, 30, 35, 41 - 43, 61, 62, 70, 81,
 87, 90, 99, 109 - 110, 133, 147, 150
Omm el-Ga'ab 133
On 56
Opet festival 143, 163, 172
Orion 156
ornate chest 80
Osiris 38, 54 - 60, 62, 64 - 66, 68 - 69, 71, 80, 100,
 108, 115, 133, 136, 139, 193, 196, 198, 205 -
 206, 209, 219 - 220
Osiris complex 145
Osiris myth 58, 65
Osiron 66, 147
outer gold coffin of Tutankhamun 80

P

painted chest 13, 80
Pairi 224
Palermo Stone 30
Palestine 33
panel with adoration scene of the Aten 80, 130
pectoral of the sky goddess Nut 80
pectoral of Osiris 80
pectoral with a winged scarab 80
Pepi I 31, 70, 101, 110, 129
Pepi II 31, 110
Peribsen 30, 68, 100
Persian Rule 35
Petrie 89, 147
Philæ 23, 35, 37 - 38, 48, 63, 277 - 278
Piankhi 34, 101
Plutarch 59
Prehistoric Period 29
Prehistory 56
Primeval gods 56
Primeval hill 163
Primeval ocean 69, 99
Primeval water 56, 101
Psammetichos I 115
Psammetichus 34 - 35
Psammetichus II 35
Psammetichus III 35
pschent 59, 65, 135
Psusennes 34

Ptah 60, 63, 66, 68 - 69, 99 - 101, 115, 133, 138,
 145, 174, 196
Ptah-hotep 41, 103, 116, 118
Ptah-Sokar 47
Ptah-Tjenen 100
Ptolemaic (Greek) Period 23, 61, 35, 67, 171
Ptolemies 115
Ptolemy II 63, 134
Ptolemy III 62
Ptolemy IV 36
Ptolemy V 23, 48
Ptolemy IX 48
Ptolemy X 150
Ptolemy XII 278
Punt 61, 228, 235
Punt Hall 229
pylon of Ramses II 162, 168
pyramid of Chephren 92, 93
pyramid of Mycerinus 97
pyramid of Teti 102
pyramid of Unas 102, 108, 109
pyramid of Userkaf 102
Pyramid Texts 49, 65 - 66, 69, 108, 109, 110
pyramids of Giza 81

Q

quail 116
Qurna 34, 188, 236

R

Ra 31, 54, 56 - 57, 59 - 60, 62, 64, 66 - 67, 69, 101,
 110, 133, 160, 193, 196, 205, 209
Ra Herakhty 62, 99, 138
Ra-Hotep 42, 70
Ramesseum 34, 236
Ramose 221 - 222
Ramses I 34, 193, 198, 240
Ramses II 34, 80, 133, 161, 168, 171, 174 - 175,
 178, 182, 280 - 281
Ramses III 34, 47, 66, 68, 101, 171, 176, 220, 243,
 245
Ramses IV 34, 175, 206
Ramses VI 179, 195, 218
Ramses XI 34
Ramses XII 175
Red Crown 60 - 61, 80, 89, 153
Red Pyramid 127
Red Sea 20, 35
Red Sea fauna 232
Rekhmire 221
Rhoda Island 21
ritual of the opening of the mouth 193
Rock-cut tomb of Mehu 111
Roman birth house 153, 159
Roman Period 36
Rome 67
Rosetta Stone 48

Bibliography

Aldred Cyril, *Egyptian Art,* 1980, Thames & Hudson, London.

Aldred Cyril, *Egypt to the end of the Old Kingdom,* 1988, Thames & Hudson, London.

Aldred Cyril, *The Egyptians,* 1987, Thames & Hudson, London.

Arnold Dieter; *Die Tempel Ägyptens;* 1992, Artemis Verlag -AG, Zürich, Cairo, 2003, The American University in Cairo Book Press.

Armor Robert A., *Gods and Myths of Ancient Egypt,* 2004, The American University in Cairo Book Press, Cairo.

Arnold Dieter; *The Encyclopedia of Ancient Egyptian Architecture,* 2003, The American University in Cairo Book Press, Cairo.

Asmann Jan, *The Search for God in Ancient Egypt,* 2001, Cornell University Press, Ithaca.

Asmann Jan, *The Mind of Egypt,* 1996, Harvard University Press, Massachusetts.

Atiya Farid, *Pyramids of the Fourth Dynasty,* 2003, Farid Atiya Press, Cairo.

Atiya Farid, *Cheps's Solar Boat,* 2002, Farid Atiya Press, Cairo.

Atiya Farid, *Valley of the Kings,* 2006, Farid Atiya Press, Cairo.

Atiya Farid & Jobbins Jenny, *The Silent Desert, Bahariya and Farafra Oasis,* 2003, Farid Atiya Press, Cairo.

Bagnal Roger S. & Rathbone Dominic W., *Egypt, from Alexander to the Copts,* 2004, The British Museum Press, London.

Baines John & Malek Jaromir, *Atlas of Ancient Egypt,* 2002, The American University in Cairo Book Press, Cairo.

Bresciani, Edda; Donadoni, Sergio; *Bildwerten und Weltbilder der Pharaonen,* 1995, Philipp von Zabren, Mainz

Bowman Alan K, *Egypt after the Pharaohs*, 1986, British Museum Publications, London.

Budge Wallis E. A., *Egyptian Magic*, 1901, Dover Publications Inc., New York.

Clayton Peter, *Chronicle of the Pharaohs,* 1994, Thames & Hudson Ltd. London.

Collier Mark & Manley Bill, *How to read Egyptian Hieroglyphs, A step-by-step Guide to teach yourself,* 1998, The British Museum Press, London.

Corteggiani Jean-Pierre, *The Egypt of the Pharaohs at the Cairo Museum,* 1986, Hachette Guides Bleus, Paris.

David Rosalie, *Religion and Magic in Ancient Egypt,* 2002, Penguin Books, London.

Dodson Aidan, *Monarchs of the Nile,* 2000, The American University in Cairo Book Press, Cairo.

Dodson Aidan & Hilton Dyan; *The Complete Royal Families of Ancient Egypt,* 2004, Thames & Hudson Ltd, London.

Doxiadis Euphrosyne; *The Mysterious Fayum Potraits, Faces from Ancient Egypt,* 1995, The American University in Cairo Book Press, Cairo.

Dunand Françoise and Zivie-Coche Christiane; *Gods and Men in Egypt, 3000 BCE to 395 CE,* 2004, Cornell University Press, Ithaca.

Edwards I. E. S.; *The Pyramids of Egypt,* 1964, Penguin Books Ltd,

Erman Adolf, *Life in Ancient Egypt,* 1971, Dover Publications Inc., New York.

Fakhry Ahmed, *The Pyramids,* 1961, University of Chicago Press, 1961.

Freed E. Rita & Markowitz Yvonne J., *Pharaohs of the Sun, Akhenaten, Nefertiti, Tutankhamen,* 1999, Thames & Hudson Ltd., London.

Grajetzki Wolfram; *Ancient Egyptian Queens,* 2005, Golden House Publications, London.

Grajetzki Wolfram; *The Middle Kingdom of Ancient Egypt,* 2006, Duckworth, London.

Griffiths J. Gwyn; *The Conflict in Horus and Seth,* 1960, Liverpool University Press, Liverpool.

Grimal Nicolas, *A History of Ancient Egypt,* 1992, Blackwell Publishers Ltd, Oxford.

Grimm Alfred, Schoske Sylvia, *Hatshepsut Königin Ägyptens,* 1999, Staatliche Sammlung Ägyptischer Kunst, München.

Habachi Labib, *The Obelisks of Egypt*, 1988, The American University in Cairo Book Press, Cairo.

Hart George, *Egyptian Myths*, 1990, 2005, British Museum Press, London.

Hawas Zahi, *The Treasures of the Pyramids*, 2003, The American University in Cairo Book Press, Cairo.

Hawas Zahi, *The Valley of the Golden Mummies*, 2000, The American University in Cairo Book Press, Cairo.

Hawas Zahi, *Silent Images : Women in Pharaonic Egypt*, 2000, The American University in Cairo Book Press, Cairo.

Hawas Zahi, *The Secrets of the Sphinx : Restoration Past and Present*, 1998, The American University in Cairo Book Press, Cairo.

Hawas Zahi, *Secrets from the Sand : My Search for Egypt's Past*, 2003, The American University in Cairo Book Press, Cairo.

Hawas Zahi, *The Mysteries of Abu-Simbel : Ramesses II and the Temples of the Rising Sun*, 2001, The American University in Cairo Book Press, Cairo.

Hoffman Michael H., *Egypt before the Pharaohs*, 1990, Dorset Press, New York.

Hornung Erik, *Conception of God in Ancient Egypt*, 1982, T. J. Press, UK.

Hornung Erik, *Die Unterwelts Bücher der Ägypter*, 1997, Artemis Verlag, Zürich.

Hornung Erik, *Die Nachfahrt der Sonne*, 1991, Artemis Verlag, Zürich.

Hornung Erik, *History of Ancient Egypt*, 1992, Edinbrough University Press, Edinbrough.

Hornung Erik, *The Tomb of Pharaoh Seti I*, 1991, Artemis Verlag, Zürich.

Ikram Salima & Dodson Aidan, *The Mummy in Ancient Egypt*, 1998; Thames & Hudson Ltd, London.

Kemp Barry J., *Ancient Egypt, Anatomy of a Civilation*, 1989, Routelage, London and New York.

Kurth Dieter, The Temple of Edfu, 2004, Wissenschaftliche Buchgesellschaft, Darmstadt.

Lehner Mark, *The Complete Pyramids*, 1997, Thames & Hudson Ltd., London.

James, T. G. H., *Tutankhamun*, 2000, The American University in Cairo Book Press,Cairo.

James, T. G. H., *Ancient Egypt, The Land and its Legacy*, 1988, British Museum Publication.

James, T. G. H., *The British Museum Concise Introduction, Ancient Egypt*, 2005, British Museum Press, London.

Kamerin, Janice, *Ancient Egyptian Hieroglyphs*, 2005, The American University in Cairo Book Press, Cairo.

Malek Jaromir & Forman Werner, *In the Shadow of the Pyramids*, 1986 Orbis Book Publishing Corporation Limited.

Malek Jaromir, *Egypt, 4000 Years of Art*, 2003, Phaidon Press Limited, London.

Oakes Lorna & Gahlin Lucia; *The Mysteries of Ancient Egypt, An illustrated reference to the myths, religions, pyramids and temples of the land of the pharaohs*, 2002, Lorenz Books, London.

Parkinson R. B., *Voices from Ancient Egypt, an Anathology of Middle Kingdom Writings*, 1991, British Museum Press, London.

Pinch Geraldine, *Egyptian Myth, A very short Introduction*, 2004, Oxford University Press, Oxford.

Pinch Geraldine, *Egyptian Mythology, A Guide to the Gods, Goddesses and traditions of Ancient Egypt*, 2002, ABC-Clio Inc., New York.

Reevs Nicholas, *The Complete Tutankhamun*, 1990, Thames & Hudson Ltd, London.

Redford Donald B, *The Ancient Gods speak; a guide to Egyptian Religion*, 2002, Oxford University Press, Oxford.

Rice Michael, *Egypt's Making*, 1990, Routelage, London and New York.

Roberts Alison, *My Heart My Mother, Death and Rebirth in Ancient Egypt*, 1995, NorthGate Publishers, England.

Roberts Alison, *Hathor Rising, The Serpent Power of Ancient Egypt*, 2000, NorthGate Publishers, England.

Romer John, *Valley of the Kings*, 1981, Castle Books, New Jersy.

Saghir Mohammed el-, *Das Statuenversteck im Luxortempel*, 1992, Verlag Philipp Von Zabren, Mainz.

Schulz, Régine and Mathias Seidel; *Egypt, the World of the Pharaohs;* Cologne, 1998 Könemann Verlagsgesellschaft mbH.

Shafer Byron E., Arnold Dieter, Haeny Gerhard, Bell Lanny, Finnestad Ragnhild Bjerre, *Temples of Ancient Egypt,* 1997 Tauris & Co. Ltd., New York.

Shahawy Abeer, *The Funerary Art of Ancient Egypt, A Bridge to the Realm of the Hereafter,* 2005, Farid Atiya Press, Cairo.

Shahawy Abeer, *Luxor Museum, The Glory of Ancient Thebes,* 2005, Farid Atiya Press, Cairo.

Shahawy Abeer, *The Egyptian Museum in Cairo, A Walk through the Alleys of Ancient Egypt,* 2005, Farid Atiya Press, Cairo.

Shahawy Abeer, *The Pocket Book of the Egyptian Museum in Cairo,* 2005, Farid Atiya Press, Cairo.

Shahawy Abeer, *The Pocket Book of Tutankhamun,* 2005, Farid Atiya Press, Cairo.

Shaw Ian, *The Oxford History of Ancient Egypt,* 2000, Oxford University Press, Oxford.

Shaw Ian & Nicholson Paul, *Dictionary of Ancient Egypt;* 1995, The British Museum Press.

Simpkins Mark A., Taylor Susan, *Ramses II,* 1985, Simpkins Splendor of Egypt, Salt Lake City.

Strouhal Eugen, *Ägypten zur Pharaonen zeit, Alltag und gesellschatliches Leben,* 1989, Wasmuth Verlag, Tübingen, Berlin.

Stadelmann Rainer, *Die Ägyptischen Pyramiden,* 1985, Wissenschaftliche Buchgesellschaft, Darmstadt.

Steindorf Georg; *When Egypt Ruled the East,* 1961, Chicago, The University of Chicago Press.

Strudwick Nigel & Helen, *Thebes in Egypt,* 1999, British Museum Press, London.

Trigtger B. G., Kemp B. J., O'Connor D. & LLoyd A. B., *Ancient Egypt, A Social History,* 2005, Cambridge University Press, Cambridge.

Verner Miroslav, *Abusir, Realm of Osiris,* 2002, The American University in Cairo Book Press, Cairo.

Verner Miroslav, *The Pyramids,* 2002, The American University in Cairo Book Press, Cairo.

Watterson Barbara; *Gods of Ancient Egypt,* 2003, Sutton Publishing, Gloucestershire.

Weeks, Kent; *The Treasures of the Valley of the Kings,* 2000, The American University in Cairo Book Press,

Wilkinson Richard H., *Reading Egyptian Art, A Hieroglyphic Guide to Ancient Egyptian Painting and Sculpture,* 1992, Thames & Hudson Ltd, London.

Wilkinson Richard H., *The Complete Gods and Goddesses of Ancient Egypt,* 2003, Thames & Hudson Ltd, London.

Wilkinson Richard H., *The Complete Temples of Ancient Egypt, 2004,* Thames & Hudson Ltd, London.

Wilkinson Toby A. H.; *Early Dynastic Egypt,* 1999, Routelage, London and New York.

Triadritti Francesco, *The Treasures of the Egyptian Museum,* 2000, The American University in Cairo Book Press, Cairo.

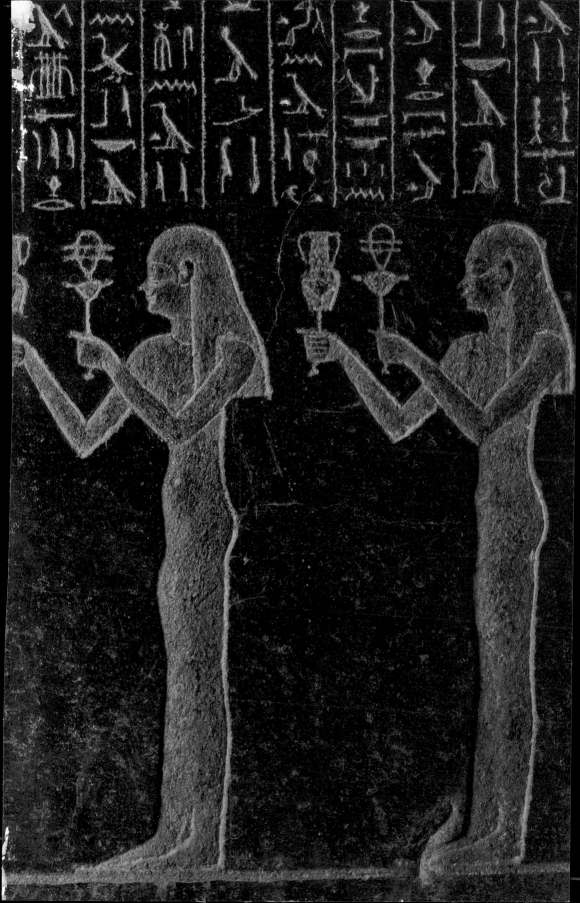